THE NUDE: A STUDY IN IDEAL FORM

A STUDY IN IDEAL FORM

THE NUDE

by

KENNETH CLARK

DOUBLEDAY ANCHOR BOOKS

DOUBLEDAY & COMPANY, INC.

GARDEN CITY, NEW YORK

To
Bernard Berenson

This is the second of the A. W. Mellon Lectures in
the Fine Arts, which are delivered annually at the
National Gallery of Art, Washington, D.C. The
present lectures were delivered in 1953 and con-
stitute Number XXXV · 2 in the Bollingen Series,
sponsored by the Bollingen Foundation, Inc., and
published by Pantheon Books, Inc.

ISBN: 0-385-09388-8

The cover photograph is a detail of Michelangelo's
David. Cover design by Leonard Baskin. Typog-
raphy by Edward Gorey.

15 14 13 12

PREFACE

In the spring of 1953 I gave six lectures on the nude, as The A. W. Mellon Lectures in the Fine Arts at the National Gallery of Art, in Washington. I have never spoken to a more responsive and intelligent audience, and I should like to have given every member of it a copy of this book as a token of gratitude as soon as the course was over. But the lectures had to be considerably lengthened, three new chapters had to be written, and at the last minute my publishers persuaded me to add a section of notes. This has meant a delay of almost three years, and I would like to thank the Mellon Lectureship and Bollingen Foundation for the patience they have shown in waiting for the book to be finished.

Considering how the nude dominated sculpture and painting at two of the chief epochs in their history, one might have expected a small library on the subject. But in fact there are only two general studies of any value, Julius Lange's *Die menschliche Gestalt in der Geschichte der Kunst* (1903) and Wilhelm Hausenstein's *Der nackte Mensch* (1913), in which much useful material is cooked into a Marxist stew. The fact is, as I soon discovered, that the subject is extremely difficult to handle. There is a difficulty of form; a chronological survey would be long and repetitive, but almost every other pattern is unworkable. And there is a difficulty of scope. Since Jakob Burckhardt no responsible art historian would have attempted to cover both antique and post-medieval art. I recognize that it is imprudent for a student of Renaissance painting to have written so many pages about classical sculpture; but I am unrepentant—indeed, I believe that these constitute the most useful part of the book.

The dwindling appreciation of antique art during the last fifty years has greatly impoverished our understanding of art in general; and professional writers on classical archeology, microscopically re-examining their scanty evidence, have not helped us to understand why it was that for four hundred years artists and amateurs shed tears of admiration before works that arouse no tremor of emotion in us.

But although I believe that this attempt to revalue the once-familiar monuments of antiquity was worth making, I cannot claim that I was fully qualified to make it. The reader should be warned that my pages on classical art are peppered with heresies, some intentional, some, no doubt, owing to ignorance. From the Renaissance onward I am more orthodox, but even then I have had to enter certain fields of scholarship—Michelangelo, for example, or Rubens—that bear the sign: "Trespassers will be prosecuted."

In trying to find my way through these dense and intricate subjects I have received generous help from eminent scholars and should like to express my gratitude to them. Professor Ashmole and M. Jean Charbonneaux have answered my questions about antique art; Professor Johannes Wilde has given me the benefit of his unequaled knowledge of Michelangelo, and on all matters concerning the survival of antique imagery I have received much help from Dr. L. D. Ettlinger of the Warburg Institute. On this last subject I must acknowledge a debt to a recent book by A. von Salis, *Antike und Renaissance,* which came to my notice when I was already at work on the nude and amplified many of my own conclusions. In the troublesome business of collecting photographs, of which only about a quarter have found a place in this book, I was greatly helped by Mrs. Anthony P. Millman. Finally, I must record my especial gratitude to Miss Caryl Whineray, without whom the notes could never have been completed.

<div align="right">K. C.</div>

ACKNOWLEDGMENTS

I acknowledge my indebtedness to Her Majesty the Queen for gracious permission to reproduce six pictures in the Royal Library, Windsor.

My thanks are due to the following who have kindly helped me in securing the photographs reproduced in this book: Professor Bernard Ashmole; Lord Ellesmere; Lord Herbert; The Earl of Leicester; G. Zarnecki, Esq.

Acknowledgments are due to the curators of the following galleries and museums, and to the following photographers and publishers:

A. C. L., Brussels; Acropolis Museum, Athens; Albertina, Vienna; Alinari, Florence; Alte Pinakothek, Munich; Anderson, Rome; Archaeological Museum, Gwalior; Archives Photographiques, Paris; Art Institute, Chicago; Arts Council, London; Ashmolean Museum, Oxford; Bakwin Collection, New York; Baltimore Museum of Art; Bildarchiv-Foto-Marburg; Braun et Cie, Mulhouse and Dornach (courtesy Soho Gallery, London); British Museum, London; Brogi, Florence; Bruckmann, Munich; Bulloz, Paris; Paul Bytebier, Brussels; Capitoline Museum, Rome; Virginie Chauffourier, Rome; Cleveland Museum of Art; Courtauld Institute of Art, London; Devonshire Collection, Chatsworth (courtesy Trustees of the Chatsworth Settlement); Fogg Museum of Art, Harvard University; Foto Grassi, Siena; A. Frequin, The Hague; Gemäldegalerie, Kassel; Giraudon, Paris; Glyptothek, Munich; Isabella Stewart Gardner Museum, Boston; Kunsthistorisches Museum, Vienna; Kupferstichkabinett, Kunstmuseum, Basel; Lahore (Pakistan) Museum; Louvre, Paris; Mansell Collection, London; Metropolitan Museum

7

of Art, New York; Museum of Modern Art, New York; National Gallery, London; National Museum, Athens; Ny Carlsberg Glyptotek, Copenhagen; Phaidon Press, London; Philadelphia Museum of Art; Photo Estel, Paris; Rheinisches Museum, Cologne; Rijksmuseum, Amsterdam; Royal Academy of Arts, London; Staatliche Kunsthalle, Karlsruhe; Staatliche Kunstsammlungen, Dresden; Staatliche Museen, Berlin; Städelsches Kunstinstitut, Frankfurt a. M.; Tate Gallery, London; Uffizi Gallery, Florence; Vatican Museums, Rome; Victoria and Albert Museum, London; Roger Viollet, Paris; Warburg Institute, London.

CONTENTS

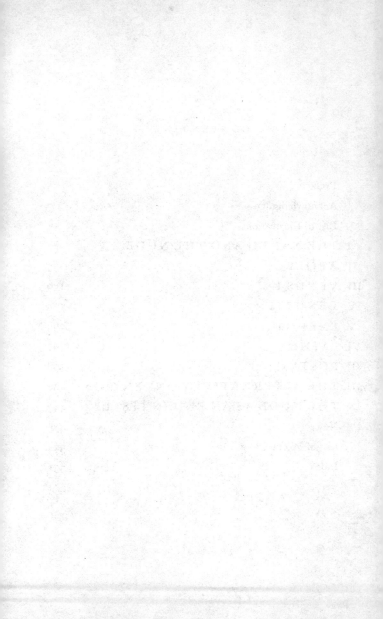

ILLUSTRATIONS

I. THE NAKED AND THE NUDE

1. *Velásquez. The Rokeby Venus. National Gallery, London*
2. *Greek mirror, 2nd century* B.C. *Louvre*
3. *Picasso. Bathers. Fogg Museum, Cambridge, Mass.*
4. *Courbet. La Source. Louvre*
5. *Rejlander. Photograph*
6. *Kyonaga. Color print. Boston*
7. *Etruscan tomb. Il Obeso. Tarquinia*
8. *Villard de Honnecourt. Antique figures. Bibliothèque Nationale, Paris*
9. *Leonardo da Vinci. Vitruvian man. Accademia, Venice*
10. *Cesariano. Vitruvian man. From the Como Vitruvius, 1521*
11. *Dürer. Nemesis. Engraving*
12. *Dürer. Measured nude. Albertina, Vienna*
13. *French, 16th century. Bronze cast of Aphrodite of the Belvedere. Louvre*
14. *Memlinc workshop. Eve. Vienna*
15. *Sansovino. Apollo. Loggetta, Venice*
16. *Greco-Roman. Apollo. Naples*
17. *Attic, early 5th century* B.C. *Palaestra scene. British Museum*
18. *Austrian ms., 12th century. Three Graces. British Museum*
19. *Michelangelo. Crucifixion. British Museum*

II. APOLLO

III. VENUS I

V. ENERGY

VIII. ALTERNATIVE CONVENTION

IX. THE NUDE AS AN END IN ITSELF

NOTES

THE NUDE: A STUDY IN IDEAL FORM

Les belles filles, que vous aurez vues à Nîmes, ne vous auront, je m'assure, pas moins délecté l'esprit par la vue que les belles colonnes de la Maison Carrée, vu que celles-ci ne sont que de vieilles copies de celles-là.

Nicolas Poussin to Chantelou, March 20, 1642

J'ai passé hier une grande heure à regarder se baigner les dames. Quel tableau! Quel hideux tableau!

Flaubert to Louise Colet, August 14, 1853

For soule is forme, and doth the bodie make.

Spenser, *Hymne in Honour of Beautie, 1596*

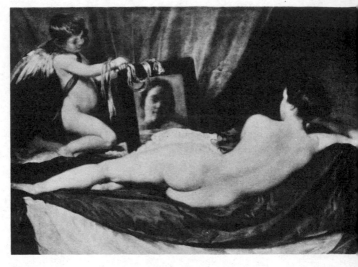

1. Velásquez. The Rokeby Venus

I

THE NAKED AND
THE NUDE

THE ENGLISH language, with its elaborate generosity, distinguishes between the naked and the nude. To be naked is to be deprived of our clothes, and the word implies some of the embarrassment most of us feel in that condition. The word "nude," on the other hand, carries, in educated usage, no uncomfortable overtone. The vague image it projects into the mind is not of a huddled and defenseless body, but of a balanced, prosperous, and confident body: the body re-formed. In fact, the word was forced into our vocabulary by critics of the early eighteenth century to persuade the artless islanders that, in countries where painting and sculpture were practiced and valued as they should be, the naked human body was the central subject of art.

For this belief there is a quantity of evidence. In the greatest age of painting, the nude inspired the greatest works; and even when it ceased to be a compulsive subject it held its position as an academic exercise and a demonstration of mastery. Velásquez, living in the prudish and corseted court of Philip IV and admirably incapable of idealization, yet felt bound to paint the *Rokeby Venus* [*1*]. Sir Joshua Reynolds, wholly without the gift of formal draftsmanship, set great store by his *Cymon and Iphigenia*. And in our own century, when we have shaken off one by one those inheritances of Greece which were revived at

the Renaissance, discarded the antique armor, forgotten the
subjects of mythology, and disputed the doctrine of imitation,
the nude alone has survived. It may have suffered some curious
transformations, but it remains our chief link with the classic
disciplines. When we wish to prove to the Philistine that our
great revolutionaries are really respectable artists in the tradi-
tion of European painting, we point to their drawings of the
nude. Picasso has often exempted it from that savage meta-
morphosis which he has inflicted on the visible world and has
produced a series of nudes [3] that might have walked unaltered
off the back of a Greek mirror [2]; and Henry Moore, search-
ing in stone for the ancient laws of its material and seeming to
find there some of those elementary creatures of whose fossilized
bones it is composed, yet gives to his constructions the same

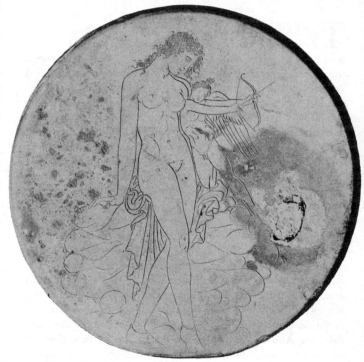

2. *Greek mirror, 2nd century* B.C.

fundamental character that was invented by the sculptors of the Parthenon in the fifth century before Christ.

These comparisons suggest a short answer to the question, "What is the nude?" It is an art form invented by the Greeks in the fifth century, just as opera is an art form invented in seventeenth-century Italy. The conclusion is certainly too abrupt, but it has the merit of emphasizing that the nude is not the subject of art, but a form of art.

3. Picasso. Bathers

It is widely supposed that the naked human body is in itself an object upon which the eye dwells with pleasure and which we are glad to see depicted. But anyone who has frequented art schools and seen the shapeless, pitiful model that the students are industriously drawing will know this is an illusion. The body is not one of those subjects which can be made into art by direct transcription—like a tiger or a snowy landscape. Often in looking at the natural and animal world we joyfully identify ourselves with what we see and from this happy union create a work of art. This is the process students of aesthetics call empathy, and it is at the opposite pole of creative activity

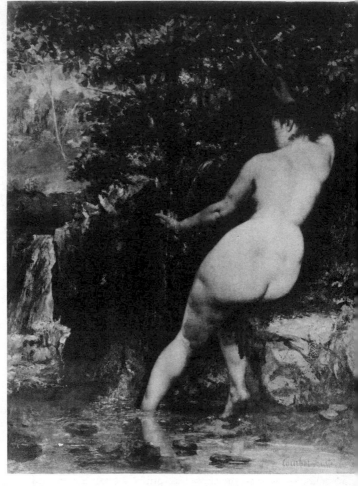

4. Courbet. La Source

to the state of mind that has produced the nude. A mass of naked figures does not move us to empathy, but to disillusion and dismay. We do not wish to imitate; we wish to perfect. We become, in the physical sphere, like Diogenes with his lantern looking for an honest man; and, like him, we may never be

rewarded. Photographers of the nude are presumably engaged
in this search, with every advantage; and having found a
model who pleases them, they are free to pose and light her in
conformity with their notions of beauty; finally, they can tone
down and accentuate by retouching. But in spite of all their
taste and skill, the result is hardly ever satisfactory to those
whose eyes have grown accustomed to the harmonious simpli-
fications of antiquity. We are immediately disturbed by
wrinkles, pouches, and other small imperfections, which, in the
classical scheme, are eliminated. By long habit we do not
judge it as a living organism, but as a design; and we discover
that the transitions are inconclusive, the outline is faltering.
We are bothered because the various parts of the body cannot
be perceived as simple units and have no clear relationship to
one another. In almost every detail the body is not the shape
that art had led us to believe it should be. Yet we can look with
pleasure at photographs of trees and animals, where the canon
of perfection is less strict. Consciously or unconsciously, pho-
tographers have usually recognized that in a photograph of the
nude their real object is not to reproduce the naked body, but
to imitate some artist's view of what the naked body should be.
Rejlander was the most Philistine of the early photographers,
but, perhaps without knowing it, he was a contemporary of
Courbet [4], and with this splendid archetype somewhere in
the background he produced one of the finest (as well as one
of the first) photographs of the nude [5]. He succeeded partly
because his unconscious archetype was a realist. The more
nearly ideal the model, the more unfortunate the photographs
that try to imitate it—as those in the style of Ingres or Whistler
prove.

So that although the naked body is no more than the point
of departure for a work of art, it is a pretext of great impor-
tance. In the history of art, the subjects that men have chosen
as nuclei, so to say, of their sense of order have often been in
themselves unimportant. For hundreds of years, and over an
area stretching from Ireland to China, the most vital expression
of order was an imaginary animal biting its own tail. In the
Middle Ages drapery took on a life of its own, the same life
that had inhabited the twisting animal, and became the vital
pattern of Romanesque art. In neither case had the subject any

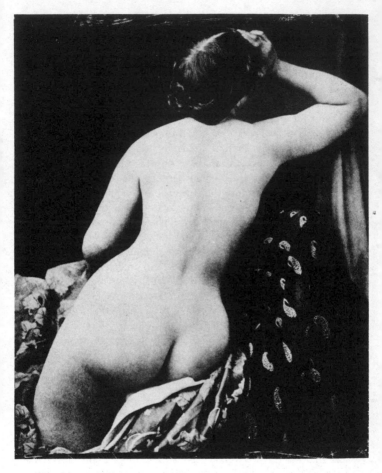

5. Rejlander. Photograph (Gernsheim Collection)

independent existence. But the human body, as a nucleus, is
rich in associations, and when it is turned into art these asso-
ciations are not entirely lost. For this reason it seldom achieves
the concentrated aesthetic shock of animal ornament, but it
can be made expressive of a far wider and more civilizing ex-
perience. It is ourselves and arouses memories of all the things

we wish to do with ourselves; and first of all we wish to perpetuate ourselves.

This is an aspect of the subject so obvious that I need hardly dwell on it; and yet some wise men have tried to close their eyes to it. "If the nude," says Professor Alexander, "is so treated that it raises in the spectator ideas or desires appropriate to the material subject, it is false art, and bad morals." This highminded theory is contrary to experience. In the mixture of memories and sensations aroused by Rubens' *Andromeda* [*107*] or Renoir's *Bather* [*121*] are many that are "appropriate to the material subject." And since these words of a famous philosopher are often quoted, it is necessary to labor the obvious and say that no nude, however abstract, should fail to arouse in the spectator some vestige of erotic feeling, even though it be only the faintest shadow—and if it does not do so, it is bad art and false morals. The desire to grasp and be united with another human body is so fundamental a part of our nature that our judgment of what is known as "pure form" is inevitably influenced by it; and one of the difficulties of the nude as a subject for art is that these instincts cannot lie hidden, as they do, for example, in our enjoyment of a piece of pottery, thereby gaining the force of sublimation, but are dragged into the foreground, where they risk upsetting the unity of responses from which a work of art derives its independent life. Even so, the amount of erotic content a work of art can hold in solution is very high. The temple sculptures of tenth-century India are an undisguised exaltation of physical desire; yet they are great works of art because their eroticism is part of their whole philosophy.

Apart from biological needs, there are other branches of human experiences of which the naked body provides a vivid reminder—harmony, energy, ecstasy, humility, pathos; and when we see the beautiful results of such embodiments, it must seem as if the nude as a means of expression is of universal and eternal value. But this we know historically to be untrue. It has been limited both in place and in time. There are naked figures in the paintings of the Far East; but only by an extension of the term can they be called nudes. In Japanese prints they are part of *ukioye,* the passing show of life, which includes, without comment, certain intimate scenes usually

allowed to pass unrecorded [6]. The idea of offering the body
for its own sake, as a serious subject of contemplation, simply
did not occur to the Chinese or Japanese mind, and to this day
raises a slight barrier of misunderstanding. In the Gothic North
the position was fundamentally very similar. It is true that
German painters in the Renaissance, finding that the naked
body was a respected subject in Italy, adapted it to their needs,
and evolved a remarkable convention of their own. But Dürer's
struggles show how artificial this creation was. His instinctive
responses were curiosity and horror, and he had to draw a
great many circles and other diagrams before he could brace
himself to turn the unfortunate body into the nude.

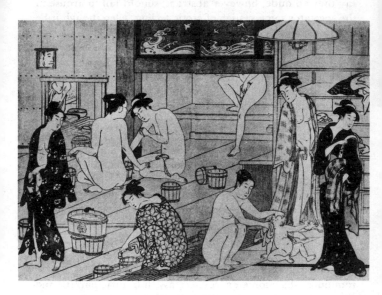

6. Kyonaga. Color print

Only in countries touching on the Mediterranean has the
nude been at home; and even there its meaning was often for-
gotten. The Etruscans, owing three quarters of their art to
Greece, never abandoned a type of tomb figure in which the
defunct man displays his stomach with a complacency that
would have shocked a Greek profoundly [7]. Hellenistic and

7. *Etruscan tomb. Il Obeso*

Roman art produced statues and mosaics of professional ath-
letes who seem satisfied with their monstrous proportions.
More remarkable still, of course, is the way in which the nude,
even in Italy and Greece, is limited by time. It is the fashion
to speak of Byzantine art as if it were a continuation of Greek;
the nude reminds us that this is one of the refined excesses of
specialization. Between the Nereids of late Roman silver and
the golden doors of Ghiberti the nudes in Mediterranean art
are few and insignificant—a piece of modest craftsmanship like
the Ravenna ivory *Apollo and Daphne,* a few *objets de luxe,* like
the Veroli Casket, with its cartoon-strip Olympus, and a num-
ber of Adams and Eves whose nakedness seldom shows any
memory of antique form. Yet, during a great part of that mil-
lennium, the masterpieces of Greek art had not yet been de-
stroyed, and men were surrounded by representations of the
nude more numerous and, alas, infinitely more splendid than
any that have come down to us. As late as the tenth century
the *Knidian Aphrodite* of Praxiteles, which had been carried to
Constantinople, it is said, by Theodosius, was praised by the

Emperor Constantine Porphyrogenitus; and a famous bronze copy of it is mentioned by Robert de Clari in his account of the taking of Constantinople by the Crusaders. Moreover, the body itself did not cease to be an object of interest in Byzantium: this we may deduce from the continuation of the race. Athletes performed in the circus; workmen, stripped to the waist, toiled at the building of St. Sophia. There was no want of opportunity for artists. That their patrons did not demand representations of the nude during this period may be explained by a number of reasonable-looking causes—fear of idolatry, the fashion for asceticism, or the influence of Eastern art. But in fact such answers are incomplete. The nude had ceased to be the subject of art almost a century before the official establishment of Christianity. And during the Middle Ages there would have been ample opportunity to introduce it both into profane decoration and into such sacred subjects as show the beginning and the end of our existence.

Why, then, does it never appear? An illuminating answer is to be found in the notebook of the thirteenth-century architect, Villard de Honnecourt. This contains many beautiful drawings of draped figures, some of them showing a high degree of skill. But when Villard draws two nude figures [8] in what he believes to be the antique style the result is painfully ugly. It was impossible for him to adapt the stylistic conventions of Gothic art to a subject that depended on an entirely different system of forms. There can be few more hopeless misunderstandings in art than his attempt to render that refined abstraction, the antique torso, in terms of Gothic loops and pothooks. Moreover, Villard has constructed his figures according to the pointed geometrical scheme of which he himself gives us the key on another page. He evidently felt that the divine element in the human body must be expressed through geometry. Cennino Cennini, the last chronicler of medieval practice, says, "I will not tell you about irrational animals, because I have never learned any of their measurements. Draw them from nature, and in this respect you will achieve a good style." The Gothic artists could draw animals because this involved no intervening abstraction. But they could not draw the nude because it was an idea: an idea that their philosophy of form could not assimilate.

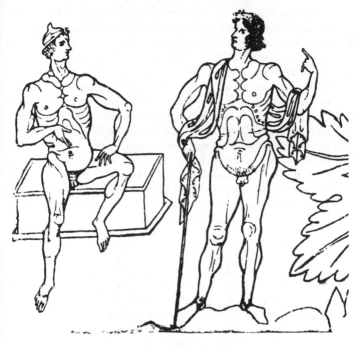

8. Villard de Honnecourt. Antique figures

As I have said, in our Diogenes search for physical beauty our instinctive desire is not to imitate but to perfect. This is part of our Greek inheritance, and it was formulated by Aristotle with his usual deceptive simplicity. "Art," he says, "completes what nature cannot bring to a finish. The artist gives us knowledge of nature's unrealized ends." A great many assumptions underlie this statement, the chief of which is that everything has an ideal form of which the phenomena of experience are more or less corrupted replicas. This beautiful fancy has teased the minds of philosophers and writers on aesthetics for over two thousand years, and although we need not plunge into a sea of speculation, we cannot discuss the nude without considering its practical application, because every time we criticize a figure, saying that a neck is too long, hips are too wide or breasts too small, we are admitting, in quite concrete

terms, the existence of ideal beauty. Critical opinion has varied
between two interpretations of the ideal, one unsatisfactory be-
cause it is too prosaic, the other because it is too mystical. The
former begins with the belief that although no individual body
is satisfactory as a whole, the artist can choose the perfect parts
from a number of figures and then combine them into a per-
fect whole. Such, we are told by Pliny, was the procedure of
Zeuxis when he constructed his *Aphrodite* out of the five beauti-
ful maidens of Kroton, and the advice reappears in the earliest
treatise on painting of the postantique world, Alberti's *Della
Pittura*. Dürer went so far as to say that he had "searched
through two or three hundred." The argument is repeated
again and again for four centuries, never more charmingly than
by the French seventeenth-century theorist, Du Fresnoy, whom
I shall quote in Mason's translation:

> *For tho' our casual glance may sometimes meet*
> *With charms that strike the soul and seem complete,*
> *Yet if those charms too closely we define,*
> *Content to copy nature line for line,*
> *Our end is lost. Not such the master's care,*
> *Curious he culls the perfect from the fair;*
> *Judge of his art, thro' beauty's realm he flies,*
> *Selects, combines, improves, diversifies;*
> *With nimble step pursues the fleeting throng,*
> *And clasps each Venus as she glides along.*

Naturally, the theory was a popular one with artists: but it sat-
isfies neither logic nor experience. Logically, it simply transfers
the problem from the whole to the parts, and we are left ask-
ing by what ideal pattern Zeuxis accepted or rejected the arms,
necks, bosoms, and so forth of his five maidens. And even ad-
mitting that we do find certain individual limbs or features
that, for some mysterious reason, seem to us perfectly beautiful,
experience shows us that we cannot often recombine them.
They are right in their setting, organically, and to abstract
them is to deprive them of that rhythmic vitality on which
their beauty depends.

To meet this difficulty the classic theorists of art invented
what they called "the middle form." They based this notion
on Aristotle's definition of nature, and in the stately language

of Sir Joshua Reynolds' *Discourses* it seems to carry some conviction. But what does it amount to, translated into plain speech? Simply that the ideal is composed of the average and the habitual. It is an uninspiring proposition, and we are not surprised that Blake was provoked into replying, "All Forms are Perfect in the Poet's Mind but these are not Abstracted or compounded from Nature, but are from the Imagination." Of course he is right. Beauty is precious and rare, and if it were like a mechanical toy, made up of parts of average size that could be put together at will, we should not value it as we do. But we must admit that Blake's interjection is more a believer's cry of triumph than an argument, and we must ask what meaning can be attached to it. Perhaps the question is best answered in Crocean terms. The ideal is like a myth, in which the finished form can be understood only as the end of a long process of accretion. In the beginning, no doubt, there is the coincidence of widely diffused desires and the personal tastes of a few individuals endowed with the gift of simplifying their visual experiences into easily comprehensible shapes. Once this fusion has taken place, the resulting image, while still in a plastic state, may be enriched or refined upon by succeeding generations. Or, to change the metaphor, it is like a receptacle into which more and more experience can be poured. Then, at a certain point, it is full. It sets. And, partly because it seems to be completely satisfying, partly because the mythopoeic faculty has declined, it is accepted as true. What both Reynolds and Blake meant by ideal beauty was really the difffused memory of that peculiar physical type developed in Greece between the years 480 and 440 B.C., which in varying degrees of intensity and consciousness furnished the mind of Western man with a pattern of perfection from the Renaissance until the present century.

Once more we have returned to Greece, and it is now time to consider some peculiarities of the Greek mind that may have contributed to the formation of this indestructible image.

The most distinctive is the Greek passion for mathematics. In every branch of Hellenic thought we encounter a belief in measurable proportion that, in the last analysis, amounts to a mystical religion; and as early as Pythagoras it had been given the visible form of geometry. All art is founded on faith, and

inevitably the Greek faith in harmonious numbers found ex-
pression in their painting and sculpture; but precisely how we
do not know. The so-called canon of Polykleitos is not recorded,
and the rules of proportion that have come down to us through
Pliny and other ancient writers are of the most elementary
kind. Probably the Greek sculptors were familiar with a system
as subtle and elaborate as that of their architects, but we have
scarcely any indication as to what it was. There is, however,
one short and obscure statement in Vitruvius that, whatever it
meant in antiquity, had a decisive influence on the Renaissance.
At the beginning of the third book, in which he sets out to give
the rules for sacred edifices, he suddenly announces that these
buildings should have the proportions of a man. He gives some
indication of correct human proportions and then throws in a
statement that man's body is a model of proportion because
with arms or legs extended it fits into those "perfect" geomet-
rical forms, the square and the circle. It is impossible to exag-
gerate what this simple-looking proposition meant to the men
of the Renaissance. To them it was far more than a convenient
rule: it was the foundation of a whole philosophy. Taken to-
gether with the musical scale of Pythagoras, it seemed to offer
exactly that link between sensation and order, between an or-
ganic and a geometric basis of beauty, which was (and perhaps
remains) the philosopher's stone of aesthetics. Hence the many
diagrams of figures standing in squares or circles that illustrate
the treatises on architecture or aesthetics from the fifteenth to
the seventeenth century.

Vitruvian man, as this figure has come to be called, appears
earlier than Leonardo da Vinci, but it is in Leonardo's famous
drawing in Venice [9] that he receives his most masterly expo-
sition; also, on the whole the most correct, for Leonardo makes
only two slight deviations from Vitruvius, whereas most of the
other illustrations follow him very sketchily. This is not one of
Leonardo's most attractive drawings, and it must be admitted
that the Vitruvian formula does not provide any guarantee of
a pleasant-looking body. The most carefully worked-out illus-
tration of all, in the Como Vitruvius of 1521, shows an un-
graceful figure with head too small and legs and feet too big
[10]. Especially troublesome was the question of how the square
and the circle, which were to establish the perfect form, should

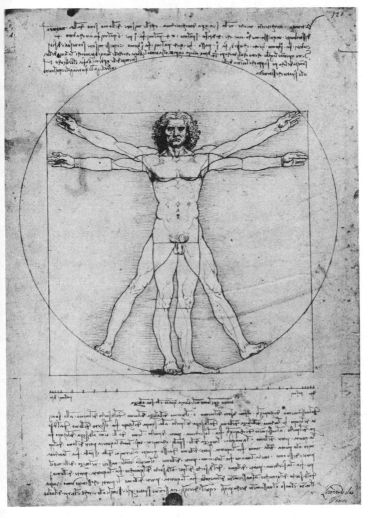

9. Leonardo da Vinci. Vitruvian man

be related to one another. Leonardo, on no authority that I can discover, said that in order to fit into a circle the figure should stretch apart his legs so that he was a fourteenth shorter

than if they were together. But this arbitrary solution did not please Cesariano, the editor of the Como Vitruvius, who inscribed the square in the circle, with unfortunate results. We see that from the point of view of strict geometry a gorilla might prove to be more satisfactory than a man.

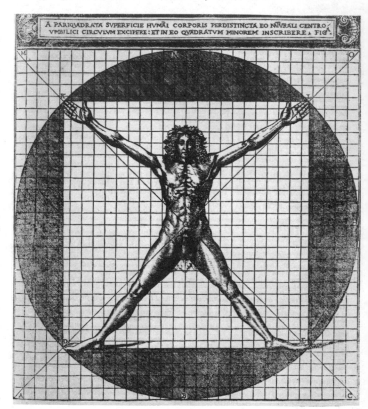

10. Cesariano. Vitruvian man.

How little systematic proportion alone can be relied on to produce physical beauty is shown by Dürer's engraving known as the *Nemesis* or *Large Fortune* [*11*]. It was executed in 1501, and we know that in the preceding year Dürer had been reading Vitruvius. In this figure he has applied Vitruvian princi-

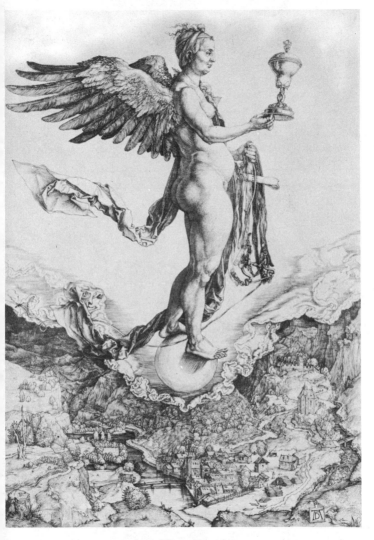

11. Dürer. Nemesis

ples of measurement down to the last detail: according to Professor Panofsky, even the big toe is operative. He has also taken

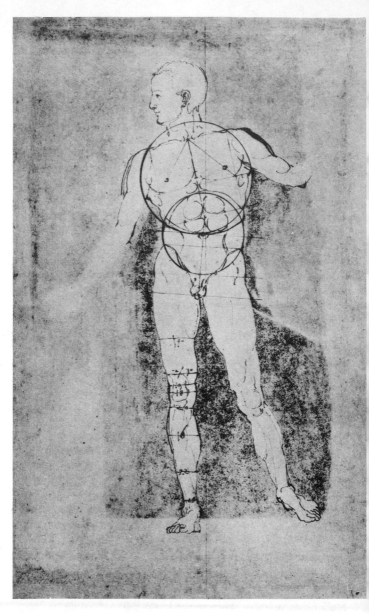

12. Dürer. Measured nude

his subject from a work by Poliziano, the same humanist poet who inspired Botticelli's *Birth of Venus* and Raphael's *Galatea*. But in spite of these precautions he has not achieved the classical ideal. That he did so later was owing to the practice of relating his system to antique figures. It was not his squares and circles that enabled him to master classical proportions, but the fact that he applied them to memories of the *Apollo Belvedere* and the *Medici Venus*—forms "perfected in the poet's mind" [12]. And it was from these, in the end, that he derived the beautiful nude figure of Adam in his famous engraving of the *Fall*.

Francis Bacon, as we all know, said, "There is no excellent beauty that hath not some strangeness in the proportion. A man cannot tell whether Apelles or Albert Dürer were the more trifler; where of the one would make a personage by geometrical proportions: the other by taking the best part out of divers faces to make one excellent." This very intelligent observation is unfair to Dürer, and suggests that Bacon, like the rest of us, had not read his book on human proportions, only looked at the plates. For, after 1507, Dürer abandoned the idea of imposing a geometrical scheme on the body, and set about deducing ideal measurements from nature, with a result, as may be imagined, somewhat different from his analyses of the antique; and in his introduction he forcefully denies the claim that he is providing a standard of absolute perfection. "There lives no man upon earth," he says, "who can give a final judgment upon what the most beautiful shape of a man may be; God only knows that. . . . 'Good' and 'better' in respect of beauty are not easy to discern, for it would be quite possible to make two different figures, neither conforming with the other, one stouter, the other thinner, and yet we might scarce be able to judge which of the two excelled in beauty."

So the most indefatigable and masterly constructor of ideal proportions abandoned them halfway through his career, and his work, from the *Nemesis* onward, is a proof that the idea of the nude does not depend on analyzable proportions alone. And yet when we look at the splendidly schematized bodies of Greek sculpture, we cannot resist the conviction that some system did exist. Almost every artist or writer on art who has thought seriously about the nude has concluded that it must

have some basis of construction that can be stated in terms of
measurement; and I myself, when trying to explain why a
photograph did not satisfy me, said that I missed the sense of
simple units clearly related to one another. Although the artist
cannot construct a beautiful nude by mathematical rules, any
more than the musician can compose a beautiful fugue, he
cannot ignore them. They must be lodged somewhere at the
back of his mind or in the movements of his fingers. Ultimately
he is as dependent on them as an architect.

Dipendenza: that is the word used by Michelangelo, supreme
as a draftsman of the nude and as an architect, to express his
sense of the relationship between these two forms of order. And
in the pages that follow I often make use of architectural
analogies. Like a building, the nude represents a balance be-
tween an ideal scheme and functional necessities. The figure
artist cannot forget the components of the human body, any
more than the architect can fail to support his roof or forget
his doors and windows. But the variations of shape and dis-
position are surprisingly wide. The most striking instance is, of
course, the change in proportion between the Greek and the
Gothic idea of the female body. One of the few classical canons
of proportion of which we can be certain is that which, in a
female nude, took the same unit of measurement for the dis-
tance between the breasts, the distance from the lower breast
to the navel, and again from the navel to the division of the
legs. This scheme we shall find carefully maintained in all fig-
ures of the classical epoch [*13*] and in most of those which
imitated them down to the first century. Contrast a typical
Gothic nude of the fifteenth century, the *Eve* in the Vienna
gallery attributed to Memlinc [*14*]. The components are—
naturally—the same. The basic pattern of the female body is
still an oval, surmounted by two spheres; but the oval has
grown incredibly long, the spheres have grown distressingly
small. If we apply our unit of measurement, the distance be-
tween the breasts, we find that the navel is exactly twice as far
down the body as it is in the classic scheme. This increased
length of body is made more noticeable because it is unbroken
by any suggestion of ribs or muscles. The forms are not con-
ceived as individual blocks, but seem to have been drawn out
of one another as if they were made of some viscous material.

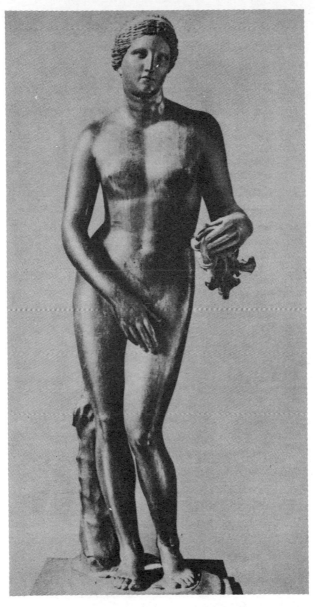

13. 16th century. Bronze cast of Aphrodite

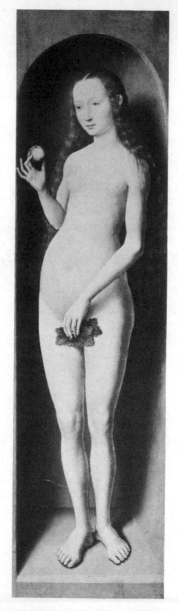

14. Memlinc workshop. Eve

It is usual to speak of this kind of Gothic nude as "naturalistic," but is Memlinc's *Eve* really closer to the average (for this is what the word means) than the antique nude? Such, at all events, was certainly not the painter's intention. He aimed at producing a figure that would conform to the ideals of his time, that would be the kind of shape men liked to see; and by some strange interaction of flesh and spirit this long curve of the stomach has become the means by which the body has achieved the ogival rhythm of late Gothic architecture.

A rather less obvious example is provided by Sansovino's *Apollo* on the Loggetta in Venice [*15*]. It is inspired by the *Apollo Belvedere,* but although Sansovino, like all his contemporaries, thought that the antique figure was of unsurpassable beauty, he has allowed himself a fundamental difference in his construction of the body. We may describe this by saying that the antique male nude is like a Greek temple, the flat frame of the chest being carried on the columns of the legs [*16*]; whereas the Renaissance nude is related to the architectural system that produced the central-domed church; so that instead of the sculptural interest depending on a simple, frontal plane, a number of axes radiate from one center. Not only the elevations but, so to say, the ground plans of these figures would have an obvious relationship to their respective architectures. What we may call the multiple-axis nude continued until the classicistic revival of the eighteenth century. Then, when architects were reviving the Greek-temple form, sculptors once more gave to the male body the flatness and frontality of a frame building. Ultimately the *dipendenza* of architecture and the nude expresses the relationship we all so earnestly desire between that which is perfected by the mind and that which we love. Poussin, writing to his friend Chantelou in 1642, said, "The beautiful girls whom you will have seen in Nîmes will not, I am sure, have delighted your spirit any less than the beautiful columns of Maison Carrée; for the one is no more than an old copy of the other." And the hero of Claudel's *Partage de midi,* when at last he puts his arms round his beloved, utters, as the first pure expression of his bliss, the words "O Colonne!"

So our surmise that the discovery of the nude as a form of art is connected with idealism and faith in measurable propor-

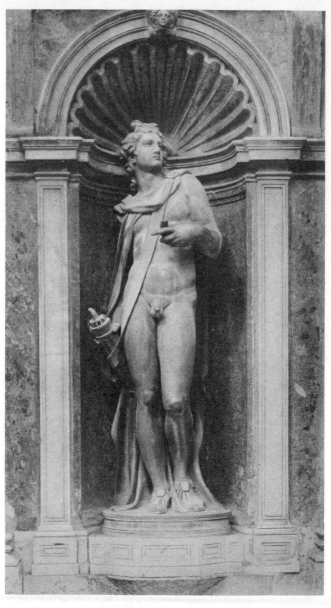

15. Sansovino. Apollo

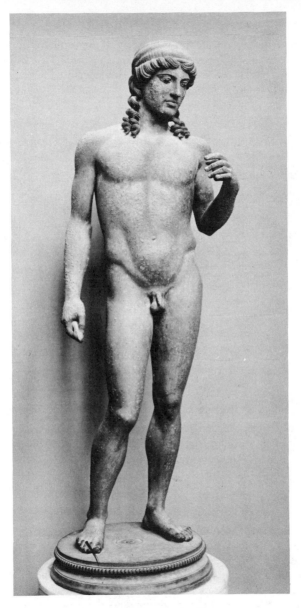

16. *Greco-Roman. Apollo*

tions seems to be true, but it is only half the truth. What other peculiarities of the Greek mind are involved? One obvious answer is their belief that the body was something to be proud of, and should be kept in perfect trim.

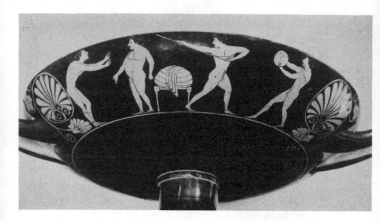

17. Attic, early 5th century B.C. *Palaestra scene*

We need not suppose that many Greeks looked like the *Hermes* of Praxiteles, but we can be sure that in fifth-century Attica a majority of the young men had the nimble, well-balanced bodies depicted on the early red-figure vases. On a vase in the British Museum [*17*] is a scene that will arouse sympathy in most of us, but to the Athenians was ridiculous and shameful—a fat youth in the gymnasium embarassed by his ungraceful figure, and apparently protesting to a thin one, while two young men of more fortunate development throw the javelin and the discus. Greek literature from Homer and Pindar downward contains many expressions of this physical pride, some of which strike unpleasantly on the Anglo-Saxon ear and trouble the minds of schoolmasters when they are recommending the Greek ideal of fitness. "What do I care for any man?" says the young man Kritobalos in the *Symposium* of Xenophon; "I am beautiful." And no doubt this arrogance was increased by the tradition that in the gymnasium and the sportsground such young men displayed themselves totally naked.

The Greeks attached great importance to their nakedness. Thucydides, in recording the stages by which they distinguished themselves from the barbarians, gives prominence to the date at which it became the rule in the Olympic games, and we know from vase paintings that the competitors at the Panathenaic festival had been naked ever since the early sixth century. Although the presence or absence of a loincloth does not greatly affect questions of form, and in this study I shall include.figures that are lightly draped, psychologically the Greek cult of absolute nakedness is of great importance. It implies the conquest of an inhibition that oppresses all but the most backward people; it is like a denial of original sin. This is not, as is sometimes supposed, simply a part of paganism: for the Romans were shocked by the nakedness of Greek athletes, and Ennius attacked it as a sign of decadence. Needless to say, he was wide of the mark, for the most determined nudists of all were the Spartans, who scandalized even the Athenians by allowing women to compete, lightly clad, in their games. He and subsequent moralists considered the matter in purely physical terms; but, in fact, Greek confidence in the body can be understood only in relation to their philosophy. It expresses above all their sense of human wholeness. Nothing that related to the whole man could be isolated or evaded; and this serious awareness of how much was implied in physical beauty saved them from the two evils of sensuality and aestheticism.

At the same party where Kritobalos brags about his beauty Xenophon describes the youth Autolykos, victor of the Pankration, in whose honor the feast was being given. "Noting the scene," he says, "the first idea to strike the mind is that beauty has about it something regal; and the more so if it chance to be combined (as now in the person of Autolykos) with modesty and self-respect. Even as when a splendid object blazes forth at night, the eyes of men are riveted, so now the beauty of Autolykos drew on him the gaze of all; nor was there one of those onlookers but was stirred to his soul's depth by him who sat there. Some fell into unwonted silence, while the gestures of the rest were equally significant."

This feeling, that the spirit and body are one, which is the most familiar of all Greek characteristics, manifests itself in their gift of giving to abstract ideas a sensuous, tangible, and, for the

most part, human form. Their logic is conducted in the form of dialogues between real men. Their gods take visible shape, and on their appearance are usually mistaken for half-familiar human beings—a maidservant, a shepherd, or a distant cousin. Woods, rivers, even echoes are shown in painting as bodily presences, solid as the living protagonists, and often more prominent. Here we reach what I take to be the central point of our subject: "Greek statues," said Blake, in his *Descriptive Catalogue,* "are all of them representations of spiritual existences, of gods immortal, to the mortal, perishing organ of sight; and yet they are embodied and organised in solid marble." The bodies were there, the belief in the gods was there, the love of rational proportion was there. It was the unifying grasp of the Greek imagination that brought them together. And the nude gains its enduring value from the fact that it reconciles several contrary states. It takes the most sensual and immediately interesting object, the human body, and puts it out of reach of time and desire; it takes the most purely rational concept of which mankind is capable, mathematical order, and makes it a delight to the senses; and it takes the vague fears of the unknown and sweetens them by showing that the gods are like men and may be worshiped for their life-giving beauty rather than their death-dealing powers.

To recognize how completely the value of these spiritual existences depends on their nudity, we have only to think of them as they appear, fully clothed, in the Middle Ages or early Renaissance. They have lost all their meaning. When the Graces are represented by three nervous ladies hiding behind a blanket [18], they no longer convey to us the civilizing influence of beauty. When Herakles is a lumbering *Landsknecht* weighed down by fashionable armor, he cannot increase our sense of well-being by his own superabundant strength. Conversely, when nude figures, which had been evolved to express an idea, ceased to do so, and were represented for their physical perfection alone, they soon lost their value. This was the fatal legacy of neoclassicism, and Coleridge, who lived through the period, summed up the situation in some lines he added to the translation of Schiller's *Piccolomini:*

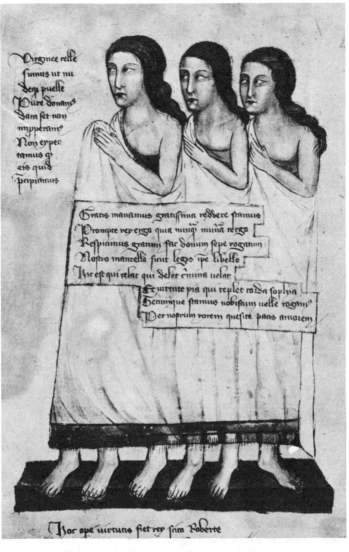

18. Austrian ms., 12th century. Three Graces

The intelligible powers of ancient poets,
The fair humanities of old religion,
The Power, the Beauty and the Majesty,
That had their haunts in dale or piney mountain,
. . . all these have vanished.
They live no longer in the faith of reason.

The academic nudes of the nineteenth century are lifeless because they no longer embodied real human needs and experiences. They were among the hundreds of devalued symbols that encumbered the art and architecture of the utilitarian century.

The nude had flourished most exuberantly during the first hundred years of the classical Renaissance, when the new appetite for antique imagery overlapped the medieval habits of symbolism and personification. It seemed then that there was no concept, however sublime, that could not be expressed by the naked body, and no object of use, however trivial, that would not be better for having been given human shape. At one end of the scale was Michelangelo's *Last Judgment;* at the other the door knockers, candelabra, or even handles of knives and forks. To the first it might be objected—and frequently was—that nakeness was unbecoming in a representation of Christ and His saints. This was the point put forward by Paolo Veronese when he was tried by the Inquisition for including drunkards and Germans in his picture of the marriage of Cana: to which the chief inquisitor gave his immortal reply, "Do you not know that in these figures by Michelangelo there is nothing that is not spiritual—*non vi è cosa se non de spirito?*" And to the second it might be objected—and frequently is—that the similitude of the naked Venus is not what we need in our hand when we are cutting up our food or knocking at a door, to which Benvenuto Cellini would have replied that since the human body is the most perfect of all forms we cannot see it too often. In between these two extremes was that forest of nude figures, painted or carved, in stucco, bronze, or stone, which filled every vacant space in the architecture of the sixteenth century.

Such an insatiable appetite for the nude is unlikely to recur. It arose from a fusion of beliefs, traditions, and impulses very remote from our age of essence and specialization. Yet even in

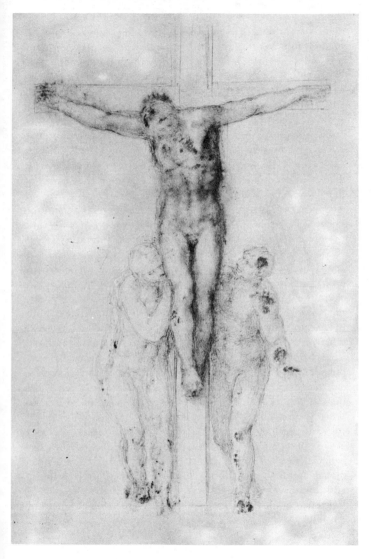

19. Michelangelo. Crucifixion

the new self-governing kingdom of the aesthetic sensation the nude is enthroned. The intensive application of great artists has made it into a sort of pattern for all formal constructions, and it is still a means of affirming the belief in ultimate perfection. "For soule is forme, and doth the bodie make," wrote Spenser in his *Hymne in Honour of Beautie,* echoing the words of the Florentine Neoplatonists, and although in life the evidence for the doctrine is inconclusive, it is perfectly applicable to art. The nude remains the most complete example of the transmutation of matter into form.

Nor are we likely once more to cut ourselves off from the body, as in the ascetic experiment of medieval Christianity. We may no longer worship it, but we have come to terms with it. We are reconciled to the fact that it is our lifelong companion, and since art is concerned with sensory images the scale and rhythm of the body is not easily ignored. Our continuous effort, made in defiance of the pull of gravity, to keep ourselves balanced upright on our legs affects every judgment on design, even our conception of which angle shall be called "right." The rhythm of our breathing and the beat of our hearts are part of the experience by which we measure a work of art. The relation of head to body determines the standard by which we assess all other proportions in nature. The disposition of areas in the torso is related to our most vivid experiences, so that, abstract shapes, the square and the circle, seem to us male and female; and the old endeavor of magical mathematics to square the circle is like the symbol of physical union. The starfish diagrams of Renaissance theorists may be ridiculous, but the Vitruvian principle rules our spirits, and it is no accident that the formalized body of the "perfect man" became the supreme symbol of European belief. Before the *Crucifixion* of Michelangelo [19] we remember that the nude is, after all, the most serious of all subjects in art; and that it was not an advocate of paganism who wrote, "The Word was made flesh, and dwelt among us . . . full of grace and truth."

II

APOLLO

The Greeks had no doubt that the god Apollo was like a perfectly beautiful man. He was beautiful because his body conformed to certain laws of proportion and so partook of the divine beauty of mathematics. The first great philosopher of mathematical harmony had called himself Pythagoras, son of the Pythian Apollo. So in the embodiment of Apollo everything must be calm and clear; clear as daylight, for Apollo is the god of light. Since justice can exist only when facts are measured in the light of reason, Apollo is the god of justice; *sol justitiae*. But the sun is also fierce; neither graceful athlete nor geometrician's dummy, nor an artful combination of the two, will embody Apollo, the python slayer, the vanquisher of darkness. The god of reason and light superintended the flaying of Marsyas.

But the earliest nudes in Greek art, traditionally known as Apollos, are not beautiful. They are alert and confident, members of a conquering race, "the young, lighthearted masters of the waves." But they are stiff, with a kind of ritual stiffness; the transitions between their members are abrupt and awkward, and they have a curious flatness, as if the sculptor could think only of one plane at a time [20]. They are notably less natural and less easy than the Egyptian figures upon which, to a large extent, they are modeled and which, over a thousand years earlier, had achieved a limited perfection. Stage by stage, in less than a century they grew into models that were to satisfy

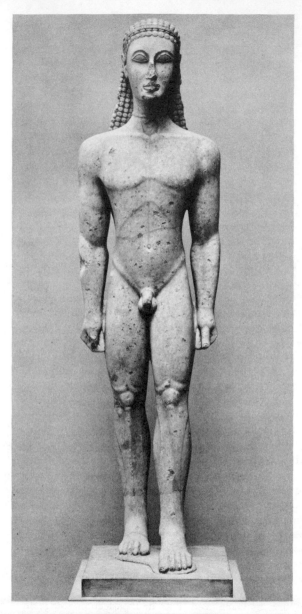

20. Attic, c. 600 B.C. *Kouros*

our Western notion of beauty till the present day. They have two characteristics, and only two, that foreshadow this momentous evolution. They are clear and they are ideal. The shapes they present are neither pleasant in themselves nor comfortably related to one another, but each one is firmly delineated and aspires to a shape that the measuring eye can grasp. Historians who have written in the belief that all art consists in a striving for realism have sometimes expressed surprise that the Greeks, with their vivid curiosity, should have approached nature so reluctantly; that in the fifty years between the *Moschophoros* and the funeral stele of Aristion, there should have been so little "progress." This is to misconceive the basis of Greek art. It is fundamentally ideal. It starts from the concept of a perfect shape and only gradually feels able to modify that shape in the interests of imitation. And the character of the shapes chosen is expressed in the word used to describe the earliest form of Greek art, geometric; a dreary, monotonous style and at first ill adapted to realization in the round. But the head yields easily to geometric treatment, and already in the most archaic heads of Apollo we see how geometry can be combined with plastic vitality. In a century the same unifying power will subordinate the dispersed and intractable forms of the body.

So Apollo is clear and ideal before he is beautiful. How and when did the transformation take place? Ranging in a hypothetical order of time the *kouroi*—the nude male figures—of the sixth century [*21*], we see the transitions from shape to shape becoming smoother, and absorbing, in the process, details that had been left as decorative notations. Then, quite suddenly, in about the year 480, there appears before us the perfect human body, the marble figure from the Akropolis known as the *Ephebe* of Kritios [*22*]. Of course he was not really a sudden, isolated creation. We have only a slender reason to attribute him to the sculptor Kritios, and we have even less reason to suppose that Kritios was the initiator of so momentous a change. Literary sources give the name of Pythagoras of Rhegium as the sculptor who "first gave rhythm and proportion to his statues." All the evidence suggests that the new concept of form would have been first expressed in bronze and not in marble; and the *Apollo of Piombino* [*23*], although slightly earlier and stiffer, may give some notion of what had been going on in the first twenty years

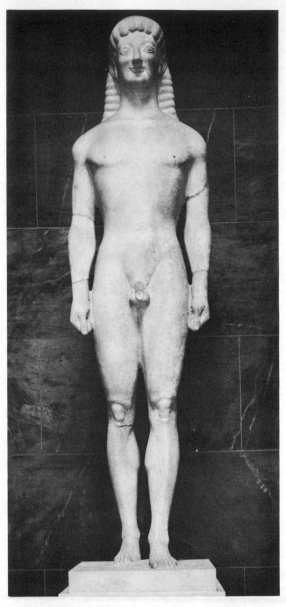

21. *Attic, 6th century* B.C. *Apollo of Tenea*

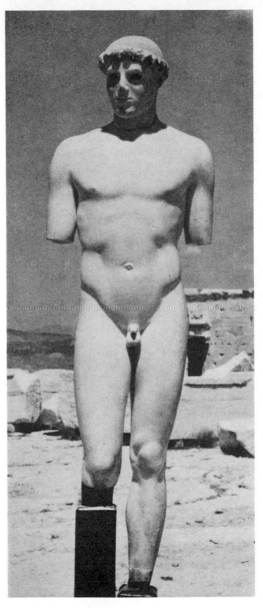

22. *"Kritios,"* c. *480* B.C. *Youth*

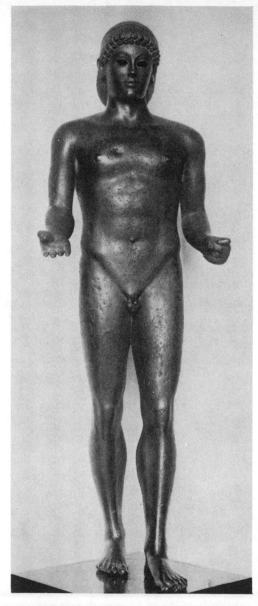

23. *Magna Graecia*, c. 490 B.C. *Apollo of Piombino*

of the fifth century. But since almost every bronze statue made in Greece in classic times has been melted down, the *Ephebe* of Kritios remains the first beautiful nude in art. Here for the first time we feel the passionate pleasure in the human body familiar to all readers of Greek literature, for the delicate eagerness with which the sculptor's eye has followed every muscle or watched the skin stretch and relax as it passes over a bone could not have been achieved without a heightened sensuality. We all have a mental picture of that strange institution, Greek athletics, so like and yet so unlike its nineteenth-century Anglo-Saxon counterpart. In our study of the nude it is the unlikeliness that is significant; not simply because Greek athletes wore no clothes, although that is of real importance, but because of two powerful emotions that dominated the Greek games and are largely absent from our own: religious dedication and love. These gave to the cult of physical perfection a solemnity and a rapture that have not been experienced since. Greek athletes competed in somewhat the same poetical and chivalrous spirit as knights, before the eyes of their loves, jousted in the lists; but all that pride and devotion which medieval contestants expressed through the flashing symbolism of heraldry was, in the games of antiquity, concentrated in one object, the naked body. No wonder that it has never again been looked at with such a keen sense of its qualities, its proportion, symmetry, elasticity, and aplomb; and when we consider that this passionate scrutiny of the individual was united to the intellectual need for geometric form, we can estimate what a rare coincidence brought the male nude to perfection.

Perfection hangs by a thread and is weighed in the jeweler's balance. We must therefore submit the classic nude, at its first appearance, to an examination that may seem fastidious, until we remember how the rhythmic organization of this form was still dominating sculpture 2300 years after its invention. When, a page ago, I used the *Apollo of Piombino* as an example of bronze casting, how strikingly it brought out the classic character of the Kritios youth! In twenty years a basic alteration of style has taken place. It can be illustrated by examining the lower part of the torso—to be precise, the junction of the hips, abdomen, and thorax. One of the most peculiar features of the early *kouroi*—for example, the *Apollo of Tenea* [21]—is their thin, flat

stomachs. They conform to a sharp, ogival rhythm, which we may describe as Gothic. The chief areas—thighs and stomach—are inscribed within elongated ovals. Gothic nudes, dominated by the pointed-arch form, do in fact display very much the same characteristics, and one of the earliest nude studies that have come down to us, a drawing in the Uffizi from the circle of Uccello, combines Gothic and naturalistic forms with a remarkable likeness to a sixth-century *kouros*. In the *Apollo of Piombino* these Gothic forms are less marked. The thorax is of classic rectangularity, but it bears an uneasy relationship to the flat triangle of the stomach. Like Perrault's façade of the Louvre, we feel that a richly classical upper story is resting on a base too stiff and thin to support it. In the Kritios youth this uneasiness has vanished altogether. The legs and divisions of the torso flow together with the same full and fruitful rhythm. How is this achieved? To begin with, the hips are not parallel, but since he rests his weight on his left leg, that hip is slightly higher. The full implications of this pose are more easily seen from behind, for, as usual in early Greek sculpture, the back is more naturalistic and more plastically developed than the front. But even from the front we can perceive, for the first time, that subtle equilibrium of outline and axis which is to be the basis of classical art. This delicate balance of movement gives the torso its unity of rhythm. It also allows the sculptor to solve the problem of the abdomen by realizing it as a dominant, as opposed to a recessive, form: and this has involved an anatomical emphasis that was to be exaggerated to the point of distortion in the next fifty years: I refer to the muscles that lie above the pelvis and mark the junction of the thighs and the torso. They are largely absent from archaic sculpture, and since it seems unlikely that between the years 500 and 450 Greek athletes really did develop these muscles to such an unequaled extent, we must reckon them chiefly a device by which the rhythmic structure of the torso might be set in motion, and its lower half supported by two buttresses, before descending to the arc of the abdomen. They were elements in the classic architecture of the human body, and as such they lasted as long as metopes and triglyphs.

All this we discover in the youth of Kritios when we compare him to the figures that precede him. But it is not obtruded. He is so straight-forwardly beautiful that we do not willingly use

him to demonstrate the mechanics of form or the rules of an aesthetic theory. To the sculptors of the next generation this grace and naturalness was a defect, or at least a danger. It is as if they foresaw the frivolous beauty of Hellenistic art, and wished to defend themselves against it as long as possible. Of such austere taste there is ample evidence in the earlier specimens of Attic sculpture, but it was given concentrated and individual expression through the peculiar genius of Polykleitos.

The great puritans of art are a curious study. They seem to be divided into two groups, those who renounce a rich, early sensuality, like Poussin and Milton, and those who hope, like Malherbe and Seurat, to purify art by giving it the logic and finality of an intellectual theorem. Our knowledge of Polykleitos, fragmentary and unreliable as it is, leaves little doubt that he belonged to the second group; yet he often reminds us of Poussin by a heavy physical momentum, a Dorian obstinacy, on account of which, no doubt, his intellectualism has survived. No other great artist has concentrated his forces with a more single-minded economy. His general aim was clarity, balance, and completeness; his sole medium of communication the naked body of an athlete, standing poised between movement and repose. He believed that this could be achieved only by the strictest application of measurement and rule. He would make no concessions. He was a fighting high-brow. Aelian tells us that he executed two statues of the same model, one according to popular taste, which we may assume, then as always, to have been naturalistic; and one according to the rules of art. He invited his visitors to suggest improvements and modifications to the former, all of which were duly carried out. He then exhibited the two statues. The former was received with ridicule, the latter with admiration; and Polykleitos did not fail to point the moral. How many artists since that time would have liked to try a similar experiment; but, except in the Italian Renaissance, they could not have expected it to turn out in their favor. That Polykleitos, pursuing his narrow specialized aim, should have been accepted as the equal of Myron and Pheidias proves how closely the Greeks associated their art with their mathematics, as being a demonstration of order, capable of accurate conclusions.

No sculptures by Polykleitos have come down to us in the original, and to judge of their effect from the existing copies is

almost impossible. As usual, they were in bronze, and the sur-
viving full-size copies are all in marble. Polykleitos said that "a
well-made work is the result of numerous calculations, carried
to within a hair's breadth." What chance have we, then, of ap-
preciating his art in those blockish parodies, the oldest and
grubbiest inhabitants of any cast-room, with which, alas, his
name is usually associated? For the general effect of his art it
is better to look at small replicas, in bronze and terra cotta,
which, although far removed from the strict precision of the
originals, seem to have preserved some of their general rhythm.
But the problems Polykleitos envisaged, and the finality with
which he solved them, are so cardinal to subsequent represen-
tations of the nude that we must force ourselves to endure the
distasteful quality of a marble copy in order to know more pre-
cisely what he achieved. His first problem was to find some
means by which the figure should combine repose with the
suggestion of potential movement. To stand firmly is inert; to
record a given point in a violent movement is, as we shall see in
a later chapter, limiting and finite. Polykleitos invented a pose
in which the figure is neither walking nor standing, but simply
establishing a point of balance. Of his two famous figures, it is
arguable that the *Doryphoros* [24] is walking: at least his pose
was thus interpreted in antiquity. On the other hand, the
Diadoumenos [25] must be reckoned as standing—a victor would
not walk when crowning himself—and the movement of his
legs is almost identical with that of the *Doryphoros*. In both, the
human body has been used as the basis of a marvelously ad-
justed composition, carried through with such consistency that
we do not realize how artificial a pose has been evolved until
we see it in a different context—for example, in the procession
of horsemen on the Parthenon frieze. Since the movement of
the leg destroys the old stiff symmetry of exact correspondence,
a new symmetry has to be created by a balance of axes. Up
and down, in and out: one could easily reduce the figures of
Polykleitos to the rods and sheet metal of modern sculpture,
and they would still work; although, of course, they would be
miserably impoverished. For, as Polykleitos told his contempo-
raries, from the toes to the last hair on the head every line was
calculated, and every surface depended on the scratch of a
fingernail.

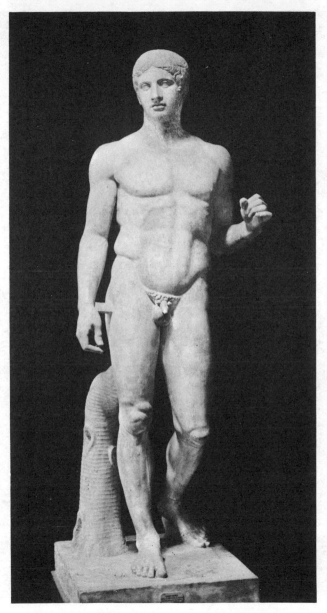

24. *After Polykleitos*, c. 450 B.C. *Doryphoros*

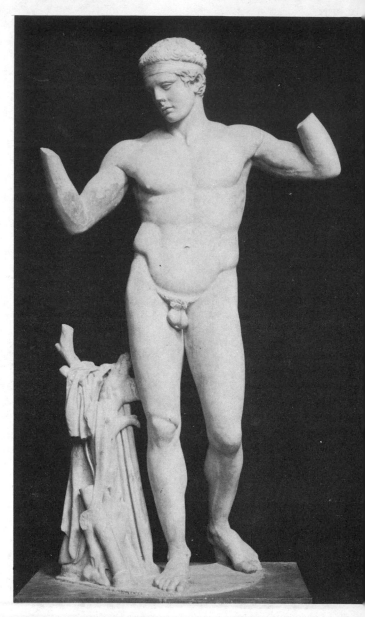

25. *After Polykleitos*, c. 430 B.C. *Diadoumenos*

This perfection of symmetry by balance and compensation is the essence of classical art. A figure may have within itself the rhythms of movement, but yet always comes to rest at its true center. It is complete and self-sufficient. But balance is only half the problem. The parts balanced must have some measurable relation to one another: there must be a canon of proportion. We know that Polykleitos composed such a canon, but all that has come down to us is the tradition of a few elementary rules—seven and a half heads to a figure, and so forth; and attempts to rediscover the canon by measuring his figures have been unsuccessful probably because it was geometrical, not arithmetical, and so is extremely difficult to reconstruct. I have said that a system of mathematical proportion appears in the nude long before the element of beauty; Polykleitos codified it and made it, no doubt, more elaborate. In doing so he sacrificed a little of the enchanting youth and grace that had flowered so suddenly in the *Ephebe* of Kritios: for, even in the originals, the athletes of Polykleitos must have been square-set and rigidly muscular. To some extent he was following an earlier tradition, as is seen in a large torso from Miletos, now in the Louvre, which must date from fifty years before his time. And this heavy physique, long accepted as appropriate to a hero, both gratified his taste for the deliberate and was more easily adapted to his calculations.

Besides these problems of balance and proportion, Polykleitos set himself to perfect the internal structure of the torso. He recognized that it allowed for the creation of a sculptural unit in which the position of humps and hollows evokes some memory and yet can be made harmonious by variation and emphasis. There is the beginning of such a system in the torso from Miletos and that of the Kritios youth; but Polykleitos' control of muscle architecture was evidently far more rigorous, and from him derives that standard schematization of the torso known in French as the *cuirasse esthétique,* a disposition of muscles so formalized that it was in fact used in the design of armor and became for the heroic body like the masks of the antique stage. The *cuirasse esthétique,* which so greatly delighted the artists of the Renaissance, is one of the features of antique art that have done most to alienate modern taste. It seems to us ungraceful in itself and completely lacking in vitality. But

although a row of formalized torsos in the Galleries of the Vatican or the Naples Museum may not cause the pulse to vary its beat, we can see from certain replicas that this was originally a construction of great power. Such is the copy of the *Doryphoros* in the Uffizi [26], which, being in a hard, smooth basalt, conveys the effect of bronze, and is executed with unusual care. It preserves some of the urgency and concentration of the original, and proves that Polykleitos' scheme of the body, like all abstractions that have survived, not only contained life, but was bursting with a vitality all the more potent because forced into so narrow a channel.

With all great artists who have thus sharpened their aims to a single point of perfection, we are sometimes tempted to ask whether the sacrifices involved are worth while. Such concentration has its negative aspect, its element of refusal, and also its element of self-hallucination. In the end, our feelings are our only guide, and to test our feelings about Polykleitos is, alas, almost impossible. But something may be achieved by comparing a direct copy of one of his works with a freer version, in which the rigor of perfection has been relaxed. Our scales are weighted heavily in favor of the latter, for we can take as example that charming bronze figure in Florence known as the *Idolino* [27], which, although of much later date, retains the freshness of an original Greek bronze. And yet when we look at it critically, how unstable and incomplete this figure seems compared even to the lifeless copies of Polykleitos' athletes! The legs are not within the rhythm of the whole and seem to lose themselves halfway down. A similar break appears in the body, and the shoulders are axially unrelated to the hips. Even the small bronze copy of the *Diskophoros* [28] in the Louvre—little more, we may suppose, than a high-class commercial product and of uncertain date—shows more of Polykleitan compactness. Now let us try to imagine such a figure as the *Diadoumenos* with all the freshness of the *Idolino* and a feeling for bronze even more sensuous and fastidious. Does it not seem that the dangerous doctrine of salvation through exclusion was for once justifiable?

Nor is it correct to discuss Polykleitos solely in aesthetic terms, for his work was based on an ethical ideal, to which formal questions were subservient. Though his purity of aim

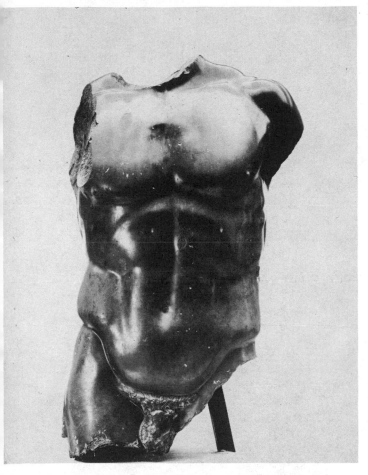

26. After Polykleitos, c. 450 B.C. Torso of Doryphoros

may recall the Chinese potter continually refining upon a
single shape, the human body is, in fact, inexhaustibly complex
and suggestive, and to a Greek of the fifth century it stood for
a set of values of which restraint, balance, modesty, proportion,
and many others would be applied equally in the ethical and
in the aesthetic sphere. Polykleitos himself would probably

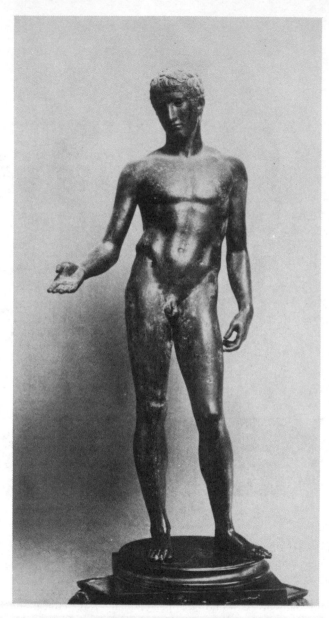

27. *Greek, 4th century* B.C. *Idolino*

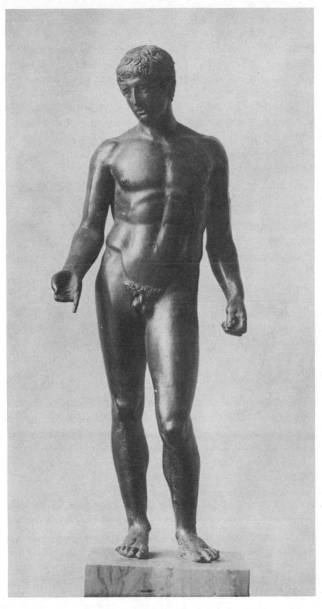

28. *Greek*, c. 400 B.C.? *After the Diskophoros of Polykleitos*

have recognized no real distinction between them, and we need not hesitate to pronounce before his work the word "moral," that vague, but not altogether meaningless, word which rumbles in the neighborhood of the nude till the academies of the nineteenth century.

The writers of antiquity recognized that Polykleitos had created a perfectly balanced man, but added that he could not create the likeness of a god. This, they said, was the achievement of Pheidias. From 480 to 440, parallel with the line of athletes was a line of votive statues, which culminated in Pheidias' great *Apollos*. Of these *Apollos* we can derive some notion from an insensitive copy at Kassel. They represent a perfecting of the image complementary to Polykleitos' perfecting of form; and in the survival of Apollo this power to satisfy our imaginations, though it came later, had the more lasting influence. One great image of Apollo from the beginning of the classic period has survived in the original: he who rises above the struggle, in the west pediment of the temple of Olympia [29], and, with a gesture of sovereign authority, reproves the bestial fury of the centaurs. Nowhere else, perhaps, is the early Greek ideal so perfectly embodied: calm, pitiless, and supremely confident in the power of physical beauty. Not a shade of doubt or compunction could soften the arc of cheek or brow; the *Phaedo* is still far away, and the Beatitudes would be totally incomprehensible. But all this we deduce from his head. His body, though not without a certain passive magnificence, is flat and inexpressive. Like all the sculptures at Olympia, it lacks the rigorous precision of Attic work. It is twenty years later than the Kritios youth, but is plastically less evolved. No doubt it was given an archaic character in order to enhance its godlike authority, for the other figures on the pediments are almost too experimental. They attempt more than was within the compass of pure classic art: greater naturalism, freer poses, more various expressions. There are nudes at Olympia of a character that never occurs again in Greek sculpture; and those who regret the limited perfection of antique art may feel that Olympia was like a last burst of freedom. From that starting point Greek art might have gone anywhere. But just as pre-Socratic philosophy, for all its charm, is made up largely of inspired guesses, so the nudes at Olympia seem haphazard and

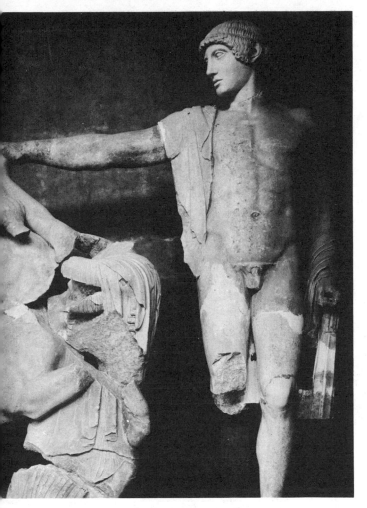

29. Greek, c. *450* B.C. *Apollo*

fundamentally formless. This was decorative sculpture, where certain rough and picturesque experiments were permissible. The real work of refining on the classic ideal took place in bronze.

Our surviving copies of these bronze Apollos happen to be of finer quality than those of the Polykleitan athletes and may be looked at with pleasure, not merely with antiquarian curiosity. How far they go back to early works of Pheidias himself is an insoluble problem, but one, at least, seems to reflect his style as we know it in the frieze of the Parthenon, the *Apollo of the Tiber* [30] in Rome. Although a copy of a bronze, it is in a beautiful piece of marble, and must be by a fine Greek craftsman. It shows most clearly the difference between Polykleitan athlete and Pheidian god. This *Apollo* is taller and more graceful, and still bears a trace of hieratic frontality consciously preserved to enhance his godlike remoteness. The flat, square shoulders seem lifted up into a different plane, from which the head looks down with a calm and dreamy interest; the torso, less insistently schematic than those of Polykleitos, renders vividly the tautness of skin stretched over muscle. If only this figure, instead of the *Apollo Belvedere,* had been known to Winckelmann, his insight and beautiful gift of literary re-creation would have been better supported by the sculptural qualities of his subject. The *Apollo of the Tiber* is worthy of the "maker of gods," the title by which Pheidias is described in ancient literature, and seems to me to give a truer reflection of his style, as we know it, from the Parthenon than does the *Apollo* at Kassel; but this may be owing to the relative transparency of the medium through which the original is seen. The copy of the Kassel *Apollo* is unusually opaque, but, straining our eyes to penetrate it, we can just catch sight of a noble image, firm, full, and complete, of the god at his most prosperous. It is the moment of balance—a physical balance between strength and grace, a stylistic balance between naturalism and the ideal, a spiritual balance between the old worship of the god and the new philosophy, in which that worship was recognized as being no more than a poetic exercise. And of these three, the last was never achieved again. During the next century the frontiers of physical beauty were extended materially. Apollo became more human and more elegant. But never again in antiquity was he transfigured by the aura of divine prerogative, which, as we can guess from our fragments of evidence, he derived from the hands of Pheidias.

Of the humanized beauty of the fourth century we can speak

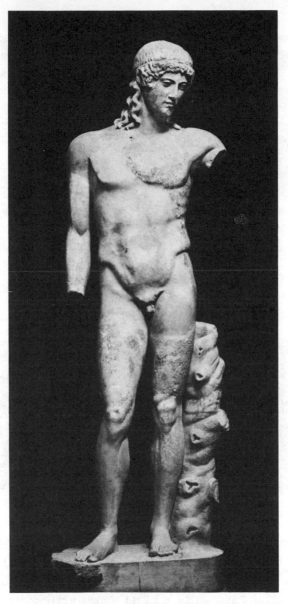

30. *Style of Pheidias. Apollo of the Tiber*

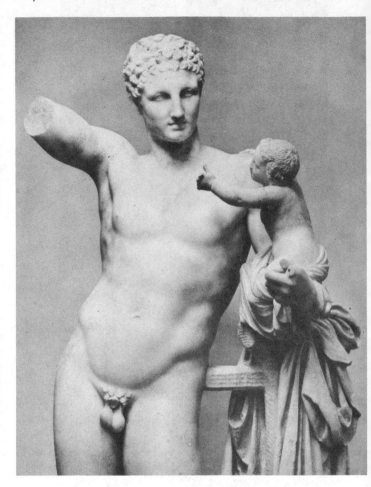

31. Praxiteles, c. *350* B.C. *Hermes*

from a more direct experience, for at least one example sur-
vives that seems to be an original work by a great sculptor, the
Hermes of Praxiteles [*31*]. True, the documentary evidence that
associates the figure at Olympia with Praxiteles is not such as
would carry any weight in a field of study where documents
were less scanty, being no more than a reference in Pausanias'

travel diaries made over four hundred years after the figure was carved. Well, we should not place much confidence in Horace Walpole's opinion of a work by Giotto; but in the history of art, as in all history, we accept or reject documentary evidence exactly as it suits us, that is to say, according to our feelings about the object referred to; and our feelings about the *Hermes* of Olympia are rather different from those aroused by any other work of antiquity. Almost alone of antique marbles it retains that translucent, sensuous quality which we know to have been a characteristic of fourth-century art in general and of Praxiteles in particular. Majesty is not lost, and the body is firm and muscular; but the overwhelming impression is one of grace and of a gentle sweetness, achieved partly by the flowing design and partly by an almost morbid delicacy of execution. The *Hermes* is the climax of that passion for physical beauty first apparent in the Kritios youth, which had been arrested by the schematic austerity of Polykleitos and by Pheidias' belief in the rectangular majesty of Apollo. We know how easily beauty of this kind may be exploited till it dwindles into prettiness. With Praxiteles, however, it was not an instrument, but a mode of being. Like Correggio, he was incapable of setting up an abrupt or uneasy relationship. Every form glides into the next with that smoothness which, as we shall see in the next chapter, has become part of the popular concept of beauty. How much the value of this legato depends on the precision of a sensitive execution we can tell from the copies of Praxiteles' works, the *Faun*, the *Sauroktonos*, the *Apollino*, where the smoothness of transition has degenerated into slipperiness and the forms themselves have been reduced, in section, to a few commonplace radial curves. So the *Hermes*, although itself one of the most obscure of Praxiteles' works, of which no replica exists, persuades us to look again at the copies of his more famous pieces and try to imagine their ravishing beauty when surface design and material all obeyed the orders of a single sensibility.

The *Hermes* of Praxiteles represents the last triumph of the Greek idea of wholeness; physical beauty is one with strength, grace, gentleness, and benevolence. For the rest of its course we witness, in antique art, the fragmentation of the perfect man, and the human body becomes either very graceful or very muscular or merely animal. Praxiteles himself contributed to this

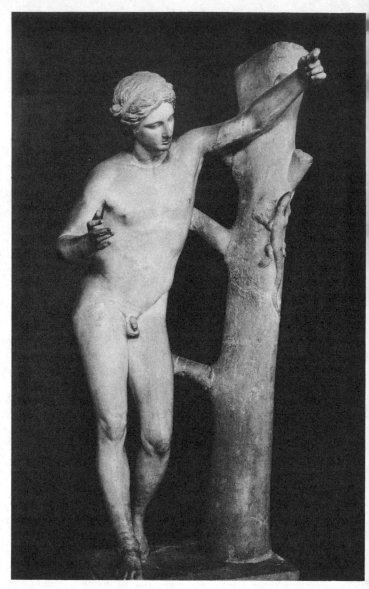

32. After Praxiteles, c. 350 B.C. *Apollo Sauroktonos*

creation of specialized types. In his *Apollo Sauroktonos* [32] the
Python Slayer has been diminished into a boy of feminine deli-
cacy who is about to transfix with his dart a harmless lizard.
His head, as so often in fourth-century sculpture, is indistin-
guishable from that of a girl, and instead of the majestic
breadth and squareness of the Pheidian torso, the lines of his
figure flow in an elegant curve. Conversely, Herakles, who in
the fifth-century metopes of Selinunte conceals his strength in
a neat and serviceable body, becomes in the fourth century a
professional strong man whose bulging muscles seem to weigh
him down like a load of sausages. To these exaggerations must
be added certain figures of athletes that aim at physical per-
fection but yet have lost the radiance, and what the Greeks
would have called the *ethos,* in which true beauty is to be
found. Amongst these are three or four original bronzes, the
so-called *Hermes* from Antikythera, the athlete with the strigil
from Ephesos, and the Praxitelean boy from Marathon [33].
They are representative of Greek art at a high routine level,
and may fairly be made the basis of generalization; and the
first thing that strikes us about them is their lack of accent. We
do not feel behind them, as we do behind quite mediocre work
of the Renaissance, the personal sensibility of an individual
artist. Moreover, the sixteenth-century Italians, emphatic
enough in their admiration of a *bel corpo ignudo,* valued it ulti-
mately as a means of expressing energy, heroism, or spiritual
victory. If we compare the boy from Marathon with the two
Davids of Michelangelo, how clearly they belong to the world
of the spirit! They are the visible form of Michelangelo's as-
pirations, whereas the Marathon boy is simply a young body,
like a ripe fruit; and his physical complaceny blocks up pre-
cisely those means of communication, those chinks and cracks
through which some ray of light may enter our shuttered world.
In the average nude of later Greek sculpture this lack of inner
life communicates itself to every articulation. Cellini was not
one of the great sculptors of the Renaissance, but how living
and sensitive his modeling appears to be if we compare his
bronze model of the *Perseus* [34] with the *Hermes* of Antikythera!
And yet the antique has retained, from the first passionate re-
searches of the fifth century, a kind of stability, a sense of ab-
solute norm, that has been the envy of artists ever since. That,

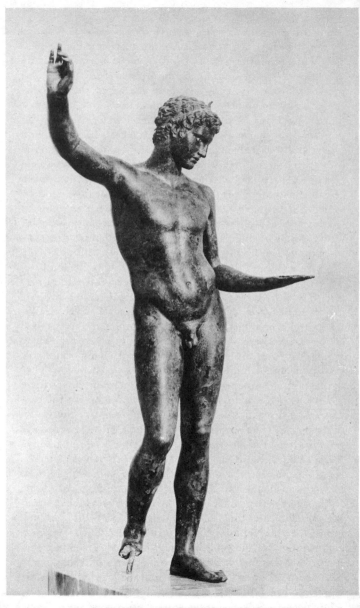

33. *Style of Praxiteles. Bronze boy from Marathon*

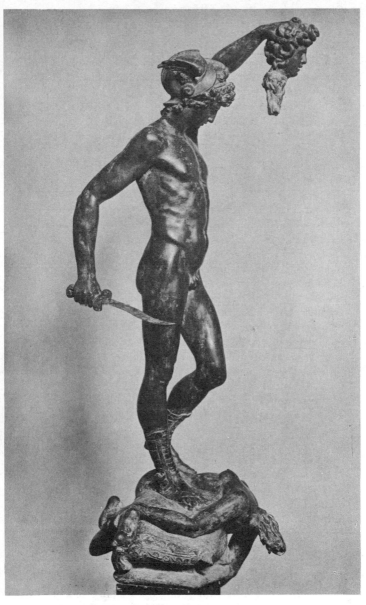

34. *Cellini. Perseus*

in the end, is the remarkable thing about these bronze athletes. They were the ordinary routine productions of antique art, equivalent to a painting of the Virgin and Child in the fifteenth century. They represent the high plateau of achievement from which alone the summits of art can spring.

The last great name in Greek sculpture is Lysippos. Ancient writers tell us that he invented a new proportion, with smaller head, longer legs, and a slenderer body. We also know that he did the figure of an athlete scraping himself, which was popular in ancient Rome, and a marble of such a subject in the Vatican fits so well with literary descriptions of his style that it may reasonably be taken as a basis for further attributions. It is in a position of arrested action more complex and more suggestive of impending movement than the earlier figures of athletes; and, in fact, all the works credibly claimed as copies of Lysippos show a consciousness of existence in space and a multiplicity of view very different from the austere frontality of Polykleitos. With this technical freedom went a new attitude toward nature, and in contrast with Polykleitos' defiance of popular opinion is a story in Pliny that Lysippos, when asked who were his masters, pointed to a crowd of men in the street. Such developments used to be called advances by evolutionary art historians, and perhaps under certain circumstances all additional mastery is a gain. But in the calculated program of the Greek nude freedom and promiscuity were by no means an advantage. Among the works claimed as Lysippic are some graceful figures of young men, the resting *Hermes* in Naples or the *Praying Boy* in Berlin, which have a strong appeal to those who do not normally care for sculpture. In the originals of Lysippos himself this pleasant obviousness was presumably accompanied by a powerful control of means; but for those who followed, the absence of limitations imposed by rules and traditional treatment meant also the absence of order and lawful harmony.

The result was the anarchy of Hellenistic art, with on one side its drunken fauns and boxers, on the other its eternal repetitions of accepted motives. No wonder that our spirits sink as we look at the multitude of marble nudes that confront us in the Galleries of the Vatican or in the Museum at Naples! No other civilization has been so artistically bankrupt as that

which, for four hundred years, on the shores of the Mediter-
ranean, enjoyed a fabulous material prosperity. During those
centuries of bloodstained energy, the figure arts were torpid—a
kind of token currency, still accepted because based on those
treasures of the spirit accumulated in the fifth and fourth cen-
turies before Christ. By artfully adapting and recombining the
inventions of that distant epoch, it was sometimes possible to
produce the illusion of novelty, though hardly ever of vitality;
but in general the means taken to make a dead style accept-
able were of the kind made familiar by many subsequent at-
tempts at vulgarization—smoother finish, more elaborate de-
tail, more explicit narrative: to which, in sculpture, restorers
have added the last deadly touches.

There is, however, one peculiar practice that has a certain
bearing on our subject: the placing of a portrait head on the
ideal nude body. This error of taste—for such I think we must
allow it to be—has been attributed, like all errors of taste, to
the Romans; but it appears in works executed before the rise
of the Roman Empire, such as the so called Hellenistic *Prince*
in the Museo delle Terme. Evidently it was thought that the
divinity of a ruler could be enhanced by giving him the au-
thorized body of a god. In consequence, the practice was ap-
proved by the early Roman emperors and became an accepted
convention. To us, who look first at the head, there is something
comic about these academic Pheidian nudes, from which every
trace of individuality had been erased centuries ago, being sur-
mounted by the likenesses of the unhappy Claudius or the
maniac Caligula. But, at a later date, there did appear in the
imperial household one individual who by his strange perfec-
tion created a new ideal of beauty, the Bithynian Antinoüs. It
was the wish of the Emperor Hadrian that the beautiful
features of his favorite should appear on the statues of the gods;
and so we find this dark Arabian head on the bodies of Apollo,
Hermes, and Dionysos, the traditional proportions being modi-
fied to suit his heavier torso. For almost the first time since the
fourth century a type of beauty is taken from a real head and
not from a copybook. That is why, in drifting round a gallery
of antique sculpture, our attention is so often caught by these
sultry features and we feel once more, though remotely enough,
the warmth of an individual attachment. No doubt the men

of the Renaissance, those supreme individualists, felt the same; and for that reason the physical character of Antinoüs is still perceptible when, after its long banishment, the Apollonian nude returns in the person of Donatello's *David*.

Before leaving the antique world one more figure of Apollo remains to be described; for, whatever its status as a work of art, it has been an image of almost magical efficacy: the *Apollo Belvedere* [35]. A hundred and fifty years ago it was, without question, one of the two most famous works of art in the world. In the great volume printed by Didot to celebrate Napoleon's triumphs one page contains nothing but the words "L'Apollon et le Laocoön emportés à Paris." From Raphael to Winckelmann artists and critics, whose understanding of art was at least equal to our own, vied with each other in its praise. "It is," says Winckelmann, "the highest ideal of art among all the works of antiquity. Enter, O reader, with your spirit into this kingdom of beauty incarnate, and there seek to create for yourself the images of the divine nature." Unfortunately for the modern reader this kingdom is closed. He can only imagine that for three hundred years the *Apollo* satisfied the same sort of uncritical hunger that was later to crave for the plumes and pinnacles of romanticism; and as long as it did so, the eye could overlook weak structure and slack surfaces, which, to the aesthetic of pure sensibility, annul its other qualities. In no other famous work of art, perhaps, are idea and execution more distressingly divorced, and insofar as we believe that they must be inseparable, if art is to take on the quality of new life, the figure of the Vatican is dead. But in the bronze cast made for Francis I, now in the Louvre, some of the mechanical smoothness of the marble is disguised, and with no great effort of the imagination we can picture the shining original, delicately modeled, scrupulously chiseled, with cloak and hair of gold. What an exquisite messenger of the gods he must have been! This is the antique epiphany, the god come to earth, alighting with the radiance of his celestial journey still about him.

A messenger, a visitor from another world, an intermediary: that is the impression the *Apollo* makes on us, and that, in fact, is what he became. A touch of self-consciousness in his ideal beauty and even something un-Greek in the turn of his head made him all the more acceptable to the men of the Renais-

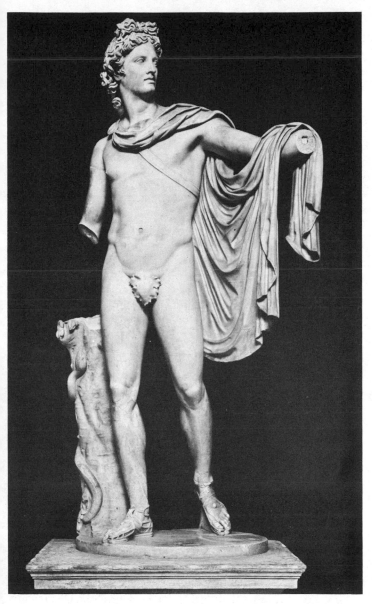

35. *Greek, 2nd century* B.C.? *Apollo Belvedere*

sance. He seems to look beyond the enclosed Greek world, as
if awaiting an answering glance of recognition from the great
romantics of the early sixteenth century.

Long before the façade of classical culture finally collapsed,
Apollo had ceased to satisfy any imaginative need. Hermes, ac-
companier of the dead, could be associated with religions of
mystery, Dionysos with religions of enthusiasm. But Apollo, the
embodiment of calm and reason, had no place in the uneasy,
superstitious world of the third century A.D., and the idea of
naked perfection appears relatively seldom in the art of late
antiquity. When at last Christianity began to evolve its own
symbols there were few contemporary models from which
Apollo might be transpersonalized into Adam. From the fifth
century there has survived an ivory panel carved with the
scene of Adam sitting in his newly created kingdom [36], and
although, by classical standards, his head and members are
disproportionately big, his body is still intended to demon-
strate the belief that man is distinguished from the animals by
superior physical beauty. But the Bargello ivory has no surviv-
ing equal. Only in the Far East does the Apollonian ideal take
on a new life and significance; for we can hardly doubt that
the measured harmony of early Buddhist art represents a Greek
conquest more lasting than the victories of Alexander. From
the fifth to the twelfth century the various cultures of eastern
Asia produced male nude figures that have the dignity and
frontal authority of some pre-Pheidian Apollo. The likeness of
the finest bodhisattvas in Khmer sculpture to sixth-century
Ionian *kouroi* is unmistakable, and proves how, given certain
conditions and ingredients, a style may follow its own logic, in
which space and time are relative terms.

In the Christian West, during the same centuries, nude fig-
ures are occasionally to be found, but they are echoes or mean-
ingless doxologies, repeated on account of some magic that has
long since evaporated from them. The ideal form of Apollo
scarcely appears again before that false dawn of the Renais-
sance, Nicola Pisano's pulpit in the Baptistery of Pisa [37].
Characteristically, it is transferred to a personification of
strength; for, as we shall see, Herakles alone of the Olympian
gods was moralized into survival. But formally Nicola's figure

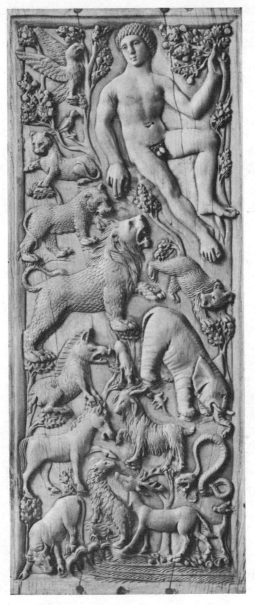

36. *Early Christian, 5th century* A.D. *Adam*

37. Nicola Pisano. Fortitudo

remains an Apollo, heavier than his Hellenistic model, but conforming with a kind of obstinacy to the canonical image of fifth-century Attica. What is lacking is the belief in physical beauty that underlies even the squarest athletes of Polykleitos, a belief that had been so long accepted as sinful that another century and a half had to pass before it could re-enter the mind. How pleasure in the human body once more became a permissible subject of art is the unexplained miracle of the Italian Renaissance. We may catch sight of it in the Gothic painting of the early fifteenth century, revealed in the turn of a wrist and forearm or the inclination of a neck; but there is nothing to prepare us for the beautiful nakedness of Donatello's *David* [*38*].

Donatello's first innovation, which was to be followed repeatedly in the Renaissance, is the transformation of the king of Israel into a young Greek god. In his youth David had been comely, and, like Apollo, had conquered by his purity of purpose an embattled monster. He was also the canonized patron of music and poetry. But the image of David most familiar in medieval art was an old man, bearded and crowned, playing on the harp or on a chime of bells; and although the young David was not unknown in the Middle Ages, it was by a prodigious leap of the imagination that Donatello saw him as a god of antiquity. Strictly speaking, he is not an Apollo but a young Dionysos, with dreamy smile and flexible pose; and the Goliath head at his feet is simply the old satyr head often found at the base of Dionysiac statues. One of these Donatello must have known, and combined it with the memory of an Antinoüs; and he must also have been familiar with certain antique bronzes, for the sense of form in relation to material is identical with such work as the *Spinario*. But these obvious sources of inspiration do not prevent the *David* from being a work of almost incredible originality, which nothing else in the art of the time leads us to anticipate. One would gladly know the comments made upon it when it was first exhibited, for during the rest of the century it continued to be far beyond the current of contemporary taste. It is curiously different, even, from the rest of Donatello's work, in which he appears as the sculptor of drama, and of man's moral and emotional predicament, and not of physical perfection. Yet we feel that in the *David* he has looked as eagerly as a Greek of the fourth century at those delicate ten-

38. Donatello. David

sions and transitions which make the youthful body sensuously
appealing. Donatello's deviations from the canon of classical
proportion are obvious. He has represented a real boy whose
chest was narrower and flank less rounded than the Greek
ideal. No doubt his model was younger and less developed than
the boy athletes to whom instinctively we compare him. But
allowing for these accidental differences, there remains a fun-
damental difference of construction. In the antique nude the
flat, rectangular chest is supported by a formalized stomach—
the *cuirasse esthétique* already described; in the *David,* and in
practically all subsequent nudes of the Renaissance, the waist
is the center of plastic interest, from which radiate all the other
planes of the body. Donatello's contemporaries, however,
would scarcely have recognized these differences of proportion
and construction, and would have been conscious only of some
pagan god returned to earth. Of both him and Brunelleschi it
was said, giving to their genius a kind of alchemical interpreta-
tion, that they had rediscovered the secrets of the ancient
world; amongst which was the secret of physical beauty.

There are several reasons why for fifty years or more Dona-
tello's *David* had no successors. One is the Gothic reaction that
took place in Florentine art at the middle of the fifteenth cen-
tury, when a fashion for the decorative tapestries and minutely
finished panels of the Low Countries superseded the heroic
humanism of Donatello and Masaccio. Another is the inher-
ent restlessness of the Florentine temperament. Apollo is static.
His gestures are dignified and calm. But the Florentines loved
movement, the more violent the better. The two great masters
of the nude in the late *quattrocento,* Pollaiuolo and Botticelli, are
concerned with embodiments of energy or ecstatic motion, with
a wrestling Hercules or a flying angel, and only once, in Bot-
ticelli's *St. Sebastian,* achieve a satisfactory nude in repose. Thus,
although the Florentines were the first to be influenced by the
remains of antiquity, the tranquil, static painting of central
Italy, scarcely awakened from its Gothic dream, was more fun-
damentally classical. The nude figures in Piero della Francesca's
Death of Adam have the large gravity of pre-Pheidian sculpture.
A man seen from behind, leaning on a spade, seems to be mid-
way between Myron and Polykleitos, and the brother and
sister, Adam's grandchildren, are like the *Orestes and Elektra* at

Naples. How far this classicism was innate, how far the result
of study, it is hard to say, but I have come to believe that Piero
was more closely acquainted with antique art, including an-
tique painting, than recent students have allowed.

His pupil, Perugino, belonged to the generation that made
free use of antiquarian pattern books, and in his drawings of
the nude the Umbrian sense of harmony is applied to Hellenistic
models. In spite of slender proportions and willowy Gothic legs
there is a classical ease of transition between one form and
another that leads directly to Raphael; and to Raphael him-
self was attributed for many years Perugino's masterpiece of
pagan imagery, the *Apollo and Marsyas* in the Louvre [*39*]. It is
the perfection of *quattrocento* classicism. For the lower part of
the figure Perugino has followed his life drawing in the Uffizi,
but by squaring the shoulders he has given it a genuinely
Praxitelean character. This Apollo is as graceful as a bronze
from Herculaneum and, in contrast to the gentle Marsyas, pot-
bellied and spindle-shanked like a faun, as confidently ideal:
and yet the total effect is entirely of its time, and no more re-
sembles a painting of antiquity than the poems of Poliziano
resemble those of Ovid. Walter Pater was fond of describing
works of the Renaissance by the word "dainty," a word that,
before its recent degradation, carried a train of chivalric asso-
ciations. It is not a word that should be applied to the Apollos
of ancient Greece, but it comes unbidden to the mind before
Perugino's pictures, expressing both the jewelsetter's delicacy
of the execution and also some element of make-believe, as of
an exquisitely learned pageant. Even at this moment which
precedes his triumph over a lower order of enthusiasm, this
Apollo lacks the impartial ferocity of the sun. He is, rather, the
elegant leader of the Muses; and as such he appears again in
that most beautiful representation of his realm, Raphael's
Parnassus.

At this point the *Apollo Belvedere* reappears. The exact cir-
cumstances of its excavation are not known, but it seems to
have taken place about the year 1479; it appears twice in the
Ghirlandaiesque pattern book known as the Escurialensis, and
shortly afterward is transformed into a David in an early en-
graving by Marcantonio, thus continuing the precedent of
Donatello. It was engraved again by Marcantonio in its unre-

39. Perugino. Apollo and Marsyas

stored state, and inspired a quantity of imitations, ranging
from the bronze statuette of the Mantuan court sculptor,
Antico, a copy so exact that we can scarcely credit its date, to
the free adaptation of Bernini's *Apollo and Daphne*. One of the
first to feel its influence was an artist who cannot have seen it.

Albrecht Dürer never reached Rome, but on his first visit to Italy he must have been shown drawings of the famous antique; and, as we have seen, he made them the basis of his exercises in proportion. Almost immediately after his return, in 1501, he executed the drawing in the British Museum of a nude man bearing in his hand a flaming disk on which is written (in reverse) the word *Apolo* [*40*]. The figure is made up of *souvenirs d' Italie*. The legs are copied from a Mantegna engraving, the style, both in penmanship and in degree of emphasis, shows knowledge of early drawings by Michelangelo: but, above all, it is the image he had formed of the figure in the Belvedere that has given this Apollo its godlike bearing. The flat rectangularity of the torso, the absence of articulation in the outline of the thighs, and the way in which they are joined to the waist—in these and many other points Dürer's drawing is far more antique than the restless figures of the Florentines. Not for the last time a German artist has constructed a work of irreproachable classicism; yet a construction it remains, concealing only temporarily (though with wonderful mastery) Dürer's real conviction that the body was a curious and rather alarming organism.

Raphael's response to the *Apollo* was exactly the reverse. Of the drawings he did direct from the figure only one has survived, a slight sketch, significantly on the back of a drawing of the Adam in the *Disputa*. But from the time of his arrival in Rome the rhythm and, we may say, the ethos of the *Apollo* are perceptible in some of his noblest creations. Not only the grace of movement, but the sense of epiphany and the glance toward a more radiant world, which are peculiar to the *Apollo Belvedere*, reappear in the saints, poets, and philosophers of the Stanze. Raphael, with his unequaled power of assimilation, practically never borrowed a form directly, and the three Apollos in the Stanza della Segnatura are his own creations. Even the figure in *The School of Athens* intended to represent an ancient statue in a niche displays the same structural difference from antique art that has just been observed in Donatello's *David;* and the figure in the center of the *Parnassus* is a mild and harmonious god, Apollo Musagetes, in whom the pride of the original Olympian has been subdued to fit him for the Christian company that surrounds him.

Since the Greeks of the fourth century no man felt so certain

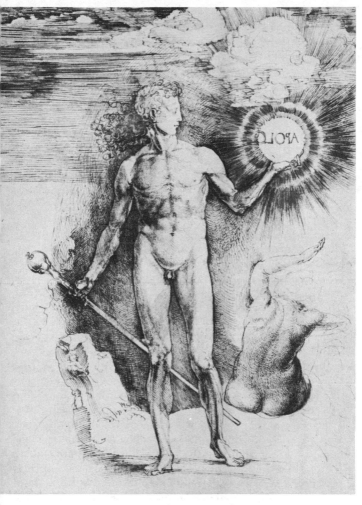

40. *Dürer. Apollo*

of the godlike character of the male body as Michelangelo. "And held it for something divine": this phrase, which occurs so often in Vasari's life when describing his hero's work, is not rhetoric, but the statement of a conviction; and Michelangelo

expresses the same belief in his sonnets to Cavalieri. It was a
belief born of emotion. Michelangelo, like the Greeks, was pas-
sionately stirred by male beauty, and with his serious, Platonic
cast of mind he was bound to identify his emotions with ideas.
This passage of violent sensuous attachment into the realm of
nonattachment, where nothing of the first compulsion is lost
but much gained of purposeful harmony, makes his nudes
unique. They are both poignant and commanding. The *Apollo*
of Olympia is commanding but not at all poignant, for he has
grown naturally out of an assumption that no man of the post-
Christian world can make, least of all the hungry soul of
Michelangelo. There can never be, in his work, the Olympian
calm or the Apollonian clarity of reason. But the fierce Appol-
lonian authority, the character of *sol justitiae,* that Michelangelo
could give, as no man since.

In his youth, as we know, he strove for the perfection of an-
tique beauty, producing imitations of classic art that were even
used to deceive the collectors of the day. The *Bacchus* shows
that he would go so far as to imitate the lifeless surface of a
marble copy. But his drawings of the nude have from the first
Tuscan strength and that nervous articulation which I have
already contrasted with the bland forms of antiquity. In the
Louvre is a drawing of a nude youth [*41*] whose godlike body
has a truly Pheidian splendor; but on analysis how un-Greek
it becomes! The outlines of the torso flow with a restless, vital
movement, and within them the modeling is so rich and con-
tinuous that the old, geometric divisions on which the classic
architecture of the body is founded have almost disappeared.
The eye never seems content to move peacefully over a plane,
but either extorts from it the last fraction of incident or omits
the passage altogether, as the arms and left breast are omitted
here. There are, moreover, several anatomical details, such as
the right clavicle and surrounding muscles, that would have
offended the Greeks but satisfied Michelangelo's love of knotted,
hard-gripping form. The drawing that comes nearest to an-
tiquity is one of an Olympian god, half Mercury, half Apollo,
also in the Louvre, evidently done from memory [*42*]. The
forms are more generalized than in the life drawings and flow
with an easier movement; but already there is that peculiar
thickening of the torso (increased, even, in a correction) which

41. *Michelangelo. Nude youth*

42. Michelangelo. An antique god

in his later work was to become almost a deformation. It would be a mistake, however, to suppose that he disregarded the classical system of proportion. On the contrary, he studied it, and himself used one that was probably derived from Pliny's account of Polykleitos. Of this we have evidence in a study at Windsor that has been marked and measured in great detail, as if for the instruction of some other painter. Michelangelo has exaggerated the Polykleitan stance, so that the axis of the shoulders contrasts violently with that of the hips, and has indicated the muscles with anatomical exactness. Since the aim of the drawing was scientific he has made no attempt at classical idealization, and the result is more like Andrea del Castagno than Polykleitos. It shows us what a confluence of mental activities, calculation, idealization, and scientific knowledge contributed to the final effect of his masterpieces.

Michelangelo's greatest embodiment of the Apollonian idea is the first marble *David*. Given the torso alone [*43*], he might be claimed as the climax of that long search for harmony which started with the fragment from Miletos or the Kritios youth. True, there is a ripple of ribs and muscles and, beneath it, scarcely perceptible, the ground swell of some distant storm that distinguishes the *David's* torso from those of the most vigorous antiques; but if it had remained a fragment we should have been astonished at the strictness with which Michelangelo had accepted the classical scheme. However, we have the entire figure; and long before our eye can take in the torso it has been caught by the head on its strained, defiant neck, the enormous hands, and the potential movement of the pose, which force him far outside the sphere of Apollo. This overgrown boy is both more vehement and less secure. He is a hero rather than a god. He sums up, and with a turn of the head destroys, the whole of that trusting, reverent, and romantic attitude toward antiquity which Michelangelo had learned from Bertoldo in the garden of Lorenzo the Magnificent. Michelangelo himself was scarcely conscious of this. The drawings already mentioned were certainly done after the *David;* and at a far later date he returned to the idea of Apollonian perfection. The most symbolic of these perfect men is the awakening *Adam* of the Sistine [*44*]. Nowhere else does Michelangelo concede so much to the accepted notion of physical beauty; but

43. Michelangelo. Detail of David

in this very image he shows the perfect body receiving that charge which was to disturb forever its equilibrium. The *Adam* is in a pose not very different from that of the figure from the pediment of the Parthenon known as the *Dionysos* [*45*]. The distribution of balance, the sense of noble relaxation, and the general architecture of their bodies are the same; and yet how strikingly the *Adam* differs from the *Dionysos* in total effect! It

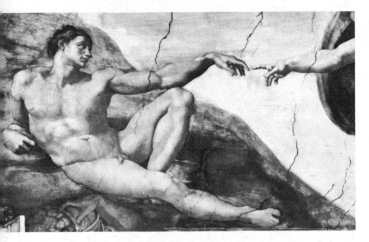

44. *Michelangelo. Creation of Adam*

45. *Pheidias,* c. 435 B.C. *Dionysos from Parthenon*

is the difference between being and becoming. The *Dionysos,* in
its timeless world, obeys an inner law of harmony; the *Adam*
gazes out to some superior power that will give him no rest.

In two other nude figures Michelangelo has given form to
aspects of Apollo, strangely different from one another and
perhaps complementary. The first is the marble figure in the
Bargello, which he seems to have intended as an Apollo (for
the shadowy suggestion of a quiver is still visible) and then
changed into a David with his sling [46]. Apollo it remains, for
the sleepy, sensuous movement of the body cannot be inter-
preted as the action of the young hero; indeed, this round-
limbed youth entirely lacks the heroic indignation of the earlier
figure. He is like a romantic dream, a poem of vanishing love,
in which already the details are slightly blurred. In structure,
in proportion, in movement, in sentiment, nothing of the an-
tique nude remains; nothing except the worship of physical
beauty.

The other figure is the exact reverse. It is the judge who, in
the enormous *Doom* of the Sistine Chapel, confounds the pow-
ers of darkness [47]. We have returned to the most primitive
aspect of Apollo, the solar energy that creates and destroys, the
embodiment of *sol justitiae.* His gesture is more imperious even
than that of the *Apollo* of Olympia, for the heights to which he
summons the blessed are more radiant, the depths to which
he condemns the unruly more atrocious. In spite of his un-
Greek proportions (and Michelangelo has not tried to resist
that strange compulsion which made him thicken a torso till it
is almost square), this Pantocrator remains Apollonian. Mich-
elangelo has discarded the bearded Syrian figure, in its stiff
robes, which even the most pagan spirits of the Renaissance
had preserved from the judges of Byzantine tradition, and has
found his inspiration in the conquering image of Alexander the
Great. His arrogant head, slightly modified in spiritual con-
quest, is set on the naked body of an athlete, and it is partly
through the crushing strength of this body that his divine au-
thority is expressed. Looking back to the Apollos of fifth-cen-
tury Greece, we recognize how much the impressiveness of the
Pheidian nude depended on a latent fear of Olympus and we
remember, with Mexican art in mind, that, next to love, there

46. Michelangelo. Apollo-David

47. Michelangelo. Detail from Last Judgment

is no more powerfully form-creating emotion than fear of the wrath of God.

It is precisely this feeling of dread that is absent from all subsequent representations of Apollo, and turns him into the complacent bore of classicism. One example will do for all, Poussin's title page to the royal Virgil of 1641 [*48*]. The poet is

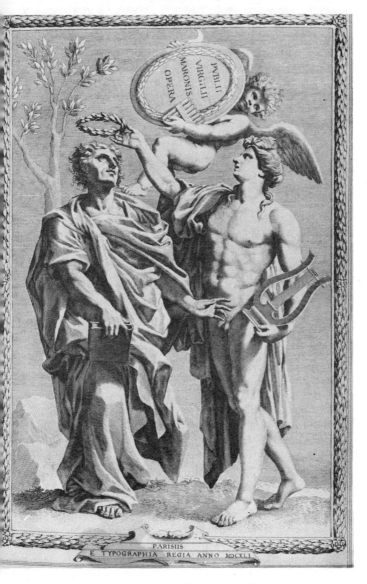

PVBLII
VIRGILII
MARONIS
OPERA

PARISIIS
E TYPOGRAPHIA REGIA ANNO MDCXLI

48. Poussin. Apollo Crowning Virgil

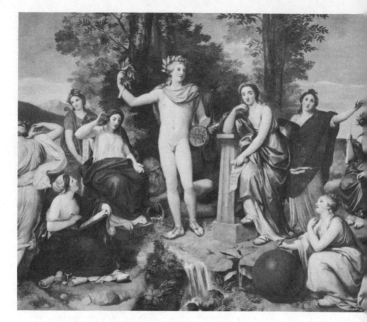

49. Mengs. Parnassus

crowned by a nude figure with short legs, broad chest, and heavy
shoulders that, since the sixteenth century, had been thought of
as iconographically appropriate to Apollo; and not even Poussin's
mastery of design can make this type of body anything but dull.
In fact, Poussin usually had the tact to avoid such figures, and
represented Apollo seated and two thirds draped. But the neo-
classicists of the next century, lacking his creative insight, were
aware only of the convenience of this respectable-looking form.
Winckelmann had asserted that the highest beauty should be
free from all flavor, like perfectly pure water, and when his
disciple, Raphael Mengs, painted for the gallery of the Villa
Albani a decoration that should be in keeping with its contents,
he aimed at an ideal insipidity. In his Apollo he achieved it [*49*].
The Muses of his *Parnassus*, although uninspiring, are average
specimens of eighteenth-century decoration; the flat formless
body of their leader is on a different plane of unreality, and so
looks as absurd to us as it looked admirable to Winckelmann's

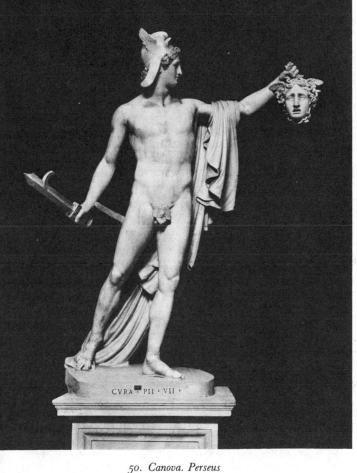

50. Canova. Perseus

contemporaries. In the next generation Canova, a brilliant portraitist and master of contemporary chic, could produce ideal figures as ridiculous as the *Perseus* of the Vatican [*50*], in which a fashion-plate version of the *Apollo Belvedere* holds at arm's length a caricature of the Rondanini *Medusa*. Apollo, with all those beliefs which clustered round his name, had lost his place

in the human imagination; and the husk of Apollo alone remained to provide a meaningless discipline in academies of art.

Myths do not die suddenly. They pass through a long period of respectable retirement, decorating the background of the imagination, until some new hot-gospeler decides that their destruction is necessary to his salvation. Apollo, who, in the early nineteenth century, was lost sight of in the smoke of materialism, has become in this century the object of positive hostility. From Mexico, from the Congo, even from the cemeteries of Tarquinia, those dark gods, of which D. H. Lawrence made himself the prophet, have been brought out to extinquish the light of reason. The individual embodiment of calm and order is to be supplanted by communal frenzy and the collective unconscious. Such impulses were well known to the Greeks. They are embedded in Greek religion; they are at the root of antique tragedy; and they are made beautifully visible to us on reliefs and drinking cups depicting Dionysos and his companions. Dionysiac enthusiasm, as we shall see in a later chapter, produced a series of nude figures that had a longer and more continuous life than the embodiments of Olympian calm. Yet when we look at the earliest representations of enthusiasm, the satyrs and rhumba dancers on sixth-century Greek vases, we realize why the Greeks felt that their art could not rest on this basis alone. Without some element of lawful harmony it would have been no different from the arts of the surrounding cultures, Hittite, Assyrian, or, as we may speculate, Minoan; and like them have dwindled into decoration, anecdote, or propaganda. This is the justification of Apollo in his cruel triumph over Marsyas. The union of art and reason, in whose name so many lifeless works have been executed and so many ludicrous sentiments pronounced, is after all a high and necessary aim; but it cannot be achieved by negative means, by coolness or nonparticipation. It demands a belief at least as violent as the impulses it controls; and if today, in the sensual wailing of the saxophone, Marsyas seems to be avenged, that is because we have not the spiritual energy to accept the body and to superintend it.

III

VENUS I

PLATO, in his *Symposium,* makes one of the guests assert that there are two Aphrodites, whom he calls Celestial and Vulgar, or, to give them their later titles, Venus Coelestis and Venus Naturalis; and because it symbolized a deep-seated human feeling, this passing allusion was never forgotten. It became an axiom of medieval and Renaissance philosophy. It is the justification of the female nude. Since the earliest times the obsessive, unreasonable nature of physical desire has sought relief in images, and to give these images a form by which Venus may cease to be vulgar and become celestial has been one of the recurring aims of European art. The means employed have been symmetry, measurement, and the principle of subordination, all refining upon the personal affections of individual artists. But perhaps this purification of Venus could not have taken place had not some abstract notion of the female body been present in the Mediterranean mind from the first. Prehistoric images of women are of two kinds, the bulging statuettes from paleolithic caves, which emphasize the female attributes till they are little more than symbols of fertility [*51*], and the marble dolls of the Cyclades, in which already the unruly human body has undergone a geometrical discipline [*52*]. Following Plato's example, we might call them the Vegetable and the Crystalline Aphrodite. These two basic conceptions never quite disappear, but since art involves the application of laws, the distinction between the two Aphrodites grows very slight;

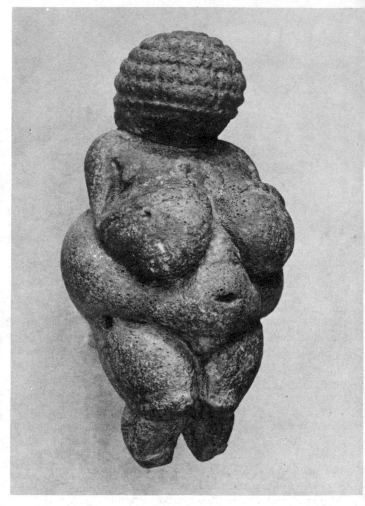

51. Prehistoric figure of a woman

and even when most unlike one another they partake of each
other's characters. Botticelli's Venus "born of the crystalline
sea of thought and its eternity" has a piercing strain of sensu-
ality; Rubens' Venus, a cornucopia of vegetable abundance,

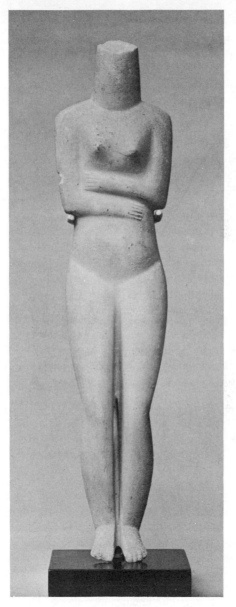

52. *Cycladic doll*

still aspires to the idea. Plato made his two goddesses mother
and daughter; the Renaissance philosophers, more perceptively,
recognized that they were twins.

Since the seventeenth century we have come to think of the
female nude as a more normal and appealing subject than the
male. But this was not so originally. In Greece no sculpture of
nude women dates from the sixth century, and it is still ex-
tremely rare in the fifth. There were both religious and social
reasons for the scarcity. Whereas the nakedness of Apollo was
a part of his divinity, there were evidently ancient traditions of
ritual and taboo that Aphrodite must be swathed in draperies.
The fables by which she arose from the sea or came from
Cyprus represent a truth, for naked Aphrodite was an Eastern
concept, and when she first appears in Greek art she has a
shape that clearly denotes her origin. This is the figure in
Munich forming the handle of a bronze mirror, which is as
straight and slim as if it were Egyptian, and without a hint of
that system of curves from which the classic Aphrodite was to
be constructed [53]. Even as late as the fourth century, the
naked Aphrodite was embarrassingly associated with Oriental
cults, and it was because the beauty of her body might seem
an inducement to heresy and not for moral reasons that
Phryne, the model of Praxiteles, became an object of clerical
disapproval. Socially the restrictions were equally strong.
Whereas the young men stripped naked for exercise and habit-
ually wore no more than a short cloak, Greek women went
about draped from head to foot, and were confined by tradi-
tion to their domestic duties. The Spartans alone were an ex-
ception. Their women scandalized the rest of Greece by show-
ing their thighs, and competing in athletic sports. The *Girl
Runner* in the Vatican must certainly have been a Spartan. Nor
must we discount the influence of that peculiar institution of
Greek life, so earnestly celebrated in the odes of Pindar and the
dialogues of Plato, by which the love of two young men for one
another was considered nobler and more natural than that be-
tween opposite sexes. It is from the rapturous scrutiny of pas-
sion that ideal beauty is born; and there is no feminine equiv-
alent to the Kritios youth. The rare drawings of naked women
on early vases are almost comically unideal—for example, the
ladies enjoying a shower bath on a black-figure vase in Berlin

[54], who are closer to the eternal feminine of Thurber than to that of Praxiteles. By the middle of the fifth century the female figures on drinking cups have become more attractive [55]. These were ladies whose physical charm was their fortune, and no doubt the artist tried to make them look as neat and sprightly as possible. But they are no more idealized than their Japanese equivalents in the print of Kyonaga. The most revealing of all

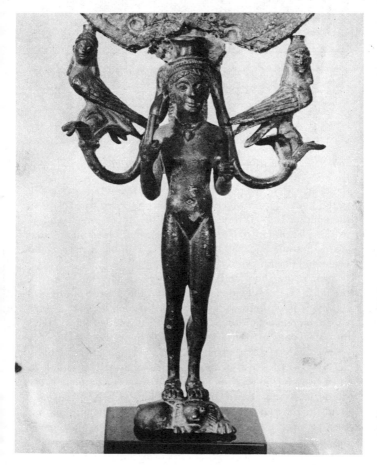

53. *Greek, early 6th century* B.C. *Aphrodite mirror handle*

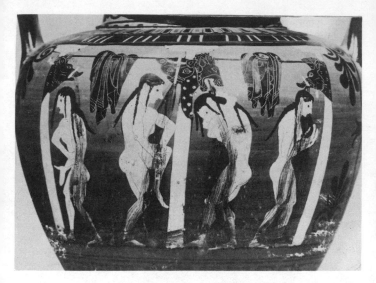

54. Attic, 6th century B.C. *Black-figure vase*

these chance survivors from the minor arts is a terra-cotta doll
in the Louvre, from which, since it was intended to be clothed,
the sculptor has not removed any of the imperfections and ir-
regularities of nature [*56*]. It shows us what observation, what
grasp of truth and substance, even a humble artisan could
command in fifth-century Greece.

Such is the short and scrappy prelude to Venus. And al-
though it contains evidence of vitality and a sense of physical
charm, it is entirely without that search for finality of form
which, on our definition, is the basis of the nude. But at about
the same date as the terra-cotta doll there was produced a
bronze figure of a nude girl, perhaps a priestess of Isis, binding
her hair, which must have been a masterpiece. It is known to
us in two marble replicas, of which the more complete is the
statue in Rome known as the *Esquiline Venus* [*58*], the more
vivid the torso in the Louvre [*57*]. No doubt the original has
been changed and elaborated by translation into marble, yet
the copies have not lost the unity of the first idea. Somewhere
not very far behind them is the work of an individual artist who,
on the surviving evidence, must be reckoned the creator of the

female nude. Not that the Esquiline girl represents an evolved
notion of feminine beauty. She is short and square, with high
pelvis and small breasts far apart, a stocky little peasant such
as might be found still in any Mediterranean village. Maillol
maintained that he could find three hundred in the town of
Banyuls alone. Her elegant sisters from the metropolis would
smile at her thick ankles and thicker waist. But she is solidly
desirable, compact, proportionate; and, in fact, her proportions
have been calculated on a simple mathematical scale. The unit
of measurement is her head. She is seven heads tall; there is the

55. Greek, c. 500 B.C. Panphaios Vase (detail)

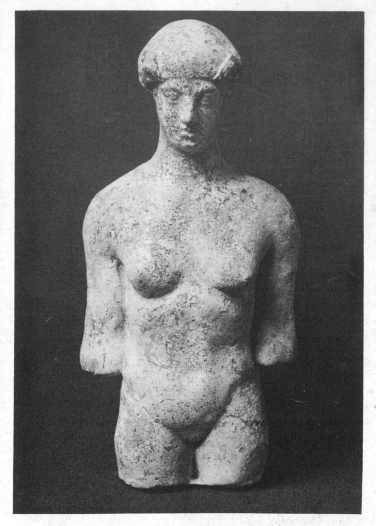

56. Attic, 5th century B.C. *Terra-cotta doll*

length of one head between her breasts, one from breast to
navel, and one from the navel to the division of the legs. More
important than these calculations, which, as we have seen from

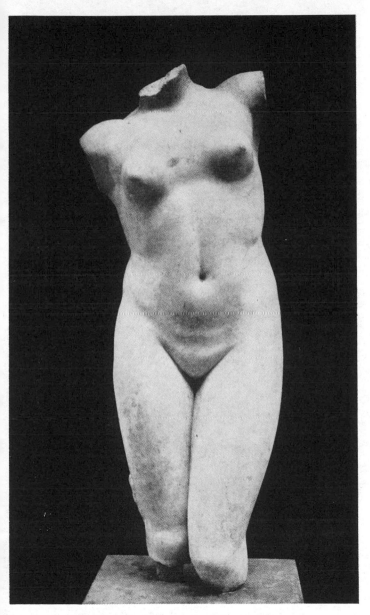

57. Greek, 5th century B.C. *Torso (replica)*

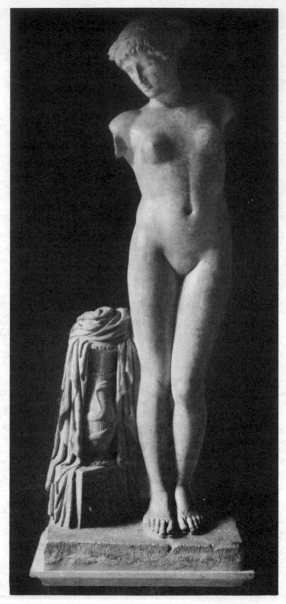

58. Greek, 5th century B.C. *Esquiline Venus (replica)*

Dürer, can be misleading, the sculptor has discovered what we may call the plastic essentials of the female body. Breasts will become fuller, waists narrower, and hips will describe a more generous arc; but fundamentally this is the architecture of the body that will control the observations of classically minded artists till the end of the nineteenth century and has been given fresh life by Maillol in our own day.

So rare are nude figures of women in the great period of Greek art that to follow the evolution of Aphrodite before Praxiteles we must not look for absolute nudity, but must include those carvings in which the body is covered by a light, clinging garment, what the French call a *draperie mouillée*. This device was used from archaic times onward, the earliest sculptors seeming to recognize how drapery may render a form both more mysterious and more comprehensible. The section of a limb as it swells and subsides may be delineated precisely or left to the imagination; parts of the body that are plastically satisfying can be emphasized, those less interesting can be concealed; and awkward transitions can be made smooth by the flow of line. Drapery makes the bodies of the sixth-century maidens as beautiful as those of the young men, and consoles us for the absence of female nudes by the presence of the *korai;* and in that isolated masterpiece, the Ludovisi Throne, the body of the naked flute player [59] moves us less than that of the lightly draped Aphrodite [60]. The flute player's pose has not allowed the sculptor to develop the leading motives of the nude, whereas in the Aphrodite, who rises with such benign confidence between the arms of her attendants, he has discovered that landscape of the breasts and thorax which for some mysterious reason, connected, perhaps, with our earliest physical needs, is one of the most satisfying the eye can rest upon. In the execution of this passage, how skillfully he has used the pleats of her shift, which outline her shoulders, vanish under the pressure of the swelling breasts, and occupy with delicate curves that plane of her chest which, without them, would have seemed too flat for continuous beauty! The modeling of her attendants' legs, half seen through their flimsy skirts, is done with equal subtlety and sensuous understanding. Clearly the schools of Ionia and Magna Graecia brought to the problem of clinging drapery a long tradition of technical skill. It

was an artist trained in this tradition, but with an imperfect
grasp of construction, who designed the "draped nudes" of the
Nereid monument, and another, whose name, Paionios, has
come down to us, who carved the shattered figure of *Victory* in
the Museum of Olympia.

In the *Nike* of Paionios almost every trace of archaic accent
has disappeared. Her limbs have the youthful fullness we find

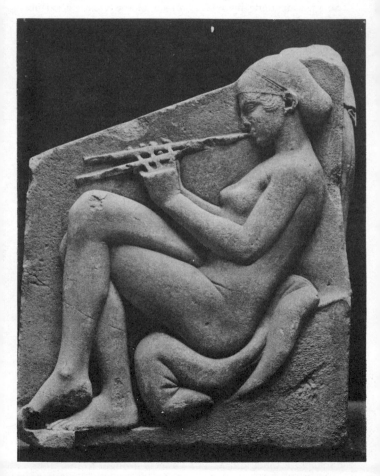

59. Ionian, early 5th century B.C. *Flute player on Ludovisi Throne*

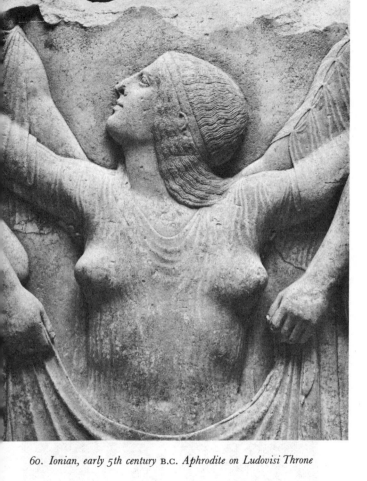

60. Ionian, early 5th century B.C. Aphrodite on Ludovisi Throne

in the early nudes of Titian or Poussin. In fact, her body must
first have been modeled in the nude and the drapery added to
bring out rather than to conceal its rotundities. A lack of
rhythmic unity suggests that Paionios did not himself invent
the style he employs, and it may well be that his contempo-
raries had already executed "draped nudes" with a more con-
fident structure, which have been lost to us. The *Fates* of

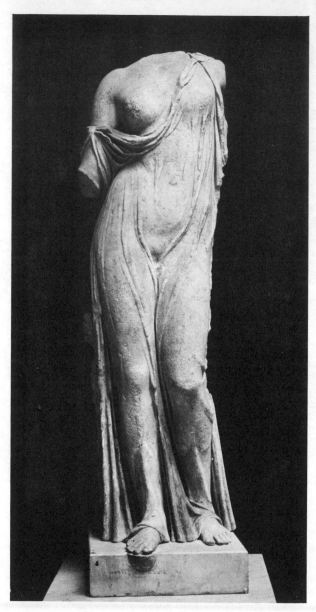

61. Hellenistic. "Venus Genetrix."

the Parthenon leave us in no doubt that the sculptors under the supervision of Pheidias could dispose the female body with the noblest and most natural effect; and toward the end of the fifth century, this tradition of the "draped nude" produced a famous Aphrodite. She has come down to us, under the misleading name of *Venus Genetrix* [61], in a number of replicas, of which those which are fragmentary are beautiful, those which are complete are dull. Of the latter, a figure in the Louvre may give a more or less correct idea of the whole, but we come nearer to sharing the sculptor's emotions when we look at a torso in Rome that reproduces the same design in reverse. The original was certainly by a pupil of Pheidias, and one of the same circle as the sculptor who executed the famous relief of *Nike* tying her sandal. In both, her chlamys has slipped from her shoulder and is tied in a knot on her arm, and, in both, the folds of drapery flow round the body, but are drawn tight over breasts and belly, so that the modeling, traversed by one vagrant line, makes its full effect. But in the *Nike* the revelation of her physical beauty is incidental, in the *Aphrodite* it is essential, and the drapery is used to accentuate it. Perhaps this was the first Aphrodite, in the sense that the beauty that arouses physical passion was celebrated and given a religious status. No longer need we complain that the response to feminity is halfhearted or incomplete. The plays of Aristophanes and Euripides are often quoted to prove that in the last quarter of the fifth century, Athenian women acquired a new importance; and to such literary examples may be added this figure, in which the subtlest rhythms of the female body are noted with an eager delicacy unsurpassed by Correggio or Clodion.

It has been suggested that the original of this lovely motive was the garden *Aphrodite* of Alkamenes, fervently praised by Pliny and Lucian; but as we do not even know if this figure was draped or nude, marble or bronze, this is only an archeologist's daydream. That nude bronze figures of women were made in this period is shown by a statuette in Munich of a girl who, in pose and proportions, is almost the undraped sister of the marble in the Terme [62, 63]. Her turbaned head suggests a date not more than twenty years later than the *Esquiline Venus,* but in these years the classical type has almost completed its evolution. Polykleitos has perfected his ideal of equilibrium, the weight

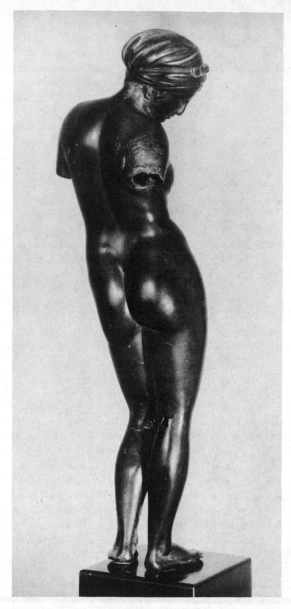

62, 63. Greek, c. 400 B.C. a girl

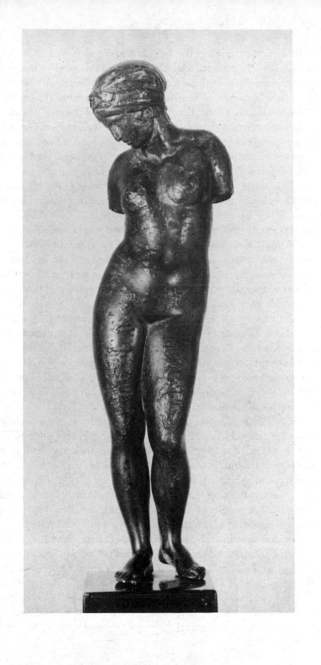

resting on the right leg, the left bent as if to move; and the girl in Munich is in this attitude. The pose was invented for the male figure, but by one of those happy accidents which often accompany the discoveries of genius, the female figure has drawn from it a more lasting profit; for this disposition of balance has automatically created a contrast between the arc of one hip, sweeping up till it approaches the sphere of the breast, and the long, gentle undulation of the side that is relaxed; and it is to this beautiful balance of form that the female nude owes its plastic authority to the present day. The swing of the hip, what the French call the *déhanchement,* is a motive of peculiar importance to the human mind, for by a single line, in an instant of perception, it unites and reveals the two sources of our understanding. It is almost a geometric curve; and yet, as subsequent history shows, it is a vivid symbol of desire. This pose seems obvious enough to us now; yet such are the strange limitations of plastic intelligence that sculptors might have continued for thousands of years, as they did in Egypt and Mesopotamia, without ever discovering it. Yet as soon as it emerged, it became one of the dominant rhythms of humanist art, and carried some evidence of the Greek mental pattern far beyond the confines of Greek philosophy. Every art in which the motive appears has been touched by Hellenistic influence; and although the austere Polykleitos might shudder at the luxurious *déhanchements* of Amaravati, he is ultimately responsible for them.

Incredible as it seems, the Munich statuette and the *Esquiline Venus* are the only sculptural records of the female nude in the fifth century. The old ritualistic feeling that the beauty of Aphrodite should not be uncovered lasted till well into the fourth century, and no doubt influenced the people of Kos when they rejected Praxiteles' nude *Aphrodite* in favor of one that was draped. The people of Knidos, profiting by their piety, thus became possessed of the most famous statue of antiquity.

The *Knidian Aphrodite* of Praxiteles [64] seems to have been executed in about the year 330, soon after his collaboration on the Mausoleum. Whether or not Pliny's story of her rejection by the people of Kos is true, there is no doubt that she was ideally suited to Knidos, an island off the south coast of Asia Minor, where Aphrodite had long been an object of devotion. A Greek author of late antiquity, whose writings were formerly

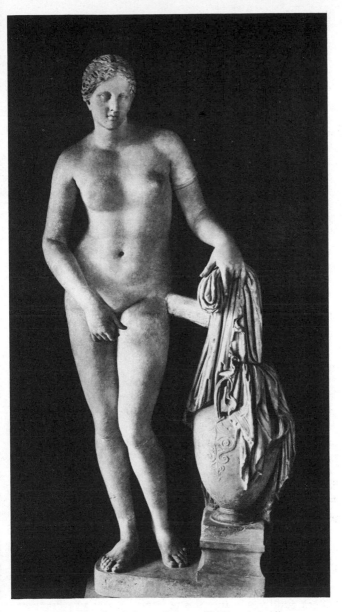

64. *After Praxiteles, c. 350 B.C. Knidian Aphrodite*

confused with those of Lucian, has left a vivid account of a visit
to her sanctuary. Instead of the usual paved courtyard, it was
surrounded by fruit trees of the finest growth, between which
hung festoons of generous grapes. In the midst of this refreshing
verdure was a small shrine, open at the front so that pilgrims
might see the figure of the goddess, white and radiant in con-
trast to the surrounding greenery. She was about to step into a
ritual bath, and one hand still held the shift she had drawn from
her shoulders. Her lips were parted in a gentle smile; yet she
had not altogether laid aside the majesty of an Olympian. The
false Lucian and his companions, however, were not overawed,
and made no pretense of aesthetic detachment. They spoke of
her exactly as if she had been a living woman of overwhelming
beauty. One of them, carried away by his excitement, leaped
on her pedestal and threw his arms round her neck. The sac-
ristan was mildly shocked, but later, for a gratuity, unlocked
the door at the back of the shrine, so that they could admire
this aspect of the goddess also; and their enthusiasm was
redoubled. Not all pilgrims, perhaps, were quite so direct in their
appreciation. The diligent Pliny writes of her as befits a pro-
fessor. But no one questioned the fact that she was an embodi-
ment of physical desire and that this mysterious, compulsive
force was an element in her sanctity.

Such sentiments may seem to us incompatible with an object
of religious veneration; but that is because the Hebrew basis of
our religion has accustomed us to a literary rather than to a
visual evocation of physical desire. Compared to the imagery of
the Song of Songs, the appeal of the *Knidian* is mild and
restrained. Both derive from the same state of mind, and perhaps
even from the same cult, because the Aphrodite of desire was,
as we have seen, a Syrian divinity; but the luxuriant sensuality
of the form is modified by the Greek sense of decorum, so that
the gesture of Aphrodite's hand, which in Eastern religions
indicates the source of her powers, in the *Knidian* modestly con-
ceals it. Perhaps no religion ever again incorporated physical
passion so calmly, so sweetly, and so naturally that all who saw
her felt that the instincts they shared with beasts they also
shared with the gods. It was a triumph for beauty; and to the
Greek mind this beauty was not simply created by Praxiteles,

but was already present in the person of his model, Phryne. She shared with him the credit for the beautiful figures with which he enriched the Greek world; and a nude statue of her in gilt bronze, openly a portrait, was erected in the sacred precincts of Delphi by a grateful community.

So much we know from literary records. Alas, when we turn for ocular confirmation of this epiphany, it is visible no longer. Of our forty-nine full-size replicas of the *Knidian,* not one can give us even the faintest notion of the original. Since the surface was painted it could not be cast and copying was probably discouraged. To add to our misfortunes, the three best replicas are all in the Vatican, where they have long been more or less inaccessible to students. Of these the so-called *Venus Belvedere* is obviously the copy of a bronze and is therefore at two removes from Praxiteles' original; while the *Aphrodite* from the Palazzo Colonna, although the main lines of the pose are convincing, has a head that does not belong to her, set on a stupid neck, and is as insensitive in modeling as the most commonplace garden statue. This is particularly fatal to a work of Praxiteles, who, as we have seen, took an almost morbid pleasure in delicacy of texture. The translucent surface still apparent in the *Hermes* and more appropriate to an Aphrodite must have added the sensual tremor which, for five hundred years, led poets, emperors, and boatloads of tourists to linger in the sanctuary of Knidos.

But in spite of this direct appeal to the senses, the *Aphrodite* of Praxiteles remains an ideal creation, complying with the abstract harmonies of art. At this distance of time we see that she belongs to the crystalline side of the family. Although she is so much taller, the proportions of her torso still conform to the first simple scheme established in the *Esquiline Venus.* And, beyond this geometrical harmony, there is, in her whole bearing, a harmonious calm, a gentleness even, much at variance with the amatory epigrams she inspired. To us she may even seem less sensually appealing than the nudes that preceded her; but in this one must make allowance not only for the dismal nature of our replicas, but for the interference of her innumerable successors. The classic nude, which Praxiteles invented, became, in less sensitive hands, the conventional nude, and as

we try to look at his *Knidian Aphrodite* we seem to see a forest of marble females, filling a vast conservatory with their chaste, monotonous forms.

There is no more curious example of conspicuous waste than the smooth white marble nudes that in the nineteenth century were considered symbolic of art. In fact, these figures do not usually derive from the *Knidian* [65], but from two Hellenistic statues of great celebrity, the *Capitoline Aphrodite* [66] and the *Medici Venus* [67]. Fundamentally, these are versions of the Praxitelean idea, but they involve an important difference. The Knidian is thinking only of the ritual bath she is about to enter. The *Capitoline* is posing. Herself self-conscious, she is the product of self-conscious art. Her pose, whenever it was evolved, is the most complete solution in antique art of certain formal problems presented by the naked female body; and it is worth trying to see how this has been achieved. The variations on the *Knidian* are subtle, but decisive. The weight has been transferred from one leg to the other, but is more evenly distributed, so that the axes of the body are nearly parallel. The action of the *Knidian's* right arm has been given to the *Capitoline's* left, but both heads look in the same direction. Finally, the most obvious change, the arm of her "free" side, instead of holding her drapery, is bent over her body, just below her breasts. All these changes are designed to produce compactness and stability. At no point is there a plane or an outline where the eye may wander undirected. The arms surround the body like a sheath, and by their movement help to emphasize its basic rhythm. The head, left arm, and weight-bearing leg form a line as firm as the shaft of a temple. Approach the *Knidian* from the direction to which her gaze is directed, and her body is open and defenseless; approach the *Capitoline*, and it is formidably enclosed. This is the pose known to history as the Venus Pudica, the Venus of Modesty, and although the *Capitoline* is more carnally realistic than the *Knidian*, and the action of her right hand does nothing to conceal her magnificent breasts, a formal analysis shows that the title has some justification. We can see why in later replicas this attiude was adopted when the more candid nudity of Praxiteles would have given offense. We can also understand why, through all the misfortunes and muta-

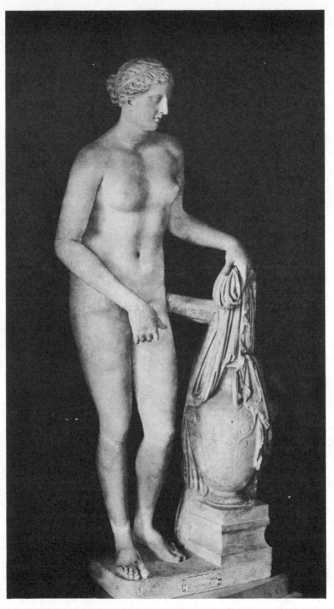

65. *After Praxiteles,* c. *350* B.C. *Knidian Aphrodite*

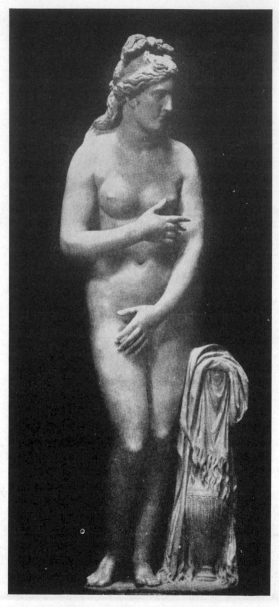

66. *Hellenistic. Aphrodite of the Capital*

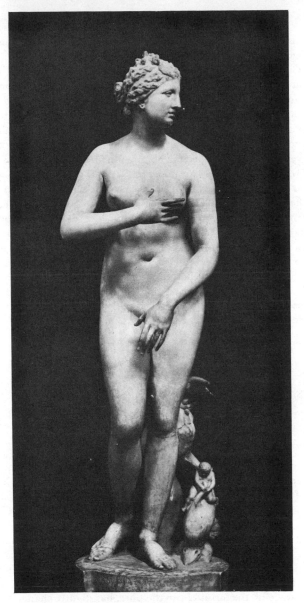

67. *Hellenistic. Medici Venus*

tions Venus was to suffer during two thousand years, this impregnable design was the chief survivor.

Curiously enough, it owes a great part of its authority in post-Renaissance art to a version in which the rhythmic completeness of the whole is almost lost: the famous *Venus dei Medici*, which so long reigned unchallenged in the Tribuna of the Uffizi. The breakdown of rhythm is partly owing to a faulty restoration of the right arm, which, in an effort genuinely to cover the breasts and deserve her reputation for modesty, is bent at too sharp an angle and does not sustain the flow of movement round the body. But at every point the *Medici Venus* is stilted and artificial. The physical opulence of the *Capitoline* has been reduced to refined complacency. The line of the body tapers up to the tiny, Praxitelean head, with the vapid elegance of a Victorian fashion plate. It was perhaps inevitable that for two centuries this modish elegance should have been confused with ideal beauty. In the literature of praise the *Medici Venus* fills almost as many pages as the *Apollo Belvedere,* and with less reason. Byron, who considered the ideal "all nonsense," devoted to the *Venus* a stanza of *Childe Harold:*

> We gaze and turn away, and know not where,
> Dazzled and drunk with Beauty, till the heart
> Reels with its fulness; there—for ever there—
> Chained to the chariot of triumphal Art,
> We stand as captives, and would not depart.
> Away!—there need no words, nor terms precise,
> The paltry jargon of the marble mart,
> Where the Pedantry gulls Folly—we have eyes.

In fact, Byron was not using his eyes at all and, like most people of his class and temperament, had himself been gulled by fashion. Wordsworth, with a firmer grasp of fact and, as we know from Hazlitt, a stronger feeling for art, confessed that in the Tribuna of the Uffizi he had turned his back on the *Venus* and fallen asleep. Nevertheless, we must admit that a number of good judges, from Winckelmann downward, have considered the *Medici Venus* a model of feminine beauty, and it is clear that the narrow boundary that separates the affected from the graceful, the insipid from the pure, has slightly changed its position. No doubt it will continue to fluctuate, but, like the

waistline, within limits: and if we think that we can place it more accurately than a great critic like Winckelmann, that is because we have the advantage of knowing at least a few of those original works of fifth-century Greece which to him were only dreams. Fortified by knowledge of the *Hermes of Olympia* and the sculpture from the Akropolis, we can return to our lifeless copies of the *Knidian Aphrodite* and find in them traces of a purity and a serene humanity compared to which the *Medici Venus* is no more than a large drawing-room ornament.

The *Knidian* was not the only famous *Aphrodite* by Praxiteles. He also executed for the Thespians a statue in which the legs were draped and the breasts nude; and this, too, has come down to us in several replicas. Once more the most complete is in the Louvre, the so-called *Venus of Arles,* and once more our heart sinks as we contemplate it. Not the faintest tremor of the artist's original feeling has been permitted to reach us, and if she were placed on the staircase of an old-fashioned hotel we should not give her a second glance. This is largely owing to the restorations of the sculptor Girardon, who on the instructions of Louis XIV not only added the arms and changed the angle of the head, but smoothed down the whole body, since the King was offended by the sight of ribs and muscles. We can see from a cast at Arles, made before the statue was taken to Versailles, that the *Thespian Aphrodite* embodied a noble idea, and one that was to prove more fruitful than the extreme perfection of the *Knidian.* She solves one of the chief problems of sculpture with the simplicity of Columbus' egg. It has always been the despair of sculptors that the torso, that perfect, plastic unity, should rest on tapering, spindly supports. Praxiteles has simply draped the legs and left the torso bare. He has thus achieved so firm a foundation for his figure that he can dispense with any support—vase, pillar, or dolphin—and allow the arms free play. Perhaps, as sometimes happens with a new discovery, he has failed to take full advantage of his freedom. The conventional appearance of the *Venus of Arles* is not owing solely to her inarticulate surface, but to a rather quiet design, which is all that a replica can transmit. In particular, the axes of the body are so nearly parallel as to deprive it of vitality; and it is in this respect that later sculptors were able to develop Praxiteles' idea. Already in the fourth century it was adapted

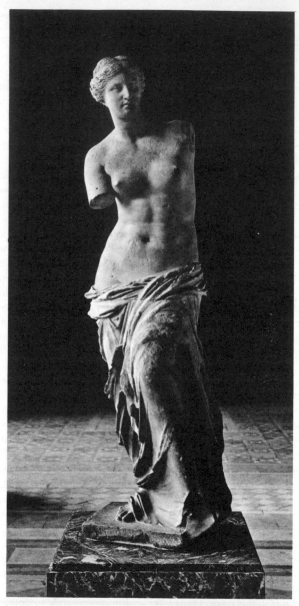

68. Greek, c. 100 B.C. Aphrodite of Melos

to the motive of Aphrodite admiring herself in the mirror of Ares' shield, supported on her knee, and the figure was recomposed on the basis of emphatic, ascending diagonals. The *Venus of Capua* in Naples is the chief replica of this statue; and for about two hundred years may seem to have exhausted the possibilities of the motive. It was, however, to undergo a further development. The *Venus of Capua* had been conceived in profile, like a relief: about the year 100 B.C. it occurred to some sculptor of genius to redesign the figure in terms of depth. The result was the last great work of antique Greece, the *Aphrodite of Melos* [*68*].

Within a few years of her discovery in 1820, the *Aphrodite of Melos* had taken the central, impregnable position formerly occupied by the *Medici Venus,* and even now that she has lost favor with connoisseurs and archeologists, she has held her place in popular imagery as a symbol, or trade-mark, of beauty. There must be hundreds of products, from lead pencils to face tissues, from beauty parlors to motorcars, that use an image of the *Aphrodite of Melos* in their advertisements, implying thereby a standard of ideal perfection. Vast popular renown of song, novel, and poem is always hard to explain and in a piece of sculpture is more mysterious still. Coincidence, merit, and momentum are imponderably combined. The *Aphrodite of Melos* gained some of her celebrity from an accident: until 1893, when Furtwängler subjected her to a stricter analysis, she was believed to be an original of the fifth century and the only free-standing figure of a woman that had come down from the great period with the advantage of a head. She thus profited by the years of devoted partisanship that had established the supremacy of the Elgin marbles. They had been praised for their heroic naturalness, their lack of affectation and self-conscious art, and the same terms could be used in contrasting the *Aphrodite of Melos* with the frigid favourites of classicism. It remains true that she is fruitful and robust beyond the other nude Aphrodites of antiquity. If the *Medici Venus* reminds us of a conservatory, the *Aphrodite of Melos* makes us think of an elm tree in a field of corn. Yet there is a certain irony in this justification through naturalness, for, in fact, she is of all works of antiquity one of the most complex and the most artful. Her author has not only used the inventions of his

own time, but has consciously attempted to give the effect of a fifth-century work. Her proportions alone demonstrate this. Whereas in the *Venus of Arles* and the *Venus of Capua* the distance between the breasts is considerably less than from breast to navel, in the *Aphrodite of Melos* the old equality is restored. The planes of her body are so large and calm that at first we do not realize the number of angles through which they pass. In architectural terms, she is a baroque composition with classic effect, which is perhaps exactly why the nineteenth century placed her in the same category of excellence as Handel's *Messiah* and Leonardo da Vinci's *Last Supper*. Even now, when we realize that she is not a work of the heroic age of Pheidias, and is perhaps somewhat lacking in the modern merit of "sensibility," she remains one of the most splendid physical ideals of humanity, and the noblest refutation of contemporary critical cant that a work of art must "express its own epoch."

The genesis of the *Aphrodite of Melos* exemplifies how the later Hellenistic artists approached the problems of creation. Not being blessed with great powers of invention, they used all their skill in combination and development. In the history of art this is neither unusual nor discreditable. In China and Egypt, for example, it was the rule, and the extreme restlessness of European art since the Renaissance has not been an unmixed advantage. But it is remarkable that in the female nude there is hardly a single formal idea of lasting value that was not originally discovered in the fourth century. An example is the beautiful motive of the crouching Aphrodite, from which Rubens and French artists of the eighteenth century were to derive so much profit. On the evidence of epigraphy this is usually attributed to a late Hellenistic sculptor from Bithynia, named Doedalsas, and no doubt he did execute a statue in this pose. But the motive occurs on a fourth-century amphora decorated by a painter from Kamiros, whose figures seem to have been inspired by the sculpture of Skopas; so that the splendid wholeness of the crouching Aphrodite must also go back to the great age of plastic energy.

The variations on the theme of Aphrodite-Venus that have come down to us from Hellenistic and early Roman times, especially those in the form of small bronzes, are often of great charm and ingenuity. Venus putting on her necklace [*69*],

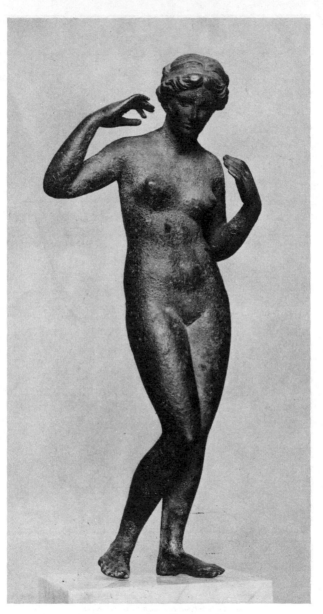

69. *Hellenistic. Bronze Venus*

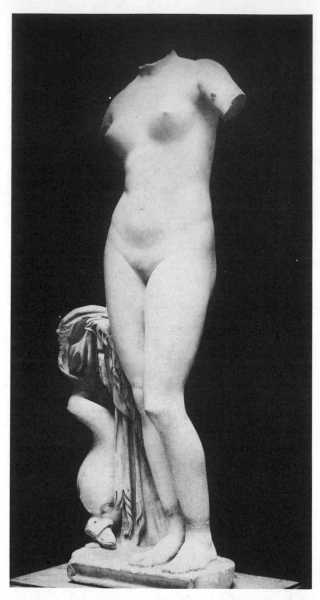

70. *Greco-Roman. Aphrodite of Kyrene*

Venus with the girdle of Mars' sword, above all Venus newly
risen from the waves and wringing the sea water from her hair
—in all of these, a slight change of motive refreshes, but does
not disturb, the basic inventions of Skopas and Praxiteles.
There are also several marbles, such as a splendid sensual torso
in the Bibliothèque Nationale, that suggest that in Alexandria
there were distinguished sculptors capable of altering the clas-
sical canon of proportion. But nearly all the surviving marble
figures are memories and mixtures, and lack both the vitality
and the unity of a fresh impulse. Even the *Aphrodite of Kyrene,*
whose combination of elegance and naturalism takes our eyes
at the first glance, proves on analysis to be a *pasticcio* of Roman
date [70]. Yet she is more delicately carved than almost any
other Aphrodite that has survived from antiquity, and still im-
parts some thrill of refined sensuality such as was the glory of
the Knidian.

The *Aphrodite of Kyrene,* by her rhythm and proportions, re-
minds us of one of the last beautiful inventions of antique art:
the three Graces. Renaissance artists have made us feel that this
interlacing of the three nude figures was usual and inevitable,
but in fact it was not known in the great ages of classicism and
its origins are obscure. The complicated pose may be derived
from a row of dancers with arms on each other's shoulders, front
to back, a motive still common in Greek choreography. From
this row some artist had the happy idea of cutting off three
figures, to form a closed, symmetrical group, and offering them
as the sweet and charitable companions of Aphrodite. It is im-
possible to say precisely when this occurred, but in all surviv-
ing versions of the Graces their proportions are those of the
first century. Nor are any of our survivors of high quality. On
the contrary, they are either mediocre commercial pieces or
such rough imitations as local masons might make of a subject
that was popular, but not yet sanctified by time. The marble
group in Siena that was to assume such importance in the
Renaissance was not, even then, considered a masterpiece of
sculpture, but only the repository of a beautiful idea [71]. A
relief in the Louvre [72], headless, alas, and of unpretentious
workmanship, may still speak to us, as it spoke to the artists of
the sixteenth century, of an art more nearly complete and con-
sistent than any that has succeeded it. For some reason the

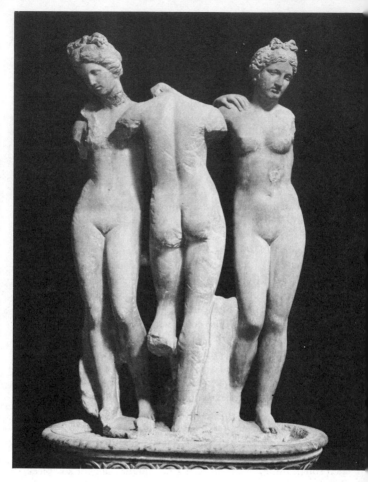

71. Greco-Roman. Three Graces

nakedness of the Graces was free from moral opprobrium, and
in consequence they furnished the subject through which pagan
beauty was first allowed to reappear in the fifteenth century;
they also offer an early example of the abandonment of that
canon of proportion which had been followed without question
since the fifth century B.C. In two wall paintings from Pompeii

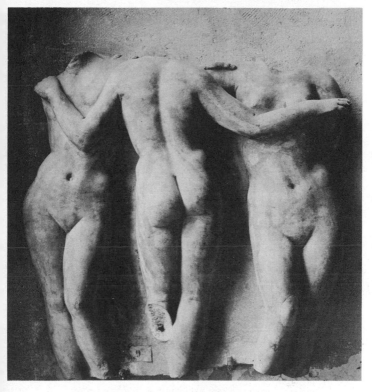

72. *Greco-Roman. Three Graces*

[73] their torsos have grown so long that the distance from the breasts to the division of the legs is three units instead of two; the pelvis is wide, the thighs are absurdly short, and the whole body seems to have lost its structural system. It is interesting to find that this deformation of the classic nude, which we think of as characteristic of late antique art, had already reached such lengths before Pompeii was destroyed in the first century A.D. Probably the painter was one of those artisans from Alexandria who occupied, in the Roman world, rather the same position as Italian decorators in eighteenth-century England; and these *Three Graces* are one of the first symptoms of that Oriental influence which was to play so large a part in the dis-

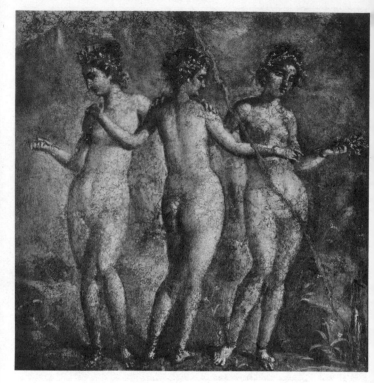

73. *Greco-Roman, 1st century* A.D. *Three Graces*

integration of the classic style. Even the Hellenizing art of Alexandria, as we can see from terra-cotta figurines, never quite abandoned the wide hips and narrow chest of the Egyptian body; the influence of this ideal is apparent in all those nudes of late antiquity, in silverware, needlework, or decorative carving, which originated in the eastern Mediterranean.

But it would be a mistake to suppose that the change in the female nude was owing solely to the pressure of an outside influence. Styles, like civilizations, collapse from within, and to a large extent the shape of these Graces represents one of those standard, popular deformations which take place whenever the discipline of an ideal scheme is relaxed. All through antiquity

the nudes engraved on the backs of mirrors or painted on inexpensive pottery tended to assume this curious proportion when the craftsmen were careless, incompetent, or provincial. Perhaps there is in this, besides incompetence, a kind of naïve realism. The drift of all popular art is toward the lowest common denominator, and on the whole there are more women whose bodies look like a potato than like the *Knidian Aphrodite*. The shape to which the female body tends to return is one that emphasizes its biological functions; or, to revive my opening metaphor, Aphrodite is always ready to relapse into her first vegetable condition.

The representations of the female nude in late antiquity from which I have drawn these conclusions are scanty and, for the most part, crude. Long before it had become the object of moral or religious reprobation it had practically ceased to be the subject for art. As far as I know, there is not a single nude statue of a woman of this period that can be dated, with any probability, after the second century A.D. Venus had suffered the fate of any motive in art that loses its meaning. She had passed from religion to entertainment, from entertainment to decoration: and then she had disappeared. When she emerged again, everything made by man had changed its shape: clothes, buildings, written characters, systems of thought and morals; and the female body had changed also. A new convention, which I try to define in a later chapter, had been invented to combine in the body of Eve the humble character appropriate to our first unfortunate mother and the ogival rhythms of Gothic ornament; and some consciousness of this convention is perceptible in the work of those artists who first attempted, in the early phase of the Italian Renaissance, to revive the canon of antique nudity.

The Renaissance, as we know, was preceded by several false alarms; and so it was with the re-emergence of Venus. In Italy she lay buried very near the surface, and even in the Middle Ages might be dug up by chance. The sculptor Ghiberti, in his book of historical anecdotes, describes one such exhumation, which took place in the middle of the fourteenth century in Siena. A statue came to light signed by Lysippos, and at first the citizens were delighted. They set it up in triumph on the Fonte Gaia, the center of the town, and it was drawn by the

74. Giovanni Pisano. Temperance

chief official painter, Ambrogio Lorenzetti. But the tradition of
iconoclasm was still strong. In 1357 a citizen made a patriotic
speech pointing out the disasters that had befallen the city ever
since the figure had been discovered; "and since idolatry is pro-
hibited by our faith there can be no doubt whence these disas-
ters arise." And on November 7, by public decree, the statue
was taken down and buried in Florentine territory in order to

bring bad luck to the enemy. It is important to notice that this decision was not taken because the figure was nude, but because it was a heathen idol. Ghiberti, who had seen Lorenzetti's drawing, does not mention its nudity or even its sex; only that it was supported by a dolphin, and so was, presumably, an Aphrodite. In the Latin countries nudity adds only a very little fuel to the fire of iconoclasm, and in a number of contexts was accepted by the Catholic Church. Fifty years earlier than the expulsion of Aphrodite from Siena, the architect of Siena Cathedral, Giovanni Pisano, had included an almost exact replica of the Venus Pudica as one of the Cardinal Virtues on the pulpit of the Cathedral of Pisa [74]. This figure, now thought to represent *Temperance* or *Chastity,* was executed between 1300 and 1310 and is one of the most surprising false alarms in art history. Giovanni's father, Nicola, working in a style formed before the conquering influence of the north, could easily incorporate pieces of sarcophagi and reliefs into his Christian subjects. But for Giovanni, the prophet of Italian Gothic, to assimilate such a completely classical pattern was an extraordinary feat of imagination. The means by which he has, so to say, Christianized the Venus is the turn and expression of the head. Instead of looking in the same direction as her body, and thus confirming her existence in the present, she turns and looks upward over her shoulder toward the promised world of the future. Her right arm, bent so that the hand comes higher on her breast and really covers it, leads the eye back to her head. Giovanni Pisano had discovered a gesture that was to become the recognized expression of other-worldly longing, and be used again and again, till its meaning was exhausted by the ecstatic saints of the Counter Reformation.

Pisano's figure is a complete anachronism. We must wait for over a hundred years before nakedness is no longer the accidental endowment of our first parents, but can claim, once more, to be represented among the worshipful symbols of human impulse. At first, as was to be expected, her position was somewhat uneasy. There remained a large section of conservative opinion that regarded her simply as the embodiment of lust. The sculptor Filarete, in his treatise on art, describes as a possible subject a garden of vice in which Venus is the central object of attraction, and it is thus that she appears in those examples of

75. Florentine, c. 1420. Marriage tray

decorative art which preserve the popular imagery of the time.
She is Venus Naturalis with a vengeance, and her body, in
consequence, is unidealized [75]. She is simply a lady of easy
manners who has taken off her clothes, and if her outlines
follow, to some extent, the Gothic convention, that is because
the craftsmen did not know how to draw in any other way. But
above this popular prejudice there existed a group of scholar-
philosophers who, loving antiquity and delighting in the pleas-
ures of the eyes, were determined that, by hook or by crook,
Venus should be given back some of her divine attributes. By
hook or by crook: the homely expression comes to mind as we
read the complicated and disingenuous arguments by which she

is transformed from the object of physical desire into the pattern of spiritual excellence; but of course it is an error to think of them as arguments at all, in the rational modern sense. They are a series of allegories in which the relationships are suggested by the merest accidents of association, astrology, or even euphony.

So Venus was rescued from her medieval disgrace by medieval means; but the vision that floated before her rescuers, leading them on to fresh feats of exegesis, was a vision of antiquity. It was because he could not resist this vision, nor believe that such perfection of form could be really harmful, that Marsilio Ficino wove his impenetrable web of commentary round the *Symposium* of Plato. The arguments were cloudy, the image was clear. And from this background of metaphor, shifting, dissolving, contradicting, there emerged, with sharp outlines, one of the greatest poets of Venus, Botticelli. His appeal is so irresistible that we may ask what is gained by associating him with the fantasies of Neoplatonic philosophers. The answer is that without them it is impossible to understand how the painter of pensive Madonnas invented the *Primavera*. His connection with the Neoplatonist circle can be demonstrated. Both the *Primavera* and *The Birth of Venus* come from the villa of Lorenzo di Pierfrancesco de' Medici, a second cousin of Lorenzo the Magnificent. Marsilio Ficino had elected himself the mentor of this rich and promising youth, and in one of his numerous letters to his pupil there is a passage that illustrates the kind of allegorical thought I have just described, and anticipates the position Venus was to hold during the next fifty years. Lorenzo, he says, "should fix his eyes on Venus, that is, on Humanitas. For Humanitas is a nymph of excellent comeliness, born of Heaven and more than others beloved by God on high. Her soul and mind are Love and Charity, her eyes Dignity and Magnanimity, her hands Liberality and Magnificence, her feet Comeliness and Modesty. The whole, then, is Temperance and Honesty, Charm and Splendor. Oh, what exquisite beauty!" Pico della Mirandola writes in the same strain. "She has as her companions and her maidens the Graces, whose names in the vulgar tongue are Verdure, Gladness, and Splendor; and these three Graces are nothing but the three properties appertaining to ideal Beauty." Such, we may suppose, were the incantations the shy young painter heard on

the lips of the learned men who surrounded his patron; and although he was unable to follow their meaning, they seemed to justify a vision of physical grace that had formed itself in his mind. But where, in the visual rather than the literary sense, did the vision come from? That is the mystery of genius. From antique sarcophagi, from a few gems and reliefs and perhaps some fragments of Aretine ware; from those drawings of classical remains by contemporary artists which were circulated in the Florentine workshops, like the architects' pattern books of the eighteenth century; from such scanty and mediocre material, Botticelli has created one of the most personal and memorable evocations of physical beauty in the whole of art, the three Graces of the *Primavera* [76]. The *Primavera* is, of course, ten years earlier than *The Birth of Venus,* and it is significant that Botticelli should have felt his way back to antiquity through the image of the Graces, for their nudity had been sanctioned, as emblematic of sincerity, by Christian writers who condemned the nakedness of Venus. What antique representations of the subject he had seen remains uncertain; perhaps it was a relief now lost, perhaps a drawing of the Siena statue similar to that in Vienna attributed to Francesco di Giorgio. In either case, he has penetrated beyond the Hellenistic replica to the impulse from which it derives, and has achieved an extraordinary affinity with Greek figures that he cannot possibly have seen. He has recognized that the Graces were part of a frieze of dancers, and has given them back their movement, animated by the rhythm of drapery. So naked beauty reappears in the Renaissance as it first emerged in Greece, protected and enhanced by *draperie mouillée.* In the management of flowing lines he was no doubt influenced by the figures of maenads, which were such a frequent motive in Hellenistic decoration. In a later chapter, where I discuss the maenads as embodiments of ecstatic energy, I suggest that they may have been first invented by a painter; and it is remarkable that the works of art that most closely resemble Botticelli's Graces are the antique paintings of the *Seasons* from Herculaneum. Obviously his figures are more slender and fragile than the ample nudes of antiquity, though not more so than those in the stucco reliefs from Prima Porta or Hadrian's Villa, some of which he may have known. The real difference lies in the more nervous articulation of each form and the more intri-

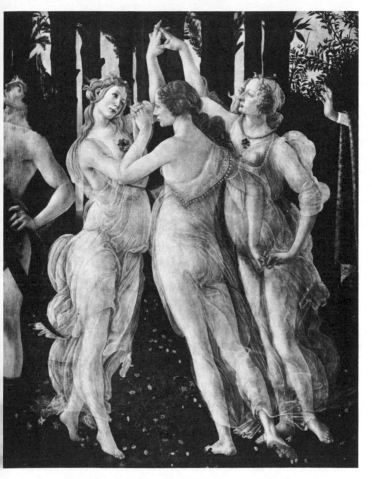

76. Botticelli. Three Graces (detail from Primavera)

cate pattern of line. Botticelli has ignored the volumetric
character of the classical nude, which, in such a figure as the
Torso in the Terme, persists under the linear drapery. And yet,
how incredibly close to the Greek rhythm, in one inspired leap
of the imagination, Botticelli has come! To see how far it has
taken him, we should look again at the three Graces as the

Middle Ages picture them, in a manuscript at Vienna, three
timid ladies huddling behind the straight lines of their single
blanket, yet not without a suggestion of impropriety; and then
turn back to Botticelli's Graces, where the body is not hidden,
but transposed into a melody of celestial beauty: celestial but
humanly touching, like a melody of Gluck. In the end it is by
their human quality that Botticelli's Graces dissociate them-
selves from antiquity. The most famous lines in Virgil remind
us how the sense of human pathos permeates antique literature,
but in the visual arts how limited it is! No doubt, it is the
strength of Venus that her face reveals no thought beyond the
present. It is a fruit among fruits, and by excluding the further
dimension of thought, it gives to the whole body an equal degree
of permanence. That is a condition that we of the post-Christian
world cannot reproduce; we cannot dehumanize the face, and
it was with a correct instinct that Chirico, when he produced
his travesties of classicism, replaced the heads by footballs. The
heads of Botticelli's Graces, seen in isolation, are extraordinarily
real. They are individual souls; and so their beautiful bodies
take on an added poignancy. They are immortal on account of
their harmonious perfection, yet they are fragile because, as we
can tell from their faces, they have no firm belief in the physical
world. In this, as in much else, the *Primavera* rests on a point of
balance between classic and medieval thought; and the inspired
certainty of Botticelli's imagination is shown by the way in which
he has combined two apparently irreconcilable concepts. Just
as the humanists incorporated their classical learning in a
framework of scholastic thought, so the Ionian grace of Botti-
celli's figures is set in the framework of a Gothic tapestry; and
as the Neoplatonists sacrificed reason to a fluid interpretation of
symbols, so Botticelli has made no attempt to represent space
or solidity, but has offered each beautiful shape on its own, like
jewels on a velvet cushion, uniting them, as symbols are united,
by their decorative affinities. Most of the other figures, more-
over, are quite unclassical. The Venus herself, decorously
clothed, raises her hand with a gesture of a Virgin Annunciate;
and the figure of Spring, fleeing from the icy embraces of the
East Wind, is a Gothic nude. His attitude, and the sweeping
line of her stomach, are close to the little Eve who tempts Adam
in the *Très Riches Heures;* yet by a more ample rhythm she is made

to harmonize with the classic figure opposite. Perhaps Botticelli himself was aware that this laying side by side of different types could not be repeated, for in his other great poem of neopaganism, painted over ten years later, he has aimed at a close and more classical synthesis.

Between the *Primavera* and *The Birth of Venus,* Botticelli spent some time in Rome, at work on his frescoes in the Sistine Chapel. Antiques, which in Florence were confined to a few collections, lay all around him. No foundations could be laid, no field freshly dug, without there coming to light some fragments of an ideal world. It was as if every day the dreams of the preceding night were to find concrete but casual confirmation. From the thickets and vineyards of the Palatine, nude figures emerged without shame or comment, and Botticelli, who had already penetrated so far into the Greek spirit, could recognize a Venus different from the gentle priestess of the *Primavera,* and no less ideal. So when, on his return to Florence, his patron Lorenzo di Pierfrancesco de' Medici asked him to paint a subject illustrating the lines of Poliziano's famous poem of the *Giostra* in which he describes the goddess rising from the sea, Botticelli had perfected in his mind a clear image of her naked body [77]. Poliziano's lines were taken almost direct from one of the Homeric Hymns, and the same passage seems to have inspired a picture of *Aphrodite Anadyomene* by Apelles mentioned in Pliny. Botticelli's commission was therefore intended as a tribute to antiquity; and the whole conception is far more classical than the *Primavera.* Instead of the tapestry composition, with its figures spread out decoratively against a background of Gothic verdure, *The Birth of Venus* is so concentrated and sculptural that it could almost be carried out as a relief. Yet, from the time of Ruskin onward, it has been observed that the Venus herself is not classical, but Gothic. This is not owing, as is usually said, to her slender proportions, for the cardinal measurements of her torso follow exactly the classical scheme. She is, in fact, considerably less elongated than many pieces of Hellenistic sculpture —for example, *The Three Graces* [71]. Her differences from antique form are not physiological, but rhythmic and structural. Her whole body follows the curve of a Gothic ivory. It is entirely without that quality, so much prized in classical art, known as aplomb; that is to say, the weight of the body is not distributed

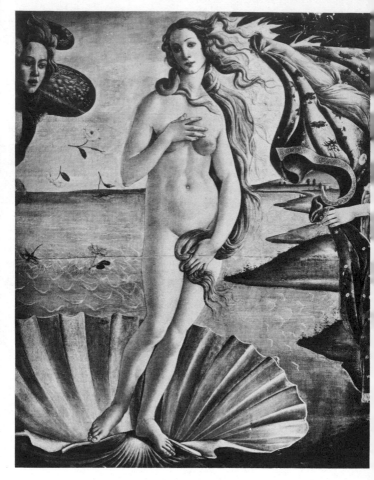

77. Botticelli. Birth of Venus (detail)

evenly either side of a central plumb line. Indeed, Venus' foot makes no pretense of supporting her body, and almost the whole of her weight is to the right of it. She is not standing, but floating. This is the rhythm of the whole picture, and, without appearing anywhere to compromise the classical scheme, it has spread to each part of her body and subtly modified its shape.

Her shoulders, for example, instead of forming a sort of archi-
trave to her torso, as in the antique nude, run down into her
arms in the same unbroken stream of movement as her floating
hair. Every movement is related to every other by a line of
unbroken grace, and Botticelli, like a great dancer, cannot
make a gesture without revealing the harmonious perfection of
his whole being. By this innate rhythmic sense he has trans-
formed the solid ovoid of the antique Venus Pudica into "the
endless melody of Gothic line," the melody of twelfth-century
drapery, of Celtic interlacings, even, but made more poignant
by a delicate perception of the human predicament. Flow of
line is the most musical element in the visual arts, continually
urging us on in time, and this gives a unity to the form and con-
tent of Botticelli's Venus. For her head is even further than those
of the Graces from the expressionless, time-free pumpkins of
antique sculpture. The word "wistful" that comes to the lips of
every tourist who tries to describe her expression is correct and
cannot be translated into Greek or Latin. It is the same head
that Botticelli uses for his Madonnas, and this fact, at first rather
shocking, is seen, on reflection, to reveal a summit of the human
mind shining in the pure air of the imagination. That the head
of our Christian goddess, with all her tender apprehension and
scrupulous inner life, can be set on a naked body without a
shadow of discord is the supreme triumph of Celestial Venus.

Although she is raised above the first impulses of nature by
the melody of line, Botticelli's Venus does not deny the empire
of the senses. On the contrary, the flow of her body is like some
hieroglyphic of sensuous delight, and behind the severe economy
of Botticelli's drawing, we can feel how his hand quickens or
hesitates as he follows with his eye those inflections of the body
which mysteriously awaken desire.

This sensuous character is made clear when we compare the
Venus with the only other female nude by Botticelli that has
come down to us, the figure of Truth [78] in his *Calumny of
Apelles*. Once again he has reproduced an antique work of art
on the basis of literary descriptions; but by this time the aesthetic
impact of antiquity on Botticelli was over. The preaching and
martyrdom of Savonarola had persuaded him that the pleasures
of the senses, even when purified of all grossness, were vain and
contemptible. He had returned to the waning enchantments of

78. Botticelli. Truth (detail from Calumny of Apelles)

the Middle Ages, from which, by some wonderful accident, the humanist philosophers had temporarily removed him. In consequence, the Truth in the *Calumny* is, of all nudes that are not positively ugly, the least desirable. Superficially she resembles the Venus (although she must, I think, have involved a separate study), but at almost every point the flow has been broken. Instead of the classic oval of Venus, her arms and the angle of her head create the zigzag diamond-shaped pattern of medieval dialectics. The long strand of hair that winds round her right hip deliberately refuses to describe it. Botticelli could not draw without firmness and grace, but in every inflection he is at pains to deny himself the smallest tremor of delight, and this puritanism has forced him to give her form a distressing meagerness. Only when the body emerges from draperies, as do the arms of Calumny, does he permit himself some physical response; and we almost regret the iconographic tradition by which even the most austere moralists permitted Truth to be naked.

With that strange indifference which visionary artists (Blake, El Greco, and Rossetti are examples) have shown toward their creations, Botticelli allowed his Venus to be copied in his workshop a number of times, and two of these copies have survived the general destruction visited on such pagan vanities under the influence of Savonarola. One of these, formerly in Berlin, was evidently done from the cartoon of *The Birth of Venus,* for it shows a difference perceptible in the underpainting of the Uffizi picture. Venus is represented alone, standing before a dark background; and as she is no longer floating forward, her figure is tilted more to the left in order to preserve her balance. The other, although slightly Gothicized, is in a similar taste. Evidently they were popular and they seem to have exported to France and Germany: at least, I cannot believe that the naked *Venus* standing before a black background that Cranach painted in 1509 is an altogether independent invention. A curious survivor of this fashion is by Lorenzo di Credi, who of all the Florentine painters of his time was least equipped with the idealizing faculty that the subject demands. His *Venus* is a model posed in the attitude of the Pudica, and the memory of Botticelli, perceptible in her left hand and legs, has hardly been enough to save him from a literal materialism [79].

There is, perhaps, only one other female nude of the *quattro-*

79. *Lorenzo di Credi. Venus*

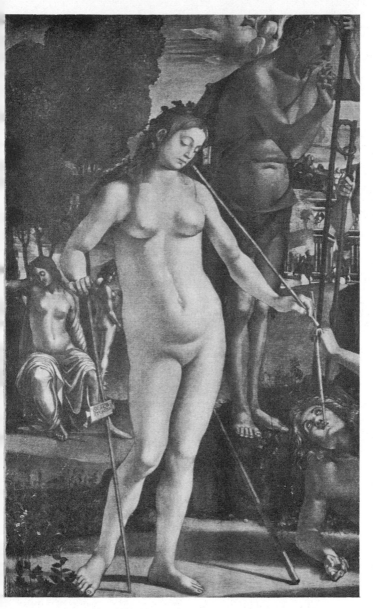

80. Signorelli. Nude. (detail from School of Pan)

cento that need be mentioned separately, the noble figure to the left of Signorelli's *School of Pan* [*80*]. Whatever the precise allegorical meaning of the whole group, there can be little doubt that she is a personification of natural instincts, simple and uncorrupted. Iconographically she is Venus Naturalis. But this has in no way affected the form of her body, which is as geometrically ideal as the Celestial Venus of Botticelli. It is, of course, designed on a very different scheme. Signorelli (with one exception) had no sympathy with the suavities of antique art and spent no time in examining them. He makes no attempt to conform to classic proportions, and in his nymph the distance between breasts and naval is of Gothic length. And yet in some respects she is more classical than the Botticelli. Her body is felt as mass and not as line; it is constructed like architecture, the weight resting on a point of balance. We approach it, as we do classic sculpture, grateful for the way in which every shape has been given its simplest and most satisfying character. Signorelli's transformation of the nude, as we shall see in a later chapter, is so personal and complete in itself that it could not be developed. The great enduring forms of art, from sonnet to symphony, must evolve step by step, so that each fresh departure is a development, with behind it an accumulated weight of ideas, to carry the next adventurer still further. We are grateful for the individual vision of Signorelli, but we can recognize that in the evolution of ideal form it is less important than the synoptic vision of Raphael.

Of all Raphael's marvelous gifts, that which was most completely his own, and seems to come from the radiant center of his personality, was his power of grasping the ideal through the senses. The harmony by which he gives a lovable perfection to the human race was never the product of calculation or conscious refinement. It was a part of his physical apprehension. He was thus endowed to be the supreme master of Venus, the Praxiteles of the post-classical world. His employers willed otherwise; and no artist ever served his employers more faithfully. He never painted the perfect picture of Venus that, as we know from his drawings, was always at the front of his mind. His contemporaries, less concerned than we are with sensitive execution, sought his ideal in engravings and the works of pupils; and we must force ourselves to follow their example. Fortunately,

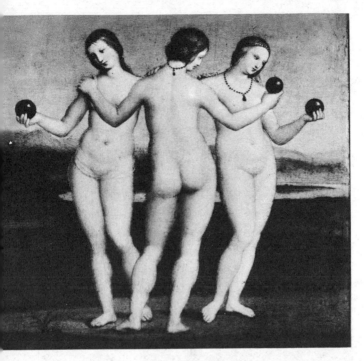

81. Raphael. Three Graces

the nude is the subject of one original painting, the earliest,
perhaps, in which Raphael was entirely himself, *The Three
Graces,* at Chantilly [*81*]. On the other side was *The Dream of a
Knight,* now in London, and it has been convincingly suggested
that the two were originally painted as a visible exhortation to
the young Scipione Borghese to follow the path of duty, with
Celestial Venus as his goal. Released from the conventional
subjects and formalized style of Perugino, Raphael discovers
that innate classicism through which he could come so close to
antique art without pedantry. Which antique Graces he had
seen, we do not know. Probably the group in Siena first stirred
his imagination, but the poses and proportions are more like
those of a relief in Rome, of which a drawing may already have
been in circulation. Raphael's little group has the flowing

82. *Raphael. Leda*

rhythm of a formal fifteenth-century lyric, a villanelle or ter-
zetto, both naïve and elaborate. It is far from the ethereal music
of Botticelli. These sweet, round bodies are as sensuous as
strawberries, and although their attitude must be derived from
art, their power to please us is owing to a grasp of nature. That
is what makes Raphael's vision of antiquity from the first so
much more classical than the learned reconstructions of Man-
tegna. We see also that the qualities of classic art so admirably
defined by Wölfflin, the sparing ornament, the uninterrupted
outline, the concentration on essentials, all came to Raphael by
nature and were by preference applied to the female nude. Yet
from the formative years he spent in Florence, when he drew
the male nude with matchless vigor and resilience, only one
study of a naked woman survives. The strenuous Florentines,
who delighted in the movement of a muscular back or an
extended arm, took no interest in the bland and static form of
Venus; and Raphael submitted himself to their authority, always
retaining from those years some taste for knotty modeling. The
single exception is revealing. It is not drawn from life or from
the antique, but is a copy of one of Leonardo da Vinci's studies
for the *Leda* [*82*]; and when a year or so later Raphael began
to decorate the papal apartments, almost his first work was a
scene of the Temptation [*83*], in which the lower part of Eve's
body is directly derived from this design. In the places where
he has had to vary Leonardo's pose, the action of the left arm
and the set of the head on the shoulders, the rhythm of his
figure breaks down, proving how little Raphael had yet been
able to study the female body. We may be permitted to guess
that he was himself dissatisfied with this Eve, for at a later stage
he produced a more memorable image of the Temptation, known
to us in an engraving by Marcantonio [*84*], in which he has
expressed, by the shapes of their bodies, the primal relationship
between man and woman. Adam, hollow and recessive, looks
questioningly at his partner, whose assurance is symbolized by
the dominating curve of her hip, sweeping up to her breast, just
as the curve of her arm leads up to her willful head. Seldom in
antiquity was this *déhanchement* quite so emphatic, so purpose-
fully expressive of sexual difference; and I believe that Raphael
may have been influenced by the memory of a piece of *quattro-
cento* sculpture he had seen in Siena, a few yards away from

83. Raphael. Adam and Eve

The Three Graces in the Cathedral, the relief of Adam and Eve
on Antonio Federighi's font [*85*].

 To this same period, roughly drawn on the back of a sheet of
studies for the *Orléans Madonna,* is Raphael's first *Venus* [*86*].
Probably it was done with no purpose in mind, and has survived
by chance, yet how warmly it illuminates our knowledge of his
feeling for antiquity! Since classic times no other painter has

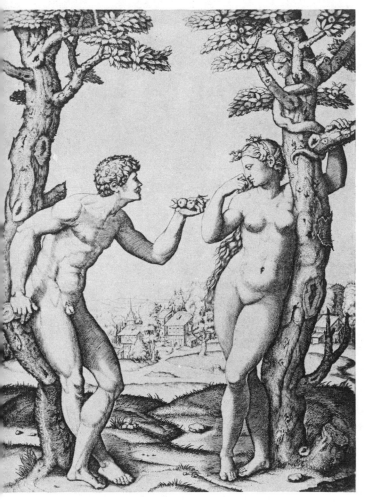

84. Marcantonio. Adam and Eve

absorbed so completely the principles of the nude. The forms
are as firmly inscribed within the ovoid as in the *Capitoline
Aphrodite;* more firmly even, for Raphael has, so to say, screwed
them in with the twist of the body and final, frontal turn of the

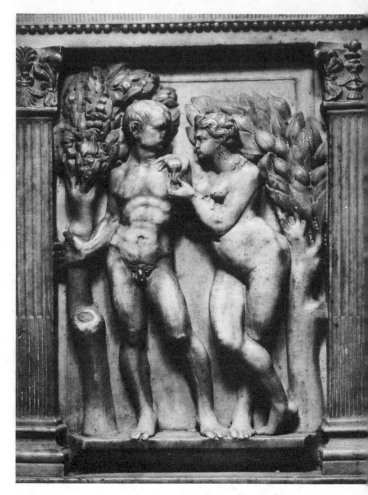

85. Federighi. Adam and Eve

head. And how classically substantial she is! This *Venus* may just have risen from the foam, but she is weighty and dense and demonstrates, by her frank acceptance of the flesh, the essential difference between Raphael and his classicizing imitators. Maratta and Mengs, we feel, were less close to him than Rubens.

86. *Raphael. Venus (drawing)*

That such a project as this Venus Anadyomene should remain
unrealized was inevitable. Raphael was working for the head
of the Church in the center of Christendom; and it is charac-
teristic of his resourceful pliability that in these years he should
have made a careful study of the draped nude—*draperie mouillée*
—using as his models the two most famous examples of antiquity,
the *Venus Genetrix* and the *Ariadne;* and incorporated their
rhythms into that vision of spiritual harmony expressed through
sensuous means, the *Parnassus.* Naked Venus did in fact enter
one apartment of the Vatican, Cardinal Bibbiena's bathroom,
where she has remained in strict retirement until the present
day. Actually, some of the nudes with which Raphael and his
pupils decorated this enchanting room were engraved by Mar-
cantonio, and through him enriched the iconography of Venus
down to the time of Poussin.

In 1516, when Agostino Chigi invited Raphael to decorate
his new villa on the banks of the Tiber, it seemed that his oppor-
tunity had come. The architect Baldassare Peruzzi had already
employed a young painter, Sebastiano del Piombo, who had
been the companion of Giorgione. Only a few years earlier the
Venetians had discovered how to give the nude a sensuous
warmth that made it one with the landscape, and Raphael, as
we know, from *The Mass of Bolsena,* had set himself to imitate
Venetian color. When, therefore, Chigi chose as subject the story
of Cupid and Psyche he must have looked forward to a triumph
of physical beauty richer and more circumstantial than anything
that the revival of paganism had yet achieved. Alas, he was too
late. Raphael was already overworked, and forced to let his
designs be carried out by pupils. As a result, the decorations in
the loggia of the Farnesina lack just that sensuous delight, that
palpitation, which we can feel in Raphael's drawings. They
are masterly inventions, but pushed through with a de-
termination that makes them almost dogmatic. Some of the
surviving studies for them show what has been lost by insen-
sitive execution. A drawing of *The Three Graces* is as fully
modeled as the fresco, but still vigorous; a study of a *Kneeling
Girl* [87] is as sweet as an apple, with a feeling of round firm
flesh, conveyed by the outline and a few touches of shadow—
the economy of conviction. We recognize the real Raphael, to
whom a tangible presence was essential, and who could only

87. Raphael. Kneeling girl

be induced to work continuously when Agostino Chigi sent for his mistress and imprisoned her in the Farnesina.

By far Raphael's finest work in the Farnesina, and the only one entirely from his hand, is the *Galatea*. Evidently this fresco was executed a few years before the *Cupid and Psyche* series, and has a radiance they lack. Nothing in painting gives us a more convincing idea of the lost masterpieces of antiquity, for Raphael had studied such surviving fragments of painted decoration as were then to be seen in the Golden House of Nero, and had adopted their light shadows and blond tonality. The *Galatea* herself is a most conscious and elaborate construction. Raphael told Castiglione that, like the painters of classical legend, he had been unable to find any one model of sufficient beauty, but had used the best parts of several. In fact, the *Galatea* does not seem to have been inspired by nature, but by other works of art. Her upper half may be found, appropriately enough, in a Nereid sarcophagus in Siena. Ultimately she derives from a *Venus of Capua* type, to which Raphael had added the head of one of his saints. Instead of looking down, like Venus, at her reflection in Mars' shield, she is looking upward to the skies. It is the same turn of the head that Giovanni Pisano gave to the Venus Pudica in his figure of *Temperance,* and proves by its application to a pagan subject how deeply the yearning for another world had entered the post-Christian spirit.

Beautiful as she is, the *Galatea* is not a dominating image of Venus. She is the central part of a magnificent decoration, subordinate to its space-filling symmetry; and as such will reappear in a later chapter. She did not contribute to the ideal. Yet it was during these years, the first two decades of the sixteenth century, that the mature image of Venus was formed, and one of the chief elements in its formation was, no doubt, the wide diffusion of engravings by Marcantonio and his imitators. These made accessible reproductions of recently discovered antiques and the most memorable inventions of Raphael and the Venetians. The antique fragments were, of course, shown as complete figures, sometimes in a very misleading fashion; for example, a print by Giovanni Antonio da Brescia, inscribed *noviter repertus,* represents the *Knidian Aphrodite* in the Belvedere version, but the engraver has forfeited the honor of being the first

to record her resurrection, for his guess at the position of her right arm is so far from correct that the Praxitelean idea is lost. On the other hand, Marcantonio's engraving of the *Crouching Venus* was evidently taken from a well-preserved original and imparts a correct notion of its character. The Renaissance appetite for articulation had led him to exaggerate the modeling; yet how classical this Venus looks compared to another, done directly from Raphael's design, who sits with leg crossed over knee in the attitude of the *Spinario*. We recognize once more the enclosed finality, the cameo quality, of antique art, which even the most Greek of Renaissance artists could not, or did not wish to, achieve.

The study of Marcantonio's engravings confirms an impression that the Venus of the High Renaissance was not invented in Rome, but in Venice. True, a long-established intercourse with Germany and the Tirol gave to the figures of early Venetian art a proportion more pronouncedly Gothic than can be found elsewhere in Italy. Rizzo's *Eve* is almost as ogival as a Conrat Meit; and Bellini himself, in his little panel of the naked *Vanitas,* has cheerfully followed the model of Van Eyck, or perhaps of Memlinc. But soon after 1500 he painted a more graceful figure, the *Lady at Her Toilet,* where for the first time we see the ample forms that were to be characteristic of Venetian art in its next phase [*88*]. Although apparently untouched by classic influence, she is the sister of the woman seated on the ground in Giorgione's *Concert champêtre*. Did Bellini see her for himself, or did the old master, with his undiminished powers of absorption, see through the eyes of his dazzling pupil? We shall never know. But as the evidence has come down to us we can say that the classic Venetian nude was invented by Giorgione. Where did he find her? He may have known a few antiques in Venice and Padua; there were paintings and engravings of the nude by Mantegna, and perhaps drawings by Perugino, who, as we can see from the Castelfranco altarpiece, played a leading part in giving his style its classic simplicity. But far beyond such quasi accidents was an appetite for physical beauty more eager and more delicate than had been bestowed on any artist since fourth-century Greece. It is because he suddenly found the shape and color of those desires which had been floating half formed in the minds of his contempo-

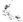

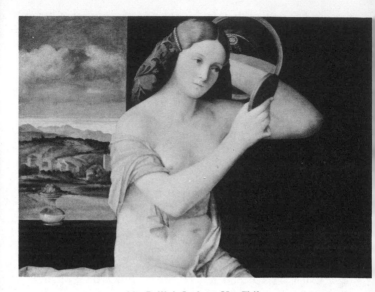

88. Bellini. Lady at Her Toilet

raries that Giorgione's work has reached us inextricably con-
fused with that of other artists. He had no sooner found the
password than all could enter at the same door, and one or two
may have pushed past him. In the nude we can be sure that
he was the real inventor. Engravings of his vanished master-
piece, the frescoes of the Fondaco dei Tedeschi, show nude fig-
ures of women used for almost the first time as units in a
decorative scheme; and a nude woman is the subject of the
picture in which his peculiar graces are most clearly apparent,
the Dresden *Venus*.

In European painting the Dresden *Venus* [89] holds almost
the same place as is held in antique sculpture by the *Knidian
Aphrodite*. Her pose is so perfectly satisfying that for four hun-
dred years the greatest painters of the nude, Titian, Rubens,
Courbet, Renoir, even Cranach, continued to compose varia-
tions on the same theme. Unlike the *Knidian*, she was herself
relatively unknown, hidden in the Ca' Marcello; but Titian's
variants, the *Venus of Urbino* and the *Venus del Pardo*, were royally
famous from the first. Her pose seems so calm and inevitable

that we do not at once recognize its originality. Giorgione's
Venus is not antique. The reclining figure of a nude woman does
not seem to have been the subject of any famous work of art
in antiquity, although it is sometimes to be found in the corners
of Bacchic sarcophagi. And apart from the absence of models,
she is not a Hellenistic shape. She lacks the weighty sagging
rhythm, as of a laden branch, in which the antique world paid
equal tribute to growth and to gravity. There remains some-
thing Gothic in her movement, confirmed by the gentle swell
of her stomach, and perhaps after all her real predecessors
were those figures of naked brides which were traditionally
painted on the inside of the fifteenth-century marriage chests.
When this is said, how un-Gothic she is in the cylindrical
smoothness of every form. If, as Winckelmann maintained,
classic beauty depends on a perfect ease of transition from one
comprehensible shape to another, the Dresden *Venus* is as clas-
sically beautiful as any nude of antiquity.

The *Aphrodite* of Praxiteles had just laid aside her chlamys,
and was modestly poised on the steps of a ritual bath. The
Venus of Giorgione is sleeping, without a thought of her naked-
ness, in a honey-colored landscape: but her outline forbids us
to identify her as Venus Naturalis. Compared to Titian's *Venus
of Urbino* [90], who seems, at first, so closely to resemble her,

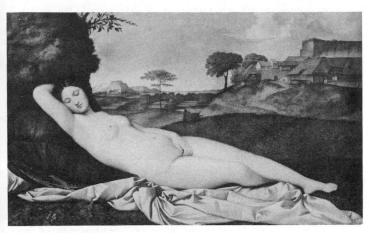

89. Giorgione. Venus

90. Titian. Venus of Urbino

she is like a bud, wrapped in its sheath, each petal folded so firmly as to give us the feeling of inflexible purpose. With Titian the bud has opened, the continent outline is broken, and, to change from metaphor to measurement, the sharp-pointed triangle formed by the breasts of the Giorgione *Venus* and the base of the neck has become in the Titian almost equilateral. The swift Gothic movement, by which the Dresden *Venus* seems to be lifted above the material world, is replaced by Renaissance satisfaction in here and now; and we scarcely need the closed eyes of the Giorgione or the inviting gaze of the Titian to point the difference between them. If the distinction between the twin sisters can ever be sustained, Giorgione's *Venus* is celestial. Yet this isolation of the nude from the vegetable life that surrounded it could not be maintained for long: it resulted from a moment of balance as delicate as that which produced Botticelli's *Primavera.* And in the culmination of the Giorgionesque, the *Concert champêtre,* the bodies have lost all sense of Gothic virginity. Far from being buds, they have the opulent maturity of an Italian summer. We have entered the realm of Venus Naturalis.

IV

VENUS II

I N FLORENCE Celestial Venus had risen from the sea of Neo-
platonic speculation. In Venice her sister was born in the
more tangible environment of thick grasses, rustic wells, and
abundant foliage; and for four hundred years painters have rec-
ognized that Natural Venus is originally and essentially a Vene-
tion. Yet by a strange quirk of genius the first Renaissance artist
to represent a naked woman as a symbol of creative and genera-
tive life was a Florentine, Leonardo da Vinci. Between 1504 and
1506 he executed at least three designs of *Leda and the Swan,*
one of which was carried out as a painting and was taken to
Fontainebleau, where it survived till the end of the seventeenth
century. The reasons that led him to depict this subject are
characteristically oblique. On the surface it would seem to be
wholly unsuitable to him. He was not moved by classical
mythology; he had no patience with the fancies of Neoplatonism
and little feeling for that kind of geometrical harmonization of
the body from which the classic nude was derived. Above all, he
was not emotionally or sensually attracted by women. But this
last was, no doubt, the determining factor. Since women did
not arouse in him any feelings of desire, he was all the more
curious about the mysterious character of generation. He could
consider the sexual act as part of that endless flux of growth,
decay, and rebirth which formed for him the most fascinating
and fundamental of all intellectual problems. In about the year
1504 he began to study the process of generation scientifically,

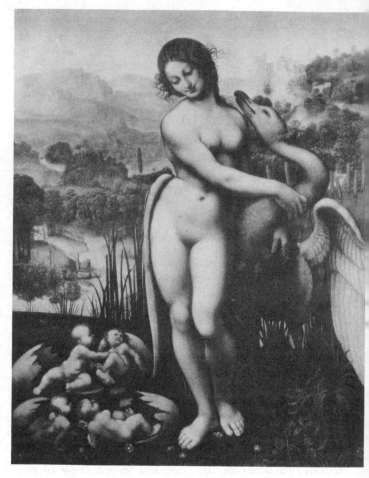

91. Cesare da Sesto. After Leonardo da Vinci's Leda.

accompanying his questions, as always, with exquisitely precise illustrations; and beside one of the anatomical drawings of this series is the first sketch of a *Leda*.

Even without this scrap of evidence the surviving copies of Leonardo's *Leda* [*91*] leave us in no doubt that he intended her as an image or allegory of generation. He has invented a pose

that ingeniously emphasizes those parts of the body which the *Knidian Aphrodite* and her descendants had concealed. True, a similar pose was known to antiquity. A Bacchic sarcophagus in the Terme [*218*] contained a maenad with arm bent across her chest, leaving the lower part of the body open, and it is conceivable that some such figure was known to Leonardo. But the word "invented" may stand, for in antique examples the arm covers the breasts, whereas Leonardo has so contrived that the same action reveals them and gives them an Oriental prominence. Oriental is, indeed, one of the first epithets we think of applying to the *Leda,* a word suggested by the swing of the hip, by the continuous flow of the modeling, and above all by a sort of tropical redundancy of rhythm. Leonardo was aware of this, and in the original painting his figure was surrounded by a jungle growth of heavy leaves, twisting grasses, and upstanding bulrushes, for which the preliminary drawings, marvelously uniting love and science, are at Windsor. As so often in his work, "nature" has been given a more urgent life than the human body.

Making every allowance for the repulsive quality of all Leonardesque replicas, it is hard to believe that Leonardo's *Leda* can ever have been an attractive work. The exploitation by the intellect of a theme usually governed by the emotions must always be disturbing to a normal sensibility. Almost the only analogous effect in European painting is to be found in the *Bain turc* of Ingres, but even at eighty-two Ingres felt the tug of physical desire, which makes his Hindu contortions both more and less disquieting. Yet what an undeniable work of genius Leonardo's *Leda* remains! The writhing, intricate rhythms of growth are carried through from the pose of her whole figure to the plaits of her headdress and the grasses at her feet. Incapable of the feeling and contemptuous of the philosophy from which, in harmonious union, Venus was born, Leonardo still contrives to hold us fascinated by the purposeful consistency of every form and every symbol.

Leonardo's *Leda* achieves intellectually, we may even say scientifically, the conception of Venus Naturalis that, in the very same year, was taking shape in the sensuous imaginations of the Venetians. Whether the design was also known in Venice is an unanswerable question. Other works by Leonardo had a

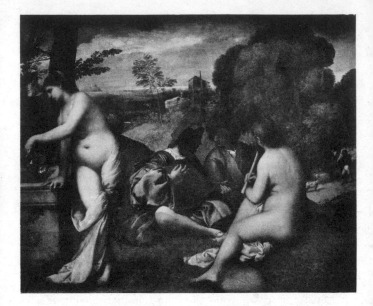

92. Giorgione. Concert champêtre

considerable influence on Venetian art, and there is no reason
some drawing for, or copy of, the *Leda* should not have reached
Venice during the first years in which Giorgione and Titian
were putting naked figures in a setting of leaves and grasses.
But there is no direct reminiscence of the figure, and the way
in which the forms slide and twist round each other is contrary
to the open, frontal presentation of Venetian art. The first great
celebration of Natural Venus in Venice is the so-called *Concert
champêtre* in the Louvre [*92*].

As Pater pointed out, in some of the finest pages of English
criticism, the aim of the *Concert champêtre* is to create a mood
through the medium of color, form, and association. Our
participation is sensuous and direct. Although it tells no story,
and the most determined iconologists have been unable to
saddle it with a subject, its theme is not altogether new, for
artists had enjoyed painting picnics since the fourteenth cen-
tury. But the *Concert champêtre* has this peculiarity, that the
ladies have undressed; and we may speculate how Giorgione

has persuaded us to accept as natural this unusual freedom. Several memories, no doubt, pictorial and literary, had helped to strengthen and clarify his imagination. There was the memory of Bacchic sarcophagi, with their naked bacchantes seated in the corner, of whom Titian later was to make so superb a use; and there was the antique habit of personification by which the essence of every pleasant thing in nature—springs, flowers, rivers, trees, even the elusive echo—could be thought of as having the shape of a beautiful girl. This, the imaginative legacy of Ovid, became fused with the imaginative legacy of Virgil, the myth of the Golden Age. So naked figures could be introduced into a landscape partly because they could be thought of as embodying some of its elements, and partly because, in the youth of the world, human beings did not need to cut themselves off from nature by the artificial integuments of dress. These are the ingredients of Arcadian poetry; and Giorgione could be represented as part of the same movement that produced Sannazaro and Tebaldeo. But the poets were encumbered with learned allusions. Their more exact equivalent is Raphael's *Judgment of Paris,* known through Marcantonio's engraving, which was to inspire a long line of academic compositions, ending, most surprisingly, with Manet's *Déjeuner sur l'herbe.* In spite of the classical completeness of each group, the engraving has an air of frigid and fanciful pedantry, as of some old-fashioned cabinet of antiquities. Paris is a stock figure, the Olympians jostle one another in the sky, and the personifications on either side add to the sense of overcrowding. Only the naiads on the left seem to be imaginatively related to the spring they personify.

In contrast to this intellectual Mount Ida, Giorgione's *Concert champêtre* is as simple, sensuous, and passionate as the poetry of Keats; and the nude figures, which sound artificial in a description, seem, when apprehended through the eye, to embody, or bring to a single point of physical apprehension, all the fruitful elements of nature that surround them. The two women, although they might have been painted from the same model, differ greatly from one another in conception. She who is seated on the ground is painted with an unprejudiced sensuality, as if she were a peach or a pear. In this she is the forerunner of Courbet, Etty, Renoir, and those life studies which were the chief

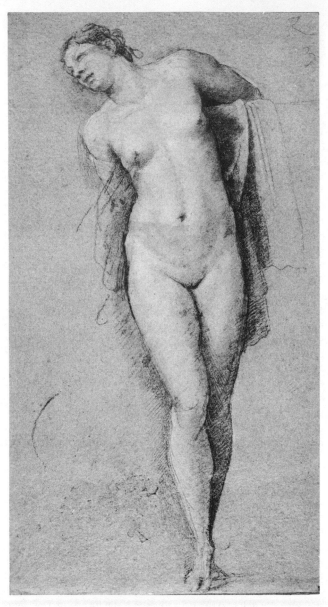

93. Sebastiano del Piombo. Life drawing

product of art schools throughout the nineteenth century. She gives an impression of directness unprecedented in the nude, but, in fact, the aspect of the female body Giorgione has selected is quite arbitrary, and the forms have been drastically simplified. The standing woman is more closely tied to the style of her own day. Her draperies inform us that she is a figure of art, and her complex pose seems to have been derived from an antique relief similar to one in the Terme, although by turning the bacchante's head into profile Giorgione has changed her heated urgency into a gentle calm. He has also given her more generous proportions than were usual in antiquity. Even figures of Alexandrian origin seldom show such width of pelvis or such ample expanse of stomach. This is the type of female nude that was to dominate Venetian art for a century, and, through Dürer, greatly to influence the physical ideal of Germany; and it seems reasonable to attribute its invention to Giorgione, for it appears in such works as the Marcantonio engraving of a woman watering a plant that antedate stylistically the *Concert champêtre*. The most famous and influential of Giorgione's nudes, those which decorated the Fondaco dei Tedeschi, have perished, and we are left with the reminiscences and developments of his two companions who, as we know, completed his unfinished works and carried out his ideals, Sebastiano del Piombo and Titian. Sebastiano, with that taste for the heroic which was later to draw him into the inner circle of Michelangelo, carried to their furthest point the sweeping proportions—long-armed, wide-hipped, and tall—of the woman to the left in the *Concert champêtre*. He was so imbued with this ideal that he could find it in nature, as we can tell from a splendid drawing of a nude model, one of the first "life drawings" of a woman that have come down to us [93]. Titian, on the other hand, developed the sensuous aspect of the Giorgionesque nude till he became one of the two supreme masters of Natural Venus.

The most beautiful of Titian's Giorgionesque nudes is in the picture known as *Sacred and Profane Love* [94]. It has been claimed, perhaps correctly, that she represents Celestial Venus, while her clothed sister is Natural. But to anyone who looks at Titian's painting as a poem and not as a puzzle, her significance is clear enough. Beyond almost any figure in art, she has what Blake called "the lineaments of gratified desire." The eve-

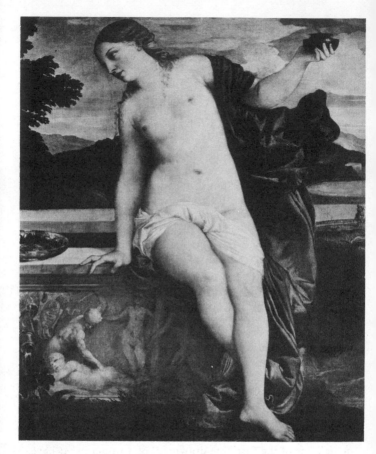

94. Titian. Sacred and Profane Love

ning light of the Veneto, with which Bellini had affirmed the
unity of vegetable creation, is now made to include that sweet
fruit, the human body. She is generous, natural, and calm.
Her outline is more classical than the women in the *Concert
champêtre,* more idealized than the pipe player, more compact
than the dipper in the well. No doubt it has been inspired by
an antique, and Titian has even broken the line of the arm by
a cast of crimson drapery exactly where it would have been

broken by time. But marble, even the sunny, time-softened marble of some statue recently brought to light in vineyard or garden, is the last thing we remember before this glowing panoply of flesh; and this (for antique art was an art of color) is what brings the Venetians so much closer to antiquity than the industrious archeologists of Rome.

Nor would the idea that he was re-creating antique painting have seemed to Titian, in the 1520's, altogether surprising. The subjects of his *Bacchanals,* painted for Alfonso d'Este, are taken from the classical repertoire of pictorial themes, Philostratos, and, quite as much as the classic architecture of Vignola or Sansovino, they were intended to support the illusion that paganism had been reborn. We may question whether any painter of antiquity achieved their palpable fullness and warmth. Yet, as in all midsummer celebrations the magical promise of an earlier season has been lost, so in the *Bacchanals* we lose the shadowy invitations, the poetical mystery, of the first Giorgionesque pastorals. A few years later Titian the friend of Giorgione and native of Cadore has been pushed out of the way by Titian the friend of princes; and the inspired idea that naked beauty could be a natural feature of the landscape has ceased to be a reality. Titian's employers were not averse to naked women, but they wanted them in their proper place; and there follows a series of nude figures reclining on beds and couches, of which the first is the *Venus of Urbino.*

To this there is one exception: the *Venus Anadyomene* of the Ellesmere Collection [95]. She has suffered from time and restoration. Her carmines have faded, some insensitive restorer has altered the outline of her left arm and shoulder; and Titian himself has repainted her head, which is now out of keeping with her body. In spite of this, she remains one of the most complete and concentrated embodiments of Venus in postantique art. If the pipe player in the *Concert champêtre* anticipates the shape of the female nude in the nineteenth century, the Ellesmere *Venus* anticipates the whole conception of the subject, which ended, for our generation, in the nudes of Renoir: that is to say, the female body, with all its sensuous weight, is offered in isolation, as an end in itself. This presentation of the nude, with no pretext of fable or setting, was in fact extremely rare before the nineteenth century, and it would be interesting

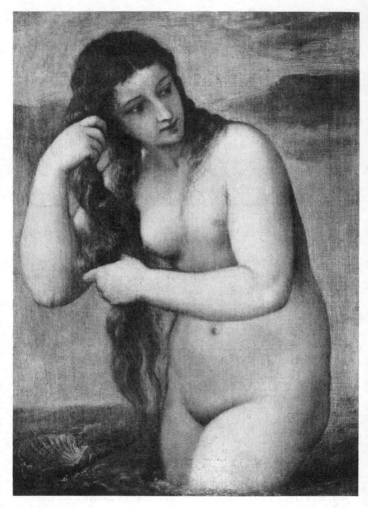

95. *Titian. Venus*

to know under what circumstances Titian conceived it. Perhaps
he was asked to preserve in the medium of oil paint a speci-
men of the single nude figures with which he and Giorgione
had frescoed the Fondaco dei Tedeschi. His point of departure

is of course an antique, presumably the same one that inspired an engraving by Marcantonio of Venus wringing the water from her hair; but Titian has changed the flowing rhythm of the Hellenistic original into the firm rectangular design of the two arms, to which even the thigh, in some measures, conforms.

That an austere tradition of design is an essential of the nude has been one of the chief themes of this book, but I will restate it here, for Titian provides its most impressive illustration. Since he was an epic poet of sensuality, an absolute master of flesh painting, one might have supposed that an infinite variety of poses and situations was available to him. And yet the number of attitudes that seemed to him to achieve finality was extremely small. It is, to begin with, astonishing that in 1538, thirty years after he had put the finishing touches on Giorgione's *Venus,* he should have used identically the same pose for almost the whole body of the *Venus of Urbino,* varying only, as we have seen, the position of the right arm and breast; and the same form, much coarsened, serves in that labored atempt to recapture his early style, the *Venus del Pardo.*

In the 1540's he discovered two fresh patterns of recumbent Venus that were to satisfy him for the next decade. One of them is the figure reclining on her left arm, her body turned round toward the spectator, who appears first alone with Cupid, in the Uffizi picture, and thereafter, in numerous replicas, with an admirer seated at her feet making music on an organ or a lute [96]. In this series only the position of her head is varied: her body remains the same, and there can be no doubt that Titian found it unusually satisfying. This is the nude that is most nearly Titian's own creation. In his other fiures Giorgione, Michelangelo, and the antique provide at least the outlines; but the *Venus with the Organ Player* series has a quality that is entirely Titianesque. It is, as has often been observed, the quality of the full-blown rose, rich, heavy, and a trifle coarse. The rose is held frontally, so that we look toward its heart, still covered by curving petals, and although the outline is clear enough, the inscape has lost its tenseness and precision. This frontality, reflecting the magnificent obviousness of Titian's nature, is no doubt what chiefly pleased him in the *Venus with the Organ Player* and led him to repeat her form so often. It also gave him the opportunity of rendering in paint his admiration

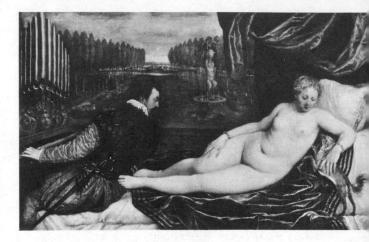

96. Titian. Venus with the Organ Player

for an expanse of soft skin, fully and evenly illuminated. But in spite of this pleasure in the flesh, the Venuses of this series are not provocative. Now that their delicate texture has been removed by restoration, the almost brutal directness with which their bodies are presented to us makes them singularly unaphrodisiac. Moreover, they are far more conventionalized than is evident at first sight. Comparison with Rembrandt's *Danaë* shows how much of the natural appearances Titian has suppressed or subordinated to his ideal scheme. Even such a highly stylized figure as Goujon's *Nymph* retains a sag of the stomach and a movement of the torso more naturalistic than the Titian and thus arouses more natural feelings.

The *Venus with the Organ Player* is entirely Venetian, younger sister of all those expansive ladies whom Palma Vecchio, Paris Bordone, and Bonifazio painted for local consumption; in the rest of Italy bodies of an entirely different shape had long been fashionable, and in 1546–47 Titian himself, who was in Rome, receiving the freedom of the city, came to terms with the new convention. The result was the *Danaë,* of which during the next years he was to paint an almost equally large number of versions [97]. Her pose is clearly based on drawings of Michelangelo, and is in fact similar to that of the *Night,* reversed, and,

so to say, opened out. Her head, instead of drooping forward
in melancholy slumber, is stretched back on her pillow, volup-
tuously contemplating the shower of gold; her arm is no longer
twisted behind her, but rests comfortably on a cushion, as do
the arms of Titian's Venuses. Needless to say, the harsh fur-
rows of the stomach have been smoothed away into a gentle
undulation and the extruding animal breast has been brought
into conformity with human expectations. At every point
Michelangelo's grandiose invention has been transformed from
an embodiment of spiritual malaise into an embodiment of
physical satisfaction.

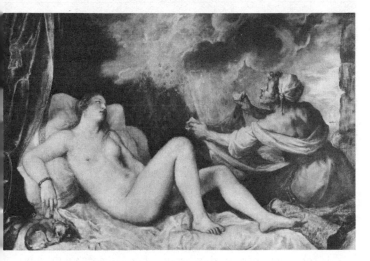

97. *Titian. Danaë*

Suddenly, in the 1550's, all Titian's self-imposed restraints
and limitations are broken through. The frontal poses and de-
cisive contours are abandoned, and in the two great "poesies"
in the Ellesmere Collection, the *Diana and Actaeon* and the *Diana
and Callisto,* the female body is seen with a freedom from stylis-
tic preconception never achieved before [*98*]. It is true that
some of the principal figures, in particular the Diana rebuking
Callisto, have an elegance that must owe something to Par-
migianino; but in both pictures the attendant maidens are of

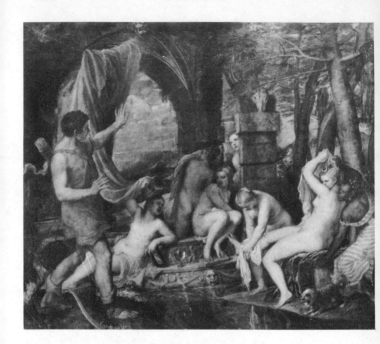

98. Titian. Diana and Actaeon

an amazing naturalness. Rubens never surrendered himself
more wholeheartedly to pleasure in the sight of the naked body,
nor greeted with better appetite generous developments of the
flesh. The figure on the left of the *Callisto* is, indeed, so far out-
side the canon of desirable beauty that Courbet might have
hesitated to accept her. The crouching figure in the center of
the *Actaeon,* on the other hand, is one of the most seductive
nudes in all painting, and was recognized as such by both
Rubens and Watteau. This freedom of imagery is supported by
an equal freedom of composition and handling. The forms are
no longer evenly illuminated, but pass through cast shadows
and reflected lights, and the paint is put on with large, broken
touches of bright color. This is the final mastery of execution
that appears in the latest works of Rembrandt, Velásquez, and
Cézanne, and perhaps it was this feeling that at last his brush
could do anything that led Titian to give free rein to his un-

diminished sensuality. The controlling factor, even in such an eager approach, is still the technical medium. Thus Titian could maintain that balance between intense participation and absolute detachment which distinguishes art from other forms of human activity.

Contemporary with Titian and complementary to him was another great poet of the body, Correggio. The difference between them is like a difference of sex or the difference between day and night. Where Titian saw form like a full, frontal relief, Correggio saw it gliding into depth. Where Titian seems to place his figures before an open window with daylight falling directly on them, Correggio seems to place them in the penumbra of a curtained gallery where the light comes from several sources. We seize upon the mass of Titian's *Venus* immediately and abruptly; Correggio's *Antiope* we caress [99]. This feeling of tenderness he achieves by a rhythmic relationship of line and shadow that ultimately derives from Leonardo da Vinci. It was Leonardo who had advised the painter to penetrate the secrets of expression by looking at the faces of women in the mysterious illumination of twilight; and it was he who had studied scientifically the passage of light round a sphere. The delicately perceived continuum of shadow and reflection in Leonardo's diagrams had its own sensuous beauty even before it was transferred from geometric spheres to the soft irregular sphere of the breast. Moreover, light that passes gently along a form, be it an old wall, a landscape, or a human body, produces an effect of physical enrichment not solely because of the fullness of texture it reveals but because it seems to pass over the surface like a stroking hand. In Correggio's *Antiope* this effect is used with the greatest delicacy. As our eye follows every undulation it passes refreshed from shadow to light. Her arm on which she rests her ecstatically sleeping head is clouded with shadows and reflections. Every form has the melting quality of a dream. This, of course, is achieved as much by linear movement as by chiaroscuro. Correggio was a natural lyricist who gave a flowing meter to everything he made, from the whole design down to the curve of a little finger. Here, too, he was influenced by Leonardo, and was perhaps the only artist who gained something from the Oriental flexibility of the *Leda*. But those curves which in Leonardo have an alienating

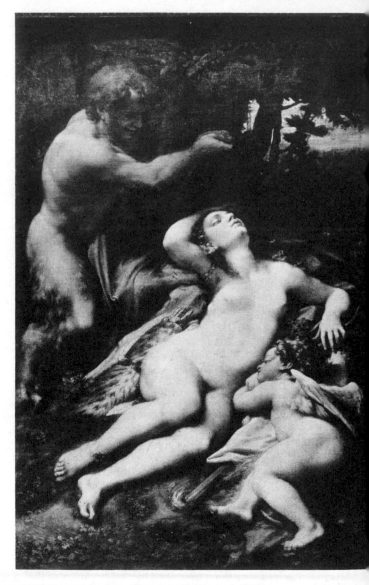

99. *Correggio. Jupiter and Antiope*

detachment—curves of marsh grass or of swirling water—become in Correggio warm and delicately human. They are, and have remained, the signature of feminine grace; and although in the last century they have been vulgarized and shamefully exploited, when we meet them first they have the freshness of morning. No other painter, as Mr. Berenson said long ago, was ever more penetrated by femininity, so that his most warlike saints are tender, his most venerable anchorites have the graceful gestures of a girl. Like Botticelli, he passed easily from Christian to pagan subjects, but whereas the earlier painter thought first of woman as the Virgin, with all her sorrows and apprehensions, and was persuaded by learned poets to transform her into Celestial Venus, Correggio thought of her as a tangible human body and was happiest when the subject allowed him to show it undraped and enjoying the amorous enterprises of Jupiter. We can be thankful that he did not live twenty years later, when such subjects were generally prohibited.

Correggio's gentle character was devoid of pruriency. His nudes are the reverse of obscene. Nevertheless, he has tried to make them as seductive as possible, and this has involved a relaxation of the classic norm and a removal, so to say, of the armor of geometry. The body of his *Antiope* is entirely feminine, small, warm, and relaxed. The *Danaë* [*100*], prettier and less passionate, is incredibly *dix-huitième,* and late *dix-huitième* at that, for she is closer to Clodion than to Boucher. The silvery light that passes with a kind of subaqueous tremor over her little body models her breasts to a form that inspired both Prud'hon and Chassériau, though neither ventured so far from the mold of antiquity. It is hard to believe that this charming creature, with her rococo complexity of movement and subtlety of expression, was painted earlier than Titian's *Venus of Urbino;* even harder to think of Correggio's *Leda* as almost contemporary with Michelangelo's heroic version of the same subject. It is composed with a freedom scarcely regained in the later Renoir and has a heedless gaiety that is not only contrary to the grandiose spirit of the High Renaissance, but far away from that kind of animal earnestness with which antique art treated everything to do with sexual intercourse.

Between Correggio's invention of sheer prettiness and its re-

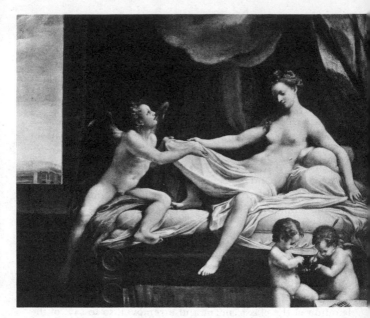

100. Correggio. Danaë

appearance in the eighteenth century, Venus underwent two
further incarnations. The first may for convenience be labeled
mannerism, a word that, however often it is misapplied, cannot
lose its association with a definite ideal of feminine beauty, with
an unnatural length of limb, an impossible slenderness of body,
and a self-conscious elegance of bearing. In this scheme of pro-
portions the classic norm is sometimes consciously rejected, and
I therefore return to it in the chapter called "The alternative
Convention," where I examine the Gothic nude. This is histor-
ically justifiable, for during the years of collapsing humanism
Italian art borrowed shapes, subjects, and actual figures from
Germany and the Low Countries. But what we call manner-
ism has its origin in the expressive distortions of Michelangelo,
to which, in the female nude, must be added the elegance of
Parmigianino; and both these physical schemes start from in-
side classic art. Michelangelo hardly became more contorted
than the *Laokoön,* nor Parmigianino more elongated than the

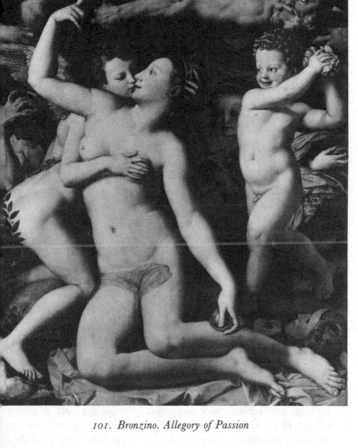

101. Bronzino. Allegory of Passion

stucco reliefs of Hadrian's Villa and other late antique deco-
rations from which his style must be derived. It is paradoxical
that Michelangelo, who took so little pleasure in the female
body, should have had an influence on the image of Venus.
But his powers of formal invention so dominated his contempo-
raries that his poses reappear in unexpected contexts. An ex-
ample is the Venus in Bronzino's *Allegory of Passion* [*101*], who

seems to be the epitome of Medicean elegance, polished, slender, and coolly lascivious; yet her zigzag pose derives from that of Christ's dead body in the *Pietà* of the Duomo. Michelangelo himself gave a lead to such transformations when, to please the duke of Ferrara, he used the pose of the *Night* as the basis of his cartoon for *Leda*. And the two female figures of the Medici Chapel continued, for half a century, to provide basic material for the decorative nudes of mannerism. The tapering limbs of the *Dawn* become longer and more streamlined, until the accidents of the flesh are almost forgotten, as in the nymph elegantly balanced on the edge of Ammanati's fountain in the Piazza della Signoria.

Nevertheless, the embodiments of Venus in the sculpture of mid-sixteenth-century Florence and Venice have hardly been surpassed in variety and grace. An equal mastery of human anatomy and of the antique convention gave to Italian sculptors of that date perfect freedom to approach and withdraw from the facts of the body. In Venice the figures of Tiziano Aspetti or Gerolamo Campagna retain, on the whole, the large oval forms of Giorgione; but in Florence the sculptors who worked for the grand dukes were more adventurous. Three bronzes from the Studiolo of Francesco I show their range. One, by Stoldo di Lorenzo, is almost Hellenistic in its proportions and easygoing sensuality; another, by Ammanati, is more elongated and shows a closer observation of the real body [*102*]. It is one of the most seductive nudes of the sixteenth century. In the third, by Calamecca, direct sensibility is almost excluded, and in its place is a useful formula of elegance for the mass-produced nudes of mannerism.

More than once in this study I have emphasized how much formalization the female body can undergo and still preserve some tremor of its first impact. The nudes of Giambologna are the most polished example of this survival. They are probably further from actuality than anything in antique art; yet we accept them as the material of sculpture that, although it does not warm the heart, achieves its ends with remarkable assurance. The finality of such a figure as his *Astronomy* [*103*] led to hundreds of imitations, yet compared to the original they are all slightly awkward or amateurish. It is the last triumph of *disegno* in Italian art, and, perhaps inevitably, the work of a

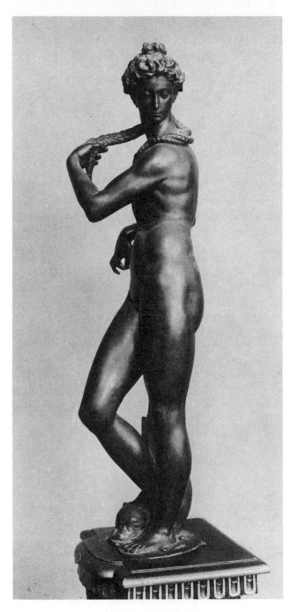

102. Ammanati. Venus

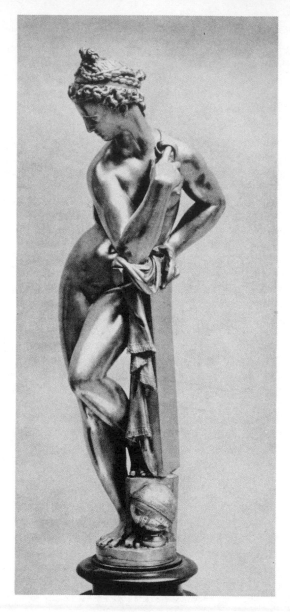

103. Giambologna. Astronomy

non-Italian. For Giambologna is not solely a stylist. He had a Northern vigor, manifested also in his enormous output, that no formula could freeze, and a certain largeness of spirit that gives nobility even to his smallest bronze figurines. Perhaps no other living artist (for he lived till 1604) had so decisive an effect on Rubens' conception of the nude when, as a young man, he first visited Italy.

Mannerism spread to France in the first years of its evolution. Rosso, Primaticcio, Niccolò dell' Abate, and Cellini found employment in Fontainebleau denied to them in their disrupted country, and, removed from the chastening influence of the classic tradition, they produced nudes of fantastic slenderness and elongation. Cellini's *Nymph of Fontainebleau* is so far from the antique canon of proportion that her legs alone are six heads long; and yet Cellini, in his native Florence, had made for the base of the *Perseus* a figure of Danaë as neat and trim as any nude of the Renaissance. The fact that mannerism flourished so luxuriantly when transplanted is owing partly to the latent Gothicism of French art, but also to the fact that, even in the Middle Ages, France had been the center of chic. The goddess of mannerism is the eternal feminine of the fashion plate. A sociologist could no doubt give ready answers why embodiments of elegance should take this somewhat ridiculous shape—feet and hands too fine for honest work, bodies too thin for childbearing, and heads too small to contain a single thought. But elegant proportions may be found in many objects that are exempt from these materialist explanations—in architecture, pottery, or even handwriting. The human body is not the basis of these rhythms, but their victim. Where the sense of chic originates, how it is controlled, by what inner pattern we unfailingly recognize it—all these are questions too large and too subtle for a parenthesis. One thing is certain. Chic is not natural. Congreve's Millamant or Baudelaire's dandy warn us how hateful, to serious votaries of chic, is everything that is implied by the word "nature." So, strictly speaking, the exquisite ladies of Fontainebleau should not be classified with Venus Naturalis. Nor are they narrowly celestial, for, in spite of their remoteness from ordinary experience, they are calculated to arouse desire; indeed, their very strangeness of

proportion seems to invite erotic fantasies, for which the substantial bodies of Titian leave less opportunity.

But it is this lack of substance that, in the end, makes Northern mannerism no more than a bewitching byway in the history of European art. However much we enjoy the seasoning of style, by the year 1600 we are in need of some more solid nourishment. In that year the duke of Mantua engaged as court painter a young man from the North, Peter Paul Rubens.

We have reached the unchallenged master of Venus Naturalis, and all the familiar words stand ready to flow from the pen—gusto, exuberance, mastery of execution. But they are not enough. Why do we burn with indignation when we hear people who believe themselves to have good taste dismissing Rubens as a painter of fat naked women and even applying the epithet "vulgar"? What is it, in addition to sheer pictorial skill, that makes his nudes noble and life-giving creations? The answer is partly in his character and partly in the discipline through which he mastered his profession. Both are evident if we compare him with the contemporary who seems at first sight to resemble him, Jacob Jordaens. There is indeed something amiable about Jordaens' hearty farmyard approach to the body. It is at least easier and more natural than that of the post-Reformation Germans. But how stupid and grossly material his naked women appear if we put them beside the nudes of Rubens! Rubens, after all, was the greatest religious painter of his time, and in his splendidly unified character sensuality could not be dissociated from praise.

> We thank Thee then, O Father,
> For all things bright and good,
> The seedtime and the harvest,
> Our life, our health, our food:
> Accept the gifts we offer. . . .

As we sing these words on a bright Sunday in September we may approach for a minute the spirit in which Rubens painted his pictures. The golden hair and swelling bosoms of his *Graces* [*104*] are hymns of thanksgiving for abundance, and they are placed before us with the same unself-conscious piety as the sheaves of corn and piled-up pumpkins that decorate a village church at harvest festival. Rubens never doubted that (in

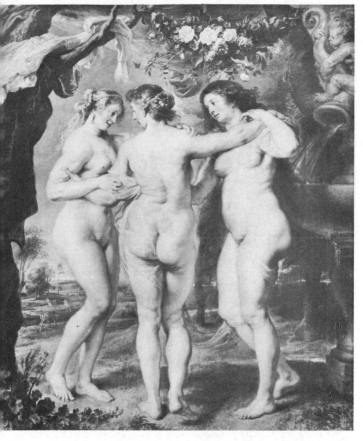

104. Rubens. Three Graces

Blake's words) "The Nakedness of Woman is the work of God," nor questioned that further Proverb of Hell: "The spring of pure delight can never be defiled." This is what gives an air of innocence to all his nudes, even when they are most conscious of their charms. They are a part of nature; and they embody a view of nature more optimistic than that of the Greeks, for thunder and the treacherous sea, the capricious cruelty of Olympus, are absent. The worst that can happen is a surprise

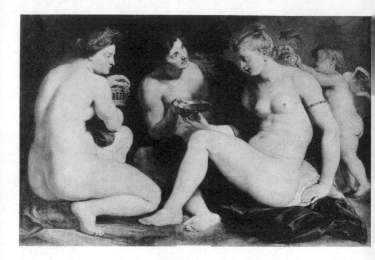

105. Rubens. Venus and Areia

attack by satyrs, and "The lust of the goat is the bounty of
God." In the seventeenth century the Triumph of the Sacra-
ment, that subject to which Rubens gave so much of his time,
was still thought to be reconcilable with a faith in natural
order, and this gave an extraordinary wholeness to all phe-
nomena. The human mind had begun to conceive a universe
governed by beneficent cause and effect but had not yet sub-
jected it to analysis. It was still expressible through personifi-
cations, that is to say, still within the grasp of popular under-
standing. This philosophy of participation was the background
for the harmonious personality of Rubens. Few men can have
been so free from pettiness or perversity, jealousy or frustration.
His figures never pause to calculate material advantage or nurse
an unacted desire. They have the sweetness of flowing water.

Not unconnected with his gratitude for God's bounty is
Rubens' humble devotion to the art of design. No other great
painter has ever made such a prolonged, laborious, and fruitful
study of his predecessors' work. From antique cameos to
Flemish primitives, from the tiny panels of Elsheimer to the
vast canvases of the Venetians, Rubens copied everything that
could conceivably add to his already overflowing resources. For

the nude his models were, of course, the antique, Michelaneglo, and Marcantonio. Titian he copied for his color, but altered his form. From them he learned what a severe formal discipline the naked body must undergo if it is to survive as art. Rubens' nudes seem at first sight to have been tumbled out of a cornucopia of abundance; the more we study them the more we discover them to be under control. His procedure was that which has become the dogma of academies: he drew from the antique and copied from his predecessors till certain ideals of formal completeness were absolutely fixed in his mind; then when he drew from nature he instinctively subordinated the observed facts to the patterns established in his imagination. The average student cannot make a success of this procedure because accident is more attractive than substance. He seizes upon tricks of style and overlooks essential structure. Rubens did the reverse. He could give his figures so much of his own peculiar style and his own responsiveness to nature than we are seldom conscious of his sources. An exception is the *Venus, Bacchus, and Areia* in Kassel [*105*], where Areia is obviously taken from the *Crouching Aphrodite* of Doedalsas and Venus from a memory of Michelangelo's *Leda;* but this, with its full relieflike treatment, is the most classical of all Rubens' compositions. A few years later, when the same Michelangelesque motive is used in *The Rape of the Daughters of Leukippos* [*106*], it is assimilated into a baroque design. In fact, the actual borrowings in Rubens' work are rare; what is important is the evidence of formal discipline, demonstrable in his drawings and implicit in his paintings. But he knew that at a certan point the constraints of classic form could be abandoned. He made copies from those great liberations of the female nude, Titian's *Diana* pictures, and his own *Diana and Callisto* contains figures as freely drawn from nature, Diana herself squatting on the ground or the girl who leans forward with her elbows on the edge of a fountain. To the left of the same composition is a woman in a pose of exceptional beauty, which reappears in several of his other works, in *The Outbreak of War* and in *The Crowning of a Victorious Hero.* With her hips still frontal, she turns the upper part of her body violently to the left and her right arm is stretched across her breasts. She is the bacchante whom we have already noticed on a sarcophagus in the Terme, and who must have existed in

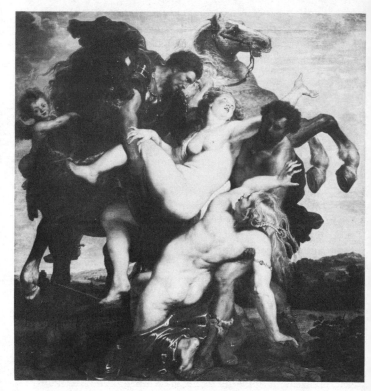

106. Rubens. The Rape of the Daughters of Leukippos

other reliefs in the sixteenth century. Naturally, Rubens was attracted by her twist and sweep, by the large arc of her hip and the shining expanse of her stomach; and he has made her one of the most characteristic of all his figures. Since this is an unusually good example of his transformation of the classical body, I may pause to ask what this change involves.

Rubens wished his figures to have weight. So did the men of the Renaissance, and they sought to achieve it by enclosed forms, which had the ideal solidity of the sphere or the cylinder. Rubens sought to achieve it by overlapping contours and rich internal modeling. In this way he hoped to gain a greater full-ness and a more pervasive movement. Even if he had not felt a

natural fondness for fat girls, he would have looked for accidents of the flesh as necessary to his system of modeling. That suggestion of movement flowing across a torso, which, in the female body, antiquity had rendered by the device of clinging drapery, Rubens could reveal in the wrinkles and puckers of delicate skin, stretched or relaxed. Wölfflin, in his masterly analysis of baroque form, spoke of a change from a tactile to a painterlike, or visual, approach. But if the word tactile be allowed its normal meaning, this definition cannot be applied to Rubens. He does not abandon the ideated sensation of solidity confirmed by touch; on the contrary, he refines upon it by transferring it from the whole hand to the finger tips. How intensely aware he was of the tactile sense is shown by his famous picture of Helena Fourment wrapping her naked body in a fur coat. The motive had been used already in a picture by Titian in the Hermitage. But the classical restraints that Titian exercised in painting the nude led him to suppress as accidental precisely that ideated sensation of texture which makes the contact of Helena Fourment's skin and her fur so stimulating.

The fact that Rubens was more concerned than his predecessors with the flesh and with the texture of the skin has sometimes been considered a symptom of superficiality. In European art there has always been a belief that the more a figure reveals its inner structure the more respectable it becomes. Perhaps there has been some confusion between physical and metaphysical terminology, and the word superficial has extended its meaning from thought to perception, reversing the mental process that leads up to Swift's famous defense of Delusion: "Last week I saw a woman flayed, and you will hardly believe how much it altered her person for the worse." But such speculations would have seemed meaningless to Rubens. He gave the solid form, the weight and movement, of the body; and in addition, inseparably, he gave that invigorating luster, that brightness, which even so grave a philosopher as St. Thomas Aquinas considered essential to his definition of beauty. It was an achievement demanding not only sensibility, but the highest technical skill. "Mille peintres sont morts," said Diderot, "sans avoir senti la chair," and thousands more, we may add, have felt it and not been able to render it. That strange substance, of a color neither white nor pink, of a texture smooth yet vari-

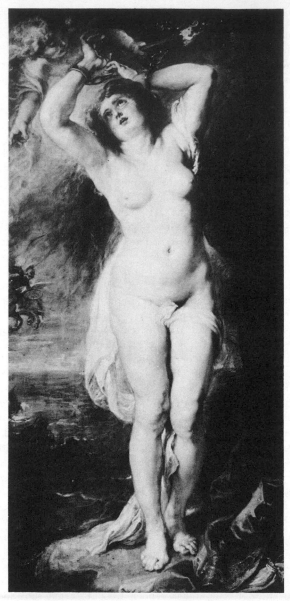

107. Rubens. Perseus and Andromeda

able, absorbing the light yet reflecting it, delicate yet resilient,
flashing and fading, beautiful and pitiful by turns, presents
surely the most difficult problem the painter with sticky pig-
ments and smearing brush has ever been called upon to solve;
and perhaps only three men, Titian, Rubens, and Renoir, have
been sure how it should be done [107].

But in the end the greatness of Rubens does not lie in the
realm of technique, but in that of imagination. He takes the
female body, the plump, comfortable, clothed female body of
the North, and transforms it imaginatively with less sacrifice of
its carnal reality than had ever been necessary before. He
creates a new, complete race of women. In this creation the
face plays an important part. I have said already how determi-
nant in any conception of the nude body is the character of the
head that surmounts it. We look first at the face. It is through
facial expression that every intimacy begins. This is true even
of the classic nude, where the head often seems to be no more
than an element in the geometry of the figure and the expres-
sion is reduced to a minimum. In fact, try as we will to expunge
all individuality in the interest of the whole, our responses to
facial expression are so sensitive that the slightest accent gives
a suggestion of mood or inner life. And so with the nude there
is a double problem: the face must be subordinate, but it must
not go by default, for inevitably it will color our response to
the body. The solution of this problem involves what is called
"creating a type"—of all forms of creation the most revealing
of an artist's whole being. Rubens' women are both responsive
and detached. To be so well favored makes them happy, but
not at all self-conscious, even when rejecting the advances of a
satyr or accepting the apple of Paris. They are grateful for life,
and their gratitude spreads all through their bodies.

Rubens did for the female nude what Michelangelo had
done for the male. He realized so fully its expressive possibili-
ties that for the next century all those who were not the slaves
of academism inherited his vision of the body as pearly and
plump. It was the century of France, and French artists, from
the illuminators of the fifteenth-century manuscripts onward,
had depicted the female body with a sharper sense of provoca-
tion than anything we find in Italy. Round the Venuses or
Dianas of the Fontainebleau School hangs a smell of stylish

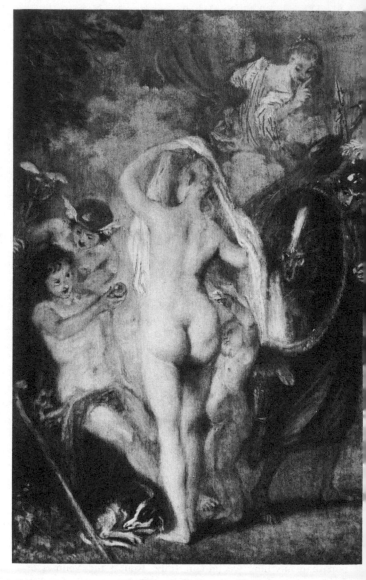

108. Watteau. Judgment of Paris

eroticism, impossible, like all smells, to describe, but strong as ambergris or musk. One reason is that a trace of Gothicism, with all that it implies of seductive guesswork, persists in their proportions. Up to the time of Lemoyne or even Houdon, the bodies of French goddesses retain the small breasts, long tapering limbs, and slightly accented stomachs of the sixteenth century. To this tradition of quasi-Gothic elegance certain painters of the *dix-huitième*—Watteau above all—added Rubens' feeling for the color and texture of skin. No other painter has had a more sensitive eye for texture than Watteau, and the rarity of his nudes may even reflect a kind of shyness, born of too tremulous desire, which the spectacle of the living surface aroused in him. Perhaps the very unfrigid statues in his parks are telling us that he could only contain his excitement when the body was supposed to be of stone. The most beautiful of all his nudes, *The Judgment of Paris* in the Louvre [*108*], combines in one glowing vision the two traditions of French art, with its Venus as tall and tapering as a figure by Pilon, but displaying an area of flesh modeled with the fullness and delicacy of Rubens.

By the middle of the century slenderness has yielded to compactness and a new ideal of naked beauty has been established: the *petite*. The small, full, manageable body, which has always appealed to the average sensualist, is to be found in the less idealized minor arts of antiquity, and in certain *cassone* panels of the Italian Renaissance, notably in the *David and Bathsheba* of Franciabigio. Correggio's *Leda* made this kind of body more consciously seductive; but the particular formalization of this physical type which we associate with the *dix-huitiéme* seems to go back to the *Basin des nymphes* of Girardon (himself a devoted student of Hellenistic art) and to have been perfected by François Boucher.

Both by nature and by the wish of his employers Boucher was a decorator, and decorators must be content with formulae. So Boucher was forced to reduce the female body to one serviceable type, which appears in his compositions so frequently and with so even an accomplishment that we end by almost forgetting that she is a nude at all and her body means little more to us than the clouds on which she floats. But in those works to which he could give individual attention, Boucher shows himself an eager and perceptive admirer of the body.

109. Boucher. Miss O'Murphy

Freshness of desire has seldom been more delicately expressed
than by Miss O'Murphy's round young limbs, as they sprawl
with undisguised satisfaction on the cushions of her sofa [*109*].
By art Boucher has enabled us to enjoy her with as little shame
as she is enjoying herself. One false note and we should be
embarrassingly back in the world of sin.

The most artful of Boucher's nudes is the *Diana* in the
Louvre [*110*], where not only the young body, with its fine
wrists and ankles, but the graceful pose and the subtle reflected
lighting combine to give an air of exaggerated refinement. We
are reminded that Boucher's chief patron was Mme de
Pompadour and that he was the willing servant of a civilization
in which women were in the ascendant. To this day a style
derived from Boucher is considered appropriate for predomi-
nantly feminine establishments, coiffeurs, and beauty parlors.
He created the image that Venus Naturalis would like to see in
the mirror, a magic reflection in which she ceases to be natural
without ceasing to be desirable.

The Venus of the *dix-huitième* extends the range of the nude in one memorable way: far more frequently than any of her sisters, she shows us her back. Looked at simply as form, as relationship of plane and protuberance, it might be argued that the back view of the female body is more satisfactory than the front. That the beauty of this aspect was appreciated in antiquity we know from such a figure as the *Venus of Syracuse*. But the *Hermaphrodite* and the *Callipygian Venus* suggest that it was also considered symbolic of lust, and before the eighteenth century the number of female nudes depicted from behind solely on account of their plastic possibilities was remarkably small. A famous exception is the *Rokeby Venus* of Velásquez [1]; but that strange, dispassionate work is outside all our preconceived notions of chronology, and seems closer to the *academies* of the nineteenth century than to the warmer images of Venus that precede and follow her. It might have been supposed that in this matter at least Velásquez had yielded to the influence of his great contemporary, but in fact the most beautiful of Rubens' goddesses are all frontal; only in *The Three Graces,* in

110. Boucher. Diana

111. Rubens. Life drawing

the Prado, and in some splendid drawings does he show his appreciation of the other aspect [*111*]. Nevertheless, it was Rubens who inspired both Watteau and Boucher. He was a master of the baroque, and the bottom is a baroque form, harmonizing with the clouds and garlands of late-baroque decoration. These decorative considerations certainly influenced Boucher and Fragonard when they so frequently depicted the nymphs of antiquity or the heroines of La Fontaine lying on their fronts, and leaning their elbows on a cushion or convenient cloud; and we must also allow that the antique motive for this pose was not excluded, although conveyed with a lightness and finesse very different from the bestial frescoes of Pompeii.

The evolved formula of delicate nudity is not to be found in the painting of the *dix-huitième,* but in its sculpture, particularly in the small figures of terra cotta or *biscuit de Sèvres* that we associate with the names of Clodion and Falconet. By Clodion Venus was observed with a more appreciative eye than by any other artist of the eighteenth century [*112*]: Boucher himself had not so fine a sense of evocative accent. But both he and Falconet could suppress observation in favor of an ideal refinement, in which we surrender to politeness almost as much of our natural appetites as, in an earlier age, was surrendered to the spirituality of Venus Coelistis. As with the small bronzes of the Renaissance, we see how a theme can be civilized till its original impulse is lost in convention. At the close of the century the curious mixture of mannerism and classicism, which was evolved by the painters of the Consulate—Boilly, Girodet, and Prud'hon—added an inflection to our image of Venus. Prud'hon, by nature her sensitive votary, could combine classic wholeness of form with Correggiesque rapture, and his life studies show how that depressing spectacle, a naked model in an art school, can be transformed.

The attempt to rescue Venus from her boudoir and restore to her some of the splendor of the *Knidian,* an attempt for which Girodet had lacked the conviction and Prud'hon the stamina, was achieved by Ingres. "Son libertinage est sérieux," said Baudelaire, "et plein de conviction. . . . Si l'île de Cythère commandait un tableau à M. Ingres, à coup sûr il ne serait pas folâtre comme celui de Watteau, mais robuste et nourrissant, comme l'amour antique."

112. Clodion. Nymph and Satyr

It is true that Ingres' response to the female body has a meridional earnestness, but his sensuality was combined with a passion for form, or, to be more precise, with a need to externalize certain expressive shapes, and his paintings are often no more than a sort of showcase in which to display those points where obsessive form and sensuality are brought into focus. In

the *Jupiter and Thetis,* for example, the whole design is taken
from two impoverished outlines by Flaxman and the Jupiter is
an admirable piece of classical furniture; but the figure of Thetis
achieves a crescendo of sensual—we may even say sexual—
excitement, starting with the outline of her body, which echoes
so mysteriously that of the neophyte in the as-yet-undiscovered
wall paintings of the Villa Item, following her swanlike neck,
and rising up her arm, boneless but disturbingly physical, till it
culminates in her extraordinary hand, half octopus, half trop-
ical flower. Ingres spent his whole life in an attempt to prize
out of himself these nuggets of obsessive form; and the intensity
of this effort made him so narrow and obstinate as to seem
unintelligent. But he recognized that he must reconcile his
insatiable appetite for particularity with an ideal of classical
beauty, and his greatness as a delineator of the nude could be
described, in modern jargon, as a tension between the two. A
contemporary critic made the same point more picturesquely
when he referred to Ingres as "un chinois égaré dans les ruines
d'Athenes." The accusation of Gothicism, provoked by the
work of his pre-Raphaelite phase, could still be applied to
drawings of his Raphael-worshiping maturity, many of which
show the accented details of Northern form and even the
morphological characteristics, small breasts and prominent stom-
achs, which in a later chapter I point out as characteristic of
the Gothic nude. These observations, made, as Baudelaire said,
with the sharp, unprejudiced eye of a surgeon, were subservient
to four or five formal ideas that came to him during his first
years in Rome. They were his moments of inspiration, and he
depended on them for the rest of his life. Like Titian, this great
amateur of the female body knew that his excitement must be
concentrated if it were to achieve finality; and the number of
his formal ideas that I have just given is meant to be taken literally.

Leaving out of account the beautiful but still experimental
picture in the Bonnat Collection, the series opens with the so-
called *Baigneuse de Valpinçon* (1808), a picture that, thank
heaven, he felt able to execute at the time of its conception
[*113*]. Of all his works it is the most calmly satisfying and best
exemplifies his notion of beauty as something large, simple, and
continuous, enclosed and amplified by an unbroken outline.
But in this instance the modeling suggested by the contour is

supported by a passage of reflected light worthy of Correggio. Ingres never again attempted this naturalistic means, just as he never again concentrated on such a natural-looking pose. In fact, the design of the *Baigneuse de Valpinçon* is of an inspired simplicity worthy of antique Greece. She speaks to us in the accents of fulfillment, and we are not surprised to find her reappearing in his work fifty-five years later. His other ideal presentations of the female body are more artificial, and, perhaps for this reason, were not carried out till long after the date of their conception. One of these is the standing figure who first appears in two pen drawings as a *Venus Anadyomene.* They suggest that in addition to the engraved backs of mirrors and other documents of antiquity, Ingres had been contemplating the Venus of Botticelli, and had there found confirmation for the sinuous embraces of his outline. How soon these drawings were used in the preparation of a painting we do not know. According to Charles Blanc, an unfinished painting of the subject existed as early as 1817, when Géricault saw it in Ingres' studio in Rome; but for some reason it was carried no further, and the picture at Chantilly is dated 1848 [*114*]. The Botticellian line has been substantiated by a full Raphaelesque modeling, but in a few places—for example, the outline of her left side— generalization has become too dominant over particularity, and perhaps this is why eight years later the sight of his concierge's daughter, recalling his days in the Via Margutta, set him to work on the motif again. It is said that already in 1820 he had thought of changing his Venus into a maiden with a pitcher of water. This was the version of his idea that in 1856 he decided to complete; and the result was one of the most famous nudes in the history of art, *La Source.* Like the *Medici Venus,* her fame has declined since Charles Blanc could call her, without fear of contradiction, the most beautiful figure in French painting; and although we may still admire certain passages of drawing, the left hip, for example, or the relationship of the legs, we are put off by the softness of the actual execution; and a generation that favors a sharper attack will prefer the clear accents of his earlier work. Of these the most uncompromisingly personal, and for this reason the least classical, is the *Grande Odalisque* of 1814 [*115*]. She could, indeed, be claimed as the culminating work of the School of Fontainebleau, in which

113. Ingres. La Baigneuse de Valpinçon

all that is approximate and provincial in the pupils of Prima-
ticcio is at last given a metropolitan finality. Whereas *La Source*
was the most immediately popular of his works, the *Grande*

114. Ingres. Venus Anadyomene

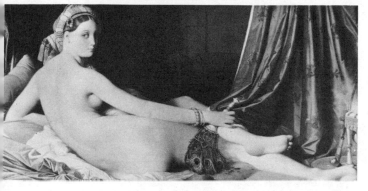

115. Ingres. La Grande Odalisque

Odalisque was the most savagely criticized. It was discovered that she had two vertebrae too many, and in later years, when Ingres had made himself the high priest of academic orthodoxy, rebels and philistines united in repeating that she was out of drawing. In fact, the drawings of which she is the culmination could be claimed as the most beautiful studies of the female nude ever executed, and show with what deliberation and sustained conviction Ingres had sought her peculiar pose.

The *Grande Odalisque* was painted as pendant to another reclining nude that had been purchased by Murat, King of Naples, in 1809. It was destroyed in the riots of 1815 and we have no certain record of its appearance, but, given Ingres' tenacity, we are probably right in assuming that the figure was in the pose repeated many years later in a series of pictures representing an odalisque and her attendant. This idea certainly goes back to the first Roman period, for it occurs in a drawing at Montauban inscribed *Maruccia, blonde, belle, via Margutta 116*. It is a pose of sinuous relaxation, which he felt he could justify by a setting in the seraglio, although, in fact, the hand of Thetis shows us that the undulating contours of the East were a necessity to him, whatever their context. Purveyors of seduction were to repeat this pose throughout the nineteenth century, but without the archaic severity that Ingres was to impose on it. In the drawing of Maruccia we see him following, with breathless delight, every inflection of her beautiful body; but

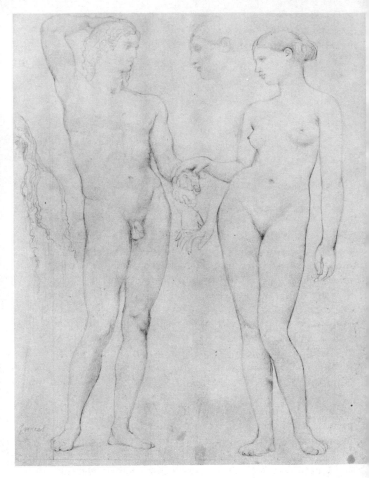

116. Ingres. Study for L'Age d'or

when he used this study in the paintings (he executed two with
his own hand, one dated 1839, the other 1842) the forms be-
come weightier and more memorable. The hips and stomach
approximate to comprehensible arcs, yet nothing is sacrificed of
their physical splendor. It is a demonstration of his aesthetic
beliefs that only the female nude could justify. Fifty years

earlier Winckelmann had asserted that whereas the male nude might achieve character, the female nude alone could aspire to beauty: an assertion uninfluenced by personal preferences but by his theory that beauty consists in smoothness and continuity. It was largely because Ingres for so long dominated the center of the academic system that this theory became reality, and naked women took the place of men as the models in art schools. Ingres could draw the male figure admirably, as he could everything else, but as a rule it bored him, and his studies of men lack that excited particularization which sharpens the edge of his studies of women. A drawing in the Fogg Museum [*116*], done with even more than his usual diligence, shows a man and woman conceived in terms of their bodily contrast, very much as in Raphael's *Adam and Eve;* but whereas in the Raphael the male figure is more naturalistic and more clearly seen, in the Ingres he is vapidly ideal, a composite memory of Praxitilean originals. The woman's body, on the other hand, in spite of her conventional pose, is observed with almost embarassing attention.

The drawing is one of the many hundreds of studies made for *L'Âge d'or,* the great mural painting at the Château de Dampierre, on which he was at work from 1840 to 1848. It consists entirely of nudes—what Ingres called "un tas de beaux paresseux"—dancing, embracing, reclining, and being joined in pagan matrimony. Many reasons, material and technical, have been given why the work is incomplete and, on the whole, unsuccessful; and no doubt one of them is that Ingres' concentrated program had not taught him to organize so large a space. But another reason is that these nude figures, beautifully observed though they are, do not come from the center. They are the result of experiences, but they are not ideas.

On one of the notes for *L'Âge d'or* Ingres has written: "One must not dwell too much on the details of the human body; the members must be, so to speak, like shafts of columns: such they are in the greatest masters." It is touching to find Ingres, at the height of his fame, warning himself against his own gifts; and of course the advice was not—could not be—accepted. He continued to dwell on details, and his figures, far from being like the columns of antique Greece, come more and more to resemble the temple sculpture of southern India.

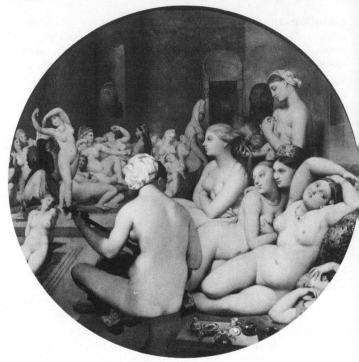

117. Ingres. Le Bain turc

The final expression of this Orientalism is the *Bain turc* [*117*].
It is dated 1862, and Ingres, with justifiable pride, has added
to his signature his age: Aetatis LXXXII. Like his fellow octo-
genarian in the *Diana and Actaeon,* he has at last felt free to re-
lease his feelings, and all that was implied in the hand of
Thetis or the sole of the odalisque's foot is now openly attrib-
uted to thighs, breasts, and luxurious *déhanchements.* The result
is almost suffocating; but in the middle of this whirlpool of
carnality is his old symbol of peaceful fulfillment, the back of
the *Baigneuse de Valpinçon.* Without her tranquil form, the whole
composition might have made us feel slightly seasick. The two
reclining figures on the right are in attitudes of relaxed sensu-
ality unparalled in Western art, and at the first glance we par-
ticipate in their languor and satiety; but after a minute we

become aware of a design so densely organized that we derive
from it the same intellectual satisfaction as is provided by
Poussin and Picasso. Even in this moment of abandonment, he
still keeps his feet—"je suis solide sur mes ergots"—on the
basis of ideal form.

The decade in which the *Bain turc* was painted may be reck-
oned the high-water mark of nineteenth-century prudery, and
perhaps only M. Ingres, the *petit éléphant bourgeois,* with his seat
in the Academy, his frock coat, and his absurdly orthodox
opinions, could have persuaded public opinion to accept so
open an evocation of eroticism. One can imagine what howls of
outraged modesty it would have produced if it had been a work
of the opposite school. Only one year later public and critics
were screaming with horror at the nude in Manet's *Déjeuner sur
l'herbe,* unaware that her outlines were taken direct from
Raphael. That fear of the body which is usually called Vic-
torian is a subject worthy of more disinterested examination
than it has yet received. Unlike the scruples of the early Chris-
tians, it had no religious motive and was not connected with a
cult of chastity. Rather it seems to have been a necessary part
of that enormous façade behind which the social revolution of
the nineteenth century could adjust itself. The unwritten code
of physical respectability that was then produced seems at first
to be full of inconsistencies, but analysis proves it to have had
one overriding aim, to avoid the coarseness of truth. Thus it
was possible to fill a conservatory with nude figures in Carrara
marble, although the mention of an ankle was held to be a
gross indecency. The Crystal Palace contained a forest of mar-
ble nudes, but only one of them, Hiram Powers' *Captive Slave,*
caused a scandal, not because of her body, which was a blame-
less pastiche on the *Knidian Aphrodite,* but because her wrists
were handcuffed. Stylistically, the basis of these figures was the
mannered classicism of Canova, from which a mechanical exe-
cution had removed the last tremors of excitement. Easier to
get with child a mandrake root than consider the marble
Venuses of the Victorians as objects of desire. And yet so magi-
cal had been the first creation of the *Knidian* that her insignifi-
cant progeny was considered a respectable form of furniture
while the impulse that had brought her into existence was
condemned.

118. Courbet. L'Atelier du peintre

The nude survived the great frost of Victorian prudery, partly owing to the prestige of classical art, never higher than in the first quarter of the nineteenth century, and partly to the system of academic instruction known as "drawing from the life." Even in England this was permitted and produced at least one modest but resolute devotee of Venus, William Etty. His daily visits to the life class did not escape censure—"I have been accused," said the poor fellow, "of being a shocking and immoral man"—but a long series of nude studies, painted with obvious enjoyment, prove that he was undeterred. Etty was one of those who, in Diderot's words, "ont senti la chair," and he might have been a considerable artist if he had known how to make his studies into finished pictures. But he lacked the imagination to use them in his compositions without surrendering their truthfulness, and he was too humbly the servant of his times to offer direct transcriptions of the body for their own sakes. To do so required the gargantuan self-confidence of Courbet.

Like all revolutionary realists, from Caravaggio onward, Courbet was far more tied to tradition than he admitted, or than his critics, deafened by the cataract of his talk, could recognize. His nudes are often little more than life studies, and when he tried to give them the additional luster of art, as in the *Femme au perroquet,* the result is as artificial in conception as the vulgarest Salon favorite. The obvious way in which he asserted his realism was by indulging his preference for heavily built models. One of these, the *Baigneuse* of 1853, was intended to provoke and succeeded imperially, for Napoleon III struck at her with his riding crop. She is, in fact, the only one of his nudes whose proportions are far outside the contemporary canons of comeliness, as we know them from the life studies of other artists and from early photographs; and even she is in a pose that reeks of the art school. How natural, compared to her, is the *Baigneuse* of Ingres! When all this is conceded, however, Courbet remains a heroic figure in the history of the nude. His doctrine of realism, poor stuff when put into words but magnificent when expressed in paint, was the overflow of a colossal appetite for the substantial. In so far as the popular test of reality is that which you can touch, Courbet is the archrealist whose own impulse to grasp, to thump, to squeeze,

or to eat was so strong that it communicates itself in every stroke of his palette knife. His eye embraced the female body with the same enthusiasm that it stroked a deer, grasped an apple, or slapped the side of an enormous trout. Such thoroughgoing sensuality has about it a kind of animal grandeur, and there are paintings in which Courbet achieves comfortably and with hardly a trace of defiance that conquest of shame which D. H. Lawrence attempted in prose. A solid weight of flesh does in fact seem more real and enduring than elegance, and the woman who stands beside him [*118*] at the center of his realized dream, that vast canvas known as *L'Atelier du peintre,* although she has the patient carnality of the life class, is, after all, more representative of humanity than the *Diana* of Boucher.

Nor is this effect owing solely to the body. It is, above all, in his faces that we realize how far Etty falls short of Courbet, for on bodies of ageless health he places heads of fashionable coyness; whereas the bovine unself-consciousness of Courbet's women gives them a kind of antique nobility.

To justify the epithet heroic, which I have just applied to him, one must look for those representations of the subject which during Courbet's lifetime and for another forty years won official favor in the Salon. They are not easily found, for the paintings of Ary Scheffer, Cabanel, Bouguereau, and Henner are no longer exhibited in public galleries, and must be sought in provincial *mairies* or the saloons of Midwestern hotels. Each of these artists had his own recipe for success, ranging from the lubricity of Bouguereau to the high-minded sexlessness of Lord Leighton; but all had one characteristic in common: they glossed over the facts. They employed the same convention of smoothed-out form and waxen surface; and they represented the body as existing solely in twilit groves or marble swimming baths. It was this grateful acceptance of unreality in both texture and circumstance which was to receive so painful a shock from the *Olympia* of Manet [*119*].

The *Olympia* is painted in the style of the young Caravaggio, with a more sensitive feeling for paint; but this alone would not have annoyed the amateurs, and no doubt the true reason for their indignation was that for almost the first time since the Renaissance a painting of the nude represented a real woman in probable surroundings. Courbet's women were professional

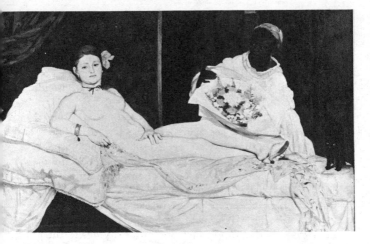

119. Manet. Olympia

models, and although their bodies were painted from nature,
they were usually placed by woodland springs in the accepted
convention. The *Olympia* is a portrait of an individual, whose
interesting but sharply characteristic body is placed exactly
where one would expect to find it. Amateurs were thus sud-
denly reminded of the circumstances under which actual
nudity was familiar to them, and their embarrassment is un-
derstandable. And although no longer shocking, the *Olympia*
remains exceptional. To place on a naked body a head with so
much individual character is to jeopardize the whole premise
of the nude, and Manet succeeds only because of his perfect
tact and skill as a painter. He himself may have felt that so
delicate a feat of balance could not be repeated, for he never
again chose the female nude as the subject of his principal
works. But he had shown that in spite of its long degradation
the subject could be saved for the living art of the time, and
two painters followed him in protesting against the falsity of
Salon nudes. The first was Degas, who as a young man had
done drawings of the female model as beautiful as those of
Ingres, and yet realized that this kind of beauty was, for the
time being, fatally compromised. The second was Toulouse-
Lautrec, whose revulsion from the hypocritical rotundities of

Henner was even sharper, and whose quick eye noted with satisfaction precisely those accents and excrescences of the female body which the Salon favorites had been at pains to suppress. His vivid notations of the naked gain in force precisely because at the back of his mind and ours is the concept of the nude, and our faculties are heightened by a reminder of how otiose this concept had become.

By 1881 it might have seemed that Venus had suffered the fate of Apollo: that she had been cheapened, falsified, and fragmented, so that between the frigid constructions of academicians and the vulgar provocations of the *Vie parisienne* she would never again dominate the imagination in her radiant entirety. In that year Renoir, who was forty years old, took his wife on a honeymoon to Rome and Naples.

Everyone who writes about Renoir refers to his adoration of the female body, and quotes one of his sayings to the effect that without it he would scarcely have become a painter. The reader must therefore be reminded that until his fortieth year his pictures of the nude are few and far between. The first to achieve celebrity was the *Baigneuse au griffon,* now in the museum of São Paulo [*120*]. It was exhibited in the Salon of 1870 and won for Renoir the only popular success he was to enjoy for twenty years. With his usual simplicity he took no pains to conceal the origins of his composition. The pose is taken from an engraving of the *Knidian Aphrodite,* the lighting and way of seeing are derived from Courbet. These contrary sources indicate the problems that were to occupy him for half his life: how to give the female body that character of wholeness and order which was the discovery of the Greeks and combine such order with a feeling for its warm reality. In the *Baigneuse au griffon,* admirable as it is, the two components are not yet united. The antique pose is too obvious, and the earthiness of Courbet's style does not express Renoir's own sunny temperament.

We may suppose that Renoir would have corrected these inconsistencies immediately, had it not been that during the next ten years he became absorbed in the theories of impressionism. Now, impressionism in its first, doctrinaire condition could not easily accept a subject that was both artificial and formal. The nude being a kind of ideal art is closely connected with that first projection of an idea, the outline; and during the '70's the

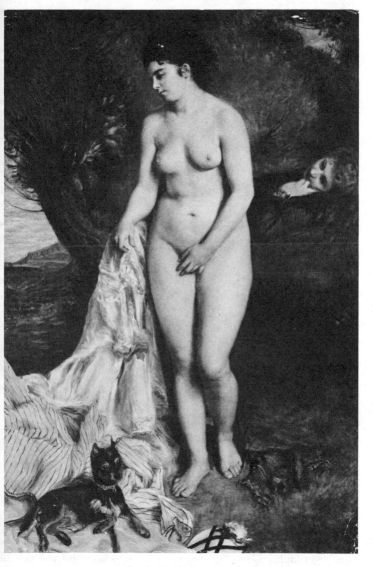

120. Renoir. La Baigneuse au griffon

121. Renoir. La Baigneuse blonde

impressionists, Renoir amongst them, were at pains to demon-
strate that the outline does not exist. When he painted the
figure he broke up its contours by dappling them with patches
of light and shadow. But even in these years his instinctive un-
derstanding of the European tradition showed him how the
great Venetians had rendered form through color, and he

painted two nudes, the *Anna* in Moscow and the *Torso* in the
Barnes Collection, that might almost be details from Titian's
Diana and Actaeon. In these the outline is minimized by over-
lapping forms and by the broken tones of the background, but
the modeling is solid, and there seems to be no reason why
Renoir should not have continued to paint a series of master-
pieces in this manner. However, it did not satisfy his convic-
tion that the nude must be simple and sculptural, like a column
or an egg, and by 1881, when he had exhausted the possibili-
ties of impressionism, he began to look for an example on
which such a conception of the nude would be based. He found
it in Raphael's frescoes in the Farnesina and in the antique
decorations from Pompeii and Herculaneum. The immediate
result was a picture of his wife known as the *Baigneuse blonde*
[*121*], painted at Sorrento toward the end of the year, in which
her body, pale and simple as a pearl, stands out against her
apricot hair and the dark Mediterranean Sea as firmly as in a
painting of antiquity. Like Raphael's *Galatea* and Titian's *Venus
Anadyomene*, the *Baigneuse blonde* gives us the illusion that we are
looking through some magic glass at one of the lost master-
pieces extolled by Pliny, and we realize once more that classi-
cism is not achieved by following rules—for young Mme
Renoir's measurements are far removed from those of the
Knidian—but by acceptance of the physical life as capable of its
own tranquil nobility.

The moment of revelation that inspired the *Baigneuse blonde*
did not survive Renoir's return to France, and for the next
three years he continued to struggle with the problems that
he had solved by instinct beside the Bay of Naples. To concen-
trate his forces he undertook a masterpiece, a composition of
girls bathing, that should have all the qualities of classic French
art from Goujon to Ingres. The general movement and some of
the poses were inspired by a relief on Girardon's *Fountain of the
Nymphs* at Versailles, and throughout the many studies for the
finished picture this sculptural conception persists. It is most
marked in a large drawing, a cartoon worthy of the Renais-
sance [*122*], where the sense of relief and the flow of line are
so perfectly satisfying that I cannot conceive why Renoir should
have altered them; yet in the finished picture every interval is
worked out afresh. The execution is equally deliberate, and al-

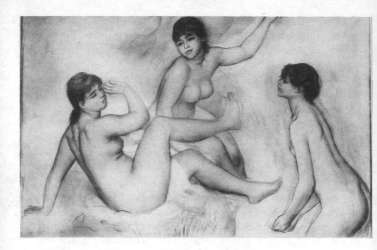

122. Renoir. Three Bathers

though the tonality recalls Boucher, the use of paint has none
of his decorative ease. In certain lights it almost seems as if the
painstaking enamel of the surface has killed the first sensation
of delight; but a passing cloud or an unexpected reflection will
soften those dry transitions so that the whole picture flatters the
eye like a Gobelin tapestry.

The *Grandes Baigneuses* occupied Renoir from 1885 to 1887,
and whether we consider it a masterpiece or a prodigious exer-
cise of will, it liberated him from his anxieties. In the next
twenty years his nudes still show to the perceptive eye evidence
of labor and calculation, but it is artfully concealed. These
charming creatures sit by the banks of streams, dry themselves,
or splash each other with an appearance of perfect naturalness
and spontaneity. They are somewhat plumper than the classi-
cal norm and have an air of Arcadian health. Unlike the
models of Rubens, their skin never has the creases and puckers
of a body that is normally clothed, but fits them closely, like
an animal's coat. In the unself-conscious acceptance of their
nudity they are perhaps more Greek than any nudes painted
since the Renaissance, and come closest to attaining the antique
balance between truth and the ideal.

We know that Renoir, like Praxiteles, was dependent on his

models. Mme Renoir complained that the maids had to be chosen because "their skin took the light well," and at the end of his life, crippled and bereaved, he needed the sight of a new model to give him the impetus to start painting again. But to write of Renoir's nudes as if they were ripe peaches, which he had only to stretch out a hand and pluck from the wall, is to forget his long struggle with the classic style, a struggle that continued after the victory of 1887. Not only Boucher and Clodion, but Raphael and even Michelangelo are drawn upon; and above all he studied antique Greece. Memories of Pompeii and the occasional sight of bronzes and terra cottas in the Louvre led him away from the official classicism of the cast room to the long, pear-shaped body of Alexandrian Hellenism. In these minor arts the nude, although still achieving the oneness of antiquity, had not been deadened by centuries of imitation, and no doubt their flavor of popular naturalism—their touch of Vegetable Venus—also appealed to him. The earliest example of this proportion known to me is the etching of a *Venus Anadyomene* that serves as frontispiece to the 1891 edition of Mallarmé's *Pages;* but in general these Alexandrian figures belong to the period after 1900, when they are often combined in scenes of antique mythology—in particular, *The Judgment of Paris*—wonderfully revived. In these years we watch Renoir gradually abandoning the fair, round girls who had won him popularity and creating a new race of women, massive, ruddy, unseductive, but with the weight and unity of great sculpture [*123*]. Indeed, it is as a piece of sculpture that Renoir's Venus achieves her most complete form, and by a strange paradox this master of oil paint has had little influence on subsequent painting, but a decisive influence on modern sculpture.

The series of nudes produced by Renoir between 1885 and his death in 1919, one of the most satisfying tributes ever paid to Venus by a great artist, knits together all the threads in this long chapter. Praxiteles and Giorgione, Rubens and Ingres, different as they are from one another, would all have recognized him as their successor. Like him, they would probably have spoken about their works as if they were simply the skilled representation of exceptionally beautiful individuals. That is the way that artists should speak. But in fact all of them were looking for something that had grown up in their minds from

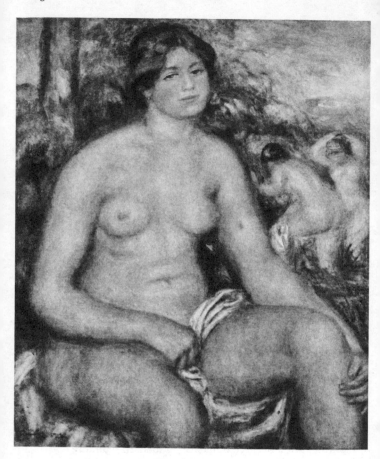

123. Renoir Bather Seated

a confluence of memories, needs, and beliefs; the memories of
earlier works of arts, the needs of their personal sensibilities,
and the belief that the female body was the token of a harmoni-
ous natural order. They looked with such eagerness at Venus
Naturalis because they had caught a glimpse of her inaccessi-
ble twin sister.

V

ENERGY

Energy is eternal delight; and from the earliest times human beings have tried to imprison it in some durable hieroglyphic. It is perhaps the first of all the subjects of art. But the astonishing representations of energy in prehistoric painting are all concerned with animals. There are no men on the walls at Altamira, only a few wretched puppets at Lascaux; and even on such evolved works as the Vaphio cups the men are insignificant compared to the stupendous bulls. These early artists considered the human body, that forked radish, that defenseless starfish, a poor vehicle for the expression of energy, compared to the muscle-rippling bull and the streamlined antelope. Once more it was the Greeks, by their idealization of man, who turned the human body into an incarnation of energy, to us the most satisfying of all, for although it can never attain the uninhibited physical flow of the animal, its movements concern us more closely. Through art we can relive them in our own bodies, and achieve thereby that enhanced vitality which all thinkers on art, from Goethe to Berenson, have recognized as one of the chief sources of aesthetic pleasure.

The Greeks discovered in the nude two embodiments of energy, which lived on throughout European art almost until our own day. They are the athlete and the hero, and from the beginning they were closely connected with one another. The divinities of other early religions were static, and everything that surrounded their worship was stiff and still; but from

Homeric times the gods and heroes of Greece proudly displayed their physical energy and demanded such display from their devotees. Something of the sort had already appeared in the mysterious culture of Minoan Crete. We have hints of acrobatic dances, and famous representations of bull vaulting. But how far this tradition of ritual athletics was carried on into the Hellenic world we cannot say. We only know that in the legendary beginnings of Greece Herakles is said to have founded the games at Olympia and that in 776 B.C. the historical Olympiads were begun. Local festivals followed, and by the middle of the sixth century there was a four-yearly contest at Athens, which grew in fame as Athens became more evidently the political center of Greece. At these games it was customary to present the winners with large jars, on which were painted representations of the branch of sport at which they had excelled: and from these vase paintings [124] begins the long history of the nude in action, which stretches to the dancers of Degas. At first it is not graceful action. The early Greek convention for the active body, with its large arcs for hips, thigh, and calf, does not promote what we have come to call physical beauty. Moreover, the athletes who raced and wrestled in the Athenian palaestra were, in the sixth century, of ungainly build. The wrestlers were strong men, Homeric heroes, hugging one another like bears. The runners had high shoulders, wasp waists, and swollen thighs. But they bound along with an elastic rhythm, more invigorating than the correct proportions of the next century, and we see for the first time what will recur at every turn in this chapter, that movement cannot be realized in art without some degree of distortion.

These prize pots, or, to give them their official title, Panathenaic amphorae, in spite of their vigorous directness, have about them an element of mass production; but at the end of the sixth century we find the hand of an individual artist in the graceful reliefs of games players, formerly the base of a statue [125], in the National Museum of Athens. The element of brute strength has diminished. These young men are still conspicuously muscular, but their bodies are neat and compact: how neat we can tell by comparing them to an engraving of nude men fighting by Antonio Pollaiuolo [126]. For all their vigor, the Florentine nudes look gnarled and uncouth beside the stylish com-

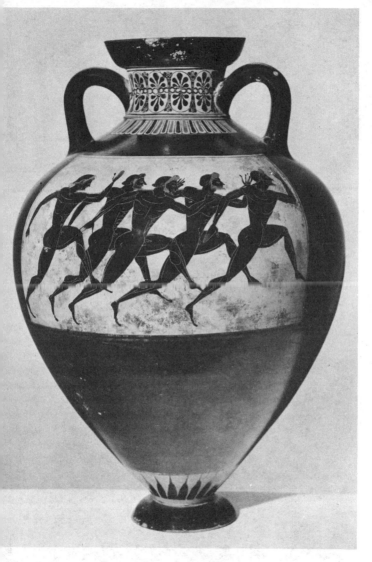

124. Panathenaic amphora, 6th century B.C.

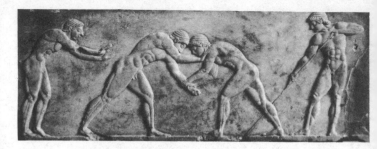

125. Attic, c. 480 B.C. Wrestlers

pactness of the Greek athletes. Pollaiuolo comes first to mind
as a term of comparison since he used very much the same
means to convey the sense of movement through the body. He
was a student of Greek pottery, and his dancing figures in the
Torre del Gallo are taken from Etruscan red-figure vases. But
the resemblance goes deeper than mere imitation. There is the
same rhythmic sense of interval between the figures, the same
taut outlines and shallow internal modeling. Low relief, that
beautiful frontier between drawing and sculpture, has always
been well suited to the expression of movement precisely be-
cause it still operates through suggestion, not through full state-

126. Pollaiuolo. Nude men fighting

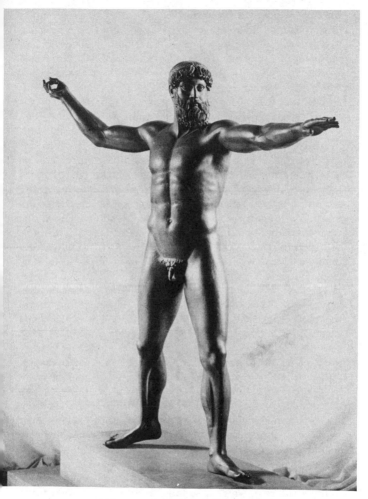

127. Attic, c. 470 B.C. Bearded god of Histiaia

ment. The moment a naked body in movement is put before
us in its solid entirety problems arise that seem to be almost in-
soluble by an intellectual approach.

The figures from the pediment of the temple of Aigina illus-

trate this. Considering that they are almost the largest complex
of sculpture to have survived from a period of Greek art—480
to 470 B.C.—to which we look with particular eagerness, how
disappointing they are! They lack precisely that vitality which
we should expect in the young conquerors of Salamis, and
which their earlier admirers, dazzled by the literary sources,
fancied that they could perceive in them. In part this is owing
to restoration, for in adding extremities the whole surface seems
to have been rubbed down; and probably they were always of
provincial workmanship. But beyond this was the dilemma
that faced Greek art throughout the fifth century: how to
achieve unity without sacrificing the geometrical clarity of the
individual forms. It might have been possible, in decorative
sculpture, to suggest movement by carrying on the lines of im-
petus from one figure to another. But this the Greeks at first
were reluctant to do. It is true that the figures at Aigina can be
arranged in some credible relation to each other, but each re-
mains enclosed within its outline. They seem to have been
frozen, or suddenly forbidden to move, as in a children's game.
Even when action is expressed in a single figure, and this was
certainly achieved within a decade of its emergence in decora-
tive groups, the same inhibition takes effect. The bearded god
casting a thunderbolt, found in the sea off Histiaia [*127*], is al-
most the first single figure in action, and the only one to come
down to us in its original bronze. He is grand, commanding,
authentic, and we may ask ourselves why, in the end, he is not
completely satisfying. The answer is, surely, that the life-
communicating power of movement is almost entirely absent.
By his determination to preserve a geometrical point of balance
in the center of the figure, the Greek sculptor has made us
more than ever conscious how plastically inconvenient is the
human body. What can be done with those long attachments
to the torso? Time usually answered that question; but there is
another solution, which is to integrate them with the central
mass by carrying their movement through the torso; and this is
what the *Zeus of Histiaia* lacks. His torso is static, and if we had
found it alone we should not have had the least indication of
the attitude of the original. The sense of rhythmic life trans-
forming the whole, which animates the drawings and reliefs of
the sixth century, has been sacrificed to a clear definition of in-

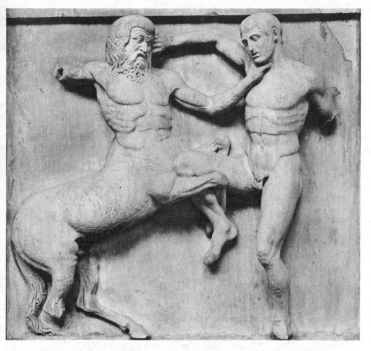

128. Attic, c. 440 B.C. Metope from Parthenon

dividual parts. Sometimes, as in the metopes of the Parthenon, this mania for preserving each part of the body as a perfect entity has an almost comical effect. The Lapith who is being throttled by a centaur remains as stiff, erect, and expressionless as a guardsman on parade [*128*]. This treatment of the body in (so to say) watertight compartments is not owing to a defect in skill or observation, but is part of that strange conformation of the Attic mind which demanded that all phenomena should be related to reasonable certainties.

Of all efforts to reconcile the body in action with geometrical perfection the most famous is the *Diskobolos* of Myron [*129*], and even allowing for precursors now lost, it remains one of those inexplicable leaps by which genius has advanced the range of human achievement. By sheer intelligence Myron has

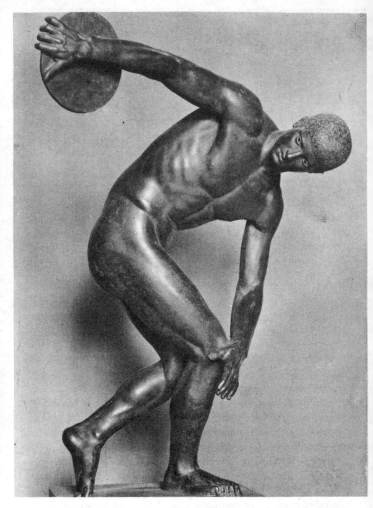

129. After Myron, c. 450 B.C. Diskobolos (reconstruction)

created the enduring pattern of athletic energy. He has taken
a moment of action so transitory that students of athletics still
debate if it is feasible, and he has given it the completeness of

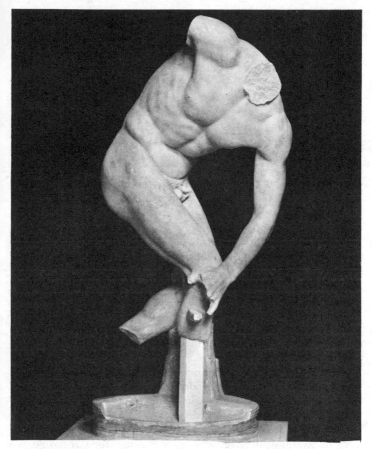

130. After Myron, c. 450 B.C. Diskobolos of Castel Porziano

a cameo. As with the *Doryphoros* of Polykleitos, this has involved a high degree of artificiality. The two problems were
complementary. Polykleitos wished to represent a figure in repose that was poised for action; Myron a figure in action that
was balanced in equilibrium. As a sculptor he was attempting
a more difficult task, for there is apt to be something painfully
finite about a solid figure in arrested action. A body in lively

repose is, as the French say, *disponible:* it may do anything. Whereas a moment of action must be absolutely fixed; the next second the body will have escaped from the sculptural idea. Often, to solve the problem at all is to solve it too completely, and to destroy that feeling of infinite possibility which the greatest works of art transmit. Rodin maintained that the only solution was to combine in one pose two different phases of the same continuous movement, and the fact that students of athletics have found it so hard to interpret the action of the *Diskobolos* suggests that this is what Myron has done.

This body, tense as a drawn bow, is, in its totality, like some Euclidean diagram of energy; and within this main figure the disposition of the parts has a clarity and a logic that become apparent only after comparison with all subsequent efforts of the same kind. To a modern eye it may seem that Myron's desire for perfection has made him suppress too rigorously the sense of strain in the individual muscles; or, at least, has not given his interior modeling the rhythmic flexibility that would carry through the movement of the whole. But, in fact, the torso [*130*] is far from the rigid isolationism of the Parthenon metopes; and if we object to his restraint and compression we are simply objecting to the classicism of classic art. A violent emphasis or a sudden acceleration of rhythmic movement would have destroyed those qualities of balance and completeness through which it retained till the present century its position of authority in the restricted repertoire of visual images. What seems at first like deadness is in fact a means of conserving life. Compared to one of Michelangelo's athletes in the Sistine [*131*], and the comparison is not unfair, for Myron's sculpture is conceived so predominantly from one point of view as to be almost the equivalent of a drawing, the Greek figure looks almost too economical. Every form has been constrained to its bare essentials by the double pressure of Greek athletics and the Euclidean idealism.

Perfection closes the door. By their perfection Raphael's Madonnas deprived classic painting of a favorite subject; perhaps Degas has done the same for ballet dancers. And this is particularly true of the representation of movement, where, as I have said, any adequate solution seems to be exclusive and becomes as fixed as a hieroglyphic. As a result, few single nude

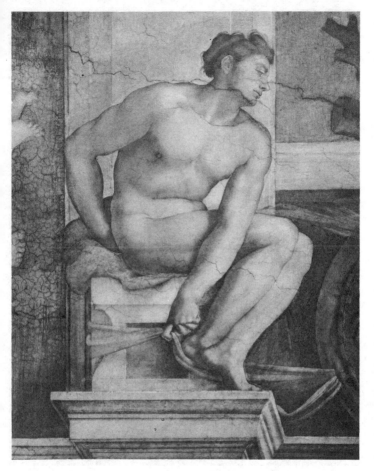

131. Michelangelo. Athlete

figures in violent action have come down to us from antiquity.
Most of those we know—the *Youth of Subiaco,* the so-called
Ilioneus, the bronze runner from Herculaneum—probably
formed parts of groups: the idea of movement being more
naturally communicable when it can be handed on from one
figure to another. It must be admitted that these Hellenistic

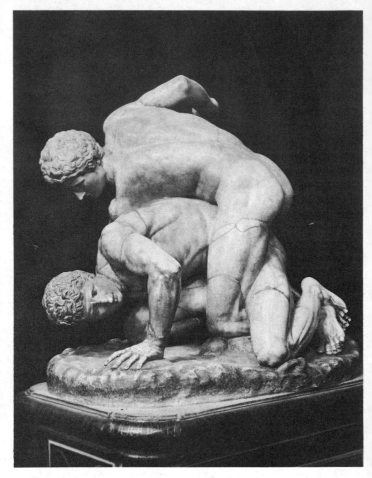

132. Greek, 3rd century B.C. *Wrestlers*

representations of athletes are strangely devoid of energy. Ideal
beauty and high finish, two characteristics of later Greek
sculpture, do not help to communicate aesthetic vitality. And
beyond this stylistic impediment was a social one. By the end
of the fourth century the religious earnestness of Greek athletics
had given place to professional entertainment. The boy athelete

had become a sentimental memory, and in sculpture his body assumed the curious smoothness characteristic of an art that aims at entertainment and self-preservation, the art of commercialized academies. Perhaps an exception should be made for a work once famous, and now unfairly neglected, *The Wrestlers*, in the Uffizi [*132*]. If we can bring our eyes to rest on the unpleasant surface of a somewhat lifeless replica, we discover that the original must have been a Lysippic bronze of masterly complexity and condensation.

In the rigorous nudity of the male athlete Myron and his successors had deprived themselves of the chief aid to the representation of movement that art has to offer: the rhythmic line of drapery. Clinging drapery, following a plane or a contour, emphasizes the stretch or twist of the body; floating drapery makes visible the line of movement through which it has just passed. Thus the aesthetic limitation of the nude body in action, that it is enclosed within an immediate present, is overcome. Drapery, by suggesting lines of force, indicates for each action a past and a possible future.

The Greeks at an early date used clinging drapery to enhance the female nude. When did they begin to recognize its power of suggesting movement? In sculpture the earliest example seems to be the small figure of a girl at Eleusis, running with head turned back, which dates from the beginning of the fifth century. The curves of her drapery cling to her body and seem to urge it on its way; but they follow the main lines of the movement without a break and are as simple as the petals of a primitive acanthus. Not until fifty years later, in the decoration of the Parthenon, is the line given a richer and more complex life. Of all the incredible developments of style achieved under the direction of Pheidias none was carried further than the treatment of drapery. At Olympia, where many of the older Parthenon sculptors must have been employed, drapery is as formalized as that of the girl in Eleusis; in the later figures of the Parthenon it has attained a freedom and an expressive power that have never been equaled except by Leonardo da Vinci. In the so-called *Iris* of the west pediment [*133*], the subtle and complex drapery both reveals the nude figure and accentuates its surging movement, like ripples on a wave. Yet this noble embodiment of energy was one of the least prominent

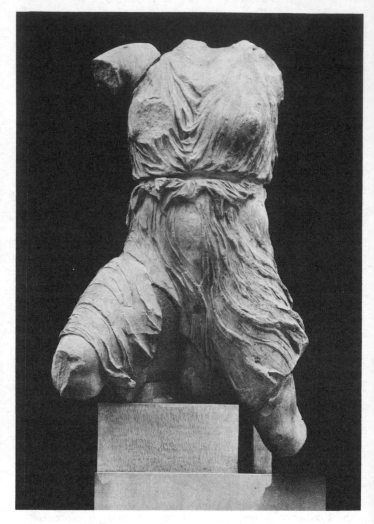

133. Attic, c. 440 B.C. Iris from west gable of Parthenon

figures in the group. It was naturally in the figures of women
that this convention of clinging and floating drapery was most
fully developed; and perhaps the part it played in carrying

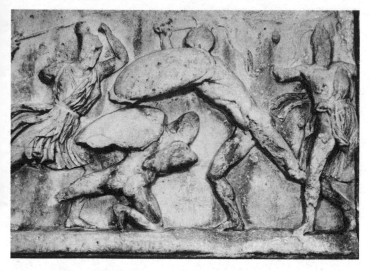

134. Greeks and Amazons. c. *350* B.C. *From frieze of Mausoleum*

movement through a composition may have been one of the
reasons a battle with Amazons so long remained a favorite sub-
ject with Greek sculptors, an iconographic motive surviving, as
so often, simply because it was artistically manageable. Male
figures, their bodies totally undraped, were kept in motion by
their flying cloaks. All through Greek art, and in its post-
Renaissance derivatives, this convention is used so shamelessly
that we are hardly aware of it and have ceased to recognize
how much the nude, as an expression of energy, depends on
this artificial device. At every stage—the temple of Bassae
provides an early example—it tends to degenerate into mere
space filling; but it remains an instrument ready for the hands
of an artist vigorous enough to use it. Such a one was the
designer of the Mausoleum frieze, one of the finest works of the
fourth century that have come down to us in the original. There
are reasons for believing that this designer was Skopas himself,
and although the execution is uneven, certain sections are
worthy of a master. In these the figures race across the field
like flames or swoop down on one another like eagles [*134*].
The frozen postures of the Aigina pediment and the impassive

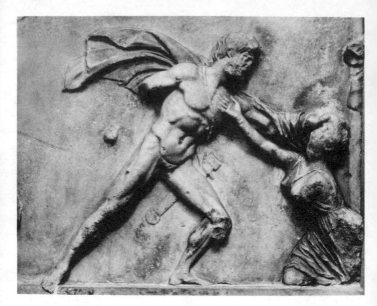

135. Greek and Amazon. C. *350* B.C. *From frieze of Mausoleum*

bodies of the Parthenon metopes are things of the past, and the
charge brought against Greek art that, compared to the art of
the Renaissance, it was incapable of conveying movement is
refuted. On the contrary, comparison with the most vigorous
works of the Renaissance can be sustained at every point. The
horse with its Amazon rider firing a Parthian shot might be
from the background of Leonardo's *Adoration;* the Greek lunging
forward and holding an Amazon by the hair [*135*] is equal, as
an embodiment of energy, to the *Hercules* panels of Pollaiuolo,
and the tense triangle of assailants with a kneeling man
crouching below two elliptical shields [*136*] recalls those draw-
ings of Raphael in which he surpasses his Florentine models in
the expression of movement. But although the Greek sculptor
shows a perfect understanding of human anatomy under the
stress of action, his figures without the help of drapery would
have looked stranded and self-contained, like dançers without
a musical accompaniment [*137*]; and as we examine these
reliefs more closely we begin to recognize the art with which

their fluttering cloaks vary their rhythm according to the character of each action.

The Mausoleum also provides an admirable example of heroic energy, and in particular of the means through which it was so long expressed, that pose, or rhythmic accent, which I may call the heroic diagonal.

In every culture certain movements and gestures are recognized as speaking a clear symbolic language, and are thus employed in the arts, particularly the art of dancing. The dance, we know, had a profound influence on Greek sculpture, and accounts not only for rhythms of movement in frieze or relief, but also for the use of certain attitudes, with the knowledge that they would be interpreted almost as precisely as the written word. At an early date it was accepted that a figure striding forward, one leg bent, the other forming a straight, continuous line with his back, should be the symbol of vigor and resolution.

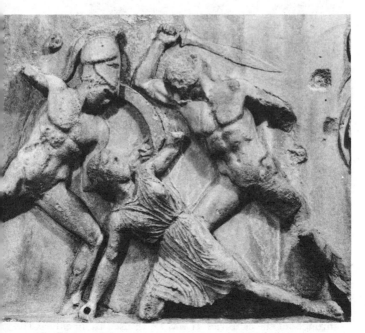

136. Greeks and Amazon. c. 350 B.C. From frieze of Mausoleum

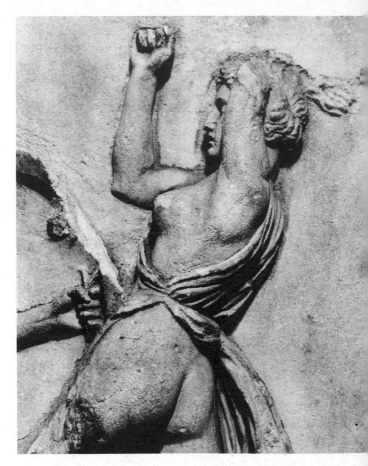

137. Amazon. c. *350* B.C. *From frieze of Mausoleum*

Thus were represented the tyrant slayers, Harmodios and
Aristogeiton, whose memorial by the sculptors Kritios and
Nesiotes is the first piece of free-standing sculpture of which both
record and replica have come down to us. This is the pose that
will reappear with the same meaning, again and again,
throughout the centuries. It was much used by Pheidias. The
figure of *Poseidon* in the center of the west pediment of the

Parthenon was in this pose, and it is still to be found in a por-
tion of the frieze in Athens. In scenes of violent action—for
example, the Amazon battles, which decorated the shield of
the *Athene Parthenos* and the base of her pedestal—the diagonals
were more sharply accented. Of this we can judge only from
fragmentary replicas and reminiscences; but from a few years
later we have an original work, the frieze of the temple of
Bassae, which shows how, when the restraining influence of
Pheidias was removed, emphatic diagonals were repeated like
oaths in popular speech. Not content with the line of leg and
body, the sculptor has added shields and draperies repeating
the same movement. What is done at Bassae with almost rustic
crudity is refined upon with supreme art in the frieze of the
Mausoleum. Nothing is heavily underlined, and the willful
insistence of diagonals is relieved by the curves of draperies and
the arcs of shields or horses' necks. Euclidean intelligence, as
this description indicates, controls the whole design. There are
squares in which the diagonal of the figures runs from corner
to corner, or groups in which two antagonists form a regular
equilateral triangle. We must suppose that the Greek artist
began each composition with ruler and compass in hand, and
the extraordinary thing is that in spite of the static and finite
character of Euclidean geometry, Skopas and his colleagues
were able to fill their compositions with the feeling of action.

The heroic diagonal survived into the less idealistic art of the
Hellenistic age, and was the basis of one of its most famous
works, the *Bourghese Warrior* [*138*], signed by Agasias the
Ephesian. The resolute stride of Harmodios and Aristogeiton
has been lengthened, accelerated, and dramatized, but two
hundred years later the idea remains the same. Agasias (if, in-
deed, he invented the pose and did not merely make a marble
copy of an earlier bronze) shows himself to be the last descend-
ant of Lysippos and the sculptors of Pergamon. All were of-
ficial artists in the employment of victorious generals, and the
heroic diagonal itself has a quality of exhortation that has fitted
it all too well for impressive public monuments. Such are the
two *Dioskouroi* of the Quirinal, once among the most famous
antique statues in the world; and if, as I believe, they are really
reminiscences, however crude, of a Pheidian original, we can
say that his image of heroic energy survived the Middle Ages

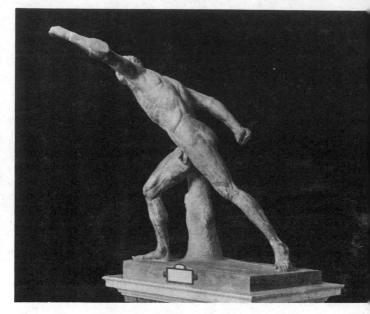

138. Greek, 3rd century B.C. Borghese Warrior

unforgotten, linked even with his name, flourished in the
Renaissance, and was ready to hand in the revival of heroic
ideals that dominated the classicism of the French Revolution.
Canova made it the motive of two famous groups, the *Hercules*
and the *Thesus;* it was a favorite with the sculptors employed to
celebrate the glories of Napoleonic France, and when the
English sculptor, Westmacott, wished to express through the
nude the vigor that (in the opinion of his countrymen) has
saved Europe from Napoleon, he chose the same pose.

Once more the nude has transferred its meaning from the
physical to the moral sphere. And if we ask how that word can
be applied to the pose of a figure in action, we need only com-
pare the reliefs from the Mausoleum to those from, say, the
temple at Amaravati a few yards away in the British Museum.
The soft, nerveless, and extravagant shapes of Indian art em-
phasize by contrast the taut, resolute, and economical forms of
the Greek. We feel in every line of these purposeful bodies a

capacity for endurance and self-sacrifice for which the word moral is not inappropriate. Of this the Greeks themselves were, of course, perfectly conscious; and it was an embodiment of moral energy, triumphing through physical means, that they created the myth of Herakles.

No doubt because he was a moral symbol, Herakles was one of the principal ambassadors between the antique and the medieval world. He was for the nude what Virgil was for poetry, and perhaps with less alteration of his original meaning. As always, survival as symbol is closely connected with existence as pattern. At a very early stage certain episodes in the legend of Herakles took the form they were to retain for over two thousand years. Most of these are based on the heroic diagonal. It is with this action that he assaults the Hydra, as we see on sixth-century vases in the Louvre and the Vatican, which are the direct precursor of the most vivid depiction of energy in the early Renaissance, Pollaiuolo's small picture in the Uffizi. The diagonal is also the basis of what must have been one of the grandest of all representations of Herakles, the metopes from Olympia. In one of them, the cleansing of the Augean stables, it is used in contrast to the calm, authoritative verticals of Athene; in another, which must, before its mutilation, have been the noblest nude in action of pre-Pheidian art, the diagonal of Herakles' body crosses the counterdiagonal of the Cretan bull, filling the square of the metope with a conflict of energies. Sometimes the diagonal is bent, like a bow, by the intensity of the labor and one knee is planted on the victim's back. This is the traditional pattern of Herakles and the stag, and appears in the best preserved of the metopes from the Athenian Treasury at Delphi, almost the earliest great carvings of the Herakles cycle; it is also the subject of the latest, a relief, in the Museum at Ravenna, of the fourth century A.D. [*139*], in which the antique style still resists the advancing tide of Eastern patternmaking. Superficially, it seems that the long curve of classic art has almost returned to its starting point. In the balance of line and modeling, and the decorative use of detail, the Ravenna relief seems to resemble the archaic style. But as expressions of energy the two carvings differ completely. In the first we feel that an inexhaustible vigor is compressed into the formalized body of Herakles; in the second the nude has be-

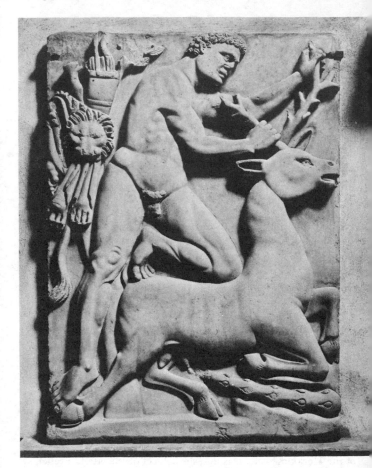

139. Late antique, 4th century A.D. *Hercules and Stag*

come a pattern, having little more relation to physical energy than the palmette has to organic growth. All the artistic vitality of the time has left the human body and been transferred to ornament.

Although he was the last to leave and the first to return, Herakles did not escape the banishment of Olympians. But whereas his fellow gods and heroes, when they appeared in the

140. Tuscan, 12th century. Samson and Lion

Middle Ages, did so in timid and pitiful disguises, so that their real significance is lost, Herakles, like many subsequent refugees, kept his status by changing his name. He took the name of Samson, some of whose exploits were similar to his own and may well have had the same origin: that is to say, the authors of the Book of Judges and the creators of the Herakles myth may both have seen Mesopotamian gems or seals of a strong man struggling with a lion or stag and have absorbed this memorable image into their own legend.

Medieval representations of Hercules and Samson show clearly how an idea may gain its value through its visible form rather than through a written description. As an example, we may compare the picture of Hercules and the lion in a French Gothic manuscript of the mid-fifteenth century with a twelfth-

141. Antico. Hercules and Lion

century relief in the Museum at Lucca [140]. The late Gothic
Hercules, confined by his dress and armor to some definite
time and place, is a ludicrous figure. He does not grapple with
the lion, but brandishes his club—sole survivor of iconographic
tradition—above his head, and holds the querulous, but un-
resisting, animal at full length. With the loss of a compact,
traditional design, based on the nude, all idea of resolute en-
ergy has vanished. The relief in Lucca is no more than a frag-
ment of decoration, and the workman who carved it had a rudi-
mentary knowledge of the nude. But because he was working in
Italy, so little estranged from classical tradition, he still re-
tained the close-knit pattern of the Hercules idea (the relief, of
course, is intended to represent Samson) and some of the con-
centration of the remote original. Even the flying cloak of an-

142. Pollaiuolo. Hercules Slaying the Hydra

tiquity has survived. A little more science and knowledge, and this idea becomes the classical Hercules of the antiquarian Renaissance, as we see it in the bronze reliefs of the Mantuan court sculptor who called himself Antico [*141*].

The Hercules-Samson figures of the Middle Ages—for ex-

ample, the *Fortitude* of Nicola Pisano or the *Samson* of the Porta
della Mandorla—are static, and it is not till after the middle
of the fifteenth century that the symbol of passive strength be-
came, once more, the embodiment of active energy. The change
seems to have occurred in the three great paintings of the labors
of Hercules that Antonio Pollaiuolo executed for the Medici
Palace. According to Antonio (but no Renaissance artist ever
gave a correct date, even for his birth), they were painted in
1460, and he was assisted by his brother. These large canvases,
twelve feet square, were amongst the most famous and influ-
ential works of their time, and remained so for over fifty years.
Like nearly every canvas of the date, they have perished, but
fortunately there remains a quantity of evidence by which two
of them can be reconstructed—engravings by Robetta, made
in about 1500, an original drawing for *Hercules and the Hydra,*
and, above all, two miniature replicas by Antonio himself,
which until 1943 were in the Uffizi Gallery [*142, 143*]. These
alone are enough to distinguish Pollaiuolo as one of the two or
three chief masters of the nude in action and as one of the
originating forces in the history of European art, whose impor-
tance has been underrated partly owing to the accidents of
time, and partly, perhaps, owing to a name that looks difficult
to pronounce. Pollaiuolo's true position was recognized in his
own day and for the next half century. Vasari says that his
treatment of the nude is "more modern than that of any of the
masters who preceded him" and that "he dissected many
bodies to examine their anatomy, being the first to show how
the muscles must be looked for if they are to take their proper
place in representation of the figure." As early as 1435 Leon
Battista Alberti had recommended the scientific study of anat-
omy as if it were an established practice; and this is confirmed
by the nude figures of both Donatello and Castagno. But not
until Pollaiuolo are we conscious of anatomical knowledge as a
positive means of artistic expression; and this may therefore be
a convenient point to ask how closely it is related to our subject.

If art is to be taught in academies and not by workshop practice,
it must be reduced to rules. The fact that perspective and
anatomy, two codifications of visual experience, are still taught
in art schools is a proof of how necessary to the teacher these
rules became. But were they necessary to the artist? The Greeks,

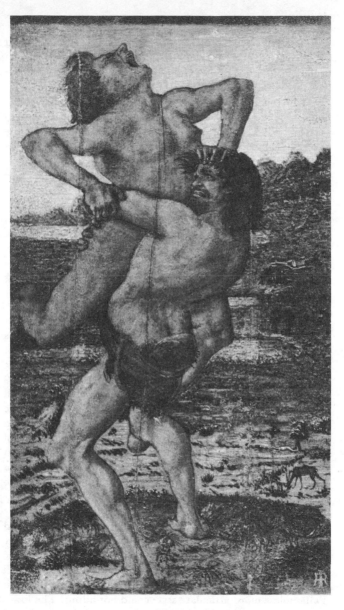

143. Pollaiuolo. Hercules and Antaeus

we know, did not study anatomy scientifically until the end of
the fourth century, and, from Kritios to Lysippos, produced
some of the most perfect nudes in art. But it does not follow
from this that the scientific enthusiasm of the Renaissance was
an error. The Gothic approach to form, with its complex artic-
ulation, made it difficult for the classicists of the *quattrocento* to
see the body with the unity and geometrical simplicity of the
Greeks. They needed some other means of animating each
form, and this they achieved by adding knowledge to visual ex-
perience. The eye always knows more than it sees; and this
knowledge can heighten the artist's powers of perception to a
point at which they can be more vividly communicated. Such
is the sense of life we derive from the muscles and sinews
of Pollaiuolo's Hercules, and, later, from Michelangelo's athletes.
Each form is tense and full; there are no slack or inflated sec-
tions. And each form confirms some knowledge we have in our-
selves without being aware of it. A dim and diffuse awareness
of our own bodies suddenly becomes vivid and precise. Knowl-
edge has become an aesthetic experience.

A restless search for the mechanism of the body and an
emphasis on its components, therefore, give to Pollaiuolo's
embodiments of energy a character very different from that of
the antique. His *Hercules Slaying the Hydra* [*142*], going back, as
we have seen, to a most ancient iconographical source, was de-
rived from one of those numerous sarcophagi decorated with
the labors of Hercules which were sculpturally amongst the
liveliest relics of antiquity; for there had been a condensed
vitality about the first patterns of Hercules that no amount of
copying could destroy. These sarcophagi seem to have been
based on Skopaic originals, and we may therefore take as a
term of comparison the striding figure of a Greek from the
frieze of the Mausoleum that has already been compared to a
Pollaiuolo. The similarity in the position of the legs is obvious;
but equally striking is the manner in which he has abandoned
the antique diagonal. Just as the Greek passion for geometry
led them to imagine a profile in which the nose continues the
line of the forehead, so they constructed these figures, in which
the body continues the same diagonal as the extended leg. This
Pollaiuolo's more articulate style could not admit. The lower
half of Hercules may be derivative; the upper is unprecedented

in the history of the nude. And even the legs show that nervous linear articulation peculiar to *quattrocento* art which makes Greek form look, by comparison, simple and compact.

In Pollaiuolo's other panel [*143*] Hercules lifts Antaeus from the ground and squeezes the breath out of his body, a subject that plays a great part in Renaissance art, but was surprisingly rare in antiquity. Indeed, the only widely diffused example seems to have been a coin of Antoninus Pius, in which Antaeus twists his body away from Hercules in an effort to escape. This was the source of inspiration used by the archeologically minded artists of north Italy, as in an engraving that must derive from Mantegna and a bronze by Antico. But, as far as I know, nothing in Greek art anticipates the pose of both Pollaiuolo versions of the subject, where the antagonists are face to face, and Hercules has hollowed his back to hoist Antaeus onto his terrific chest. His miniature replica is one of the most marvelous realizations of muscular strength in all painting. "A most beautiful picture," says Vasari, describing the lost original, "in which one really sees the effort of Hercules in squeezing, for the muscles and tendons of his body are all concentrated on bursting Antaeus; and as for his head, one sees him grinding his teeth in a way that corresponds to all the other parts of the body, right down to his toes, which swell with the effort." Subsequent criticism has not greatly improved on this first appraisal, and Vasari is right in stressing how Pollaiuolo's anatomical knowledge has allowed him to show the effect of muscular tension in every member. But, of course, his knowledge has been used with a power of vivid selection and emphasis, based on observation. It is one of the forms of intellectual discipline that must be applied to direct perception; and just as we may imagine a Greek artist sitting down to his work with compass and ruler in hand, determined to unite the physical beauty he had observed in the palaestra with geometrical perfection, so Pollaiuolo must have watched the swelling muscles of some Florentine mason as he hammered a pile or hoisted a basket of stones; and found his pleasure doubled because it confirmed long hours of anatomical investigation.

The bronze statuette of *Hercules and Antaeus* [*144*], now in the Bargello, shows even more clearly how Pollaiuolo's means of conveying energy differed from that of antiquity. The silhouette,

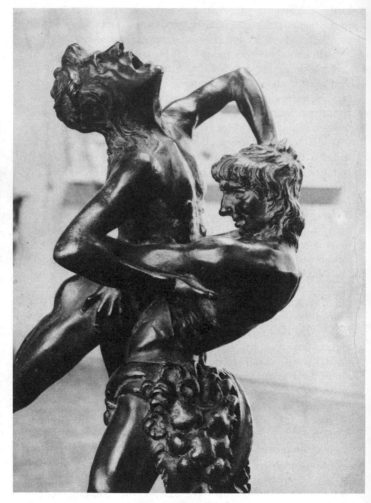

144. Pollaiuolo. Hercules and Antaeus

with its sharp excrescences, its flying buttresses of form, would
have shocked a classic eye, and the clear, emphatic planes of
the internal modeling would have seemed crude and abrupt.
A fair term of comparison is *The Dancing Faun* at Naples [*145*],

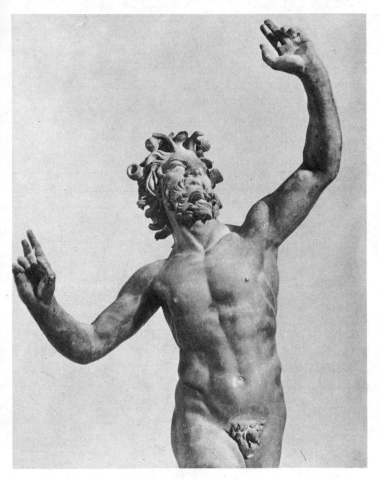

145. Greco-Roman. Dancing Faun

which is of higher quality than most of the furnishing bronzes
found at Pompeii and Herculaneum. The pose is light and
graceful, the modeling well understood, the general sense of
movement admirably sustained. But to anyone trained in
Renaissance art, the whole impression is artificial and dead,
and as our eye glides on without the stimulus of sharply con-

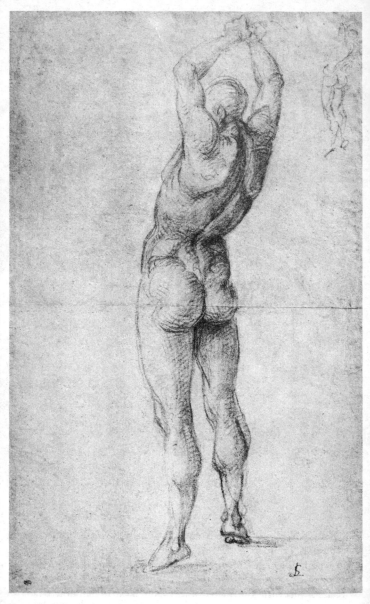

146. *Signorelli. Drawing*

trasted planes we begin to lose interest, and turn with delight
to Pollaiuolo's Hercules, his back and shoulders jutting out like
some rocky escarpment.

In the planes of the shoulders the *quattrocento* discovered a
symbol of energy almost comparable to the antique torso. There
is a large, uncompromising angularity about this shape that
seems to be inherently Florentine; but in fact its greatest ex-
ponent came from the borders of Umbria: Luca Signorelli
[*146*]. Whatever his origins, his early paintings, like the *Flagel-
lation* in the Brera, leave us in no doubt that he discovered his
true bent when he first came in contact with the art of Pollaiuolo.
In this picture the nude flagellators might be by a Florentine,
so closely do they follow his kind of articulation and emphasis;
but after about 1490 Signorelli developed a new architecture of
the human body that departs even further than Pollaiuolo
from classical precedent. His simplification of certain contrast-
ing masses—shoulders and buttocks, chest and stomach—gives
his nudes a disturbing plastic force, as if we had been suddenly
endowed with a sort of stereoscopic vision. There are few
things in painting to which the term tactile values has a more
valid application; and as we look at the vigorous rotundities of
the figures crowded together in his frescoes at Orvieto, we begin
to share the Florentine passion for the solidly comprehensible,
that which can be grasped alike by mind and hand. In the
scene of *The Blessed* [*147*], his vigorous blend of sense and intel-
lect is latent in the forms, but in the still more astonishing
scene of *The Damned* [*148*], it is released and rages with purpose-
ful ferocity. Signorelli does not attempt to make his nudes the
vehicles of beauty. Muscles and sinews are given unflinching
emphasis, so that some of his devils are like *écorchés*. They do
not embody the victorious energy of athlete or hero, but a
demonic energy, triumphant, too, in its way, which was to re-
appear in the romantic movement of the early nineteenth cen-
tury, in the slave drivers and executioners of Géricault and in
certain evil spirits in Blake.

The history of art could be written in terms of a sequence
of compulsive subjects that seem to succeed each other for
purely internal or artistic reasons. Such, for example, was the
succession of apples, harlequins, and guitars that occupied
artists in the early years of the present century. And in Florence,

147. Signorelli. The Blessed

from about 1480 to 1505, the compulsive subject was a battle
of naked men. It had no social or iconographic justification; it
was simply art for art's sake. The subject seems to have ap-
peared first in the work of Pollaiuolo as a pretext for the com-
bination of nude figures in action, and has come down to us in

148. Signorelli. The Damned

an engraving and several drawings. In these he no doubt had
in mind an antique battle sarcophagus such as that in the
Campo Santo, but he never approaches its evolved Skopaic
style. About 1490 a battle piece of truly classical character was
produced by a much less gifted artist, Bertoldo [*149*]. He was
keeper of Lorenzo de' Medici's collection of antiquities, and it

149. Bertoldo. Battle piece

150. Michelangelo. The Battle of the Centaurs

is understandable that his masterpiece, the bronze relief now
in the Bargello, should have had a dogmatically antiquarian
character. To us it gives all too clear an indication of the
fate that was to overtake Italian art when the antique manner
had been correctly understood. But to the young men of that
date, it seemed a model worthy of serious study. No doubt
Michelangelo, who worked as a boy under Bertoldo's eye in
the Medici gardens, believed that his marble relief of *The
Battle of the Centaurs* [*150*] was rough and clumsy compared to
that of his master.

It may have been executed in the Medici garden shortly be-
fore Lorenzo died in 1492, and is thus only a few years later
than the nude battles of Pollaiuolo; but what a gulf separates
it from the light-limbed compositions of the *quattrocento!* As with
Leonardo's *Adoration,* we seem to be looking into the boiling
caldron of his mind, and fancy that we can find there, forming
and vanishing, the principal motives of his later work, figures

from *The Battle of Cascina,* from the lunettes of the Sistine and the Medici tombs, above all from *The Last Judgment.* We know how this small nucleus of energy will expand, and how each pose will reappear, polished by art and weathered by experience, to create a new heroic style of painting. The young Michelangelo could not know that he had released a world of shapes that were to travel with him all his life, and prove, after his death, a Pandora's box of formal disturbance.

In the cartoon of soldiers surprised while bathing [*151*], which he executed for the Palazzo Vecchio in 1504, Michelangelo steps back into his own time. Iconographically it was not very suitable for public commemoration. The incident depicted was unimportant and slightly discreditable. It was chosen solely as a pretext for depicting the nude in action, and as such was accepted with enthusiasm; indeed, of all his works it was that which his contemporaries, and in particular his colleagues, were best able to appreciate. It revealed to them, and demon-

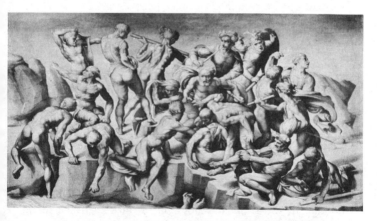

151. After Michelangelo. Copy of Cascina cartoon

strated to perfection, their belief that the highest subject of art was a group of nude male figures, physically perfect, and so arranged that their bodies could convey through movement a life-giving energy. This had been the aim of Myron and Skopas, but the men of the early sixteenth century could not remain satisfied with the limited range of poses employed in antiquity.

Nor were they content to spread their figures out at regular intervals in one plane, as on a frieze, or pile them flatly on top of one another, as in a Roman sarcophagus. Michelangelo's *Battle of Cascina* demonstrated the value of twist and foreshortening, which not only increase the stock of admirable attitudes, but make it possible to compose in depth. These devices also increase the power of communicating energy. Twist accelerates movement; foreshortening is an urgent appeal to the eye, which must hasten to recognize in a small space what it is accustomed to visualize in extension. But in the end these compositional devices are subordinate to one overriding intention, to enhance, by movement, the beauty of the naked body. An example is the figure in the center of the group seated on the bank and twisting backward, for which, fortunately, we have Michelangelo's original drawing [*152*]. This famous sheet, which, since the Renaissance, has been considered the summit of academic drawing, is one of a type that, at a later date, was viewed with a certain suspicion. True, it lacks some of the graphic spontaneity through which great draftsmen have communicated to us their first responses to life and movement; yet if we regard it as an independent and final creation, how splendidly it realizes Michelangelo's desire to close on a complete form and follow it as it turns away, concentrating on every vital juncture, pressing round it with the passionate chisel strokes of his pen! The same is true of a study for the figure in the background thrusting with a lance [*153*], which shows his anatomical knowledge assimilated and subordinate to an ideal. The musculature is no longer harsh and schematic, as in Signorelli's devils, but flowing and continuous; and at every point it contributes to the movement of the figure. And what drawings must be lost! As we pass from one figure to another in the Holkham copy, and picture each one in the light of our two or three surviving studies, we grow to share the Florentine passion for the *bel corpo ignudo;* we recognize what a noble ideal was then intended by the sacred word *disegno,* and we understand why the cartoon continued to be, in Vasari's words, "the school of all the world" even after it had been torn in pieces, like Dionysos, by its admirers.

Among the artists to be inspired by *The Battle of Cascina* were Leonardo da Vinci and Raphael. We think of Leonardo as the

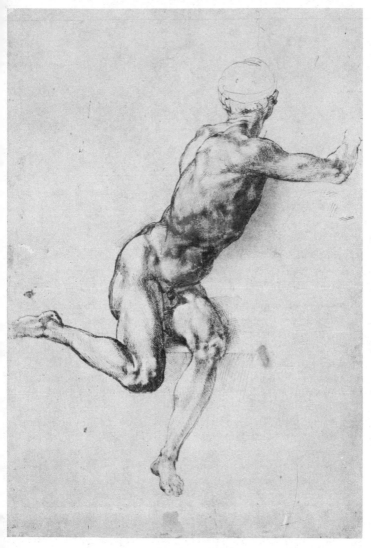

152. Michelangelo. Bathing soldier for Cascina cartoon

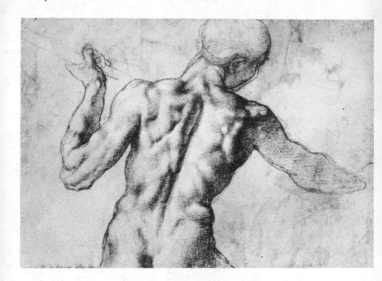

153. Michelangelo. Study for Cascina cartoon

inventor of forms, the giver, rather than the receiver, of ideas.
But where the nude is concerned, he is derivative. The grace-
ful, active figures of his early drawings are in the style of Pol-
laiuolo; the drawings for *The Battle of Anghiari* are clearly in-
fluenced by Michelangelo. Between them come the first
anatomical studies, for the most part factual, although seldom
entirely without an underlying sense of nobility. The finest
nudes are those done in Florence during the years his com-
mission in the Palazzo della Signoria brought him into open
rivalry with Michelangelo. They assume, with extraordinary
skill, the heroic manner; but even so the scientific interest pre-
dominates. In one of the most impressive the arm is cut off and
the muscles numbered, as for some anatomical demonstration.
Others are simply *écorchés* in warlike attitudes. Only in his
magnificent studies of muscular legs [*154*] has Leonardo used
the body to convey an idea rather than a quantity of informa-
tion. These are his symbols of human energy, superbly power-
ful, and yet, because they are human, less important to him
than the cascades and waterspouts that are his symbols of the
energy of nature.

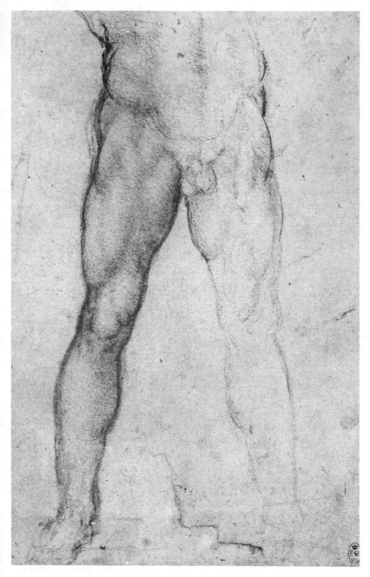

154. Leonardo da Vinci. Muscular legs

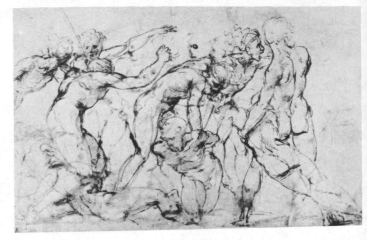

155. Raphael. Men fighting

Raphael is at the opposite pole. His confidence in humanity
was greater than that of any artist since the fourth century B.C.,
and his anthropocentric system of order was closer to antiquity
than were the restless researches of the Florentines. But during
the later years of his stay in Florence he absorbed the heroic-
classical style of Bertoldo and Michelangelo. Whether the three
magnificent drawings at Oxford of naked men fighting [*155*]
were done before or after *The Battle of Cascina*, we do not know,
and Raphael's almost telepathic gift of absorbing the artistic
ideas of his time makes it unwise to guess. In any case, they re-
main, with Michelangelo's drawings, the finest surviving testi-
mony of this noble ambition. Raphael equals the Florentines in
the communication of energy, and surpasses them in clarity.
The way in which outline, by the variation of its accent, is
made to suggest both movement and weight is a model of clas-
sical draftsmanship. Did Skopas, we wonder, make such draw-
ings for the frieze of the Mausoleum?

The nude figures in Michelangelo's drawings for *The Battle of
Cascina* are graceful and perfectly poised as well as strong and
resolute. Heroic and athletic energy are one. And it is under
the title of athletes that we refer to the most famous nudes in
all painting, the young men who represent, we are told, the

animae rationali of the Prophets on the Sistine ceiling. Whatever their precise intention, it is clear that Michelangelo intended them as mediators between the physical and the spiritual worlds. Their physical beauty is an image of divine perfection; their alert and vigorous movements were an expression of divine energy. The beautiful bodies of young men, controlled by the forms of Greek idealism, have been so charged with the spirit that they can enter the service of Christianity. Several of the athletes of the Sistine are derived from antique originals, notably the two earliest, which are in poses that have come down to us in gems. In these there remains the same basic rhythm of movement that first appeared in the *Diskobolos* of Myron; but already there is a sense of urgency expressed in every inflection of the outline, in every transition of modeling, which the Greeks would have considered fretful or undignified. In spite of his movement, the *Diskobolos* exists entirely in the physical present; the Michelangelo athletes are struggling toward some bodiless future, which may perhaps be a past—

> *L'anima, della carne ancor vestita,*
> *Con esso è gia più volte aciesa a Dio.*

This ceaseless tremor, this feeling that every form is, so to say, pawing the ground in its anxiety to be gone, can make its effect only because it is confined by knowledge of anatomy, without which the winds of expressionism would blow the figures out of shape. Conversely, it is this knowledge that allows Michelangelo to take poses from antiquity and develop them to a point of expression far beyond the classic norm. An example is the athlete beside the *Persian Sibyl* [*156*]. Strangely, his pose seems to have been suggested by an Ariadne reclining in the lap of Dionysos on a Hellenistic relief. But the muscles of his right shoulder are unlike those of any antique figure, let alone that of a woman. If we compare his back with a classical athlete—for example, the *Illioneus* at Munich—we see how far Michelangelo could depart, even in 1512, from orthodox classical proportion. These immense shoulders tapering abruptly into tiny buttocks are, by any standards, a distortion. Yet we accept them because a compelling rhythmic force drives every inflection of the human body before it. The outline of the back may seem almost as abstract as the profile of a molding in one

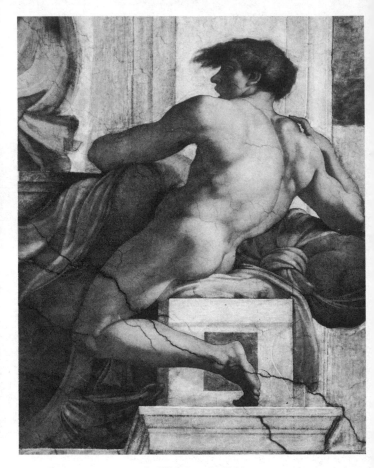

156. Michelangelo. Athlete

of Michelangelo's own magnificent architectural drawings; and
yet it would not convince us unless it was based on a profound
knowledge of anatomy. Nor, perhaps, would the molding.

The athletes of the Sistine confirm a statement made at the
beginning of the chapter: that some degree of exaggeration is
necessary to a vivid representation of movement. This accounts,
in part, for the distortions in the athlete of the *Persica,* where

the line of the thigh and back twists round with terrific emphasis and shoots forward along the upper surface of the arm. But the curious physical structure of Michelangelo's nudes is not simply a pictorial device; it is part of the inward-looking character of his whole art. If we imagine the figures of fourth-century sculpture suddenly come to life, they would be dazzlingly beautiful men and women; but Michelangelo's athletes exist purely as vehicles of expression· In life they would be squat and disproportionate. The graceful youth to the left of *Jeremiah* is almost the only one whose beauty would survive realization. His companion, based on the *Torso Belvedere,* would be a monster. Now, it is obviously foolish to criticize Michelangelo's nudes from the point of view of a supposed norm of human beauty. But it remains true that Michelangelo's intensely personal use of the nude greatly altered its character. He changed it from a means of embodying ideas to a means of expressing emotions; he transformed it from the world of living to the world of becoming. And he projected his world of the imagination with such unequaled artistic power that its shadow fell on every male nude in art for three hundred and fifty years. Painters either imitated his heroic poses and proportions or they reacted against them self-consciously and sought a new repertoire of attitudes in the art of fifth-century Greece. In the nineteenth century the ghost of Michelangelo was still posing the models in art schools, and compelling would-be realists to see a system of forms invented to express his own troubled emotions. Géricault has used one of the athletes of the Sistine as the culminating figure in his *Radeau de la Méduse,* and even the archrealist Courbet, in his *Wrestlers,* was not able to shake off what Blake called that Outrageous Demon.

Michelangelo's use of the nude as a means of expressing emotion will be treated more fully in the next chapter; but there remains in his work another embodiment of energy that must be mentioned here, more particularly since it brings us back to the theme of Hercules. The ambassador of antiquity in the Middle Ages was equally suited to the heavier and more heroic mood of the High Renaissance· Already in the thirteenth century he had appeared on the seal of the city of Florence as an emblem of good government, and by the sixteenth century he had become a favorite political symbol, claimed equally by

both parties, like the word democratic. His appearance in
the adornment of public buildings was thought to promise the
cleansing of corruption and a resolute conduct of affairs. The
power of a symbol is shown by the way in which this figure
spread to the remotest part of Europe, so that in Sweden or
Wales the public buildings of the late sixteenth century were
decorated with the labors of Hercules. As his was the first nude
figure to penetrate the darkness of the Middle Ages, so he was
the first to spread the image of naked energy among the
Hyperboreans. It was inevitable that Michelangelo should turn
his attention to Hercules. His youthful statue of the hero leaning
on his club was sent to Fontainebleau, and is lost; but in 1508
Pietro Soderini, head of the free Florentine Republic, who had
already commissioned the battle cartoon, invited Michelangelo
to execute a gigantic *Hercules* as a companion to his other huge
embodiment of heroism, the marble *David*. Largely for political
reasons, the Medici popes prevented him from executing it. The
plan dragged on for twenty years, and in the end the commis-
sion was transferred to his enemy Bandinelli, who executed
almost the largest and certainly the ugliest *Hercules* in existence.
But several of Michelangelo's thoughts on the subject have
survived in visible form and, as usual, are a turning point in
the subject. Three of them, contained in a noble drawing at
Windsor, are not studies for sculpture, but independent graphic
ideas, worked out for presentation to a friend [*157*]. In the
Hercules and the Lion, an intense, living texture of modeling is
compressed within a simple outline; in the *Hercules and Antaeus,*
the forms are knotted so closely that we seem to feel the tension
that pulled them together. Thus Michelangelo says the last
word on two iconographical motives that had occupied the
Mediterranean imagination for two thousand years.

In two pieces of sculpture the idea of Hercules creates a new
motive in which the nude was to take some of the most vigor-
ous forms in the next century· The first of these in not osten-
sibly a Hercules. It is the marble figure in the Palazzo Vecchio
[*158*] in which a youthful embodiment of energy kneels in
triumph over a bearded man who is not so much a defeated
enemy as caryatid to the beautiful youth who bestrides him.
His head shows no anguish of defeat, but only a sad and
troubled resignation. Whatever this may mean as a symbol, as

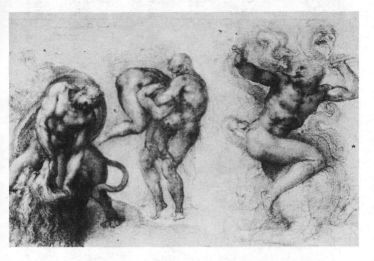

157. Michelangelo. Three Labors of Hercules

design it is of the greatest importance, for it solves a major
problem of the nude in action, a problem that had defeated
sculptors ever since the bronze *Zeus* from Histiaia: how to avoid
the spindly effect of striding legs and support the weight of the
torso on a solid base. Michelangelo's victor can turn his body
with a violence that would have upset his sculptural stability,
had he not been securely planted on a living plinth; and by
this spiral movement he can achieve an effect of energy that
the two-dimensional geometry of the *Diskobolos* could not give.
This was the principle on which, as we know from several
models, Michelangelo intended to execute his gigantic group of
Hercules. It involved changing the episode from Hercules and
Antaeus to Hercules and Cacus, since the point of the Antaeus
legend was that he was lifted from the earth, and Michelangelo's
design required the second figure to be at Hercules' feet; and it
is an indication of how little strict iconographic considerations
weighed with the great artists of the Renaissance that just as
he turned his Apollo into a David, so halfway through this
commission he changed his Hercules into a Samson defeating
the Philistines [*159*], simply because he required two figures
instead of one at the base of his composition.

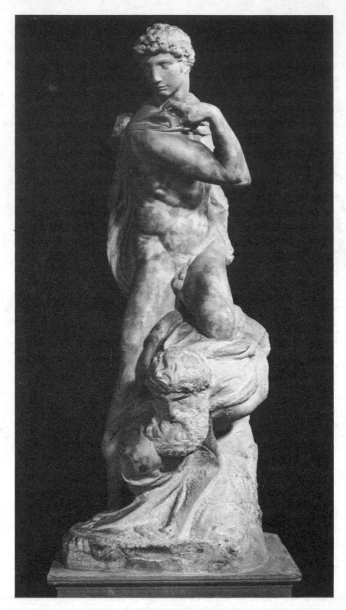

158. Michelangelo. Victory

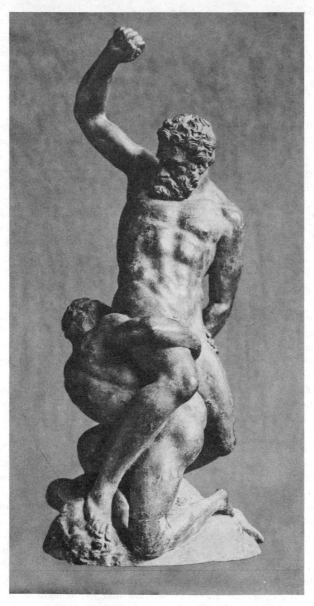

159. After Michelangelo. Samson defeating Philistines

These models show a full development of the motive that was to dominate sculptural representations of energy during the baroque period. In contrast to the heroic diagonal, we may call it the heroic spiral. Its potentialities were barely understood by Michelangelo's immediate followers; for example, Vincenzo Danti's splendid group of Honor pulling out the tongue of Falsehood in the Bargello [*160*], although one of the finest compressions of energy in sculpture, is still thought of in separate aspects, whereas Michelangelo's movement in space is continuous. Perhaps the first sculptor to recognize the possibilities of the heroic spiral was Giovanni da Bologna, who made it the basis of those impressive, heartless groups in the Loggia dei Lanzi and the Bargello. It was Giovanni da Bologna, incidentally, who, in the *Mercury* [*161*], created one of the few images of energy that have gained a place in the popular memory. Just as the *Aphrodite of Melos* has become a trademark for beauty and the *Diskobolos* of Myron is still given as a prize for athletics, so the *Mercury* has become an accepted symbol of victorious speed. Giambologna has set out to solve the same problem as Myron: to give balance and finality to an almost inapprehensible movement. But, unlike the *Diskobolos,* we do not believe that the *Mercury's* movement is possible. By his memorable clarity he stands out among the confused and redundant figures of the late sixteenth century, but he is a piece of rhetoric, intended to persuade rather than to convince, and the self-consciousness of his pose is very different from the seriousness with which the *Diskobolos* concentrates on his task.

The twist into depth, the struggle to escape from the here and now of the picture plane, which had always distinguished Michelangelo from the Greeks, became the dominating rhythm of his later works. That colossal nightmare, *The Last Judgment,* is made up of such struggles. It is the most overpowering accumulation in all art of bodies in violent movement. But can we speak of energy before these tortured giants? Certainly not in the sense that we can before the Mausoleum frieze or the *Hercules* of Pollaiuolo. They do not enhance our vitality by their own, but rather induce in us a feeling of insignificance or mere terror. However, *The Last Judgment* had to be mentioned in this chapter, for the twisting movement it epitomizes and many

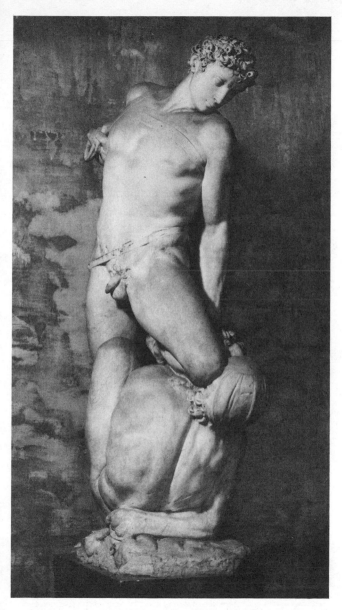

160. *Vincenzo Danti. Honor*

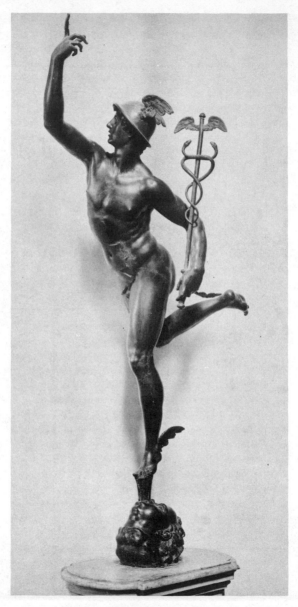

161. *Giambologna. Mercury*

of the actual poses it contains were to be used as embodiments of energy by later painters from Tintoretto to Blake. Whether we admire or deplore that shattering of the classical scheme which is now described by the word mannerism, we must admit that it released a current of energy. Nude figures, derived from classical antiquity, suddenly took on the feverish violence of the North. Winds that had curled the draperies of Gothic saints now blew round naked, elongated bodies and swept them into the air or shot them headlong out of the clouds. Tibaldi may not have possessed, as Sir Joshua Reynolds believed, "the true, genuine and noble mind of Michelangelo"; but the use he made of motives from the Sistine Chapel is not devoid of energy, even when, as in the Palazzo Poggi, it takes the form of cynical caricature. In spite of repeated protests, the word mannerist must be applied to Tintoretto. Of course, his strong conviction is far from the irresponsibility of Tibaldi and Rosso; yet what we may call his thematic material is often the same, and in the nude particularly he relied on the inventions of Michelangelo. He owned casts of the Medici tombs and drew them repeatedly from every angle. His *Fall of the Damned* is peopled with figures from *The Last Judgment* of the Sistine. In his later studies the Michelangelesque musculature is reduced to a few dots and dashes, which look at first like a formula; but the long discipline of *disegno* has them under control, and these scribbles are as precise, in their life-communicating force, as a prehistoric drawing of a buffalo.

The other major transformation of Michelangelo's poses into abounding energy was achieved by Rubens. I have already referred to his laborious study of the past, and of all his predecessors it was Michelangelo whom he copied the most frequently and the most faithfully. We have careful drawings done after almost all his works, from the centaur relief to *The Last Judgment*, and anyone so minded could discover a number of these reproduced with little change in Rubens' paintings. An example is the sketch of *The Abduction of Hippodameia* [*162*] in Brussels, in which the chief figure is obviously taken from Michelangelo's drawing at Windsor of *Archers Shooting at a Mark*. This in turn had been derived from a decorative painting in the Golden House of Nero, now destroyed, but well known to the Renaissance, which certainly reproduced one of the great pictures of antiq-

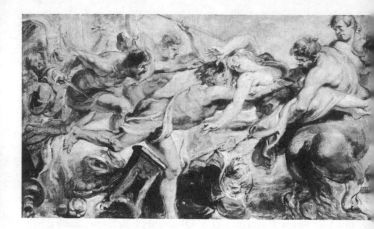

162. Rubens. The Abduction of Hippodameia

uity. So this vivid embodiment of speed and vitality, like so
many others, reflects an image first minted in the great age of
the figure arts. Its value as independent form can be gauged
from the fact that although the figures were originally flying
forward, in the Rubens they are supposed to be pulling in the
opposite direction: and yet we accept it without question. It is
curious how seldom the male nude (except in the form of
satyrs) appears in Rubens' finished paintings. His men are all
draped or dressed in armor, often, no doubt, to provide a con-
trast with the shining nakedness of his women. Moreover, it
seems that he was reluctant to accept the convention by which
male figures are nude when the subject does not warrant it. For
this reason he treats his nude male figures almost like quo-
tations, as in *The Miracle of St. Benedict,* where the figures climb-
ing the wall and clinging to the column are obviously taken
from Raphael's Stanze, one in the foreground from Michel-
angelo's *Last Judgment.* Like all great artists, Rubens was able
to borrow so directly because he knew that he could give to his
transcriptions his own abundant vitality and rhythmic buoy-
ancy. The rhythm is exactly the opposite of those early Greek
artists whom I mentioned as being incapable of communicating
the flow of movement through the body as a whole. That the
Greeks themselves overcame this limitation we know from the

163. Greek, 2nd century B.C. Torso of Satyr

art of Pergamon, and Rubens must have been greatly influenced by Pergamene sculpture, not only by the *Laokoön*, but also by the torso of a *Satyr*, now in the Uffizi [*163*]. Thus he evolved a style very different from the nervous agitation of mannerism, fuller, weightier, more unified. Behind it lies not only the vitality of Rubens as an individual, but the force of a living popular belief. His figures draw some of their energy from the

same source as the façades of the great baroque churches in Rome, from the conviction that thus, and only thus, can all shapes work together to the glory of God.

In eighteenth-century painting, with its diminished force and seriousness, the embodiment of energy almost disappears; but toward the end of the period there is an unforeseen explosion. Roman connoisseurs and artists took a fresh interest in Michelangelo and Tibaldi; and this mannerist revival was brought back to England by the numerous artists who had studied there, above all by Fuseli. This was the material that formed the style and furnished the imagination of William Blake. He had an exceptional power of secreting retinal images, and it was, to some extent, the unconscious memory of these images that he identified with inspiration. He was justified in saying that "All forms are perfected in the poets mind," but it was seldom in his own mind that the forms in his work had originally been perfected. The long and painful interaction between ideal form remembered and natural appearances observed, which is the foundation of all great drawing from Michelangelo to Degas, was beyond his powers. But although the outlines of his nude figures were borrowed from sixteenth-century Rome and Bologna, he was able to give them a fresh energy that was his own. Sometimes it is as if the old Celtic spiral had been wound up tight and was ready to impel his figures through space [164]; and sometimes his spiritual radiance shines through a dead form and transfigures it. Such is the splendid design known as *Glad Day* [165], which is derived from a woodcut of "Vitruvian man" [166] in an old edition of Scamozzi's *Idea del' architettura universale*. Blake must have seen it as a young man, for the figure occurs first in one of his earliest drawings, and have recognized the importance to him of its geometrical clarity. In the engraving of 1780 it has become a symbol of liberated vitality; the arms are no longer stretched out for convenience of measurement, but as a gesture of eager acceptance; the right leg is no longer bent to fit into a circle, but to give the impression of movement. Geometrically perfect man is given back some of Apollo's lost vitality. On one print of the engraving Blake wrote the words, "Albion arose from where he laboured at the mill with slaves"; which, in his symbolic language, meant precisely that the human imagination has freed itself from the

164. Blake. From Europe, printed book

doctrines of materialism. He might equally have written the
words with which this chapter opens (and which, in fact, he

165. Blake. Glad Day

wrote in that burning bush of wisdom, *The Marriage of Heaven and Hell*), "Energy is eternal delight."

I have observed how, in the nineteenth century, the nude

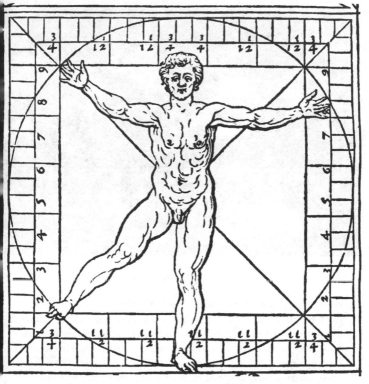

166. Vitruvian man from Scamozzi's

came to mean, almost exclusively, the female nude. This ap-
plies even to the nude of energy. The superb drawing of *Leda*
by Géricault [*167*] provides a revealing example. Formally it is an
almost direct transcript of the so-called *Illissos* of the Parthenon,
which Géricault had drawn from a cast when in Rome in 1817.
But the *Ilissos* has undergone two transformations. It has
changed its sex; and the slow movement of an Olympian has
become a spasm of physical excitement. These changes have
involved Géricault in certain difficulties of construction not
perfectly solved; but in spite of them, how much more authentic
is this female nude than are the male figures in, for example,
the Fualdes drawings, which show that aspect of Géricault cor-

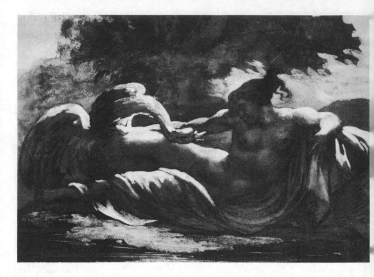

167. Géricault. Leda

rectly described by Degas as his "côté Bandinelli"! The sub-
jects in which nude women can be represented in violent action
are somewhat limited, and it is curious that two of the most in-
telligent painters of the nineteenth century, Delacroix and
Degas, turned to the passage in Euripides that describes how
Spartan girls stripped naked and competed with the boys in
the palaestra. Delacroix considered using the motive in one of
the pendentives of the Chambre des Députés, and his drawing
of girls wrestling [*168*], their bodies round and solid, like the
nudes in Michelangelo's *Deluge,* is one of his most considered
designs. But it remains archeological and, in the highest sense,
academic. Delacroix's real conviction of energy was centered
on wild animals, and the back of a lion grappling with a horse
was to him what the back of a *bel corpo ignudo* had been to
Michelangelo. Degas, on the other hand, was a natural humanist
who needed no substitute for the human body, and had the
power of mind, hand, and eye to reinterpret it.

If we allow to the word "drawing" the meaning a sixteenth-
century Florentine implied by the word *disegno,* Degas was the
greatest draftsman since the Renaissance. His subject was the

figure in action, his aim to communicate most vividly the idea
of movement; and he felt that vividness of movement must
somehow be expressed through shapes that convince us that
they are complete in themselves. This is the characteristic of
disegno: that it enhances the vitality of a form by our recogni-
tion of its completeness. The great draftsmen of this kind—
Signorelli or Michelangelo—are not content to record a move-
ment, as a Tiepolo might do, but press round it, till it approaches
some ideal pattern that lies at the back of the imagination:
hence the continual hammering at the same motive, the trac-
ings, copies, and replicas that so astonish the profane.

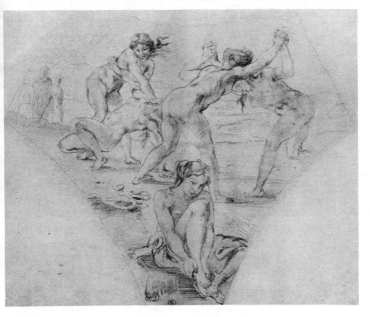

168. Delacroix. Girls wrestling

One of Degas' earliest drawings is a copy—no doubt from
Marcantonio's engraving—of those figures in the *The Battle of
Cascina* which I mentioned earlier as being the triple essence of
Florentine design; and looking through the drawings and
pastels of his later years, when he was entirely himself, we are

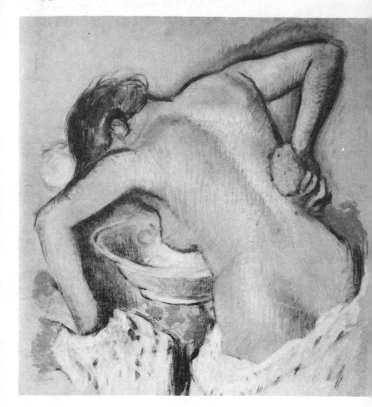

169. Degas. Woman drying her back

surprised to see how little his sense of form changed. The
woman getting into her tub is still the soldier scrambling up
the bank; the woman drying her back [*169*] is still the soldier
fastening his armor. But before he could achieve this transforma-
tion Degas had to pass through an intermediate stage. Already
in 1860, he recognized that his gifts for classic draftsmanship
might lead him into false academism; so, having done the most
beautiful life drawings of the nineteenth century, he renounced
conventional "beauty," and in his *Jeunes Filles spartiates* [*170*]
imagined two groups of awkward and defiant adolescents,
whose slender bodies seem to gather up and realize the points

of resemblance between Pollaiuolo's drawings and the vase paintings of sixth-century Greece. This feeling that immature forms have a vivid truthfulness that the developed body has lost guided his choice of the *rats de l'Opéra*. In his earlier drawings of the ballet, nudes are relatively rare, and we may deplore the accident by which the dancers in the Paris Opéra rehearsed in *tutus* instead of the tights usual today. But gradually his dancers come to be conceived as nudes, till finally the pretext of the ballet school almost disappears. At the same time their bodies become more mature. Pollaiuolo turns into Michelangelo. Having gone back to the sources of *disegno* in the severe style of the *quattrocento*, Degas feels free to repeat in himself the evolution that took place in Florence between 1480 and 1505, and is no longer afraid of false classicism because he knows that he has absorbed a new kind of truth.

But on the word truth a gulf seems to open between him and Michelangelo. Instead of almost worshiping beautiful young men, Degas said with satisfaction of his models, "la femme en général est laide." Instead of conceiving the body as the repository of the soul, he said, "J'ai peut-être trop considéré la femme comme un animal." The gulf should be unbridgeable,

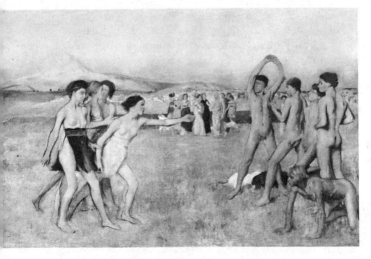

170. Degas. Jeunes Filles spartiates

but for some reason it is not. For we are back to our first observation, that in the nude of energy the body as such is easily forgotten in our pleasure at the life-enchancing completeness of art.

As I mentioned earlier, many of Michelangelo's figures, if they came to life, would be monsters and would shock us more than Degas' women, who, as he always maintained, are normally well-developed specimens. It is true that they do not provide the same elaborate muscular scheme as the athletes of the Sistine. They depend more on outline and the direction of the larger planes, and in this respect are closer to Signorelli. We must also grant that Degas retained from his impressionist period something that was contrary to the principles of classic art: the element of accident or surprise. Photographs and Japanese prints are said to have revealed to him how this quality could be achieved; we may also claim it as something Gothic, and fancy that we can catch a likeness to the angular movements of *The Last Judgment* at Bourges [*253*]. But this "Gothic" movement is entirely without the self-conscious, protesting character of German nudes. It always remains classic in its concentration on formal values. So by an unequaled combination of skill, intelligence, and honesty Degas won a place near the summit of that European tradition which had crushed so many of his contemporaries, or forced them into rebellion.

Already in 1911 the futurist manifesto suggested as a contemporary symbol a racing motorcar, with great pipes like snakes with explosive breath, "a roaring motorcar that seems to run on shrapnel" (this antediluvian monster of 1911 would look ridiculous to us, but it seemed a dragon to Marinetti), and since that date what new manifestations of mechanized energy have been evolved, whizzing, screeching, flashing, supersonic! The vast crowds that attend a motor race or an air rally are there to witness a display of power of a different order to anything they could see in an athletic stadium. The poor human body has been put back where it was in the Stone Age; or lower, for it was at least on the same plane of activity as the saber-toothed tiger and ruled by the same natural laws; yet perhaps it will be a long time before we renounce our old symbol that for almost three thousand years has provided the invigorating joys of self-identification.

VI

PATHOS

IN THE nudes of energy the body triumphed. Hercules triumphed over the tasks imposed upon him; the athlete triumphed over gravity and inertia. But there is also a nude that expresses defeat. The beautiful body, which seemed secure and serene, is defeated by pain. The strong man who has overcome all obstacles by his strength is defeated by fate. Hercules triumphant becomes Samson Agonistes. This nude embodiment, which I have called pathos, is always the expression of the same idea, that man in his pride has suffered the wrath of the gods. And because this may be interpreted as the triumph of the divine over the material, it admits of this development, that the body must be sacrificed to the spirit if man is to preserve his status "a little lower than the angels."

The early legends in which the gods assert their divinity are, often, to our way of feeling, cruel and unjust. Because the Greek gods were so handsome we tend to forget that they were as jealous as Jehovah, and less merciful. Four of these legends, above all, touched the imagination of the Greek artists, and through the images they created were to affect the whole course of European art. They were the destruction of Niobe's children; the death of a hero, Hector or Meleager; the agony of presumptuous Marsyas; and the fate of Laokoön, the disobedient priest.

Of these themes only the first belongs to the classic period of the fifth century, and in pre-Pheidian art the works in which

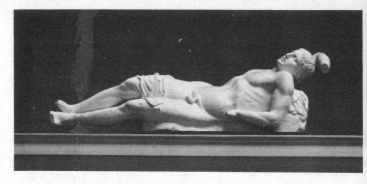

171. Greek, 5th century B.C.(?) Son of Niobe.

the body by itself is expressive of pathos are few and doubtful.
In the Akropolis Museum, the gravestone of a crouching foot
soldier, datable about 500 B.C., is a possible exception, for
whether he is wounded or merely fatigued at the end of a race,
his hands raised to his breast and the inclination of the head
make a touching effect that is surely intentional. The fallen
warriors from the temple of Aigina, although they are cold and
mechanical, like all the figures from that unlovable assembly,
show that the twisted body was already recognized to be a
vehicle of pathos. But it is not given emotional resonance till
the earliest Niobids. Two of these have been dated in the second
half of the fifth century, a recumbent son, in Copenhagen
[*171*], and a kneeling daughter, in the Museo delle Terme,
Rome [*172*], In both, pain is expressed by the tension of
the body, by the head thrown back and arm stretched above
it, a gesture we might connect with relaxation, but accepted by
the Greeks as symbolizing anguish; and in the kneeling figure
the rising, tapering line has the quality of a cry or of that sensa-
tion of pain which seems to shoot higher and higher, till it
reaches the summit of our nerves. To the Greeks pain and
beauty were almost contrary states, and these two figures are
perhaps the first in which they have been united. In doing so,
a little of the pure Greek sense of form has been sacrificed;
there is something uneasy, for example, about the relation of
the daughter's neck to her shoulders, and the son's body shows a
stress and a contraction that might have seemed too painfully

physical to Polykleitos or even to Pheidias. Yet it reveals possibilites of expression that reach their fulfillment in Michelangelo's *Dying Captive*.

The death of the hero is a sarcophagus motive, and, like many such, it probably goes back to some great paintings of

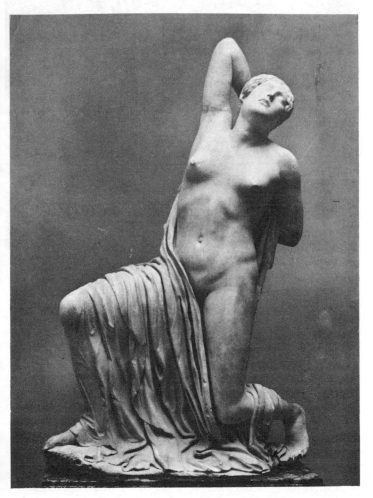

172. Greek, 5th century B.C.(?) Daughter of Niobe

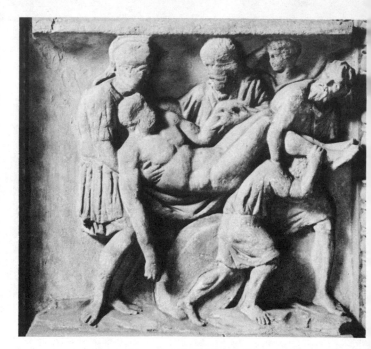

173. Greco-Roman. Soldier's gravestone

which no record remains. It is, in fact, as a painting that the
theme first appears, in those drawings on white lekythoi show-
ing Sleep and Death carrying a corpse to the tomb. From this
group is evolved the design of the dead hero carried by his
companions from the field of battle [*173*]. His right arm hangs
limp, his left is raised by a friend who looks at him for some
sign of life. The hero depicted is sometimes Hector or Sarpedon,
sometimes an unknown soldier; and in addition to such gen-
eralized scenes of military death, there was also depicted the
particular fate of Meleager. We see him stretched out on his
bier, dying before our eyes, as the wooden brand, his life token,
is consumed by fire, and the group of women who surround
him cry out in horror at the sight of his emaciated body. It is
a strangely unclassic scene; and indeed the whole legend, with
its background of forest hunt and blind destiny, gives us a feel-

ing of the cloudy North. Perhaps, after all, that is why Swinburne could make the subject into his masterpiece, and Donatello, with so little alteration, could adapt it to the Gothic motive of lamentation over the dead Christ.

The other embodiments of pathos in antique sculpture almost without exception originate in the art of Pergamon. For over fifty years this kingdom of Asia Minor defended Hellenism from the attacks of the Gauls. The struggle was desperate and unceasing, and when victories were commemorated it was with a sense of gravity and of the tragic character of all conflict; so the sculptors who worked at Pergamon, and who came, no doubt, from all over the Greek world, had to give their efficient Lysippic style an added seriousness. The two famous figures of defeated Gauls that have come down to us, copies of the bronze figures dedicated about the year 230, express this mood of heroic tragedy with admirable restraint, and if we cannot quite claim *The Dying Gaul* in the Capitoline for this chapter, it is because the pathos is expressed through the head rather than the lean and leathery body. The first Pergamene school did, however, produce one work in which the body was a direct means of communicating emotion, the *Marsyas* hanging with his hands and feet bound to a tree, waiting in terror for the knife [*174*]. In its origins this myth had expressed the cruel arrogance of the Apollonian idea; but the men of Pergamon, with their romantic respect for barbarians, felt enough sympathy with Marsyas to make his figure into a tragic symbol. The stretched-out body is as defenseless as a dead animal in a butcher's shop, and the columnar form allows a concentration, a bare basic simplicity, that was to satisfy the ultimate needs of Michelangelo.

The high seriousness of Pergamene art did not last for long. An enormous altar, dedicated in the beginning of the next century, is an example of that inflated official art with which the nineteenth century made us so familiar. It was, however, out of this milieu that there emerged the most influential of all embodiments of pathos, the *Laokoön* [*175*].

Of all the famous works of art that, in this study of the nude, I have tried to see with fresh eyes, the *Laokoön* is the most tarnished by familiarity. It is also the one whose fame can be least easily dismissed as an error of taste or residue of earlier excitement; and the artists, poets, critics, and philosophers who

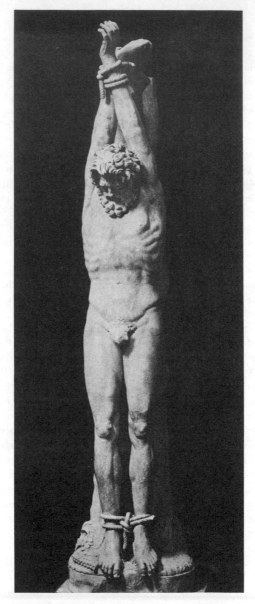

174. *Pergamene, 3rd century* B.C. *Marsyas*

have praised it have done more than read into it their own needs and poetic aspirations. In fact, one of the greatest of critics, Lessing, used it as an example of those excellencies which are peculiar to the visual arts. That this work, so highly recommended, should have failed in its effect during the last fifty years is owing to a quantity of causes, of which two may be mentioned now, its elaborate completeness and its rhetoric.

Antique art has come down to us in a fragmentary condition, and we have virtuously adapted our taste to this necessity. Almost all our favorite specimens of Greek sculpture, from the sixth century onward, were originally parts of compositions, and if we were faced with the complete group in which the *Charioteer of Delphi* was once a subsidiary figure, we might well experience a moment of revulsion. We have come to think of the fragment as more vivid, more concentrated, and more authentic. That revelation of personal sensibility, the quality of the sketch, to which Croce has given a philosophic justification, is overlayed and smothered by labor. We can test this by imagining, or seeing in a cast, a fragment of the *Laokoön* for example, the father's torso and thigh. How life-enhancing they are when allowed to make their effect by formal qualities alone, without encumbering detail! There is scarcely another nude in which emotion is communicated with such absolute mastery of means. The accessory snakes and sons seem to lessen the immediacy of this effect. Now, I think we should be wise to mistrust an aesthetic that habitually prefers the part to the whole; and, in this instance, we know that the anguished strength of Laokoön's body is intended to gain in effect by contrast with the exhausted relaxation of his younger son. The criticisms of Winckelmann and Lessing are not mere literary exercises; they indicate that a great masterpiece must, so to say, fire off more than one gun. The first aesthetic shock is not enough. But to appreciate this demands time and a continuous state of alert receptivity, and in a philosophy of art based on the immediate sensation it is not easily achieved.

Then, as to rhetoric: the *Laokoön* is too rich for our frugal taste, and, in particular, we are apprehensive of this sauce by which our parents were persuaded, as we believe, to swallow many impure substances. No one will deny that rhetoric, the mechanism of art used to persuade us through our emotions, has

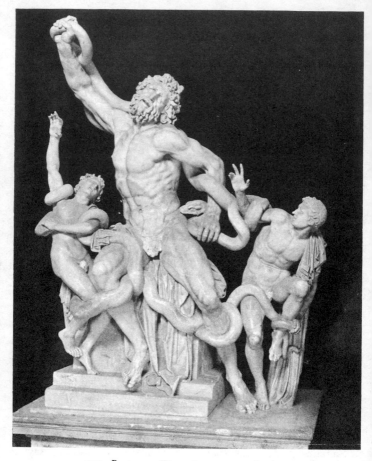

175. Pergamene(?), 2nd century B.C. *Loakoön*

been generously employed in the *Laokoön*. But rhetoric is not
necessarily a garnishing added to an idea to make it persuasive;
it may invest the idea so closely as to become a part of it, as in
some famous speeches of Shakespeare; and such, it seems to
me, is the case with the *Laokoön*. It contains no movement that
cannot be justified by necessity as well as art, except some that
are owing to its restoration in the sixteenth century. We know

that the father's right hand was originally behind his head, the symbolic gesture of pain, and Montorsoli's eloquent reconstruction not only deprived the group of its classical enclosure, what I have called the cameo quality of antique art, but has also introduced a new kind of oratorical language. Moreover, we must not confuse rhetoric with sentimental exaggeration. Winckelmann stressed particularly the restraint of the *Laokoön:* "He raises no terrible shriek. . . . The pains of body and grandeur of soul are, as it were, weighed out and distributed with equal strength throughout the whole frame of the figure." Winckelmann was contrasting it, of course, with the works of the decadent baroque tradition, the current style of his youth, which his own writings were about to displace. For a hundred and fifty years artists had been trying to enhance the effectiveness of their works by gestures and expressions that went far outside the warrants of their subjects. The result was not precisely rhetoric, because in such a work as Guido Reni's *Samson* the nude figure is not trying to persuade us to feel any emotion, except satisfaction in the art itself: it is as much a piece of "art for art's sake" as a sculpture by Brancusi, and in certain moods we welcome it because it is at such a comfortable remove from reality. In the *Laokoön,* on the other hand, although the situation is improbable, the conduct of the fable is remarkably real and afflicting. To quote Winckelmann again, "The pain discovers itself in every muscle and sinew of his body, and the beholder, while looking at the agonized contraction of the abdomen, without viewing the face and the other parts, believes that he almost feels the pain himself." The nude of pathos could have no more persuasive recommendation.

Such, then, were the motives through which, in antique art, the nude communicated the pathos of defeat. All four were to be revived at the Renaissance. But during the long banishment of the body, there arose one symbol of pathos more poignant, more inclusive, and more compelling than all others: Our Lord on the Cross. The Son of Man, the embodiment of perfect goodness, has suffered the will of God; but the spiritual power that has caused His death has come from within Himself. Nothing in our subject shows more decisively the ideal character of the antique nude than that, in spite of the Christian horror of nakedness, it was the undraped figure of Christ that was finally

176. Rome, 4th century A.D. *Crucifixion.*

accepted as canonical in representations of the Crucifixion.
Early images of the Crucifixion are of two types, that which
shows the Crucified undraped, the so-called Antioch type, and
that which shows Him draped in a long tunic, the so-called Je-
rusalem type. Both are extremely rare in early Christian
iconography and do not date from earlier than the fifth cen-
tury, partly, it is said, because the memory of the Crucifixion
was thought less likely to make converts than that of the Res-
urrection or the miracles, and partly because of the great theo-
logical difficulties the subject involved. An ivory plaque in the
British Museum [*176*] and the famous panel from the doors of
Santa Sabina, which are, with the doubtful exception of some
engraved gems, our earliest surviving representations of Christ
on the Cross, show a classical figure, nude save for a loincloth,
standing erect and frontal, with no indication of pain or death.
Very shortly after come the draped figures, of which the
Monza ampulae and a miniature in the Codex Rabulensis are
the first datable examples. We might have supposed that this
would have been more acceptable to the monastic West, but
there is evidence that the nude version survived the Dark Ages.

177. Constantinople, 10th century. Crucifixion

Toward the end of the sixth century Gregory of Tours tells how
in the Cathedral of Narbonne there was a painting of a "naked

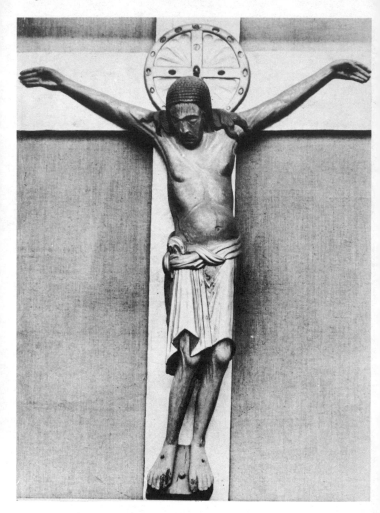

178. German, 10th century. Gero Cross

Christ upon the Cross, and that Christ appeared to the Bishop
in a dream and commanded that His body be covered with
drapery." Under Charlemagne the self-conscious imitation of
antique forms naturally involved a nude figure. Sometimes it is

the Incarnate Word, upright and free from pain; but in ivories of the tenth century [*177*], and in such manuscripts as the prayer book of Charles the Bald, we see a nude figure with a drooping head and a compensating bend of the body. It has ceased to be a symbol of the Word and has become the pathetic image of the Son of Man. Once this element of pathos, expressed through movement, was established, the stiff, conventional drapery of the Jerusalem type became impossible, and when some puritanically minded patron insisted that the "pathetic" body should be draped, as in an ivory plaque in Cluny, the figure appears to be dancing, and the spiritual quality is lost.

It is a curious fact that the origin of this image, which became of such supreme importance to Western man, is totally obscure. We do not know whether, like much of Carolingian art, it was a revival or a new invention of the time: and if the latter, whether it was invented in Constantinople or in the West. In any case, this was the image that was to satisfy medieval Christianity, and in the Germanic North it soon takes on the intense poignancy that it retains, and develops to the limits of sanity, during the next five centuries. A surprisingly early example is the Cross in Cologne Cathedral [*178*], made for Archbishop Gero (d. *976*), which anticipates the German Gothic spirit in every pitiful line of the body. We see the same rhythms in simplified, linear form in certain Anglo-Saxon drawings, or on the reverse of the Cross of Lothair in Aix-la-Chapelle. In evolved Gothic the head drops further, the emaciated body sags, the knees are bent and twisted: it is a hieroglyphic of pathos. In Italy this image of the Crucified appears at the same time as the rigid, hieratic figure; but when the followers of St. Francis, in their eagerness for a human, emotional Christianity, preferred the more poignant image of the dead Christ, it seems to me probable that they looked for their iconography, as they did for their architecture, to the more fervent and vital rhythms of the North.

Once more the body has become a controlled and canonized vehicle of the divine. But in the contrast between the *Apollo* of Pheidias, smooth, solid, and serene, and the painted crosses of Cimabue [*179*] and Coppo di Marcovaldo, the human capacity for creating a god in man's image has been stretched to its

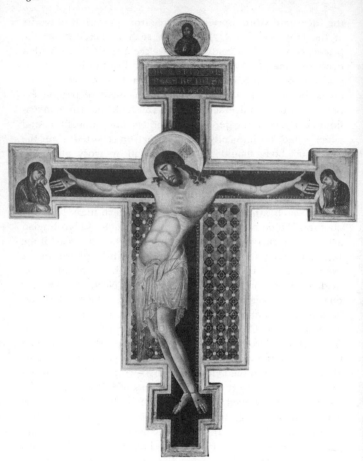

179. Cimabue. Cross

fullest extent. Since suffering is precious in the domain of the
spirit, and prosperity in the domain of the body, the image of
suffering is no longer corporeal, but has become a sort of
ideograph; and of all the symbols used by man to stimulate
his faith, to take him out of his natural, daily preoccupations
and awaken the consciousness of a soul, these painted crosses
are perhaps the most powerful. The sweep of the torso, like the

polyphonic wailing of a choir, the sustained rhythm with which every detail of head, hands, and feet adds its cry of anguish to the whole, the thick, dark outlines that stamp this terrible image on our minds, all express with irresistible force those impulses which turned mankind away from body-worshiping paganism. And yet, the basis of this ideograph is still the nude, which still obeys, as in the canon of Polykleitos, laws of compensation and balance. We can recognize this as soon as the figure of Christ on the Cross is accompanied by the two thieves. For centuries theologians had been troubled by the question: if Christ really died upon the Cross, how then did His body differ from those of the thieves? But when the three crosses appear in Western art, the problem is solved by purely aesthetic means. Long before the epoch of realism, the crucified thieves are realistic. Their coarse, ungainly bodies twist and writhe with pain. They are accidental, the Crucified Christ is essential: because, like the earliest nudes of Greece, His body conforms to a canon and satisfies an inner ideal.

It is true that certain of the greatest artists broke through this formula. They did so because it seemed to them that any convention, by holding the truth at arm's length, lessened the emotional impact of the tragedy; and looking at the smooth, peaceful figures in certain *Crucifixions* by Perugino, we may share their feelings. It was, in fact, exceedingly difficult to take the formalized figure of iconographic tradition and make it into the body of a real man without loss of spirituality. Giotto has done so in his *Crucifixion* in Santa Maria Novella, and such is the grandeur of his imagination that we do not feel any lessening of divinity. But before the *Crucifixions* of Andrea del Castagno we instinctively ask ourselves if Christ could have been so muscular and so coarsely built; and Donatello's Crucifix in Santa Croce, touching as it is, does not entirely satisfy us, not, as Brunelleschi said, because the Christ is a peasant, but because in Italian art our feeling of divinity is so closely united with an ancient tradition of form.

The further we go from the main centers of classic art, the less does this apply. The spiritual disease that, from the Black Death onward, made trouble in all the arts demanded that the body of the Crucified should display the utmost degree of anguish. The spectators must be roused to the same pitch of

horror as they were by the ghastly recitations of Lenten
sermons. This hysterical emotionalism occurs in provincial
Italian art, but it is, of course, in the North that the body is
subjected to the most painful indignities. The tragic intensity
of the Gero *Kreuz* continues in woodcarving and in such paint-
ings as the Barbara Altar in Breslau, till it culminates in that
horrifying masterpiece, Grünewald's Isenheim Altarpiece,
where the scars and bloodstains made familiar in popular
woodcuts or *biblia pauperum* are overwhelmingly magnified. This
is the most corporeal of all Crucifixions, in which every line
contributes to the image of a living organism in torment. Never
before or since have the sufferings of Christ been made so real
to us. We may speculate on the feelings it would have aroused
in those doctors of the early Church who first allowed a naked
body to be shown on the Cross, provided that it symbolized
the Incarnate Word, incapable of pain or death.

The subjects of Christian art in which nude figures are ap-
propriate or permissible are, with one exception, subjects of
pathos: the Expulsion, the Flagellation, the Crucifixion, the
Entombment, and the *Pietà*. And so we may imagine the
artists of the early Renaissance, who recognized that the nude
was the creation of classical art, searching eagerly among
abundant disorderly fragments of antiquity for motives that
could be adapted to Christian needs, and discovering those
four embodiments of pathos with which this chapter begins.
There were, of course, subjects to which antiquity provided
not even the most fanciful parallel, and Renaissance artists had
to invent for the body poses and gestures that were entirely
new. Such was the Expulsion of Adam and Eve from Paradise,
one of the first subjects of Christian art to inspire expressive
nudes. Yet both Masaccio [*180*] and Paul de Limbourg gave to
Eve the pose of the Venus Pudica, and in general the artists of
the Renaissance showed an astonishing clairvoyance in divining
the original meaning of a classical fragment and transposing
that meaning into a Christian context. An example is the first
classically beautiful nude of the *quattrocento,* the Isaac in
Ghiberti's trial relief of Abraham's sacrifice [*181*], which was
certainly inspired by one of Niobe's children. The young figure,
kneeling in fear and silent supplication, aware that he must ac-

180. Masaccio. The Expulsion

181. Ghiberti. Sacrifice of Isaac

cept the fate prepared for him by a jealous God, has passed
easily from one legend to the other.

The interpenetration of Christian and classic imagery is well
seen in two great subjects of pathos, the Entombment and the

182. Provençale, 15th century. Pietà

Pietà. The Entombment had been given satisfying shape in
Northern art, but the most memorable product of the Gothic
imagination was that legendary incident known as the *Pietà,*
when the dead body of Christ was supported on his mother's
knees. It is first represented in the fourteenth century, in Ger-
man carved wooden figures of great intensity, but its perfected
expression belongs to the mid-fifteenth century, and in painting
may be found in that masterpiece of French art, the *Pietà* of
Villeneuve-lès-Avignon [*182*]. It is a design composed of angles,
rising and conflicting, like the buttresses and gables of Gothic
architecture; and from the first the key and center of this con-
struction is the harsh accent of Our Lord's emaciated ribs.
Thus, the moving quality of the design depends directly on the
distress of the body, on a condition that is exactly the reverse
of physical beauty. Now, what could the Italians, with their
thirst for bodily perfection, make of this ungraceful motive? A
few accepted it. Ercole Roberti, almost untouched by the forms
of antique art, painted a *Pietà* that could, at first sight, be
a Flemish picture of unusual economy. Botticelli, in his final
rejection of paganism, made this moment of intimate pathos

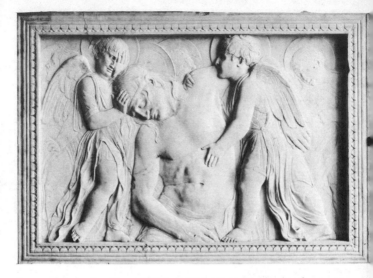

183. Donatello. Dead Christ Supported by Angels

into the choric lamentation of the *Pietà* at Munich. But this
Gothicism could not satisfy the creators of the classical Renais-
sance. They had somehow to reconcile the subject with their
own ideals. Donatello took the first step by recognizing that
the death of a hero could be transformed, practically without
alteration, into an Entombment. This did not at once result
in bodily beauty, for, as we have seen, the body of Meleager
is sometimes shown wasting away, and even Donatello could
not surpass the tragic horror of the Meleager sarcophagus in
the Louvre. Yet, the antique motive once admitted, the classic
sense of form would follow inevitably. Meanwhile, Donatello
took from Gothic art another image of the dead Christ, that
which shows his body halfway out of the tomb, supported by
child angels; and in a marble relief in London [*183*] gives it a
drooping movement, one side crumpled, the other stretched to
its extreme, a Niobid movement that was to inspire one of the
most beautiful drawings of Michelangelo.

Different as is this heroic torso from the undeveloped bodies
of the North, it is not so beautiful as to disturb us, and conveys
through its modeling a sense of tragedy and pain. It was for

Giovanni Bellini, Donatello's greatest disciple, to carry this de-
velopment a stage further. He begins with Northern stress and
angularity and produces, in the Brera *Pietà,* one of the most
soul-piercing pictures in the whole of art, where the stiff, wintry
body, with no obvious signs of pain, yet seems to have a tragic
structure, as have certain austere façades of medieval churches.
A few years later, probably in about 1480, there is a decisive
change. In *The Dead Christ Supported by Angels* at Rimini [*184*],
the body of Our Lord is, on analysis, no more physically per-
fect than in a Donatello, yet in general effect it is the beauty

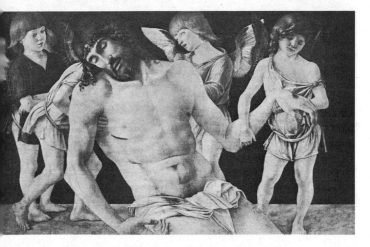

184. Bellini. Dead Christ Supported by Angels

rather than the anguish that enhances our pity. Still later, in a
picture of the same subject, formerly in Berlin, the torso is al-
most Greek, as beautiful as a son of Niobe, but more peacefully
resigned.

Thus, Bellini asserts the victory of the spirit by exalting the
body's beauty rather than by dwelling on its corruptibility. He
himself was probably unconscious of the Neoplatonic doctrines
implicit in these Olympian torsos, but toward the end of the
century the same idea was developed with full consciousness of
its meaning by an artist steeped in Neoplatonism, Michelangelo.
His *Pietà* in St. Peter's [*185*] is one of those sublime conjunctions

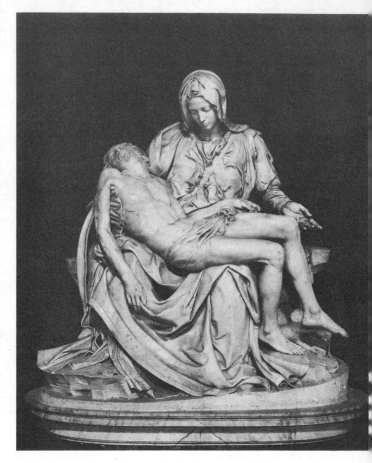

185. Michelangelo. Pietà

of classic and Christian philosophy to which, for a few years either side of 1500, Italian art could give visible expression. He has accepted the touching Northern iconography of the subject, the Christ stretched out on his mother's knees, and yet has given to Our Lord's body such an extreme refinement of physical beauty that it makes us hold our breath, as though to suspend the action of time. Michelangelo has adapted antique perfection

to its Northern setting by giving the body a rhythmic structure
the reverse of that in the Gothic *Pietà*. Instead of rising in a series
of angular gables, it sags like a garland; and, in fact, it is inspired
by an antique relief, the death of a hero or *pietà militare,* in
which the figure is being carried. Perhaps only Michelangelo,
with his unequaled power of *disegno,* could have thus reversed
the original function of a pose and yet made us accept it as
inevitable. The stages by which he did so are lost to us—not a
single drawing for the St. Peter's *Pietà* survives—but it happens
that we can trace the adaptation of the same motive in another
famous work of art, Raphael's *Entombment* in the Borghese [*186*].
It was commissioned by Atalanta Baglioni and was intended to
commemorate the execution of her son. The events leading up

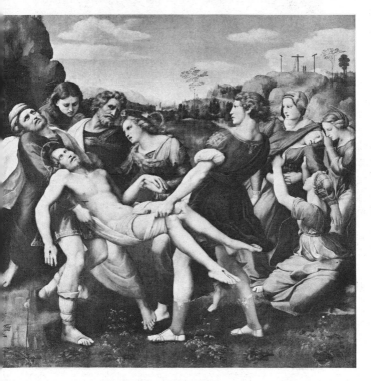

186. Raphael. Entombment

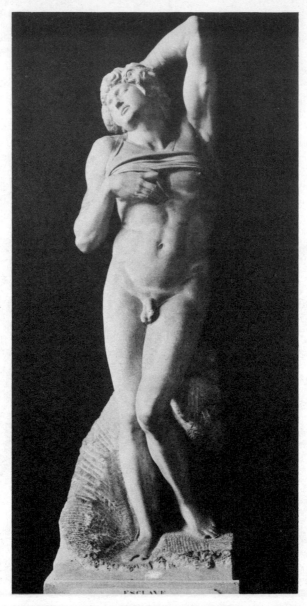

187. Michelangelo. *Dying Captive*

to his death, as related by the chronicler Matarazzo, still seem
to have the quality of antique tragedy, and in the drawings for
Raphael's composition we see him giving his Christian subject
a more antique character at every stage. First come drawings
in a Peruginesque style, which show the Holy Women weeping
over the stretched-out body of the dead Christ. This Lamenta-
tion becomes an Entombment; and, in effecting this change,
there can be no doubt that he has been influenced by an antique
grave relief or sarcophagus, perhaps the actual piece illustrated
on p. 300 [*173*]. The sag of the body, the limp right arm, the
action of the lifters, all make this clear. An intermediary drawing
at Oxford is catalogued as *The Death of Adonis* and may, in fact,
have some pagan intention. It is revealing that, after some
uncertainty as to how to treat the limp left hand, he follows
exactly the antique iconography, by which the central figure
raises it, and gazes intently at the dead man's face: a motive that
would be literally appropriate if, as in the case of Meleager,
there were still doubt that the hero was dead. Through these
drawings we can see how miraculously the spirit of some Greek
artist, whose name and work are forgotten, has been transmitted
by crude derivatives and re-created by a genius equal to his own.
In the end, however, Raphael returns to his own time: for it can
hardly be doubted that the figure of Christ in the Borghese
picture has been influenced by Michelangelo's *Pietà*. Even
allowing that both artists were inspired by the same original,
there is in Raphael's Christ a *morbidezza* that he could have
found only in the work of his overwhelming contemporary.

After *The Battle of Cascina* almost all Michelangelo's nudes
have this quality of pathos. The body can no longer triumph in
its physical perfection, but feels itself vanquished by some divine
power. And in the post-Christian world this power is no longer
the external agency of a jealous God, but comes from within.
The body is the victim of the soul. But, as Michelangelo's work
develops, it is truer to put this position in reverse, and to say
that the soul is the victim of the body, which drags it down and
prevents its union with God.

The two *Captives* in the Louvre are illustrations of his attitude.
The first [*187*], as I have said, is inspired by a Niobid: and it is
hard to believe that Michelangelo did not know some figure with
the emotive power of the young man stretched on the ground,

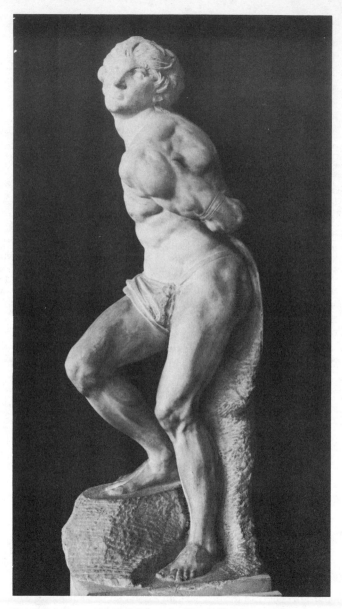

188. *Michelangelo. Heroic Captive*

now in Copenhagen; although it had not then been discovered and the most probable source of his inspiration is a mediocre figure in the Casa Maffei Collection, Rome, much admired by artists of the Renaissance. He had recognized the meaning of that ancient signature of pain, the head bent back, supported by the hand, and may even have had in mind some version of a wounded Amazon. But no direct expression of physical pain remains; it is more the gesture of a sleeper, half sunk in the luxury of sleep, half anxious to struggle free from some oppressive dream. This is the passive attitude to our mortal bondage. The second prisoner [*188*] represents the active. Whereas *The Dying Captive* touches with languid finger the line of drapery on his chest, *The Heroic Captive* twists and struggles to be free from his bonds. The mood has changed, and with it the source of inspiration. The first is like a commentary on the ideal beauty of the fourth century B.C.; the second derives from the charged and convulsive rhythms of Pergamon. This is one of the first of many references in Michelangelo's work to a decisive event in his career as an artist, the discovery of the *Laokoön*.

It happened on Wednesday, January 14, 1506, in a vineyard near San Pietro in Vincoli; and within a few hours Michelangelo was on the spot. Pliny's description of the *Laokoön* group had touched the imaginations of Renaissance artists, and even before its excavation attempts had been made to draw what it could have been like. Michelangelo, and his friend Giuliano da Sangallo, identified the newly discovered group immediately. He also recognized that this was the sanction of his deepest need. From the centaur relief onward he had wished to make violent muscular movement expressive of something more than a physical struggle. But he had found little authority for this aim in classic art, which was his only criterion where the nude was concerned. And then, from a subterranean chamber, marvelously intact, there appeared the authority he wanted, the statue that Pliny himself described as a "work of art to be preferred above all else in painting and sculpture." Even at this distance of time there is something miraculous about the whole event, because after centuries of excavation the *Laokoön* remains an exceptional piece of antique sculpture, and one of the few that does anticipate the needs of Michelangelo.

But although we may justifiably imagine the deep sense of

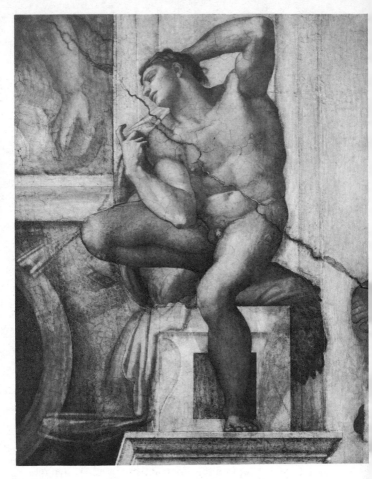

189. Michelangelo. Athlete

confirmation Michelangelo derived from the group on its first appearance, it had no immediate influence on his style. In the first period of work on the Sistine ceiling, 1508–09, the movements of the athletes grow more violent in each bay, but there is no reflection of the *Laokoön*. When, however, Michelangelo resumed work on the ceiling, the athletes changed their char-

acters. A few are still in the mold of classic beauty; others are high-strung to the point of hysteria; yet others seem to be wrestling with intolerable burdens. Of these last, one who is probably the latest of the series is based on the other antique discovery that so greatly influenced Michelangelo, the *Torso Belvedere*, and is almost like an attempt to reconstruct its pose in reverse. But the muscular body of the athlete has, by its weight and a feeling of thundery oppression, become an embodiment of pathos rather than energy. Diagonally across the panel from him is a reminiscence of Laokoön's elder son [*189*], also in reverse, but with his broken arm put back behind his head in the position of *The Dying Captive*. Of all the athletes, this is the one who best shows the predicament of physical beauty when burdened with a soul.

But the strangest examples of spiritual struggle manifested through the body are the four *Captives,* now in the Florentine Academy, in which the figures are only just emerging from the marble block [*190*]. This "unfinished" element in Michelangelo's work may at first seem to have no bearing on our subject. Yet when we search for the reasons he left so many of his works in a condition far removed from the artistic ideals of the Renaissance, we find that one, at least, of the explanations is connected with his concept of the nude as a vehicle of pathos.

The influence of antique art on Michelangelo's style derives from works of two different kinds. On the one hand were the gems and cameos, which nourished his sense of physical beauty, that smooth perfection of limb realized in such a drawing as *The Dream of Human Life.* On the other were the battered fragments, the fallen giants, half buried in the weeds and rubbish of the Campo Vaccino. In these the eye could comprehend the large lines of movement and then come to rest at those places sufficiently intact to provide it with a nucleus of form. May we not suppose that these noble ruins, which seemed to be struggling to give some message of eternal order through the chaos of time and decay, became associated in his mind with the pathos of the human body, just as the figures from gems were associated with its sensual perfection? Such, at least, is the effect these figures still have on us. Moreover, his contemplation of half-obliterated antiquities sanctioned a practice he had followed in his earliest drawings: the concentration on certain passages of

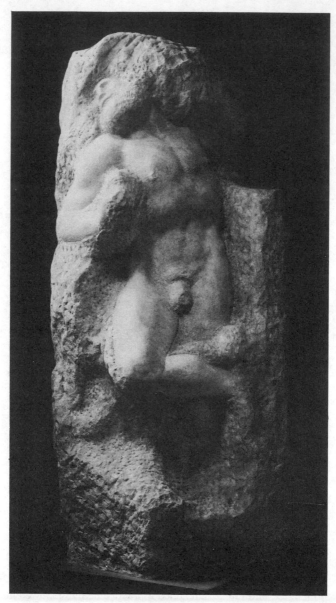

190. *Michelangelo. Captive*

modeling, which were by themselves so expressive that the rest
of the figure needed no more than an indication.

I have already, more than once, spoken of the eagerness with
which all great lovers of form grasp at certain closely knit
sequences of the body, the muscle landscape of the torso, or the
knot of muscles round the shoulder and on the knee. At such
points they find the elements of tension and relaxation, firm and
soft, following a logical pattern. They are the most concrete
examples of that kind of formal relationship which artists are
trying to discover everywhere in the natural world. Michel-
angelo, in his nudes of energy, fastened upon these nuclei, and
made them the focal points of his drawings; and when he came
to use the body chiefly as an instrument of pathos, he developed
an extraordinary power of communicating his feelings through
knots of muscles, often presented to us almost without a context.
How can a mere detail of anatomy move us so deeply? It is true
that our instinctive familiarity with the body makes us sensitive
to every inflection; but the answer must also lie in the nature
of the classic scheme. Since the Greeks had turned the body into
a kind of independent harmony, it was possible by almost imper-
ceptible changes of emphasis to alter its whole effect. Just as in
architecture, where, with the same components, a classical
façade may be serene or tragic, ominous or gay, so Michelangelo
with a few elements, the muscles of the torso and thighs, above
all the junction of the thorax and abdomen, can evoke an
immense range of emotional effect.

The four *Captives* in the Accademia are the supreme illustra-
tion of this power. Their heads only just emerge from the stone,
and in two cases are practically invisible; their hands and feet
are equally buried in their parent marble. They speak to us
through their bodies alone. Their "pathos," as was appropriate
to figures intended to decorate the tomb of Julius II, is heroic.
The body, in its struggle with the soul, still commanded a
Promethean energy. In the Medici tombs this heroic character
is abandoned. The figures no longer attempt to free themselves
or to shoulder their burdens. They are languid and resigned, as
if drowned in some deep sea of melancholy. "Yet even here
encumbered sleepers groaned." From this great depth the
ascensio, the upward flight of the spirit to God, has become
almost beyond hope. The pose Michelangelo has chosen to

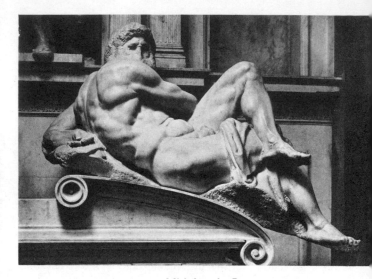

191. Michelangelo. Day

express his despair is one of great plastic and emotional power.
From the pediment of Olympia onward, recumbent figures have
been amongst the most satisfying forms of sculpture. Stretched
on the ground, the body loses its look of instability, and the
sculptor needs no devices of tree stump or drapery to make us
believe in its equilibrium. The human race is no longer hoisted
above the natural world on stilts, but seems to belong to the
earth, like a rock or a root. This closeness to the earth is asso-
ciated in our minds with the loss of animation, with sleep or
death. Of this there were great examples in antiquity, such as
the *Son of Niobe* in Copenhagen, and perhaps some such was the
model in Michelangelo's mind when he first thought of the
recumbent figures of the tombs. The *Evening* is also connected
with an image of death of a more obvious kind, a Roman tomb
figure; and although Michelangelo has modeled the torso with
an eloquence beyond the powers of late-antique artisans, this
remains the least expressive of the four great figures. On the
opposite side of the chapel is the grandest example of Michel-
angelo's muscle architecture, the *Day* [*191*], where the shoulders
of the *Torso Belvedere* [*192*] have been "developed," like a theme

192. Greco-Roman. Torso of the Belvedere

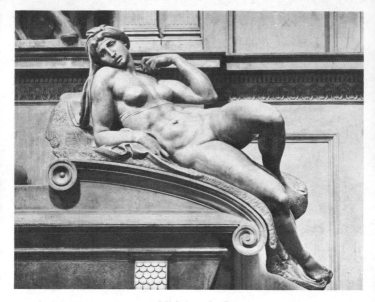

193. Michelangelo. Dawn

of Beethoven. Before this majestic landscape of hill and hollow, each undulation tense and purposeful, each related to the other by laws of natural growth, it seems that the transformation of human anatomy into an instrument of expression can go no further. That it was a transformation and not a mere imitation of a muscular back may be seen if we compare it with the antique bronze boxer in the Museo delle Terme, an able and obviously a truthful piece of work, but one so grossly material that we flinch from it, as from the carcass of a bull. These slabs of muscle weigh us down, whereas, in contemplating the back of Michelangelo's *Day,* we seem to leave the material world and ascend in our imaginations, as into a cloudy sky.

The Medici Chapel is peculiar in Michelangelo's sculpture in that two of the chief figures are women [*193, 194*]. We know, from a quantity of evidence, that Michelangelo considered the female body inferior to the male. Not a single drawing of a woman done from life has come down to us, and his studies for female subjects, such as the *Leda,* are invariably drawn from

men. It is true that in the Sistine ceiling he had been compelled
by his theme to introduce the naked body of Eve, and in the
history of the Fall had created two vivid and valid images of
woman, the temptress twisting her body with heroic sensuality
and the cowering animal fleeing from Eden. But the compul-
sion had been dramatic rather than formal, and it is at first hard
to know why, of his own free will, he should have introduced
the female body into a work so oppressively personal as the
Medici tombs. One answer may be that he felt the need of a
contrast to the emphatic muscularity of the other figures, and
since this was the period of his life when he was most troubled
by his erotic feelings for young men, he may not have trusted
himself to include in the Chapel a male embodiment of softness
and grace. There was also, in the emotional atmosphere of the
Medici Chapel, a passive character that the female body could
express better than the male. This distinctively feminine pathos
had been recently revealed to Renaissance artists by the dis-
covery of a splendid and moving work of antiquity, the so-called
Ariadne of the Vatican [*195*]; and although neither of Michel-
angelo's figures imitates her pose, both sustain the same flow of

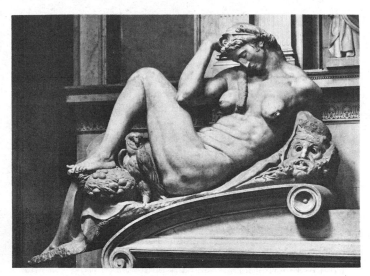

194. Michelangelo. Night

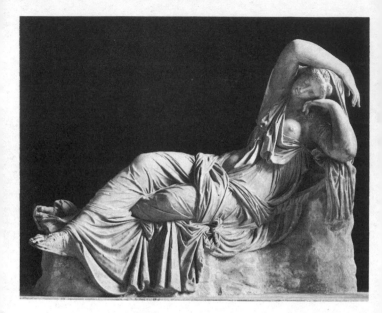

195. Greek(?), 2nd century B.C. *Ariadne*

languid movement. But in spite of a feminine rhythm, they are
entirely without those basic sequences of form by which, as we
saw in an earlier chapter, artists had given a plastic order to
physical passion. The breasts, for example, which from the fifth
century onward had been intermediaries between geometry and
the senses, and in the profoundly sensual art of India are made
to dominate the whole body, are reduced, in the *Night,* to
humiliating appendages; and the stomach, instead of being a
soft modulation of the other spheres, is a shapeless trunk, cut
across by four horizontal furrows.

Several preliminary studies for the *Night* have survived. They
are done, as usual, from male models and show how much more
at ease he was with the rocky male thorax and abdomen, but
they also show that in the sculpture Michelangelo has given the
thigh a female character, and has gained a new plastic interest
from its tapering form. The body of the *Dawn* [*193*] is a little
less far from our normal conception of beauty, and represents
a sort of agreed version of the female body that could be incor-

porated into the Michelangelesque style without inconsistency. Although its feminine attributes have been so drastically stylized, it is not without a latent sensuality, as we can tell from the numerous variations mannerist sculptors and painters were to play upon this form during the next hundred years, ranging from the elegance of Ammanati to the feverish lubricity of Spranger and Cornelisz of Haarlem.

Strange as these figures are when judged by the criterion of the classic nude, as embodiments of pathos they are creations of genius. Every line of the *Dawn's* body is like a lamentation at the sovereignty of the senses; as for the *Night,* Michelangelo has allowed his statue itself to speak in the poem he addressed to a friend who had said, wishing to flatter him, that it might wake and come to life,

> *Caro m'è'l sonno et più l'esser di sasso,*
> *Mentre che'l danno et la vergogna dura.*
> *Non veder, non sentir m'è gran ventura;*
> *Però non me destar, deh! parla basso.*
>
> *(Welcome to me is sleep, and dearer still,*
> *While wrong and shame endure, my stony death.*
> *Neither to see nor hear is my good luck.*
> *Do not awake me: pass with bated breath.)*

At two periods of his life, in his youth and old age, Michelangelo's mind was occupied by the subject of the Crucifixion. Soon after the death of Lorenzo de' Medici in 1492 he made for the prior of Santo Spirito a carved wooden crucifix, just below life size, which was placed over the high altar. It is lost, and was never, perhaps, one of his major works; but this commission is important in the formation of Michelangelo's spirit, because it was under the protection of the prior that he was first able to study anatomy; and at the same time he had his first vivid experience as a Christian, the preaching of Savonarola. Although never a direct follower—his life's work is a refutation of the *frate's* puritanism—he studied Savonarola's works throughout his life, and, sixty years later, told Condivi that he could still hear the *frate's* voice ringing in his ears. These two great experiences, the study of anatomy and the teachings of Savonarola, came to him at the same impressionable moment, and whatever the immediate result in the Santo Spirito Cross, the

final outcome seems to commemorate Savonarola's tragic
denunciation of human vanity.

The later *Crucifixions* begin with a famous drawing done by
Michelangelo for his friend Vittoria Colonna in about the year
1540 [*196*]. It was the result of special circumstances. The
recipient was a pious lady of aristocratic birth who might
equally have been found in the Rome of St. Jerome or the
Paris of Bossuet, exercising an influence out of proportion to her
intellectual powers. To Michelangelo she symbolized a release
from the tyranny of the senses. His long struggle with physical
passion was almost over, and, as with many other great sen-
sualists, its place had been taken by an obsession with death.
So the drawings done for Vittoria Colonna represented with an
eloquent poignancy the death of Christ—the *Crucifixion* and the
Pietà. They were in the polished style of the sheets presented to
his friends, and this was no doubt pleasing to their recipient,
who wrote that she had examined them with a magnifying glass
and could find no mistakes in them. But since this high finish
is combined with an emphatic sentiment anticipating that of
the Counter Reformation, this *Crucifixion* was not to the taste of
the preceding generation of connoisseurs. The pose seemed arti-
ficial, the turn of the body too elegant, the modeling too smooth.
It was therefore dismissed as a copy. I think we may safely
accept it as an authentic drawing, and surrender ourselves to
its eloquence; but it was not a communication of Michelangelo's
deepest feelings. Fifteen years later he penetrated beyond these
conventions of style and piety and produced a series of drawings
in which the idea of the Crucifixion, in all its tragic solemnity,
is given its most concentrated form [*197, 198*]. Looking back at our
antique prototypes of pathos, we can say that Michelangelo has
turned from the second style of Pergamon to the first, from the
Laokoön to *Marsyas*. He has felt how the body hanging stark
and defenseless has a quality of truth far more moving than the
elaborate *contrapposto* of the Vittoria Colonna drawing. But the
terrible strain that, as a means of touching our emotions, has
taken the place of the *curva bisantina* depends on the arms being
raised high above the shoulders; and in order to achieve this
Michelangelo has revived the Y-shaped Cross sometimes found
in late Gothic art. The two drawings that follow this pattern
gain in tragic force from our feeling that this, in actual fact, is

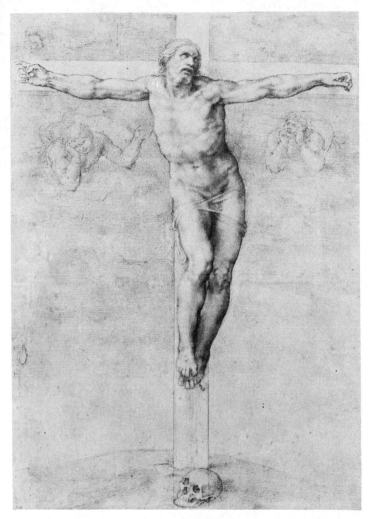

196. Michelangelo. Crucifixion

how a body would hang. Other drawings in which the body is
straight, but the arms are extended, may belong to a stage be-
fore he had thought of the Y-shaped Cross; or they may repre-

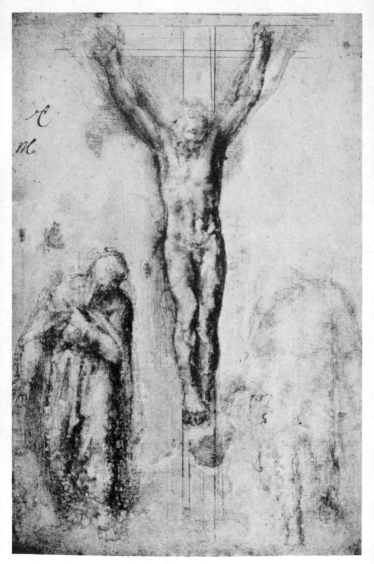

197. Michelangelo. Crucifixion

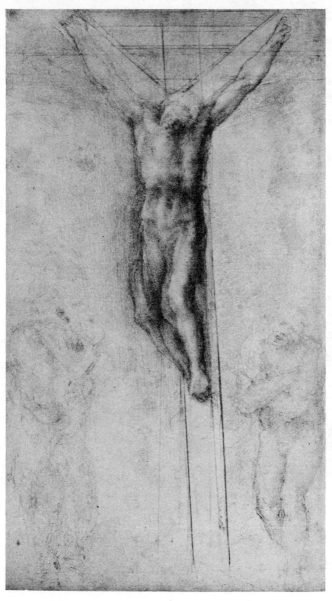

198. Michelangelo. Crucifixion

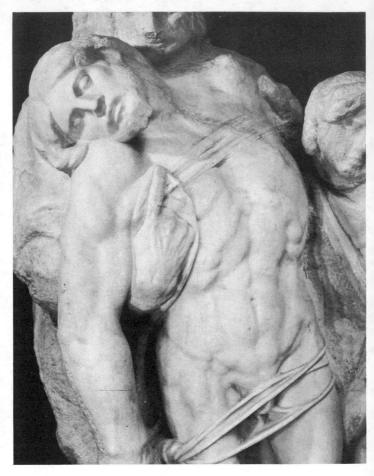

199. Michelangelo. Pietà (detail)

sent a sort of recoil from his own originality, a feeling that at
all costs the ancient, sanctified image of the Crucifixion must
be preserved. Fig. *19* supports this second alternative, for the
figures of the Virgin and St. John, which have been used to
express a whole range of emotions—fear, horror, pity, repul-
sion, and attraction—are brought close to the Cross in a mood

of transcendent union; and we feel that this must be the last of the series.

In these drawings, as in certain passages of Dante or St. John of the Cross, we reach a realm of the spirit where analysis is inappropriate and critical language inadequate. We can only be grateful that we have been permitted to catch a glimpse of the *nobilissima visione*. For a second those great mysteries of our faith, the Incarnation and the Redemption, are made clear to us by an image of the naked human body. Has Michelangelo finally achieved the aim that had haunted him since the Sistine ceiling, and before: to grasp physical beauty so firmly that he may carry it with him to the realm of the spirit? Not entirely, for he has been forced to awaken from that dream of antiquity, in all its strength and radiance, which had been the first inspiration of his art. His three last *Pietàs,* those carvings on which he worked in secrecy and self-imposed loneliness almost to the day of his death, show that in the end the ideal of physical beauty had to be abandoned. In the *Palestrina Pietà* [*199*] the distortion is so great that certain critics have doubted its authenticity. The gigantic arm and torso weight down the body of Our Lord, so that the legs seem crushed, and almost disappear, and even the torso itself has lost its firm physical structure and become like some ancient rock face pitted by the weather. In the group in the Duomo [*200*] the nude figure follows an angular, crisscross movement that is entirely unclassical. This is not the suave geometry of the godlike body, but the stressful geometry of the great cathedrals. Finally, the *Rondanini Pietà* [*201*], where, in the humility of his last years, Michelangelo has pared away everything that can suggest the pride of the body, till he has reached the huddled roots of a Gothic wood carving. He has even eliminated the torso, for we can deduce from a drawing that the right arm, which now stands in a strange isolation, was once attached to the body. And the sacrifice of this form, which for over sixty years had been the means of his most intimate communications, gives to this shattered trunk an incomparable pathos.

In the general collapse of humanism of the later sixteenth century, the nude survived as an instrument of pathos, for it could be made to satisfy the intense emotionalism that accompanied

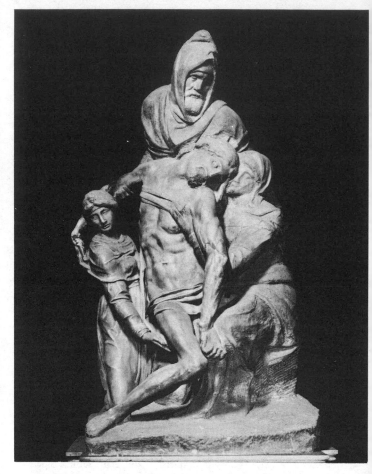

200. Michelangelo. Pietà

the religious upheavals of the time. The death of Our Lord and
the sufferings of the saints were, for about a hundred years, al-
most the only way in which the naked human body could be
represented without official disapproval. But the use of the
nude was not limited by an external sanction alone: there was
also a decline of confidence in the body. And with this decline

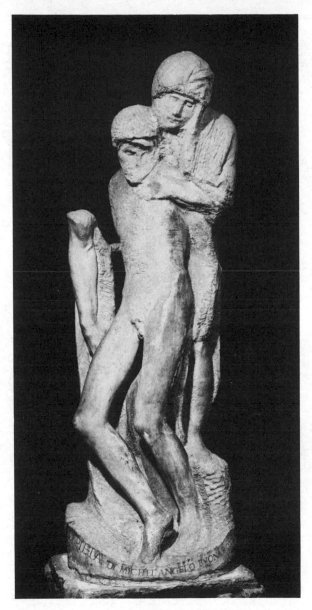

201. Michelangelo. Pietà

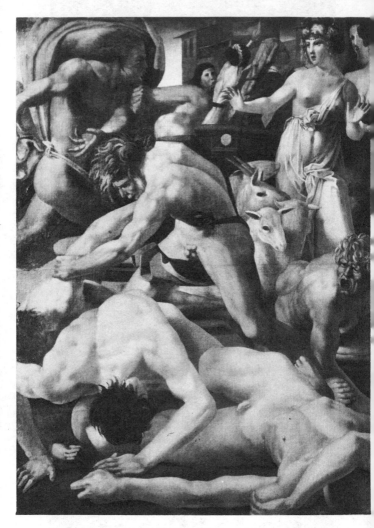

202. Rosso The Children of Jethro

it was no longer possible to lift the physical to the spiritual
plane; all that could be done was to abstract from the nude
certain ideal elements, which had already been discovered by

Michelangelo or in antiquity, and offer them in an almost disembodied state.

Such is the procedure of those two neurotics with whom the anticlassical movement of the sixteenth century begins, Rosso and Pontormo. Already in the 1520's in two pictures of *The Descent from the Cross,* which were to remain their finest works, each of them had produced figures of the dead Christ that are, once more, like hieroglyphs of pathos: only, the hieroglyph is based on Michelangelo and not on the tradition of Byzantium. In the Rosso it is, in fact, the Christ from the St. Peter's *Pietà* in reverse, and the fact that a figure designed for a recumbent position is now used with the body vertical shows how little the solid reality of matter entered into Rosso's calculations. The most curious of these abstract nudes of pathos are to be found in that eccentric work, *Moses and the Children of Jethro* [202], painted by Rosso in about 1523. All that the humanist nude had aimed at, from the Greeks onward—the rounded limbs, the smooth, full forms—has been abandoned. The bodies in the foreground are flat and angular, the transitions abrupt. There is an insistence on pattern rather than solid form, which looks back to the fallen knights in Uccello's *San Romano* and forward to the dead bodies in the Douanier Rousseau's *La Guerre.* Yet this hysterically anticlassical work is based on an antique original. The nude figures in the foreground come from the lid of a Niobid sarcophagus, and the woman in the center is actually a figure of Niobe, which Rosso clearly thought was too good to be omitted, although she has nothing whatsoever to do with the scene depicted.

This early revolt against the tyranny of the antique, where the nude was concerned, may be illustrated by another example. Titian, who passed so easily from the humanism of *Sacred and Profane Love* to the Counter Reformation sentiment of the Frari *Assumption,* had borrowed freely from the *Laokoön* in his Brescia Altarpiece. The risen Christ is one aspect of the famous group; the *St. Sebastian* [203] is another. Yet the authority of *Laokoön* was so oppressive that he was impelled to produce a drawing in which the father and his two sons are represented as monkeys; and incidentally he has studied the group with such care that his reconstruction of the missing parts is more accurate than that adopted in Montorsoli's res-

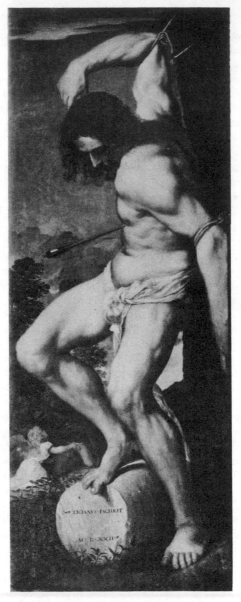

203. *Titian. St. Sebastian*

toration of the original. That the drawing was reproduced as a woodcut proves its popularity; and, in fact, it expressed two eternally popular opinions: that nature is superior to art, and the authority of famous masterpieces is a bore. The monkeys are not only ridiculous but natural and are part of the rich vegetable landscape in which Titian has placed them. The nude body of the *Laokoön* was ideal and belongs to the arid intellectual world of museums, already in the sixteenth century peopled with theorists and pedagogues.

Titian's protest against idealism and authority anticipated a general reaction. In the realistic painting of the early seventeenth century the suffering bodies of martyrs are so emphatically unideal as almost to persuade us that they should be treated in a later chapter. But, as with Rosso's *Jethro*, a closer consideration shows that they have not in fact departed very far from the patterns of pathos in antiquity and the Renaissance. Marsyas, Meleager, and the children of Niobe all reappear, but with unshaven faces and dirty fingernails. We may turn for an example to the archrealist himself, to Caravaggio's *Entombment* in the Vatican [*204*]. Fundamentally, it is a Renaissance composition, grandiose and compact, and considerably less "baroque" than Raphael's *Transfiguration*. The body of Christ has a genuine pathos rare in Caravaggio, and we recognize that this is owing to his having retained the motive of the antique *pietà militare*. He has, in fact, followed it more closely than Raphael, but instead of making the body more graceful, he has added the coarse hands and feet that were his usual declaration of independence. A similar procedure may be found in the work of the chief Spanish realist, Ribera. In his picture of *The Trinity* in the Prado, the figure of Christ is claimed as an example of extreme realism. Yet it touches the imagination chiefly because it derives from the inventive genius of Michelangelo. True, the physical type is very far from heroic; but the pose is almost that of the Christ in the Duomo *Pietà*. Very rarely, as in his *Martyrdom of St. Bartholomew,* do we feel that the suffering body is primarily a record of something Ribera has seen. This is realism at its best, in which facts achieve the dignity of art from the grave and simple manner in which they are presented. Complementary to it, academism at its best, is the *Pietà* of Annibale Carracci in Naples. The fig-

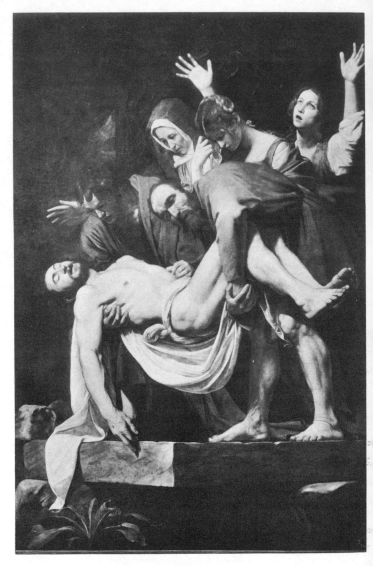

204. Caravaggio. Entombment

ure of Christ is a Michelangelesque invention, corrected and
smoothed out, but with such art that we are not offended; on
the contrary, such high-minded eclecticism almost amounts to
creation. Yet in neither Ribera nor Carracci does the body
achieve that role of a complete and independent means of ex-
pression which it held in antiquity and the Renaissance. It is
not part of a style, inseparable from the architecture of the
time. This reintegration could be achieved only by an artist in
whom the appetite for life and the mastery of style were
equally powerful.

Peter Paul Rubens painted his two masterpieces of baroque
pathos for the Cathedral of his native Antwerp soon after his
triumphant return from Italy, *The Raising of the Cross* in 1611,
The Descent from the Cross in 1613 [*205*]. As well as great paint-
ings, they were decisive battles in the history of art, and, like
David's *Oath of the Horatii,* they were recognized as such from
the beginning. They were intended to supplement one another
in style and sentiment, and the eloquent chapter of *Peintres
d'autrefois* in which Fromentin describes the contrast between
them must be amongst the few passages of criticism that would
certainly have pleased the artist. Between them they estab-
lished, for the next century, the range of pathos as it could be
expressed through the nude body. I have already described in
the chapter on "Energy" how laboriously Rubens had studied
Michelangelo. In the central figures of his two great triptychs
there are certain reminiscences of the Medici tombs and *The
Last Judgment*—for example, the twist of Our Lord's right arm
in *The Descent.* More generally, the vigorous cursive style in
which everything is described is ultimately derived, through
Tintoretto and Michelangelo, from the *Laokoön.* But when this
is allowed, it is Rubens' own splendid powers that have drawn
together all the stylistic and emotional currents of the time.
Not only was he a master of his profession, but he had an im-
mense generosity of heart through which he could take the
commonplaces of sentiment and make them moving. When he
painted the dead body of Our Lord, his feelings were as sincere
and heartfelt as when he painted the nude body of Helena
Fourment. Thus, the artificiality of the baroque style, the ele-
ment of make-believe that had been present from Correggio

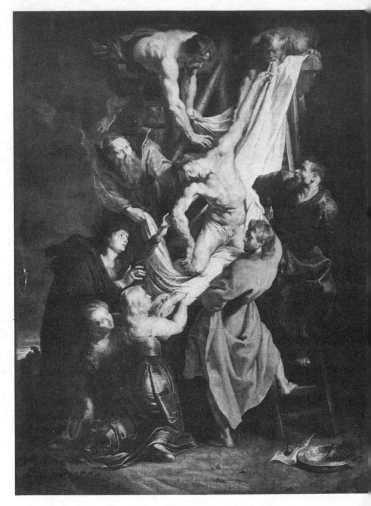

205. Rubens. The Descent from the Cross

onward, is swept away by Rubens' glorious confidence in the body.

Or should we say in the flesh? An old antithesis between flesh and spirit makes it, at first, hard to accept the part played

by the surface of the body in Rubens' paintings of the *Deposition* and *Entombment*. Yet the painter, communicating with us through pictorial means, must use whatever elements in the visible world affect him most strongly; and the skin was to Rubens almost what the muscles had been to Michelangelo. It may be convenient to call one response sensuous, the other intellectual; but if we judge the resulting work of art simply by its effect on our emotions, we must grant that Ruben's feeling for the changing color and delicate texture of flesh has added a new element to the nude of pathos. Titian, in that splendid expansion of the *pietà militare,* the Louvre *Entombment,* had emphasized the contrast between the pale body of Our Lord and Joseph of Arimathea's brown arm, and Rubens, who was a profound student of Titian, must have recognized how this simple device added poignancy to the traditional design. In his own nudes of pathos the color of the flesh is often the main theme of the picture, and ranges from the deathly pallor of the *Deposition* to the incorruptible pink of certain *Pietàs,* where, the subject being symbolic rather than realistic, he has simply made the body as beautiful as he could; and we feel that any insult to that unblemished surface would be more than ever cruel.

In addition to these pictorial achievements of the kind usually associated with Rubens, there are certain other paintings of his—the *Crucifixion* and the *Deposition*—that have the stark directness of the greatest classic art. Such is the *Crucifixion* in the Van Beuningen Collection [206], where all three figures hang like Marsyas and yet are subtly differentiated by the character of their bodies and by the incidence of the stormy light. The long tradition of Christian iconography by which the figure of Christ is ideal, while that of the unrepentant thief has a brutal materiality, has seldom seemed more convincing, for, in spite of the divine beauty of Our Lord's body, Rubens has kept the three crucified men united by a sense of shared humanity. Equally concentrated is the small picture in Berlin of the two Marys: *Mourning over the Dead Christ* [207]. It goes back to a classical relief both in the rigid figure with arm hanging down and in the severe frontal composition; yet in painting it is as rich and dramatic as a Delacroix. It is one of the many inspired "asides" in the great declamation of Rubens' religious painting, and seems almost to anticipate the so-called classic

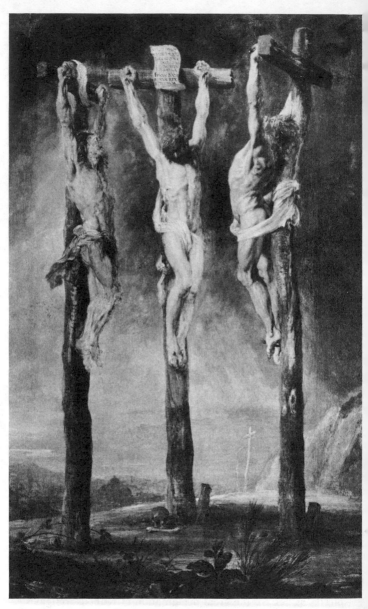

206. Rubens. Three Crosses

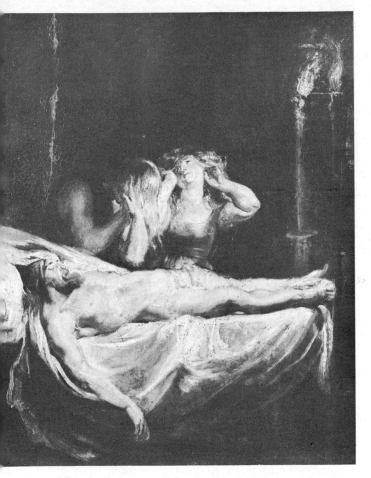

207. Rubens. Mourning over Dead Christ

baroque that was to grow up under his shadow in the person of
Nicolas Poussin.

For too long our responses to the powerful and moving qual-
ity of Poussin's imagination have been falsified by the stock
epithets of criticism—"learned," "judicious," even "academic."
Such exclamations, foolish enough before his bacchanals, must

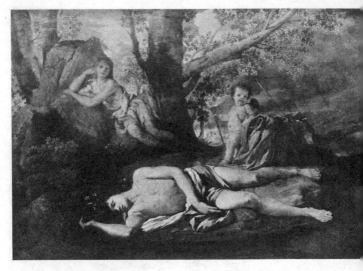

208. Poussin. The Death of Narcissus

die on the lips when we contemplate his scenes of pathos. Of
course, he was familiar with the antique nudes of suffering, the
Niobids or the dying Meleager; but his transformation of his
models was, in the end, almost as great as that of Rubens. An
example is *The Death of Narcissus* in the Louvre [208], where the
figure seems to have been inspired by a relief in the Terme.
Poussin has reconstructed such a figure in order to place at the
center of his composition the rectangular block of the chest and
the contrapuntal movement of the arms; and yet, as with all
Poussin's most satisfying designs, these feats of pictorial archi-
tecture are subordinate to an intense imaginative participation
in the drama. They are the means of forcing us to respond
more vividly to the pathos of Narcissus' death. This is even
truer of that tragic masterpiece, the *Mourning over the Dead
Christ,* in Munich [209]. Here, instead of the clear, rectangular
torso of the Narcissus, there is the rocky thorax of a Gothic
Pietà, united with that of the dying Meleager. Apart from these
correspondences in the pose, the body has evidently been
studied from nature; and this combination of realism with a
full, frontal composition, extending no further into space than

a relief, reminds us irresistibly of Donatello. That we should also think of him before the later drawings of Rembrandt shows how the great spirits of the seventeenth century returned unconsciously to the serious, humane, imaginative world of the first Renaissance.

In the eighteenth century this sense of tragic humanity was driven underground (where it was visited by Gluck's *Orpheus* and Mozart's *Don Giovanni*), and when it reappeared in the work of the great romantics it had grown more self-conscious, more assertive, and more grandiloquent. In much of early-nineteenth-century painting the nudes are as artificial in their

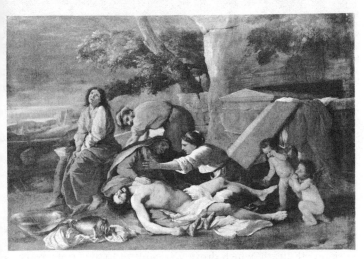

209. Poussin. Mourning over Dead Christ

pathos as in their pretensions to Apollonian beauty; but from amongst the huge, theatrical canvases of Vernet, Girodet, and Delaroche, there emerges one even vaster, which still convinces us, *The Raft of the Medusa*. It is a triumph for the Byronic, and gains its authenticity from the fact that Géricault was a genuinely Byronic character—impulsive, generous, unstable, pleased to be a child of the time, yet technically traditional to the point of reaction. Just as Byron believed that there had been no real poetry since Pope, so Géricault took his poses from antique re-

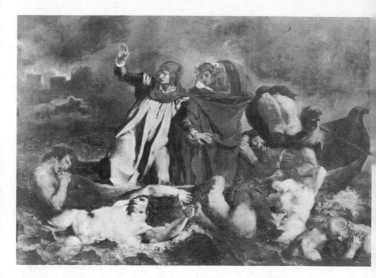

210. Delacroix. The Barque of Dante

liefs and his style from the mannered draftsmen of the sixteenth century. When painting the *Medusa* he fired his imagination by talking to the survivors and had made in his studio a model of the raft; but he peopled it with figures from the Sistine ceiling and from Raphael's *Transfiguration*. In spite of this reliance on artifice, perhaps inseparable from the construction of so large a pictorial unit, *The Raft of the Medusa* remains the chief example of romantic pathos expressed through the nude; and that obsession with death, which drove Géricault to frequent mortuary chambers and places of public execution, gives truth to his figures of the dead and the dying. Their outlines may be taken from the classics, but they have been seen again with a craving for violent experience.

With Delacroix the romantic death-wish was under the control of a lucid intelligence. No great poet ever had a clearer head; yet he had visited the infernal regions, and his first famous painting foreshadows the whole course of his imagination [*210*]. Somehow, with the help of Virgil, Dante will just succeed in crossing the Styx, as in later works Apollo will just

succeed in conquering the Python and Western thought just
survive the ravages of Attila. And this survival of civilization
by so narrow a margin was symbolized for Delacroix by the
formative genius of a few men, Gluck, Mozart, Shakespeare,
Rubens, Michelangelo. Such is the spirit in which he ap-
proached the nude. The body is defeated, as the Gauls were
defeated by the Romans, yet it survives because the great artists
of the past had been able to give it perfection of form. The
damned souls who cling to the barque of Dante, or float beside
it, are such defeated Gauls, some with an antique form, others
derived from Michelangelo, but transformed by Delacroix's
imagination. After this magnificent beginning, it is sad to find
how seldom, in his later work, Delacroix attempted the nude.
The chief exception is the half-naked woman, pale, delicate
and defenseless, who in many of his pictures awaits the on-
slaught of brutality. She appears, with other admirable nudes,
in *The Massacre of Chios,* she sprawls voluptiously on the funeral
pyre of Sardanapalus, and kneels before the trampling hooves
of the Crusaders as they enter Constantinople. She is that
typically romantic image, the flower beneath the foot; but
Delacroix treats her without a trace of sentimentality. His jour-
ney to the infernal regions had taught him that cruelty is a
necessary part of creation. His contemporaries have recorded
how closely he resembled the tigers he painted with such loving
admiration; and so in these nineteenth-century daughters of
Niobe there is a new flavor of sadistic appetite, as if Delacroix,
while pitying them, would willingly crunch them up.

The last heir of the great romantics was Rodin. This state-
ment would not have pleased him, for he always claimed to be
a disciple of the Greeks and of the Gothic sculptors. But no one
can escape from his time, and looking at him in perspective we
recognize him as extending into sculpture the pathos of Géri-
cault and Delacroix, taking Michelangelo's inventions, making
them more transient and more pictorial. His sense of form was
remarkably close to that of Delacroix, and it is hard to believe
that some figures from *The Gate of Hell* were not influenced by
the lost souls who cling to the bark of Dante or the marble
Danaïd by the flowerlike girl drooping before the Crusaders'
horses. I make these comparisons to situate, not to belittle him.

In fact, few sculptors have been less derivative, and many of his figures—the crouching woman, the prodigal son—add a new, convincing image to the restricted repertoire of the nude.

No other artist of the nineteenth century had so profound a knowledge of the body. Like Degas, he recognized that the deadness of the academic nude was partly owing to the artificial and limited conditions under which the model was observed. That familiarity with the naked body which the Greeks had acquired in the palaestra and Degas had sought in the ballet school, Rodin achieved by having a number of models in his studio playing about and adopting their poses unconsciously. He moved amongst them, observing, noting in his incomparable shorthand, and acquiring an understanding of the body that none of his contemporaries could equal. But when, in a piece of considered sculpture, he colored observation with thought, the result was almost always an embodiment of pathos. Rodin was so saturated with the feeling of man's tragic struggle with destiny that his figures could hardly move without expressing it. If they walk, it is toward their doom; if they turn to look round, it is for fear of some avenging angel. It was no accident that for thirty years all his nude figures were thought of as parts of a grandiose, misconceived project, *The Gate of Hell,* and in fact 186 of them were fitted into the final scheme. Unfortunately, Rodin was all too conscious of the soul-stricken character of his imagination, and occasionally exploited it, hollowing a cheek or accenting the tenseness of a muscle beyond conviction. But, as in Wagner, the false and theatrical elements in his work are only an extension of the true, slightly vulgarized to suit modern conditions; and his finest pieces, the *Eve,* the *Three Shades* [211], or the studies for *The Burghers of Calais,* are worthy of the tradition of sculpture that began with the Lapiths of Olympia, the daughters of Niobe, and the Marsyas.

In spite of the vitality with which he maintained this tradition, we feel that with Rodin an epoch and an episode have come to an end. The idea of pathos expressed through the body has reached its final stage and is in decay; and the cause is fundamentally the same as that which led to the decline of belief in its divinity. In Greek mythology and the Christian religion, suffering was the result of the direct intervention of a god. Michelangelo, it is true, made that suffering come from within,

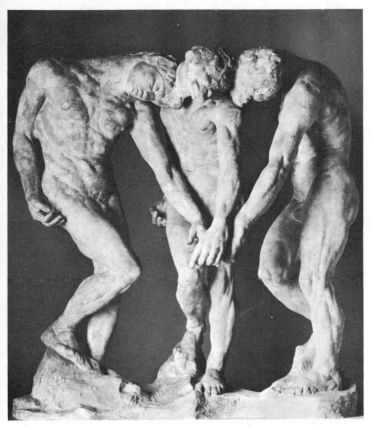

211. Rodin. Three Shades

but he never doubted that God was there to superintend and ultimately to direct it. Pathos was focused. In the work of Rodin it is diffused. It is simply part of the *Götterdämmerung,* the death-wish, that the poets of romanticism had foreseen and the tech-nicians of the present century have so brilliantly accomplished.

VII

ECSTASY

A LITTLE OLYMPUS outside the greater": with these words
Walter Pater, in his "Study of Dionysus," describes that
population of satyrs, maenads, sylvans, and Nereids which
represented, in the Greek imagination, the irrational elements
of human nature, the remnants of animal impulse that the
Olympian religion had attempted to sublimate or to subdue.
And in art, too, beside the embodiments of measured harmony
and justice, of celestial beauty and determination, were lesser
embodiments of impulse, of abandonment to enthusiasm or
panic or to the mysterious influences of nature. The works of
art in which these impulses are expressed are smaller and less
impressive than the monuments dedicated to the Olympians;
yet just as the blood of Dionysos could flow into the cup of
Christianity, so, in the history of art, Dionysian motives had a
longer and more fruitful life, diffusing classical forms to the rim
of the antique world, and reappearing as soon as the figure
arts could receive them. At an early stage in Greek art painters,
and perhaps sculptors, had discovered poses and movements
that expressed something more than physical abandonment,
which were, in fact, images of spiritual liberation or ascension,
achieved through the thiasos or processional dance; and the
thiasos, whether of bacchantes or Nereids, became the favorite
motive of sarcophagi; for it showed that death is only the
passage of the soul through some less rigid element in which

the body is remembered for its joy of sensuous participation
rather than for its weight and dignity.

In the nude of energy the body was directed by the will. It
lunged forward in a rigid diagonal, and even when it assumed
the complicated poses of athletics it was under control. In the
nude of ecstasy the will has been surrendered, and the body is
possessed by some irrational power; so it no longer makes its
way from point to point by the shortest and more purposeful
means, but twists and leaps; and flings itself backward, as if
trying to escape from the inexorable, ever-present laws of gravity
[212]. The nudes of ecstasy are essentially unstable, and if they
do not collapse it is not through conscious control, but through
the precarious equilibrium of enthusiasm, the providence that
is said, not always quite correctly, to look after drunken men.

The first Dionysiac scenes appear, appropriately, on drinking
cups, where, in the beginning of the fifth century, satyrs and
maenads take the attitudes they retain for the next eight hun-
dred years, the satyr leaping in the air, the maenad, with head
flung back and arm raised, swaying forward in the processional
dance. This was evidently a pictorial and not a plastic motive,
and the sculptural form in which it has come down to us is,
from its linear character, clearly inspired by painting. Two sets
of reliefs show us something of what we have lost. One of them
is of ritual dancers, perhaps priestesses of Apollo Karneios,
wearing short kilts and the high straw hat called a *kalathiskos*.
They are almost certainly replicas of the "Spartan girls dancing"
mentioned by Pliny as the work of Kallimachos. We know them
from gems and Aretine ware, and also from two marble
carvings in Berlin so fresh and vivid that they might be the work
of Desiderio da Settignano. Unlike the maenads, their gestures
are tense and controlled; but their flamelike movements give
them an ecstatic quality and they are on tiptoe to leave the
earth [213, 214].

The other series represents maenads or bacchantes, their
bodies abandoned to the ecstasy of the thiasos, and probably
derives from an alter of Dionysos [215]. These we know best
from elaborate reliefs in the Metropolitan Museum and Madrid;
later they provided motives with which to decorate urns, cis-
terns, pedestals, and furniture of all kinds throughout Hellen-
istic and Roman times. Even in the earliest replicas they are

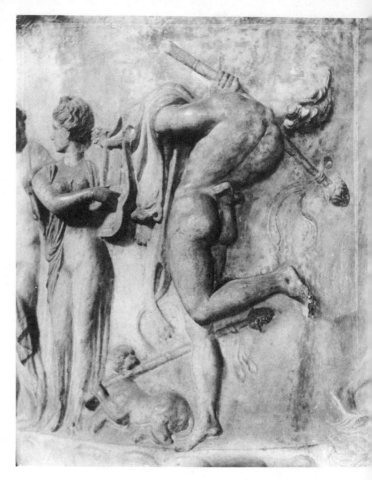

212. Hellenistic, 1st century B.C. *Borghese Vase*

highly artificial productions, and it is hard to believe that they
were invented in the fifth century, although a quantity of
evidence in vase painting and on friezes confirms this early
date. In contrast to the Spartan dancers, the maenads depend
for their effect on clinging drapery, which not only accentuates
their actions, but creates a pool of movement in which their

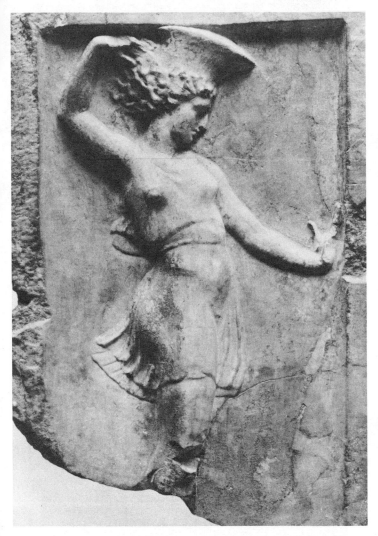

213. After Kallimachos, 5th century B.C. Dancer

bodies seem to swim. No doubt this swirling line, with its deep-
rooted powers of visual excitement, helped to give them their

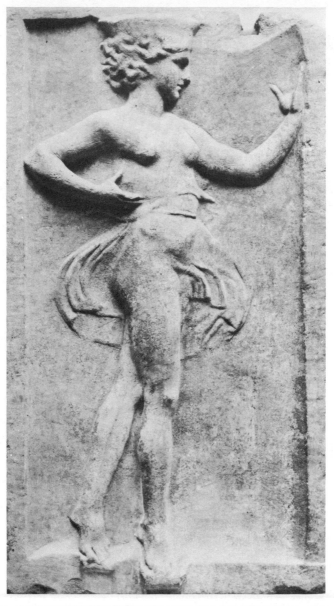

214. *After Kallimachos, 5th century* B.C. *Dancer*

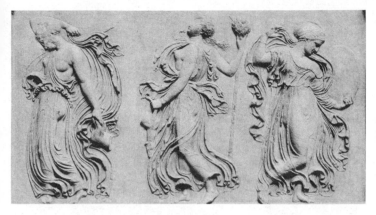

215. *Greco-Roman. Three Maenads*

long life as objects of art. We are half hypnotized by its move-
ment, as we are by swirling water, and, like the maenad her-
self, surrender our faculties of reason. But the predominance of
drapery also led, as it so often does, to an ornamental unreality.
The well-known maenad who holds in one hand the severed
carcass of a kid and in the other brandishes a knife above her
head is little more than a decorative hieroglyphic. Her blood-
thirsty act is forgotten in the elegance of her pose, her body is
subordinated to the convolution of her draperies. She antici-
pates the mere space filling of Agostino di Duccio or Burne-
Jones. Yet, such is the rhythmic completeness of these designs
that few works of antiquity were to have a more liberating
effect on the art of the *quattrocento.*

From its essential instability, the ecstatic nude was unsuited
to sculpture in the round, and those pieces which attempt it,
like the Hellenistic faun looking at his tail, are, for the most
part, trivial. But in the fourth century, we are told, both
Praxiteles and Skopas took maenads as the subject of sculptured
groups; and, by rare good fortune, that of Skopas has come
down to us in a small-scale replica which preserves some of the
vitality of the original [*216*]. Skopas' figure was recognized in
its own time as communicating, with unusual intensity, the
sculptor's mastery of violence. "Who carved this bacchante?"
asks an epigram in the *Anthology*. "Skopas. Who filled her with

216. After Skopas, 4th century B.C. *Maenad*

this wild delirium, Bacchus or Skopas? Skopas." This is just. The passionate energy the Dresden *Maenad* still radiates from her battered surface is the result of a highly developed skill. Her body has been given a double twist, to which her thrown-back head adds a third; and her drapery is so artfully devised that one side, being relatively austere, enhances the sensuous shock of the other. Her naked flank combines the luxury of Hindu sculpture with the plastic vigor of a Donatello; and yet the whole is kept within the bounds of classic form. Her ecstasy has the ferocious single-mindedness of the possessed, compared to which the bacchantes of Titian are enjoying a romantic diversion. They are the highest product of decorative art; she is still part of that antique religion of sensuality from which, in the end, the nude derives its authority and momentum.

The Dresden *Maenad,* taken in conjunction with the frieze of the Mausoleum, leads us to believe that a number of Dionysiac motives that survive on reliefs and sarcophagi also originated in the workshop of Skopas. They are distinguishable from those of fifth-century derivation by a greater plasticity and by a twisting movement. Instead of the stylized lines of transparent drapery, the maenad's cloak hangs from her shoulder and reveals her naked side. The figure striking a tambour, with head thrown back, hair and drapery streaming behind her, as she surges forward in the pursuit of the god, is worthy of the great sculptor of passionate movement; and when we consider that it has come down to us only in the carvings of artisans done three or four hundred years later than the first source of inspiration, we can estimate the vitality of the original [*217*].

If the earlier maenads remind us of the *quattrocento,* of Agostino di Duccio and Botticelli, those deriving from Skopas recall the High Renaissance and the *Bacchanals* of Titian. A sarcophagus in the Terme, which preserves in stone the quality of a splendid relief in bronze, has the bodily opulence and warmth of the great Venetians, and the bacchante in the center, standing with her arm bent across her chest, has been referred to frequently in the chapter on Venus Naturalis. To the right we see the Skopaic twist at its most extreme [*218*]. The dancer with her back to us, standing on tiptoe, has turned her head right round to look at us over her shoulder. Evidently, the sculptor was

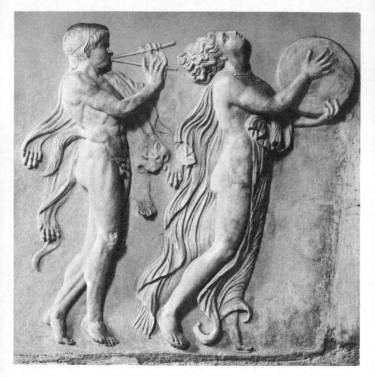

217. Greco-Roman. Dionysiac procession

recording the dance of a Dionysiac votaress, for we find a simi-
lar pose in one of the finest surviving paintings of antiquity,
the scene in the Villa Item, where a priestess purifies, by her
orgiastic dance, a terrified initiate.

It seems that Skopas also provided vivid images of the other
Dionysiac population, the Nereids, Tritons, and *chorus phorci,* as
Pliny calls them, describing his sculptured group after it had
been brought to Rome by Domitius Ahenobarbus. Of this, too,
there remain some fragmentary indications, less certain and less
moving than the *Maenad,* but retaining enough of the resonance
of the original greatly to influence romantic art. One of them,
the *Grimani Triton,* looks unbelievably Giorgionesque, and must
have been known to Venetian artists of the early sixteenth cen-

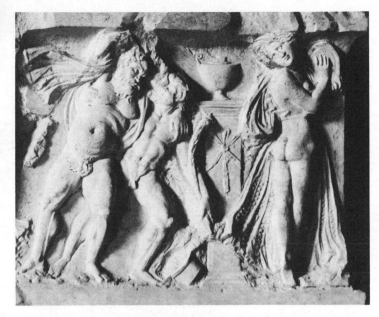

218. Greco-Roman. Dionysiac sarcophagus

tury. We might suppose it to be a Renaissance forgery, had not
a small *Tritoness,* apparently deriving from a group by the same
artist, recently emerged from the excavations in Ostia. Her
head is thrown back in ecstasy, her hair is thick and vital like
that of the Dresden *Maenad,* and her body is modeled with a
sense of the flesh that gives her a strangely unantique look [*219*].

But most of the Nereids that have come down to us show no
trace of a Skopaic origin. They are less charged with move-
ment and more at ease in their surroundings than anything we
presume to be of his invention. These are the figures found on
sarcophagi, and later on metal work, that seem to have been
made with the same pattern all over the antique world. Their
origin is entirely obscure, but they are (with one exception) con-
sistent with one another, and seem to derive from the design
of a single artist. In general, these Nereids are un-Dionysiac.
They sit comfortably on the backs of their fishtailed companions,
sea centaurs or hippocamps [*220*], and turn to converse with

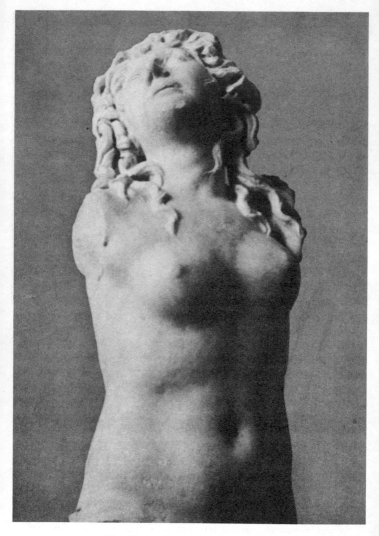

219. After Skopas(?), 4th century B.C. *Tritoness*

them or look backward with an air of pleasant detachment.
The only one who resembles the maenads in enthusiasm is she

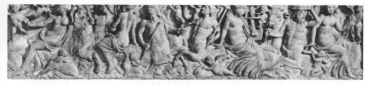

220. Greco-Roman. Nereid sarcophagus

who stretches out on her front and flings up her arms to embrace a goat or bull [*221*], with a gesture that leaves us little doubt of her significance. Her abandoned pose seems to derive from a source different from that of her more decorous sisters, and is perhaps of Eastern origin. Amongst the seated figures are some that imply an advanced understanding of the nude; but they are all resolved into plastic ideas so simple that a modest artisan could use them almost as easily as if he were carving an alphabet. We realize how rich and elaborate the originals must have been only when we see them revived, almost unaltered, in the work of Nicolas Poussin

The Nereids, like the maenads, start as expressive sculpture, concerned with some important experience in human life; and both end as decoration. It is worth digressing to discover, if possible, what this transformation of the Dionysiac nude implies.

Decoration exists to please the eye; its images should not seriously engage the mind or strike deep into the imagination, but should be accepted without question, like an ancient code of behavior. In consequence, it must make free use of clichés, of figures that, whatever their origins, have already been re-

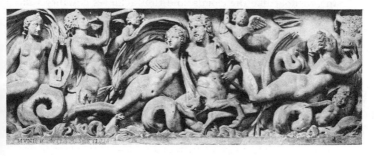

221. Greco-Roman. Nereid sarcophagus

duced to a satisfactory hieroglyphic. From this point of view, the nude provides a store of perfect decorative material. It pleases the eye, it is symmetrical, and it has been reduced to a simple, memorable form almost as a condition of its survival. It can be used as a component part in building up a pictorial construction with only a faint flavor of its original intention being perceptible; and yet there is always, in the human body, a latent warmth that can save such compositions from frigidity. But the nude figures that fulfill this function must be of a kind in which the rational faculties are superseded and the mind consents to be lulled out of its daily preoccupations; and for this the subjects we have just described, the triumph of Bacchus and gamboling of sea gods, are ideally suited. In both the reason is agreeably banished and its place taken by dreamy exaltation and voluptuous instability. In the Bacchic scenes there is the grape, the wine vat, the clashing of cymbals, and the rhythmic dance to deprive us of our rational faculties; in the other group the means are rather subtler and perhaps more profound, for the half-magical buoyancy of these Tritons and Nereids, the ease with which they ride on each other's backs or recline in the trough of a wave, appeals to our instinctive rebellion against the most inhibiting restraints of our body. In our dreams we fly or swim, and attain thereby a rapture of sensuous freedom that, in our waking lives, we know only in love. So the body, to be a perfect motive for decoration, must be in ecstasy, not only because it is then on a different plane of reality, but because, when no longer confined by stasis, it can be used with greater rhythmic freedom. It can flourish like the vine, or float like the clouds, and thus achieves equality with the two chief sources of ornament in human history.

The history of the Nereids shows how certain shapes will satisfy us and survive long after their iconographical meaning has been forgotten. Whatever may have been in the mind of the artist who first invented them, on sarcophagi they were accepted as symbolizing the passage of the soul to another world; but on Coptic needlework or the ivory caskets of Alexandria the Nereid is purely ornamental. She is simply a form with agreeable associations, in which the stresses are resolved and enclosed, so that it can be included at any convenient point; yet has a cursive outline, which leads the eye on easily to the next

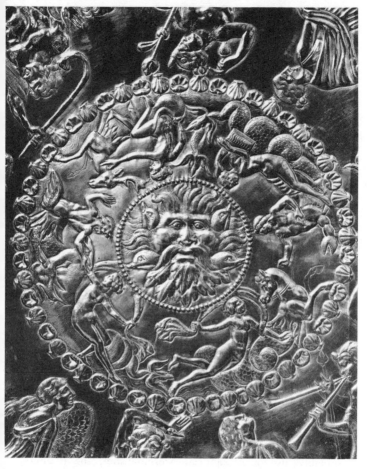

222. *Late antique, c. A.D. 350. The Mildenhall Dish*

unit of decoration. For this reason the Nereid achieved, in the late Roman Empire, a wider diffusion than has been the lot of any motive based on the nude. Pieces of silver, embossed or engraved with these compact, desirable shapes, were sent to the barbarian perimeter of the antique world, and Nereids have been found in the most improbable places, in Northumberland

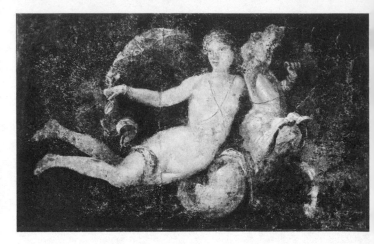

223. Greco-Roman, 1st century A.D. Nereid

and Baku, in Ireland and Arabia. A Greco-Buddhist carving
in the Lahore Museum contains a Nereid almost identical with
one in Grottaferrata, which was a favorite in the Renaissance.
The most elaborate of all Dionysiac dishes was recently turned
up by the plow near the village of Mildenhall, in Suffolk, and
shows the two types of thiasos combined: the Bacchic, com-
plete with familiar maenads and satyrs on the rim, and the
marine, with Nereids, Tritons, and a gigantic head of Poseidon
in the center [222].

The proportions of these export Nereids are often exceedingly
unclassical. Already in the first century a wall painting of a
Nereid from Stabia [223] shows the same very long torso and
short thighs as *The Three Graces* from Pompeii, and was pre-
sumably also of Alexandrian workmanship; she is almost
identical with the Nereid on the lid of the silver casket of Pro-
jecta [224], which can be dated *c.* A.D. 370, and, a century later
still, the same figures, even further declassicized, appear in the
carvings and needlework of Coptic Egypt. The Oriental luxury
of their hips also reminds us how much the Nereid must have
contributed to art in India, where they appear in the sixth
century practically unchanged, as flying Gandharvas [225].
And as we look at such figures, we realize that it was incorrect

to imply that the Nereid survived solely for formal reasons.
Perhaps survival on those terms is impossible, and it is only
when a form is valued as a symbol that it is also valued as a
shape. For the Nereid, who was invented to symbolize the lib-
erated soul, continued to do so, in countries where and times
when her first intention was unknown. In the Middle Ages she
appears among the blessed in the Last Judgment; and even in
such an emphatically Gothic work as the triptych of Hans
Fries, at Munich, a sea maiden with wind-swept hair is being
taken up to heaven. The painter could not resist that compact
and eminently portable shape; portable because, in the original,
transported from cumbersome earth to the abodes of bliss [226].

It was this sense of floating into new life that led to the
Nereid shape's being transformed into the figure of Eve as she
was evoked from the side of sleeping Adam. The idea occured
first of all to that lonely exponent of bodily grace in the four-
teenth century, the sculptor who designed the story of the
Creation and Fall on the façade of Orvieto Cathedral. He
seems, almost certainly, to have been the Sienese architect
Lorenzo Maitani, and he would thus have been familiar with
several Nereid sarcophagi, one of which was set over the door-
way of the Cathedral workshop in his home town. His Eve
[227], of course, is flatter and less voluptuous than a Nereid
and, instead of staring at her companion with level, amorous
gaze, she turns her long, serious face with an air of submission
to God the Father. But her derivation is unquestionable, and

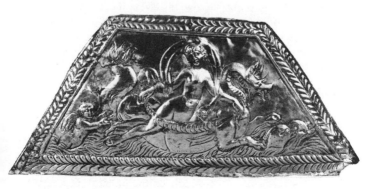

224. *Late antique, c. A.D. 370. Casket of Projecta*

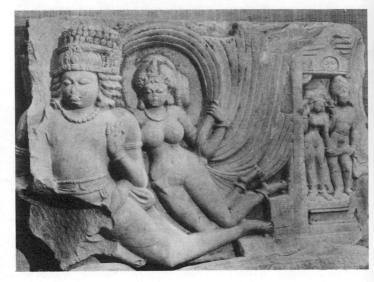

225. Indian, 6th century A.D. Flying Gandharvas

she has retained, with her actual shape, some of the dreamlike quality of the original sea festival.

Over a hundred years later Ghiberti, who was familiar with the sculptures at Orvieto, uses the same idea in the second doors of the Baptistery. He was a student and collector of antiques, and so was able to give his Eve a more classical sweep than was possible in the preceding century. She is not derived from a placid, passenger Nereid, but from one of her more active sisters; and the source of her shape has determined her character. The Eve at Orvieto is modest and obedient; Ghiberti's Eve is bold, the first, perhaps, of all the proud, naked beauties of the Renaissance [228].

Ghiberti, by his artful mixture of Gothic and classic rhythms, evolved a style that is often curiously outside its epoch. Many of his figures, if seen in isolation, could be dated a hundred years later. But when we find the same antique motives in the work of his contemporaries we realize how powerful the Gothic style remained right up to the middle of the fifteenth century. An example is the group of drawings by Pisanello and his pupils

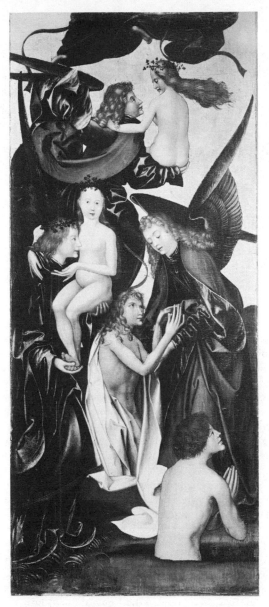

226. *Hans Fries. Detail of Last Judgment*

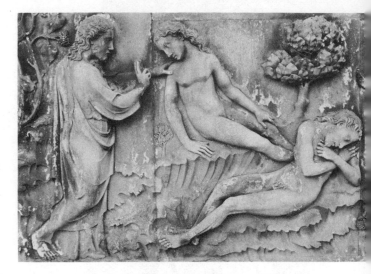

227. Lorenzo Maitani. Creation of Eve

that are copies of Bacchic sarcophagi in the Campo Santo. No part of the body, chest, stomach, or thighs is given its simple geometric shape, but each is accented and articulated with a restless eye for detail. Little is left of the antique except the iconographic motive. Yet Pisanello did not think of these pagan shapes purely as decoration. His figure of *Luxury* in the Albertina shows that he has recognized the character of the most enthusiastic Nereid, and has added to her abandoned pose an evil thinness, a kind of Baudelairean corruption, that is quite unclassical [*229*].

As archeological knowledge progressed, this free, creative attitude to antiquity declined. I have mentioned more than once the sketchbooks containing drawings of antique sculpture and architectural detail that were part of the stock in trade of certain *quattrocento* workshops. Turning the pages, we see how much in demand were the subjects of Bacchic and Nereid sarcophagi; and the comparison of a drawing in the so-called Codex Escurialensis with the original sarcophagus from Santa Maria in Trastevere, now in the Louvre, shows how self-effacingly, and on the whole, accurately antique art was being

228. Ghiberti. Creation of Eve

recorded and diffused during the last decade of the fifteenth cen-
tury. From this dead level of antiquarian knowledge there
emerged those works of genius, Mantegna's engravings of
Tritons and hippocamps fighting, in which pedantry is trans-
formed by a severe and scrupulous technical skill. In fact,
Mantegna's use of depth is entirely unantique, but it is improb-

229. *Pisanello. Luxury*

able that he realized this, for his mind was fixed on giving to
every detail a form that could be justified by reference to some
vase, gem, or relief.

The opposite approach to antique art, in which context and
accuracy are ignored, and only the rhythmic life is maintained,
may be seen in two works of decorative art in Florence, Dona-
tello's *Cantoria* [230] and Pollaiuolo's frescoes in the Torre del
Gallo [231]. For many reasons, I have excluded children from
this study of the body; but Donatello's *putti* must be an excep-
tion, for they are primarily symbols of Dionysiac abandon, and
the childish character of their bodies is forgotten in our sense of
liberated animal life. If in a photograph we cover their heads,
our first glance reveals a Bacchic sarcophagus more intricate
and more vigorous than anything in antique art; and only on
looking more carefully are we aware of their fat tummies and
chubby legs. The transference of Skopaic poses, invented to

230. Donatello. Detail from Cantoria

convey the climax of physical passion, to the immature bodies of children accounts for the feeling of uneasiness, of perversion, almost, that this great masterpiece arouses in an unprejudiced mind. Pollaiuolo's frescoes in the Torre del Gallo have suffered no such violent transposition. They are simply the figures from Etruscan pottery enlarged to the scale of mural decoration. We recognize familiar satyr poses, expanded and made more realistic by articulate Florentine outline. Under the influence of his antique model Pollaiuolo has renounced the Renaissance craving for depth. The light figures, stripped of all accessories, are silhouetted against a background of flat color, and our whole attention is focused on their bodily movement. Our eyes, accustomed to the rigorous economies of cave men and of M. Matisse, may be grateful that for once a Renaissance painter has been willing to throw away some of the heavy baggage of his epoch.

Somewhere between the romantic archeology of Mantegna and the rhythmic re-creation of Pollaiuolo is the use made, throughout the *quattrocento,* of the maenad with clinging, windblown draperies. We find her first, I believe, in the predella of Donatello's *St. George,* and she remains, to some extent, a pretext for introducing the free, cursive rhythm of antiquity into the rigid groups of *trecento* iconography. Often she is no more than a decorative adjunct, or visitant from another world, joining, in an unaccountable manner, the company of staid Florentine ladies, such as those who come to the bedside of St. Eliza-

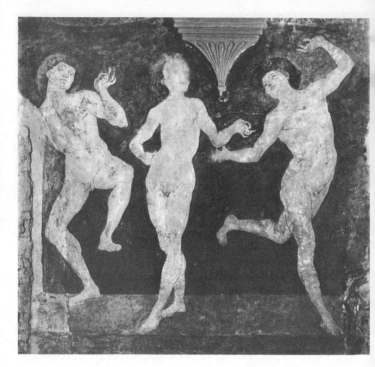

231. Pollaiuolo. Dancing Nudes

beth in a fresco by that least Dionysiac of painters, Domenico
Ghirlandaio. But, as with the Nereid, her symbolic intention is
not always forgotten, and it is in the person of Salome that she
most often appears. On Donatello's marble relief at Lille she is
in Herod's courtyard, dancing with arms raised above her head
and leg irresponsibly kicked up behind her; a few years later
we see her in Fra Filippo's fresco at Prato, where, however, she
is decorously clothed and retains something of Gothic stiffness.
Botticelli uses the same stock figure in the Sistine frescoes; and
not content to bring it in as a decorative adjunct, he makes the
closest transcription of a Bacchic sarcophagus of the whole
quattrocento in an engraving of Bacchus and Ariadne drawn on
their chariot. It could almost have been copied direct from a
relief, similar to one in Berlin; but the weary droop of Dionysos'

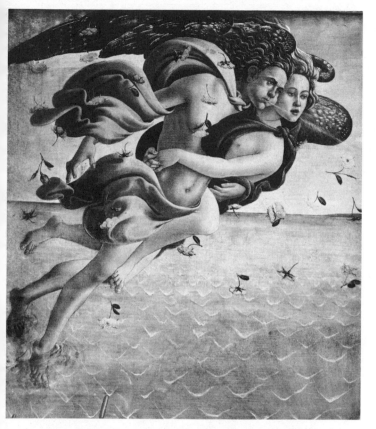

232. Botticelli. Winds (detail from Birth of Venus)

head and the half-trusting, half-diffident gesture of Ariadne re-
tain some Gothic delicacy of human perception and seem to be
of his own invention.

Far beyond such a direct tribute to antiquity are the two fly-
ing Zephyrs in *The Birth of Venus,* who are perhaps the most
beautiful example of ecstatic movement in the whole of paint-
ing. Here for the first time (if Indian art be excepted) we see
the defiance of gravity transferred from water to air. The
dream of buoyancy, with all that it implies of liberation, be-

233. Titian. Bacchus (detail from Bacchus and Ariadne)

comes more rapturous and more invigorating. As with the first
embodiments of ecstasy, the suspension of our reason is achieved
by the intricate rhythms of the drapery that sweep and flow ir-
resistibly around the nude figures. Their bodies, by an endless
intricacy of embrace, sustain the current of movement, which
finally flickers down their legs and is dispersed like an electric
charge. Though we may find precedents for them in the flying
Victories of antiquity, Botticelli's wind gods, like his Graces,

are an individual inspiration, without sources or successors
[232]. In the next century painters were to become much oc-
cupied with figures in the clouds, but only once again was the
ecstasy of flight brought so near to us, in the *Bacchus and Ariadne*
of Tintoretto. The nude is now an instrument in the hands of a
virtuoso; and the goddess Venus, who skims over the head of
Bacchus without causing us a moment's anxiety, was, from the
first, acclaimed a tour de force. Yet this triumphant artifice is
subordinate to a poetic purpose, and the flying figure is above
all a projection of eager longing and imminent delight.

It was in Venice, as Tintoretto's picture reminds us, that the
nude of Dionysiac ecstasy regained its original warmth; above
all, in the two great *Bacchanals* Titian painted for Alfonso
d'Este from 1518 to 1523. In these he imagines the protagonists
of an antique relief, with added splendor of flesh and colored
silks, transported from their abstract setting into a landscape as
sensuous as their bodies. In the *Bacchus and Ariadne* it is Bacchus
himself [233] who expresses the idea of ecstasy, by the turn of
his body, his fluttering drapery, and his momentary pose. In
the Madrid *Bacchanal* the reclining maenad [234], whom we
often find in the corners of sarcophagi, overcome by the gen-
erosity of the grape, has been developed into one of the most
splendid nudes of the High Renaissance, an ecstatic counter-
part to Giorgione's *Venus*. The utter relaxation of her head and
stretched-back arm had been used already as a symbol of luxury
by Perugino in the allegorical *Victory of Chastity*, which he
painted for Isabella d'Este's study, and was to occur again in
Poussin's *Bacchus and Midas*. Her firm, shameless torso must
have been in Goya's mind when he painted the *Maja desnuda*.

At the end of his life, with undiminished sensuality, Titian
again drew his inspiration from a scene of thiasos, this time
from an erotic Nereid whom he has transformed into a figure
of *Europa* [235]. But although the motive is antique, the concep-
tion of the nude is profoundly unclassical. Titian has painted
the open, full-blown body of his Europa entirely from nature,
without any of those astringent simplifications which hitherto
had refined away the accidents of the flesh. The folds and
puckers of her right leg are as far from the basic severity of the
Greek nude as anything in Rubens. Yet just as the Hellenistic
Hermaphrodite is saved from mere eroticism by harmony of form,

234. Titian. Reclining Maenad (detail from Bacchanal)

so this figure is raised to the highest realm of art by color and
by the glowing consistency of Titian's imagination, through
which he can both participate in and withdraw from the crea-
tive turmoil of the senses.

I have already contrasted the robust eagerness of Titian with
Correggio's delicate tremor of the flesh. They are the sun and
moon of sensuality. And it is this sense of nocturnal rapture
that Correggio has realized in his picture of Io submitting to
the cloudy embraces of Jove [236]. Her outline is like a pattern
of ecstasy, combining the thrown-back head of a maenad, the
naked flank of a Nereid, and the outline of a figure of Psyche
in a Hellenistic relief famous in the Renaissance as the *Letto di
Policleto;* and we can understand why this lineament of gratified
desire could fill an ill-balanced nature with destructive envy.
In the eighteenth century the picture passed into the possession
of Louis d'Orléans, son of a famous lecher, the Regent of
France. He at once ordered its destruction and is said himself
to have struck the first blow with a knife. Can Dionysiac symbol
ever have produced a more truly Dionysiac result! Fragments
of the canvas were surreptitiously collected by the gallery di-
rector, Charles Coypel, and put together: all but the head,
which had been completely destroyed. A merciful providence

reincarnated Correggio in the person of Prud'hon, who painted the present head.

The line between sacred ecstasy and profane, fine drawn at all periods of true religious fervor, was at its finest in the anxious years of the early sixteenth century. Correggio, the poet of pagan physical love, anticipated both in form and in sentiment the art of the Counter Reformation. That other precursor of baroque imagery, Lorenzo Lotto, more closely concerned with Lutheran ideas, could not admit Correggio's easy, catholic acceptance of the flesh. He did not paint the nude, and avoided pagan subjects. There is, however, one revealing exception, *The Triumph of Chastity,* in the Palazzo Rospigliosi [237]. In this the naked Venus, who is being driven away by an angry peasant Chastity, is taken direct from a Nereid sarcophagus. Lotto has not attempted to disguise his source, and has hardly varied the outline of the torso, partly, no doubt, because nude figures of this sort were unfamiliar to him,

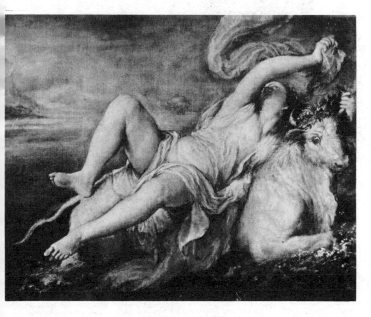

235. Titian. Europa

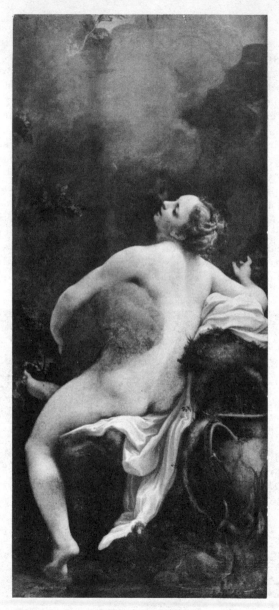

236. Correggio. Io

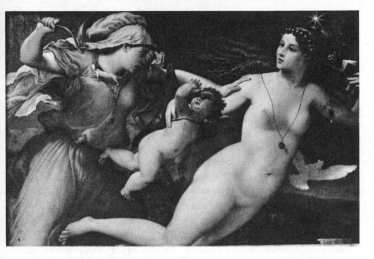

237. Lotto. The Triumph of Chastity

but partly because he felt that this Nereid was an accomplished symbol of desire. Just as the medieval sculptors understood the transports of the sea thiasos in a spiritual sense, and used the Nereids as blessed souls on their way to heaven, so Lotto has turned them the other way, the puritan way, as it was shortly to become, in which all that is expressed through the body is fundamentally evil.

Rubens is the noblest refutation of puritanism; and in an earlier chapter I have tried to show how his religious and his pagan painting are the fruit of a single well-grown tree. But although he imagined so many scenes of Dionysiac enthusiasm, nude embodiments of ecstasy are rare in his work. The catalogues tell us that his nymphs have been surprised by satyrs, but they show no sign of this emotion. They remain placidly seated, and, only once, in the picture in the Prado, is there a widespread commotion. Nor do they give the feeling of freedom from gravity that characterizes the nude of ecstasy as I have described it. They do not fly or float or seek to lose contact with the earth, of which they are such welcome offspring. On the other hand, Rubens' religious pictures often contain ecstatic gestures and expressions that show that such transports

were not unknown to him. In this he showed himself a true son
of the Catholic Reformation, which, although it encouraged a
condition of spiritual self-surrender that was certainly not de-
void of sensuality, also frowned on the pagan nudity of the
Renaissance. It is a proof of the sincerity with which Rubens'
saints turned their eyes to heaven that (unlike Raphael) he did
not give the same expression to Venus and Diana.

The Church's opposition to the nude was more effective in
Italy than in the North, and the saints in ecstasy who play so
prominent a part in the imagery of Bolognese and Roman
baroque are all enveloped in waves of billowing drapery. Out
of the seventeenth century only one ecstatic nude comes to
mind, the marble carving in which Bernini, taking as his points
of departure the *Apollo Belvedere* and a Nereid sarcophagus, has
transformed them, through the unifying bouyancy of the baroque
style, into the beautiful group of *Apollo and Daphne* [*238*]. This
is the ecstasy of metamorphosis. All the figures described in this
chapter have symbolized through the body some change or
translation of the soul; and here Bernini has imagined how,
when the body itself is changed, it must be like one of those
great ecstatic moments, love, levitation, or the sudden lift of a
wave.

While, from Titian to Bernini, ecstatic motives were being
used to enhance the sensuality of the nude, they were also
being employed, as they always have been, in the interests of
decoration. It may seem slighting to apply this word to Raphael's
Galatea [*239*], and of course his great fresco is in a different
category of art from the Mildenhall plate; and yet, compared
to Botticelli's *Birth of Venus,* decoration it remains, voluntarily
renouncing just that sharpness of poetic reality which takes
root in the imagination and grows there with an independent
life. In the *Galatea* Raphael has taken the inhabitants of a
Nereid sarcophagus and, without greatly altering their occupa-
tions or their outlines, has given them a new character; or, per-
haps we should say, has given them back their old character,
for I cannot resist the fancy that the *Galatea* must be miracu-
lously like the great decorative painting of antiquity from
which, in the first instance, the Nereid sarcophagi derived. We
must suppose, however, that Raphael's figures are more fully
modeled than anything in early Greek painting and penetrate

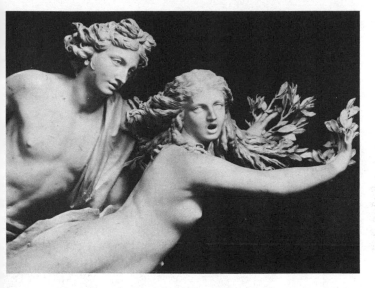

238. Bernini. Apollo and Daphne

further into space; and no doubt there is a difference in the whole intention of Raphael's design. Not only has he made the episodic oblong into an upright, but he has filled it according to the rules of Renaissance geometry. Galatea's head is the apex of a triangle, the upper half of the space is related to the lower by the golden section, and the two are joined by intersecting circles. We know from a preparatory drawing that Raphael followed the same scheme in the *Transfiguration*. In these ways the *Galatea* leaves the realm of narrative and entertainment, to which decoration normally belongs, and enters that of philosophy; and yet this is what makes its decorative qualities so deeply satisfying. A fresco in the Palazzo Vecchio by Vasari and Gherardi, in which all the elements united by Raphael into a logical system are once more spread out episodically over the surface, fails as decoration, for it has not recaptured the close, rhythmic structure of an antique relief, and we see how these nude figures, which seemed to be ornamental material of universal value, were in fact dependent on their close relationship with one another.

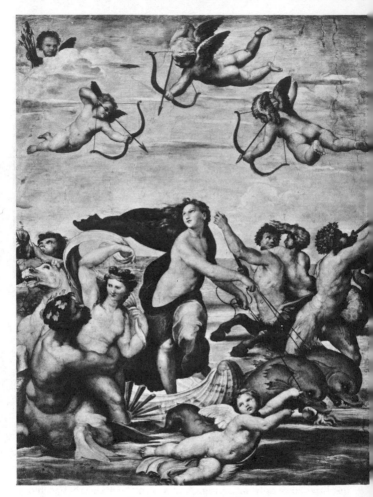

239. *Raphael. The Triumph of Galatea*

In the seventeenth century two beautiful *Triumphs of Galatea*,
by Agostino Carracci [240] and Nicolas Poussin [241], show al-
ternative methods by which this can be done. Carracci reverts
to the classical oblong and almost to the classical sense of space.
His figures are not taken direct from antiquity, but he has

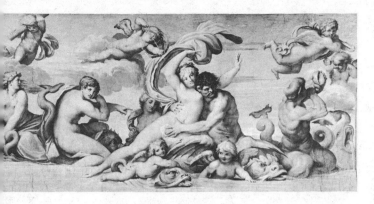

240. Carracci. The Triumph of Galatea

given them that air, at once sensuous and detached, which fits them for classical decoration. His pictorial imagination is less fresh and vigorous than that of Raphael; indeed, the Galatea herself is more artificial than anything in antiquity. In antique sarcophagi the Nereids who balance on the tails of Tritons must have been studied from nature, for they are in exactly the pose adopted by their daughters in modern Italy who occupy an equally precarious seat on the pillions of motor scooters. But the attitude of Carracci's Galatea, like Guido Reni's *Samson,* is a piece of coloratura, in which the vocal line is accompanied by the orchestra of her floating drapery. The classical relief composition that Carracci has employed so skillfully cannot suppress the fact that he is a master of the baroque. Poussin follows the opposite system, and proves the fundamental truthfulness of antique art. Almost every figure in his *Triumph of Galatea* is taken from an antique in pose and outline, but has been studied over again from nature. Most characteristic are the two Nereids to the right. Although both are to be found on sarcophagi, he has accentuated their modeling and recombined them so that they achieve that quality of counterpoint, that logical interplay of contrary directions, which was his peculiar gift.

As if to encourage the art historian in his analytic functions, Boucher's *Triumph of Galatea,* in Stockholm, illustrates a further stage of the same idea. Instead of Poussin's logic, everything

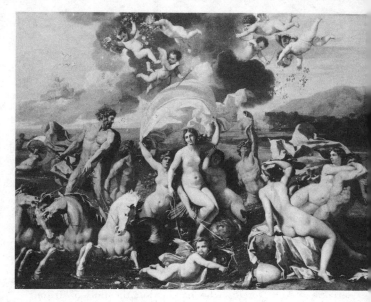

241. Poussin. The Triumph of Galatea

appears to be the result of fancy and happy coincidence. In fact, the picturesque façade of rococo conceals a solid science of composition, but the flickering outlines and wayward interruptions put us off our guard. Everything is in movement. The figures loll on the waves with a new abandon, and the customary loop of drapery breaks away and flies up into the air. Sweet, plump, and desirable, the Nereids have evidently been studied from nature and then transferred, with no loss of substance, into a setting of enchanting unreality. If art, like cookery, existed solely to gratify the senses, it could hardly go further.

The nude of ecstasy has continued to provide decorative material till the present day. In the nineteenth century, when decoration was not so much a matter of stylistic conviction as of horror vacui, the vacant spaces in theaters and restaurants were filled with a vulgarized Dionysiac imagery unrelated to the real creative impulses of the time. Only one man, perhaps, gave this commercialized decoration any distinction, the sculptor Carpeaux; and his group on the Paris Opéra representing

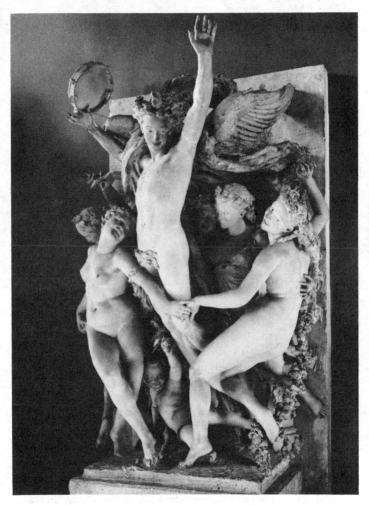

242. *Carpeaux. Dance*

The Dance [242] provides a link between the false art of the postindustrial epoch and the true art that preceded it. Its relationship with Bernini's *Apollo and Daphne* is obvious, and the female figures prolong the tradition of eighteenth-century French

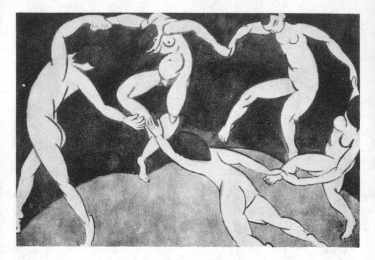

243. Matisse. Dance

sculptors like Pajou and Clodion. They are, on comparison, lacking in style and substance, and their smiles betray the slightly vulgar self-consciousness of the Second Empire; but Carpeaux has given to the whole group the genuine movement of the dance, so that we discount the details and abandon ourselves to the ancient rhythms of ecstasy.

Ecstatic art began with the dance; and heaven knows what splendid decorative paintings of Dionysiac dances are lost to us. We can only guess at them from Etruscan tomb paintings (no doubt executed by wandering Greek artists who carried with them memories of Attica and Ionia), and from the scenes of ritual dancing that, from the mid-sixth century onward, are to be found on some of the finest Greek vases. It is not by chance that two of the chief decorative paintings of our own day continue the same theme. These are the two great decorations by Henri-Matisse, the first commissioned by Stchukin in 1909, and still, I suppose, hanging in Moscow; the second commissioned by Dr. Barnes in 1931 and almost equally inaccessible in the suburbs of Philadelphia. The ring of dancing figures of 1909 was one of the most revolutionary works of its time. It was painted with an inspired frenzy that Matisse seldom re-

gained, and communicates more vividly than any work since the Renaissance the sense of Dionysiac rapture. Matisse maintained that he had taken his theme from the rhythms and gestures of the farandole; perhaps the sophisticated transports of Isadora Duncan also had some influence; but artistically he has not disguised his indebtedness to early Greek painting, and has revived not only the severe concentration of an expressive silhouette but also the actual movements of sixth-century dancers. Whether he was also aware of Pollaiuolo's frescoes at the Torre del Gallo [231], I cannot say, but, in fact, the enlargement of the Greek motives has produced a very similar result [243].

Over twenty years later, when Dr. Barnes commissioned the decorations at Merion, Matisse had come to mistrust the spontaneity of his earlier style. Partly in order that his murals should not compete with the great pictures in the gallery for which they were destined, and partly on account of a growing preoccupation with essences, Matisse has eliminated all the life-giving accidents inherent in the subject. Such Cartesian maenads may seem to involve an internal contradiction; and yet the drastic simplifications imposed, stage by stage, on Matisse's design have preserved the fundamental rhythms of Dionysiac art. We recognize (in the first series) a figure remarkably similar to the central dancer in the Carpeaux, we discover the familiar satyr with head thrown back, who is ultimately changed into a woman; above all, we are aware of that feeling of levitation and escape which is the essence of the ecstatic nude. In the first series half the figures have actually shot up out of the lunettes so that only their legs remain visible—a movement that, as photographic records show us, took place progressively as the work proceeded. Like all Dionysiac art, they celebrate the up-rushing of vital forces breaking through the earth's crust.

For the nude of ecstasy, even when it seems to be only a factor in decoration, is always a symbol of rebirth. Throughout its history it has been associated with resurrection—on the sarcophagi of ancient religion, where it shows the solemnizations of fertility or the passage of the spirit to new abodes; as the Blessed Souls in the Last Judgment, even in the early Renaissance Eve who rises out of the side of her sleeping spouse. Indeed, the "lesser Olympus" of Demeter and Dionysos had

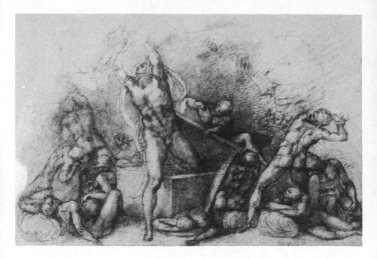

244. Michelangelo. Resurrection

been peopled under pressure from the most ancient of all re-
ligious instincts, those aroused by the rebirth of vegetable life
after the deathlike sleep of winter. And, with this serious theme
in mind, we may turn back from water frolics and decorative
dances to the greatest embodiments of ecstatic movement in
art, Michelangelo's drawings of the *Resurrection*.

The subject began to occupy his mind in about the year 1532,
at a period of his life when the physical beauty of the antique
world had laid its strongest enchantment on him, and seemed
to have been reborn in the person of Tommaso Cavalieri. Yet
his Christian meditations continued, and of all the themes they
suggested to him, none was more apt for pagan interpretation
than that of the slain God emerging from the tomb. Icono-
graphic tradition had shown him only half awake from the
trance of death; but Michelangelo imagined him as the em-
bodiment of liberated vitality. A carefully worked-out draw-
ing at Windsor [244] shows a Dionysiac scene beyond the
imagination of antiquity. The sleeping soldiers to left and right
are in the poses of bacchanalian stupor, the naked man start-
ing back is like an astonished satyr; but the figure that bursts
out of the tomb, gigantic and irresistible as a force of nature,

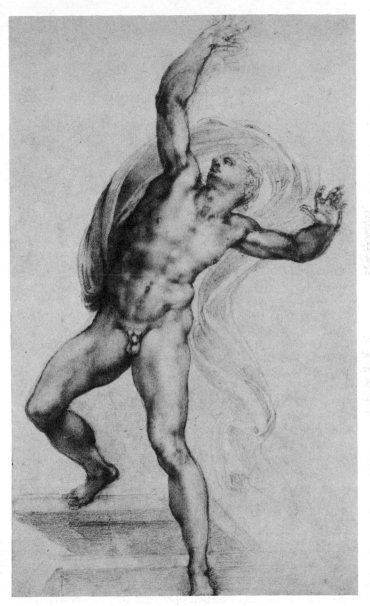

245. *Michelangelo. Risen Christ*

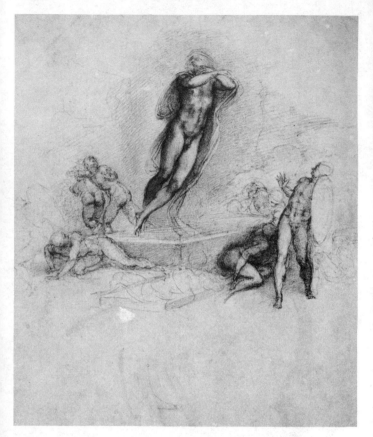

246. Michelangelo. Resurrection

has a rhythmic singleness of purpose that classic art never at-
tempted. In antiquity the actual facts of the body were too im-
portant for them to be so subordinated to expression. Not that,
in treating this theme, Michelangelo has wished us to forget
the physical beauty of his reborn God. A finished study of the
risen Christ, also at Windsor [*245*], is perhaps the most beauti-
ful nude of ecstasy in the whole of art. The thrown-back head,
the raised arms, the momentary pose, the swirl of drapery, are
all those of the old Dionysiac dancers. But how marvelously,

even at this period of physical desire, Michelangelo has suc-
ceeded in spiritualizing the body!

Whether or not it is the latest of the series, Michelangelo's
last word on the subject is a drawing in the British Museum
[246] in which the risen Christ does not burst from his sarcoph-
agus like an explosion, but glides irresistibly into the air. It is a
movement more marvelous than any display of energy, and in-
tensifies the visionary character of the scene. The guards, no
longer like startled satyrs, gaze at him with awe, as if they were
astonished as much by his divine beauty as by his emergence
from the tomb. Perhaps no other nude by Michelangelo con-
forms more closely to our modern ideals of physical grace. If
we compare this risen Christ with an image of earth-bound
human beauty, as Michelangelo conceived it, that dreamer
who is only just awakening to the claims of spiritual life, in the
drawing known as *A Dream of Human Life,* we realize how
consciously he has refined away the encumbrances of flesh and
muscle. It is the same process that was to lead to the tragic
mutilation of the *Rondanini Pietà;* but as yet he has not lost faith
in physical perfection, and feels it almost as a recommendation
to a higher world. *Ascender vivo fra gli spiriti electi:* these words in
one of Michelangelo's sonnets summarizes his life's ambition,
and nowhere more than in this drawing, where the human
body, for all its sensuous beauty, has freed itself from the pull
of the earth, do we feel that this prayer has been answered.

VIII

THE ALTERNATIVE
CONVENTION

Roots and bulbs, pulled up into the light, give us for a moment a feeling of shame. They are pale, defenseless, unself-supporting. They have the formless character of life that has been both protected and oppressed. In the darkness their slow, biological gropings have been the contrary of the quick, resolute movements of free creatures, bird, fish, or dancer, flashing through a transparent medium, and have made them baggy, scraggy, and indeterminate. Looking at a group of naked figures in a Gothic painting or miniature, we experience the same sensation. The bulblike women and rootlike men seem to have been dragged out of the protective darkness in which the human body had lain muffled for a thousand years. Given my initial distinction between the nude and the naked, it may be asked by what excuse the Gothic body is included in this book at all. The answer is that since nakedness was required in certain subjects of Christian iconography, the body had to be given a memorable shape, and in the end the Gothic artists evolved a new ideal. We may call it the alternative convention.

In the first centuries of Christianity many causes had combined to bury the nude. The Jewish element in Christian thought condemned all human images as involving a breach of the second commandment, and pagan idols were particularly dangerous because, in the opinion of the early Church, they

247. Rogier van der Weyden. Last Judgment (detail)

were not simply pieces of profane sculpture, but were the abode
of devils who had cunningly assumed the shapes and names of
beautiful human beings. The fact that these gods and goddesses
were, for the most part, naked gave to nudity a diabolical
association that it long retained. But iconoclasm and supersti-
tion were in the end less powerful factors than the new attitude
to the body that accompanied the collapse of paganism. To
some extent it was a survival of the old Platonic contention
that spiritual things were degraded by taking corporeal shape;
and this, like so much else in Hellenic philosophy, became
amalgamated with Christian morals. We still say morals. Mod-
ern psychologists might maintain that the privations enjoined
by the founders of monasticism, their denunciations of the
pleasures of the senses, and their wholesale condemnation of
women were not so much ethical judgments as symptoms of
hysteria or of mental illness. Yet they were, and have remained,
effective. Even today we cannot turn the pages of Petronius or
Apuleius without being slightly shocked by the absolute matter-
of-factness with which the antique world accepted the body,

248. German, c. 1235. Adam and Eve

with all its animal needs; and perhaps in the end the half-crazy austerities of the anchorites were necessary in order to establish a balance between spirit and senses.

But as a result the body inevitably changed its status. It ceased to be the mirror of divine perfection and became an

object of humiliation and shame. The whole of medieval art is a proof of how completely Christian dogma had eradicated the image of bodily beauty. That human beings were still conscious of physical desire we may assume; but even in those subjects of iconography in which the nude could properly be represented the medieval artist seems to show no interest in those elements in the female body which we have come to think of as inevitably arousing desire. Did he deliberately repress his feelings? Or is our own delight in a body, like our appreciation of landscape, partly the result of art; dependent, that is to say, on an image created by a succession of peculiarly sensitive individuals? At least there is no doubt about the puritanism of the Christian tradition as we see it, for example, in the first full-size, independent nude figures of medieval art, the *Adam* and the *Eve* at Bamberg. Their bodies are as little sensuous as the buttresses of a Gothic church. Eve's figure is distinguished from Adam's only by two small, hard protuberances far apart on her chest. Yet these statues have a gaunt nobility and an architectural completeness that make them nudes and not naked people [248].

In general, the unclothed figures of the early Middle Ages are more shamefully naked, and are undergoing humiliations, martyrdoms, or tortures. Above all, it was in this condition that man suffered his cardinal misfortune, the Expulsion from Paradise; and this was the moment in Christian story of his first consciousness of the body, "They knew that they were naked." While the Greek nude began with the heroic body proudly displaying itself in the palaestra, the Christian nude began with the huddled body cowering in consciousness of sin.

The reformulation of the naked body through Christian art took place in the West. Although nudes appear in Byzantine artifacts as late as the ninth century, occupying the labors of craftsmen when sacred subjects were prohibited, they are no more than freaks in a backwater of antiquarian dilettantism. In contrast to the naked imps of the Veroli Casket, hopping and twirling with the irresponsibility of anachronisms, the Adams and Eves of early Romanesque art are heavy and crude. They follow a scheme of stylization found in the most primitive representations of the figure. Eve's breasts hang down flat and formless, and there is no other attempt to suggest that the structure of her body differs from that of Adam. At the begin-

249. Wiligelmus, c. 1105. Adam and Eve

ning of the eleventh century there is a certain advance. Wili-
gelmus, who carved the reliefs on the façade of Modena
Cathedral, was so intent on telling his story that he gave his
Adam and Eve [*249*] a touching seriousness; but almost fifty
years later, on the façade of San Zeno in Verona, the figures
are still inexpressive blocks. The earliest works of medieval art
in which the naked body becomes articulate are the five scenes
of the Creation and Fall on the bronze doors of Hildesheim,
executed for Bishop Bernward between 1008 and 1015 [*250,
251*]. They probably reproduce illustrations of a manuscript of
the school of Tours and through it are remotely connected with

250. *The Fall* c. *1010*. *Hildesheim*

classical antecedents; but the sculptor's use of the figures is
unantique, not solely from lack of technical skill, but because he

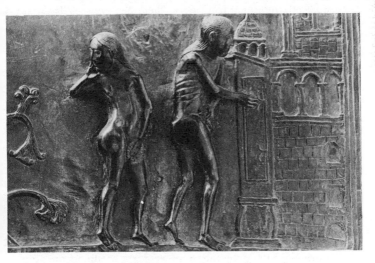

251. *The Expulsion* c. *1010*. *Hildesheim*

252. French, 12th century. Eve

is aiming above all at dramatic expressiveness. In this he suc-
ceeds beyond every other sculptor of the early Middle Ages.
Our first parents, accused of their sin, wince and double up with
shame. Adam accuses Eve, and Eve accuses the serpent with a
gesture of astonishing truth; and when they are expelled from
the garden, Adam marches resignedly forward, while Eve turns
back with a movement so revealing and so complex that ana-
tomical crudities are forgotten. For the next two centuries the
sculptors of naked Eve in Romanesque and early Gothic style
render the body with a kind of prehistoric brutality. Almost the
only exception is the lintel of a door from Autun Cathedral, in
which Eve crawls or crouches on the ground. This beautiful re-
lief makes an effect curiously like that of early Indian sculpture,
but the similarity lies in the balance of form and decorative de-
tail and the filling of the space rather than in any likeness of
physiology. Compared to the swelling thighs and abundant
bosoms of Maurya sculpture, the *Eve* at Autun is hard, flat,
and ribbed like a tree trunk. Her body is still an unfortunate
accident of her human condition, and instead of being presented
as the summit of visual experience, it is made to go on all fours
with ornamental leaves and fabulous animals [*252*].

 In the middle of the thirteenth century, at almost the same
date that the Gothic sculptors began to look attentively at

leaves and flowers, and illuminators to look at birds, a new direction in iconography forced artists to study the naked human body. This was the decision that the encyclopedic history of human life portrayed on the great cathedrals should no longer end with the Apocalypse, but with the Last Judgment as described in the twenty-fourth and twenty-fifth chapters of St. Matthew. Human beings were to take the place of winged bulls and many-headed monsters. It was a visible victory for the humanism of the twelfth century; and in the instructions for artists usually followed, those contained in the *Speculum* of Vincent of Beauvais, the subject is given an interpretation directly derived from the humanist philosophy of Greece. It states that in the Resurrection the figures rising from the grave must not only be naked, but that each one must be in a state of perfect beauty, following the laws of his being. What, we may imagine, were the feelings of a medieval craftsman confronted with this subject so greatly at variance with all those for which he had learned a traditional stylistic equivalent? Where did he look for his material? In the twelfth century, as at Autun, he took it from manuscripts, and his figures are mere puppets. But with the growing naturalism of the thirteenth century he sought other models. No doubt he looked at classical sarcophagi, as the sculptors at Chartres and Rheims had done, and found in defeated Gauls attitudes in which to represent the damned. But he must also have studied the figures from life, and probably have had recourse to those institutions so much condemned by medieval moralists, the public baths. When, in the fifteenth century, communal baths are represented in manuscripts, we recognize forms already made familiar in the Last Judgments of the preceding century.

Not all thirteenth-century patrons could bring themselves to accept the official iconography of the Resurrection. At Notre-Dame in Paris, for example, the figures were shown clothed, and at Rouen they are draped in their shrouds. But in the famous *Last Judgment* at Bourges [253] the sculptor has looked at the human body with an interest that had not been shown since antiquity. The man seen from behind pushing up the lid of his tomb has an action and a muscular back worthy of the *quattrocento*. In the middle of this group stands a maiden of confident virtue who shows, for the first time, the Gothic style ap-

253. French, 13th century. Last Judgment

plied to the female nude. Her body is exactly what we should
expect the bodies of the Virgins on Gothic ivories to be like if,
by some impious accident, they were divested of their exquisitely
stylized draperies. Her form must owe something to the study
of antique fragments; she has, for example, a Polykleitan
stance, with the weight of her body borne on the right leg. But
unlike those medieval sculptors who incorporated the Nereids
of late-antique industrial art as complete rhythmic entities, the
Bourges master has reduced the classical model to the more
rarefied Gothic style. The supporting hip is not a sensuous arc,
but flattens out immediately after the hipbone. The chest and
stomach are also flattened into a single unit, in which the small
breasts are placed far up and far apart. It was the perfect
Gothic formula for the female nude, and if it was not im-
mediately adopted, that is because few other sculptors could

have been available at the time with the Bourges master's interest in the body and skill in depicting it.

The other great series of nudes in the high Middle Ages is to be found on the façade of the Cathedral of Orvieto, and dates from the early fourteenth century. The sculptor Lorenzo Maitani had a strong personal interest in the subject, and deliberately chose to portray those scenes of sacred iconography, the Creation and Fall of Man and the Last Judgment, in which the nude must appear. I have pointed out in the preceding chapter how his Eve rising from Adam's side [227] was inspired by a Nereid sarcophagus, then familiar to the sculptors of Siena. Her small breasts and large head follow the Gothic proportions, and in the scene that shows her standing beside the tree, listening to the admonitions of the Almighty, she scarcely differs from the medieval mold. But she is also delicately feminine, and we feel, almost for the first time, that a Christian artist has recognized the body as something that might contain and express the soul. The same is true of the sleeping Adam. His limbs flow into one another with a sweetness that only an artist who loved the human body could perceive; and yet, as with Raphael, the body seems to reflect a state of spiritual grace. In the *Last Judgment* [254] Maitani returns to the tradition of the Northern cathedrals. The melodious intervals of his Eden are abandoned in favor of the densely crowded, evenly accented composition that the Pisani had taken over from antique battle sarcophagi. Some of the figures are inspired by dying Gauls; others are completely Gothic, with tattered movements similar to those at Bourges. Right up to the time of Michelangelo the Last Judgment kept this character of an infernal rubbish heap, as we see it in Memlinc's altarpiece in Danzig, where the broken and the uprooted have no cohesion, but only the haphazard angularity of haste. In Rogier van der Weyden's great polyptych at Beaune, the source, no doubt, of Memlinc's inspiration, the figures retain their identity, but still have the sharp scissor movements of the Gothic Judgment [247]. They are amongst the most highly wrought nudes of terror, an open, distracted cry, contrasting with the inturned, buried misery of Masaccio's *Expulsion from the Garden of Eden*.

In its final form, which lasted for over a century, the alter-

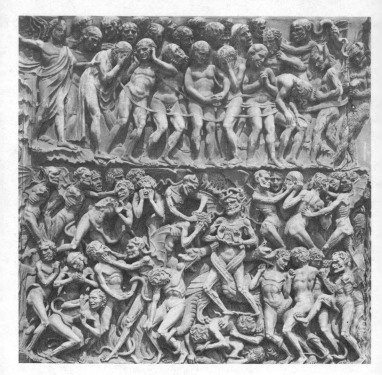

254. Maitani. Last Judgment

native convention seems to have been evolved as part of the so-called international Gothic style. It first appeared in France, Burgundy, and the Low Countries about the year 1400, and the earliest datable example is in the manuscript known as the *Très Riches Heures* of the Duc de Berri, executed in about 1410 by the brothers De Limbourg. One miniature shows the story of the Temptation and Fall of Man [255]. Within the Garden of Eden, circular like the known world, Eve is as naked as a shrimp, and seems at first entirely ignorant of her condition. But as she is reproved by the Almighty she grows conscious of shame, and when she is expelled through the traceried portico of paradise, she is in the attitude of the Venus Pudica, with a fig leaf before her. The brothers were acquainted with classical

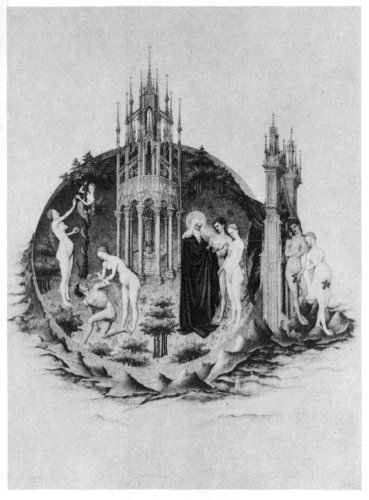

255. Limbourg. The Fall

models, for their kneeling Adam is taken from an antique
statue of a conquered Persian or Gaul similar to those in the
Attalos groups at Naples. Here, and elsewhere, they leave us
in no doubt that they appreciated the classical ideal of physical

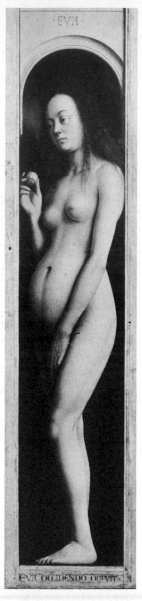

256. Van Eyck. Eve (detail of Altarpiece)

beauty and could reproduce it, if they chose to do so. But in the naked Eve they did not so choose, and have deliberately created, or adapted, a new feminine shape, which was to satisfy Northern taste for two hundred years. Their Eve has the elongated torso we first observed in *The Three Graces* of Pompeii. But the essential structure of her body is very different from that of Hellenistic art, however orientalized. Her pelvis is wider, her chest narrower, her waist higher; above all, there is the prominence given to her stomach. This is what distinguishes the Gothic ideal of the female body: that whereas in the antique nude the dominating rhythm is the curve of the hip, in the alternative convention it is the curve of the stomach. This change argues a fundamental difference of attitude to the body. The curve of the hip is created by an upward thrust. Beneath it are bone and muscle, supporting the body's weight. However sensuous or geometric it may become, it remains in the end an image of energy and control. The curve of the stomach is created by gravity and relaxation. It is a heavy, unstructural curve, soft and slow, yet with a kind of vegetable persistence. It does not take its shape from the will but from the unconscious biological process that gives shape to all hidden organisms.

Perhaps this is what historians have in mind when they say that the Gothic nude is realistic, for the words "realistic" and "organic" are often confused. If the former be taken to mean "imitating a conjectural average," it is incorrect, for relatively few young women look like a Gothic Eve. But it is true that two painters of unflinching truth portrayed their Eves in this convention. The first is Van Eyck, and his Eve in the Ghent altarpiece is a proof of how minutely "realistic" a great artist may be in the rendering of details and yet subordinate the whole to an ideal form. Hers is the supreme example of the bulblike body. The weight-bearing leg is concealed, and the body is so contrived that on one side is the long curve of the stomach, on the other the downward sweep of the thigh, uninterrupted by any articulation of bone or muscle. Above this relaxed oval the two spheres of the breasts also feel the pull of gravity, and the head itself weighs heavily on the neck [256].

The other unforgettable Eve of fifteenth-century Flemish painting is in the small painting of the Fall by Hugo van der Goes, now in Vienna [257]. It was painted a generation later

257. *Van der Goes. Adam and Eve*

than the Van Eyck, but is in many respects less "modern," and
the pathetic little Eve, observed with loving accuracy, still il-

lustrates the unfortunate condition to which the female body
was reduced in the medieval mind. We may legitimately see
her as the descendant of the Eve in the Hildesheim doors, with
very similar proportions, although of course with a more ac-
curate command of such anatomical details as the placing of
the breasts. The docile mother of our race, homekeeping, child-
bearing, flatfooted with much serving, has seldom been de-
picted with so little attempt to modify the humble usefulness of
her body. But can we be quite sure that these unathletic pro-
portions, which are far from our own idea of grace and de-
sirable beauty, aroused the same responses in a man of the
fifteenth century? Several examples suggest that they did not.

From the same circle of taste as Van der Goes' Eve, and
painted only a decade or so later, is a picture at Strasbourg, of
the school of Memlinc, that symbolizes female vanity [258], and
was presumably intended to embody sensual charm, unabashed
and irresistible. The components of *Vanitas'* body are identical
with those of a Gothic Eve: the same large, sagging stomach,
the same small breasts, the same short legs that can scarcely
carry their owner to church or market. Even in Italy the nude
Vanitas of Giovanni Bellini follows a similar pattern [259]. And
if it be argued that in these examples the painter had some
satiric intention, consider the alabaster figure of *Judith* by Con-
rat Meit [260], in the National Museum at Munich. She fol-
lows exactly the same bodily scheme as the Memlinc *Vanitas,*
but there can be no doubt that the sculptor has intended her
to be physically desirable; and after the eye trained in classical
proportions has allowed the first shock to subside, I think one
must agree that he has succeeded.

At this point, a century after it was created, the alternative
convention takes on a new character. From being an embodi-
ment of humility and shame it becomes a means of erotic
provocation. Given the nature of the Gothic nude, this was
perhaps inevitable. In the popular imagery of the Middle Ages
a naked woman had exactly the same significance she has re-
tained in popular imagery ever since. And the very degrada-
tion the body has suffered as a result of Christian morality
served to sharpen its erotic impact. The formula of the classical
ideal had been more protective than any drapery; whereas the
shape of the Gothic body, which suggested that it was normally

258. *School of Memlinc. Vanitas*

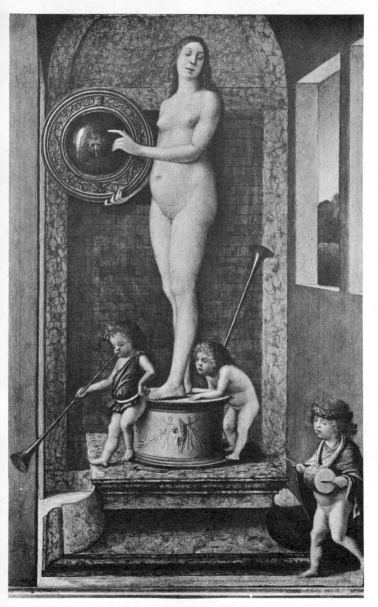

259. *Bellini. Vanitas*

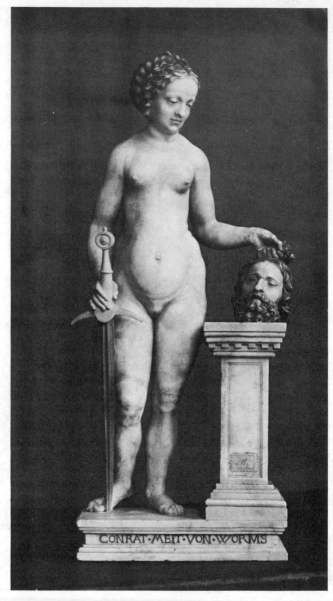

CONRAT · MEIT · VON · WORMS

260. *Conrat Meit. Judith.*

1293

261. Dürer. Naked Hausfrau

clothed, gave it the impropriety of a secret. When, toward the end of the fifteenth century, Northern artists became aware that a new liberation of the body had been taking place for some thirty years in Italian art, their feelings were those of schoolboys. They were shocked, curious, and impressed. We may study the progress of their emotions in the work of the cleverest schoolboy of all, Albrecht Dürer. As an apprentice he must have learned that naked women had become the subject of art, and in 1493 he made a drawing of a middle-aged Nuremberg *Hausfrau* in which horrified curiosity predominates [*261*]. A year later he began to study through prints and drawings the Italian masters of the nude, Pollaiuolo and Mantegna; and by the time he reached Venice he was prepared to be impressed. He made his first attempt to conquer the Italian nude, which he was to use in various drawings and engravings during the next years, notably in *The Dream,* where the female figure who troubles the drowsy scholar is intended to suggest a pagan goddess. Such classical fullness of form, however, was owing to an effort of will. His other nudes of the same period show how much more his eye, with its appetite for accident, sought for the peculiarities of the body. In the drawing of *The Women's Bath,* dated 1496 [*262*], Gothic curiosity and horror are still uppermost, mixed with memories of Italy. The figure on the left is almost Michelangelesque, the woman combing her hair in the center is taken from a Venus Anadyomene, and the woman kneeling in the foreground is purely German. The fat monster on the right confirms his feeling of the obscenity of the whole situation and must have been observed from nature, although he might not have thought of introducing her without the example of Mantegna's *Bacchanal* engraving, where, in fact, the fat bacchante is taken from an antique. The engraving of naked women known as *The Four Witches,* dated 1497 [*263*], shows clearly his unresolved mixture of curiosity and respect for classicism. He had seen and admired a relief of the three Graces, and may have set out with the intention of producing his version of the subject. But already in the central figure his eye became engaged by the heavy irregularities of flesh, and the left-hand female, a formidable German matron divested of her clothes but not of her local headdress, upsets the classical scheme altogether. So the three Graces become infernal gos-

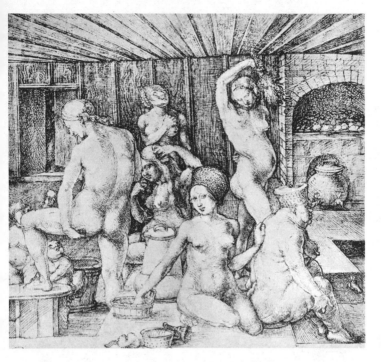

262. Dürer. Women's Bath

sips, with a skull at their feet and the devil peering round the corner.

The Four Witches has a further interest for us through its connection with an engraving of two naked women by the Venetian artist Jacopo de' Barbari. How far Dürer borrowed from Jacopo will always be a puzzle, because Jacopo's engravings cannot be dated with precision; but he was probably twenty years older than Dürer, and had achieved the position of court artist to the Emperor Maximilian in the year 1500. Moreover, we have Dürer's own word for it that Jacopo had shown him two figures, a man and woman, constructed on geometrical principles, when he was "still a young man and had never heard of such things"; which can only mean when he was in Venice in 1494. Jacopo was a somewhat feeble, though per-

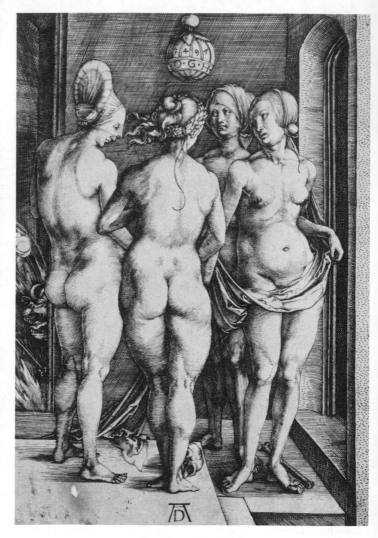

263. Dürer. Four Witches

sistent, draftsman of the nude, whose elongated females look as
if they were melting like fat tallow candles, and it is revealing

that Dürer could not discover more genuinely classical models.
But the examples of Rizzo and Bellini show that in Venice in
the 1490's a Gothic conception of the female nude was still
fashionable; and perhaps the latent Gothicism in Jacopo's
languorous figures made them easier for Dürer to assimilate
than the relics of antiquity, which ten years later were to in-
spire Giorgione. Dürer goes on to tell us that Jacopo had re-
fused to explain how his figures were constructed; thus setting
up in Dürer's mind the conviction that the classical nude de-
pended on a secret formula, a sort of masonic mystery guarded
by Italian artists in order to surpass their Northern colleagues.
In his determination to discover this secret Dürer began, and
continued throughout his life, the elaborate geometrical analysis
of the human figure that I have referred to in the first chapter.
But somehow he felt that the mystery had escaped him, and as
late as 1521, some years after Jacopo's death, he asked the
Regent of Malines to present him with Master Jacopo's book.
In common with all Northern artists, he found it hard to be-
lieve that the harmony of the classical nude did not depend on
a set of rules, but on a state of mind. In 1504, when he ex-
ecuted the engraving of *Adam and Eve,* he was in such a state
and produced two figures at least as close to the classical ideal
as anything in contemporary Italy. But the mood passed, and
even after his most sustained analysis of proportion his painting
of *Eve,* now in the Prado, remains essentially Northern. Thence-
forward his measured figures were not intended to demonstrate
an ideal of beauty, but to analyze various laws of growth; and
since his aim was no longer aesthetic but scientific, what may
be called his taste was free to revert to the bulbous proportions
of the early drawings.

The physical types evolved by Dürer in his attempt to recon-
cile the ideals of Nuremberg and Rome served as points of de-
parture for a whole group of Swiss and German artists who,
standing on his shoulders, could treat the nude without any of
his struggles and anxieties. To Urs Graf and Niklaus Manuel
Deutsch the fact that a painter was required to draw naked
women was a rather comical piece of good fortune, to be ac-
cepted with undisguised enthusiasm. Their drawings, which
date from about 1520 to 1530, show the broad-hipped, full-
bosomed, High Renaissance Venus translated, with no loss of

sensuality, into the alternative convention. An example is the
masked flute player by Niklaus Manuel Deutsch, whose stance
is entirely classical and who may be derived from a Marcantonio
engraving, but whose body has been turned round so that her
right side is outlined by her generous stomach, which runs up
to her breasts in an ogival sweep [264]. As a result, Dürer's
condition that "all things should rhyme alike" is better fulfilled
than in many of his own nudes. With Urs Graf this Gothic
swagger often degenerates into boisterous brutality. His *Lands-
knechte* are the men who sacked Rome and cut short the
revived authority of Apollo. His nudes are Venus Vulgaris undis-
guised, even when accompanied by the attributes of Renais-
sance pedantry. But his vitality is irresistible. A drawing at
Basel of a woman stabbing herself, hideous, horrifying, and
absurd, yet contrives to show the nude as a part of those
organic forces which control the growth of roots and knotted
trunks and assimilate it to the swirl of late Gothic ornament
[265].

There can be no doubt about the quantity or the kind of sat-
isfaction that patrons of art in the Germanic countries derived
from the nude during the first half of the sixteenth century. It
became so much an accepted part of decoration that in 1519
naked women, with supreme impertinence, appear on the title
page of Erasmus' New Testament. Hundreds of popular prints
and boxwood figures prove their popularity, and in the paint-
ings of Lucas Cranach they delighted the most fastidious con-
noisseurs of the day.

Cranach achieved a version of the Northern nude so personal
and so perennially seductive that his work must be considered at
greater length. Relatively early in his career, in 1509, he
painted a life-size *Venus and Cupid*, now in the Hermitage [266],
which clearly derives from a Mediterranean source. He is usu-
ally said to have been inspired by an antique or a drawing of
the antique; but the way in which the figure is presented
against a plain black background suggests that he had seen one
of those paintings of Venus, deriving ultimately from Botticelli,
which were fashionable in Italy during the last years of the
quattrocento. Those by Lorenzo Costa [267] are the closest sur-
vivors, but he may have known an original Botticelli and have
made his own stiff translation. Evidently, the patrons for whom

264. *Niklaus Manuel Deutsch. Masked flute player*

265. Urs Graf. Woman stabbing herself

Cranach worked in the provincial court of Saxony were too far
off the trade routes of fashion to relish the nude: or perhaps his
employer, Frederick the Wise, did not approve of it. For in

spite of his natural gifts for the subject he seldom attempted it again till late in the 1520's, and the surprising series of naked beauties for which he is famous date from after 1530, when he was sixty years old. Taste and morals had changed. The post-Reformation appetite for provocative nudity, which I have already noted, had spread to all the Protestant states of Germany, and Cranach's third patron of the Saxon house, John Frederick, must have had a personal liking for these desirable bibelots. The characteristic Cranach nude is, therefore, of a much later date than Dürer's experiments and bears no relation to the first attempts of Northern artists to master the Italian ideal. By this time, too, the Italian nude had been transformed, and we remember with a shock that Cranach's sinuous Lucretias are contemporary with the elongated figures of Pontormo. They are, indeed, most artful productions, in which elements of mannerism and revived Gothicism are mingled and concealed.

How successfully Cranach gave new style to the Gothic body can be seen by comparing his paintings to those of his contemporary who took the greatest pains with the nude, Jan Gossaert of Mabuse. Gossaert was in Rome in 1508 and returned to Flanders full of ambition to excel in the Italian manner. In 1509 he seems to have entered into some sort of partnership with Jacopo de' Barbari, and it is from Jacopo that he derived the model for several highly polished paintings of the nude, such as the *Neptune and Amphitrite* at Berlin. In other works, such as the *Adam and Eve* in the same gallery, the Italian attitudes are rendered with a painstaking Flemish realism. This unresolved mixture of conventions has the result of making Gossaert's nudes curiously indecent. They seem to push their way forward till they are embarrassingly near to us, and we recognize how necessary it is for the naked body to be clothed by a consistent style. This is what Cranach achieves. Endowed with a sense of chic that should make him the patron saint of all fashion designers, he evolved a decorative convention for the nude equal to that of tenth-century India. It is, of course, a development of the sprightly Eves of fifteenth-century manuscripts—a conscious development, for Cranach was an ingenious archaizer who did actual copies of fifteenth-century pictures; but his skill in combining sinuous line with shallow internal modeling is unprecedented in the North, and reminds us of Egyptian

PELLE · CVPIDINEOS · TOTO CONAMINE · LVXVS
NE · TVA · POSSIDEAT PECTORA · CECA · VENVS

266. *Cranach. Venus and Cupid*

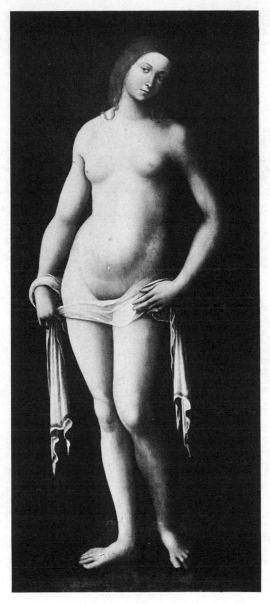

267. *Lorenzo Costa. Venus*

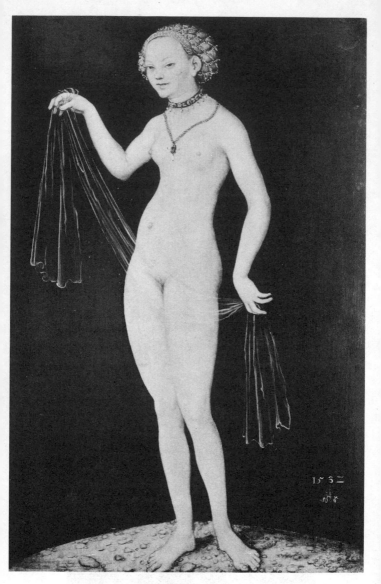

268. *Cranach. Venus*

reliefs. With this sense of style went a highly developed appetite that allowed him to convince us that his personal taste in physical beauty is our own. He takes the Gothic body, with its narrow shoulders and prominent stomach, and gives it long, slender legs, a slender waist, and a gently undulating outline. As a result, his naked charmers are as much to our taste today as they were to that of John Frederick the Magnanimous [268].

Cranach is one of those rare artists who have added to our imaginative repertoire of physical beauty. The necklaces and waistbands, enormous hats and filmy draperies, worn by his goddesses leave us in no doubt that he did so with an erotic intention; and it is curious how often Cranach has discovered devices used by purveyors of this kind of effect before and since. In some of his pictures of *The Judgment of Paris* [269] the rival ladies adopt exactly the same attitudes of seduction that we find in Indian painting of the eighth century [270] or in the illustrations of Ludwig Kirchner. Aphrodisiac art is seldom successful in Europe. Cranach succeeds because he does not exploit the advantage of his universally attractive subject to the neglect of his precise and delicate style. In spite of their sidelong glances, his sirens never cease to be *objets d'art*, to be enjoyed, by him who may, as dispassionately as crystals or enamels.

With Cranach the Gothic nude, in the narrow sense, fulfills itself and expires; but anticlassical proportions are still perceptible in the nude figures of Northern art up to the nineteenth century; and this elongated elegance retains its physical impact, even when it is most strained and unnatural. The real successor to Cranach was the Antwerp painter Bartholomaeus Spranger, who, as servant to Rudolf II, supplied the court with presentable erotica, based on his training with the Zuccaros in Rome, but Northern in their restless diabolism. The mannerist formula, which I have already described, was itself influenced by Gothic urgency, and was more easily acceptable in the North than the Euclidean proportions of Raphael. Rosso and Primaticcio, working at Fontainebleau, felt free to make their nudes extravagantly unclassical, although at the same time importing from Italy bronze casts of classical sculpture that convey the spirit of antique art almost more persuasively than the originals.

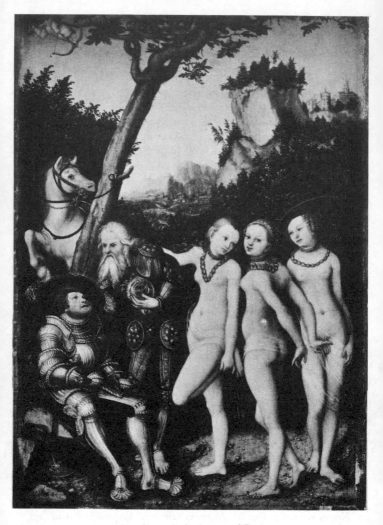

269. Cranach. Judgment of Paris

We must admit, however, that the most disturbing of all
anticlassical elongations was made by a Florentine in Florence.
It is to be found in a drawing by Pontormo where, as if in con-

270. *Indian Dancer. Ajanta caves*

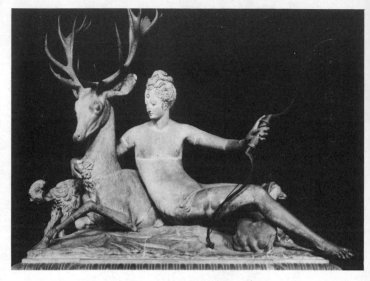

271. Goujon. Diana of Anet

scious defiance of antique measure, he has represented, or
caricatured, the most harmonious of all classical subjects, *The
Three Graces.* Their long, thin bodies are scarcely thicker than
their legs; their articulate arms twist in and out like branches.
They remind us of some insatiable creeper, ivy or ancient vine,
in which we often seem to discover obscene likenesses to the
human body, here, in Pontormo's drawing, startlingly con-
firmed. To some extent this strange distortion is owing to
Pontormo's personal taste, to some extent it is the result of
Michelangelo's cartoons for *The Last Judgment,* which domi-
nated and obsessed the Roman and Florentine artists of the
1530's almost as the work of Picasso has obsessed international
painting in our own day, and with a similar destruction of
order. Cellini's *Nymph of Fontainebleau,* executed in the same
decade as Pontormo's *Graces,* shows the same almost incredible
deformations.

The *Nymph of Fontainebleau* makes an uncomfortable impres-
sion, less, perhaps, on account of her proportions than because
Cellini, brought up on the tradition of *disegno,* could not quite

abandon himself to mere modishness. In the *Diana of Anet,*
traditionally ascribed to Goujon [271], unclassical proportions
are acceptable because the unknown carver was content to
produce a work of decoration, a superfashion plate, in which
peculiarities of drawing can be passed over. Instead of clearly
defined and logically related areas of form, each part glides
into the other, and the breasts, which gave a modulus to the
antique geometry of the torso, have practically disappeared.
All this is familiar in the Gothic nude, but the *Diana* is not
Gothic. Hers is not a body that is normally clothed. She is as
much at ease in her nudity as a Giorgione, and this sense
of poise, which is also a balance between the Northern and the
Mediterranean spirit, has made her almost a symbol of the
French Renaissance. It is interesting to find that the two other
nude figures of women that seem to fill, in French art, the
same symbolic role for their epochs remain fundamentally un-
classical, the *Diana* of Houdon, whose limbs and torso still
aspire to the elongated ovals of Gothicism, and the *Grande
Odalisque* of Ingres. Her long, sinuous body and legs perversely
crossed are closer to Primaticcio's Fontainebleau than to
Raphael's Rome. In spite of his obstinate professions of ortho-
doxy, some instinct has inspired Ingres to follow the alternative
convention, with the result that the *Grande Odalisque* is more
authentic and exciting than *La Source.*

After the erotic fantasies of Spranger and Goltzius and the
splendid animal exuberance of Rubens it seemed as if the
humble body, from which the Northern nude had originated,
could never again be the subject of art. But in about the year
1631 there appeared two etchings of naked women in which
the pitiful inadequacy of the flesh is more unflinchingly por-
trayed than in any representation before or since. They were
the work of a young Dutchman, then chiefly known for his
studies of beggars and expressive heads, Rembrandt van Rijn.
What was in his mind when he felt impelled to set down these
painful visions of human nakedness? First of all, no doubt, a
kind of defiant honesty. Although Rembrandt was willing to
adopt any device that would contribute to the technical de-
velopment of his art, he was unable to accept a formula that
might compromise the truth of his vision; and such, pre-

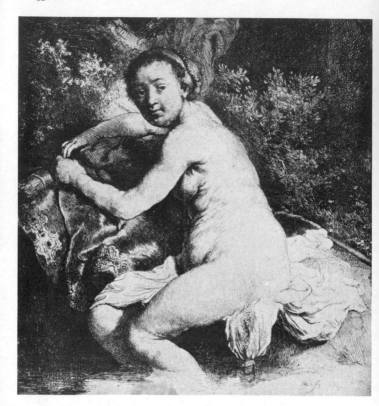

272. Rembrandt. Diana

eminently, was the artificial shape his contemporaries, even among his countrymen, had agreed to impose on the naked body. As a sort of protest Rembrandt has gone out of his way to find the most deplorable body imaginable and emphasize its least attractive features. Few young women in Amsterdam, and the face of the *Woman Seated on a Mound* suggests that she was still under thirty, can have had so huge and shapeless a stomach. We can hardly bring our eyes to dwell on her: and that, I imagine, was exactly Rembrandt's intention. In the second etching, the figure is less monstrous, but the defiance of classicism is more explicit, for the fat, flaccid creature has been given the

attributes of Diana [272]. The drawing for the etching in the British Museum makes Rembrandt's intention apparent, for it shows a young Dutchwoman of average appearance and possible activity. In the etching his eye has dwelt on every baggy shape, every humiliating pucker, everything, in fact, that the convention of the nude obliterates but that Rembrandt is determined we shall see. The protest implied in these two etchings did not go unnoticed. The poet Andries Pels, in his poem on *The Use and Misuse of the Theater*, describes these etchings in great detail and laments that Rembrandt should have misused his great gifts:

> *Flabby breasts,*
> *Ill-shaped hands, nay, the marks of the lacings*
> *Of the corsets on the stomach and of the garters on the legs,*
> *Must be visible if Nature was to get her due:*
> *That is his Nature, which would stand no rules,*
> *No principles of proportion in the human body.*

Pels is not only recording contemporary opinion, but also, we may assume, Rembrandt's own justification, that appeal to nature against rules which has been the repeated battle cry of all great revolutionaries in art.

But what his critics naturally failed to see, for it became plain only in his later years, and what Rembrandt could not say for himself, is that another impulse besides defiant truthfulness had impelled him to do these etchings: pity. Perhaps some element of curiosity led him to investigate these wrinkles of fat; but the feelings they aroused in him were different from the chilly repulsion that the women's bath aroused in Dürer. Still more did they differ from the many representations of the unfortunate body—fat men, cripples, drunken old women, and the like—that have come down to us from antiquity. Sometimes, as in the *Old Fisherman,* which so much distressed Winckelmann, this Hellenistic realism achieves an honorable stoicism. But it is without a breath of pity. The majority of such pieces were, I suppose, considered funny, and were popular because they flattered the spectator's sense of superiority. They are amongst the many elements in antique culture that make even the unbeliever grateful for Christianity. To Rembrandt, the supreme interpreter of Biblical Christianity, ugliness, poverty, and other

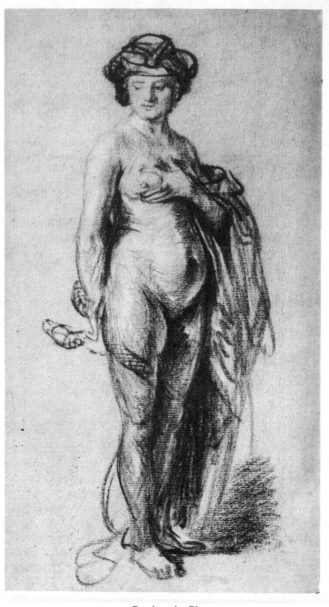

273. *Rembrandt. Cleopatra*

misfortunes of our physical life were not absurd, but inevitable, perhaps he might have said "natural," and capable of receiving some radiance of the spirit because emptied of all pride.

It is curious how this medieval view of our bodily estate led him to see the nude in the same shape as did the artists of the Middle Ages. All his studies from life accept this Gothic convention, even when, as in a beautiful drawing [273], they represent a heroine of antiquity; and his male nudes are as thin and flat as the Adams of Van der Goes or Van der Weyden. Just as he could have found plenty of girls in Amsterdam with firm young bodies, so there must have been boys with well-developed muscles. Yet, in general, Rembrandt's male models are as miserably thin as his women are embarrassingly fat. By a paradox, the academic search for perfection of form through a study of the nude has become a means of showing the humiliating *im*perfection to which our species is usually condemned.

This feeling of the inherent pitifulness of the body had another strange result: that the most considered nudes of Rembrandt's maturity, the three etchings dated 1658 [274], are of old women Twenty-seven years have passed since the *Diana* that outraged Pels, and Rembrandt's truculence has subsided. He is no longer anxious to shock us; and yet the idea of classical elegance still worries him so much that he prefers the Gothic hulk of an old body to the comely proportions of a young one. The etching of an old woman bathing her feet in a brook is indeed a most noble piece of bodily architecture, the obstinate, undefeated shape, as of an old boat, set down without a trace of sentimentality or extenuation. We try to think where else in art an aged body has been so grandly portrayed, and can remember only Piero della Francesca's Adam and certain anchorites by Carpaccio.

However, Rembrandt's greatest painting of the nude is of a young woman, clearly intended to be physically attractive. This is the *Bathsheba* in the Louvre [275], one of those supreme works of art which cannot be forced into any classification. The composition is derived from the combined memories of two antique reliefs, which Rembrandt had seen in engravings; but his conception of the nude is entirely unclassical and, in fact, must represent his beloved Hendrickje. Now, when the dogmatic insistence of early etchings has been abandoned, we feel the value of Rembrandt's humble and scrupulous honesty. For this

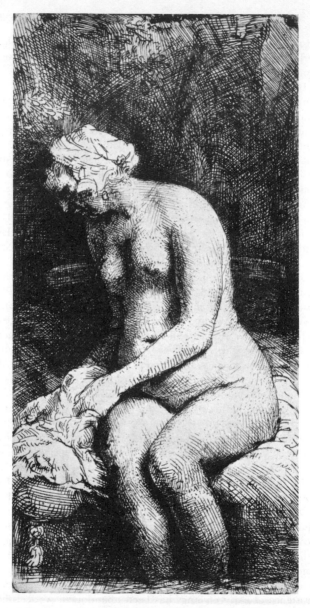

274. *Rembrandt. Old woman bathing her feet*

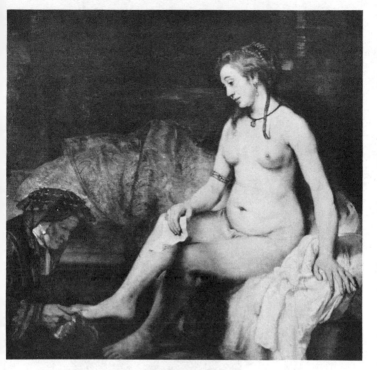

275. Rembrandt. Bathsheba

ample stomach, these heavy, practical hands and feet, achieve
a nobility far greater than the ideal form of, shall we say, Titian's
Venus of Urbino. Moreover, this Christian acceptance of the
unfortunate body has permitted the Christian privilege of a
soul. The conventional nudes based on classical originals could
bear no burden of thought or inner life without losing their
formal completeness. Rembrandt can give his *Bathsheba* an
expression of reverie so complex that we follow her thoughts
far beyond the moment depicted: and yet these thoughts are
indissolubly part of her body, which speaks to us in its own
language as truthfully as Chaucer or Burns.

The miracle of Rembrandt's *Bathsheba*, the naked body
permeated with thought, was never repeated. But the late nine-

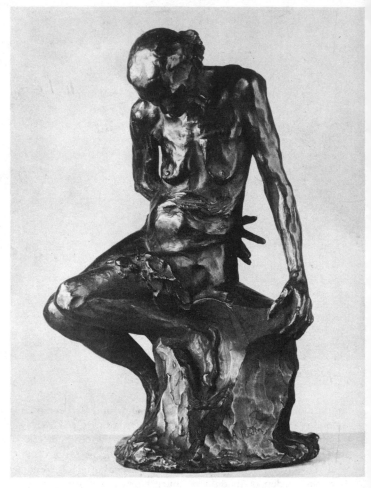

276. Rodin. La Belle Heaulmière

teenth century produced one or two memorable nudes of pity, of
which the most pitiful is Van Gogh's *Sorrow*, an image so starkly
terrible that we can hardly bring our eyes to dwell upon it; and
the most fully realized, as a work of art, is Rodin's *La Belle*

Heaulmière [276]. This goes further than Rembrandt's etching. The body of Rembrandt's old woman, though lacking in grace, is still strong and serviceable. Rodin's old woman is a final image of decrepitude, a *memento mori*, reminding us of certain Gothic figures with exactly this intention. It has been compared with Donatello's *St. Mary Magdalen* in Florence, and there is a certain similarity in technique, both Rodin and Donatello modeling the furrowed flesh with the powerful nervous movement of their fingers and creating thereby a living texture. But in sentiment the two figures are entirely different. Donatello's *Magdalen* is a female fakir, whose small, sunken eyes, gazing across the desert, have beheld the vision of God. Her body is no longer of the least importance to her; whereas Rodin's *Heaulmière*, although conceived in a graver spirit than the old courtesan of Villon's poem, is still bound to the body, and brooding on its deficiencies. Yet she is far from those pitiless figures of late Hellenistic art in which the worn-out body is represented as contemptible or derisory, for Rodin has seen in her shrunken members a Gothic grandeur of construction.

German painters of the last seventy years, both "realists" and "expressionists," have produced a number of nude figures that can be claimed for the alternative convention: that is to say, they still conform to proportions of the Gothic nude, with short legs and long body, and are still dominated by the sagging curve of the stomach. It is questionable, however, if we can apply the word convention to the welter of competing manners, each claiming to be based on truth, that at the beginning of this century had taken the place of a style. And perhaps the "Gothic" character of the nude in recent German painting proves, simply, how true to observation were the original Gothic nudes. Any European artist who is unable imaginatively to accept the abstraction of the classic nude seems to see the naked body in these terms. An example is Cézanne, the least Germanic of artists, whose only "life study" of the nude [277] has a Gothic character simply because it aims at the truth. It is appallingly sincere, and proves that Courbet, for all his defiant trumpetings, continued to see the female body through memories of the antique. But beyond mere realism, there is another reason for depicting the naked body stripped of the garment of antique

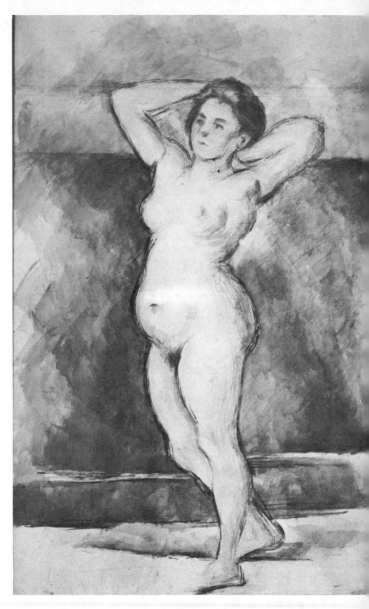

277. *Cézanne. Nude*

harmony; and this, within the limits of language, I must now examine, for it represents the last violent twist in the history of the nude.

Few more horrifying images have ever been put before us than the painting of naked prostitutes Rouault executed in the years 1903–04 [*278*]. What had compelled the gentle pupil of Gustave Moreau to turn from Biblical scenes and Rembrandt-esque landscapes to these monsters of brutal depravity? Fundamentally, no doubt, the Neo-Catholic doctrines of his friend Léon Bloy, by which, in the lukewarm, materialistic society of 1900, absolute degradation came closer to redemption than did worldly compromise. But the curious thing, for our present purpose, is that Rouault should have chosen to communicate this belief through the nude. He has done so precisely because it gives most pain. It has hurt him, and he is savagely determined that it will hurt us. All those delicate feelings which flow together in our joy at the sight of an idealized human body, the Venus, shall we say, of Botticelli or of Giorgione, are shattered and profaned. The sublimation of desire is replaced by shame at its very existence; our dream of a perfectible humanity is broken by this cruel reminder of what, in fact, man has contrived to make out of the raw material supplied to him in the cradle; and, from the point of view of form, all that was realized in the nude on its first creation, the sense of healthy structure, the clear, geometric shapes and their harmonious disposition, has been rejected in favor of lumps of matter, swollen and inert.

And yet Rouault convinces us that this hideous image is necessary. It is the ultimate antithesis of the *Knidian Aphrodite*, appearing rather late, after more than two thousand years, but none the less inevitable. All ideals are corruptible, and by 1903 the Greek ideal of physical beauty had suffered a century of singular corruption. A convincing assertion of complementary truth began, perhaps, in the drawings done by Degas in brothels: thus suggesting how the formal falsity of the academic nude was also, to some extent, a moral falsity, for the amateurs who praised the nudes of Cabanel and Bouguereau had seen the real thing in the Maison Tellier. Degas' prostitutes are living beings, like obscene insects carved by an Egyptian sculptor, and Toulouse-Lautrec's pastels of the same subjects convey the

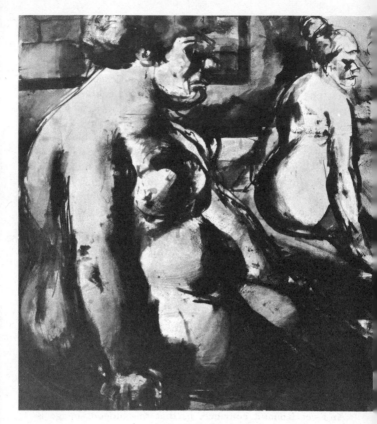

278. Rouault. Prostitute

character of an epoch and a society. Rouault's figure belongs
to a different world. Like the *Knidian Aphrodite,* she is an *objet
de culte,* though of a religion closer to that of Mexico than
of Knidos. She is a monstrous idol inspiring us with fear rather
than pity. In this respect Rouault is also entirely unlike Rem-
brandt, whom he so greatly admires, and who was his most
fearless precursor in the exploitation of physical ugliness.
Rembrandt's approach was moral, Rouault's is religious. This
is what gives his menacing prostitute her importance for us.
Her hideous body is ideal because conceived in a spirit of awe.

IX

THE NUDE AS AN END
IN ITSELF

I N this book I have tried to show how the naked body has
been given memorable shapes by the wish to communicate
certain ideas or states of feeling. I believe that this is the chief
justification of the nude, but it is not the only justification. At
all epochs when the body has been a subject of art artists have
felt that it could be given a shape that was good in itself. Many
have gone further and have believed that they could find there
the highest common factor of significant form. At the back of
their minds is a notion similar to that which inspired the
Renaissance theorists with their mystic belief in Vitruvian man
or sent Goethe in his equally hopeless search for the *Urpflanze*.
They abandoned, of course, the Platonic fancy that Godlike
man must conform to a mathematically perfect figure—the
circle and the square; but they continued to reverse the propo-
sition and say that our admiration of an abstract form, a pot
or an architectural molding, has some analogy with satisfying
human proportions. I myself have implied my acceptance of
this belief many times in the foregoing pages—notably when I
drew a parable between the back of one of Michelangelo's
athletes in the Sistine and his outline of a molding for the
Laurenziana. I must now examine rather more closely this
notion of the nude as an end in itself and as a source of inde-
pendent plastic construction.

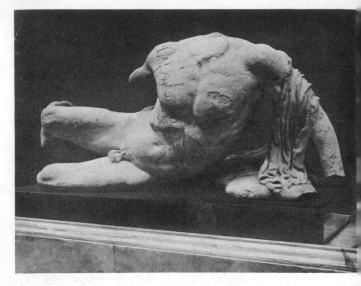

279. *Greek, c. 438 B.C. Illisos*

The two reclining figures from the pediments of the Parthenon, the socalled *Ilissos* [279] and *Dionysos,* do not express particular ideas, and could not be classified under any of the headings of the preceding chapters. Yet they are indisputably two of the greatest pieces of sculpture in existence and they represent formal discoveries as valid as the formulations of a philosophic truth. During the Renaissance they were almost entirely inaccessible. They could not have been known to Raphael or Michelangelo. Yet both these artists discovered the same combinations of form and used them in some of their most memorable inventions. That relationship of the open legs to the twisted thorax which we find so moving in the *Ilissos* arouses a similar emotion when we encounter it in the dying Ananias of Raphael's cartoon or the stricken Paul of Michelangelo's sublime fresco. The *Dionysos* [45], which majestically accepts the earth from which the *Ilissos* struggles to be free, has an equally satisfying relationship of legs to torso, and this too was rediscovered by Michelangelo in his fragmentary *River God* [280] in the Florentine Academy. In both cases the interplay of axes, the balance

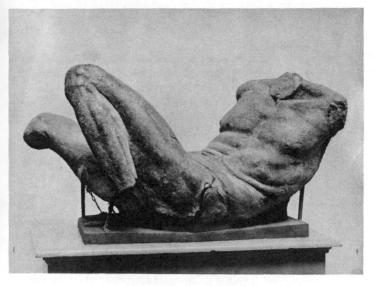

280. Michelangelo. River God

of tensions, and the rhythmic sequence of hump and hollow seem to convey an important truth, although it is a truth that cannot be referred to the ordinary needs or actions of our lives. Or, to take an example from the female nude: the *Crouching Venus* [*281*], which catalogues and textbooks attribute to Doedalsas but which certainly dates from the early fourth century. The plastic wholeness of her pear-shaped body has delighted all the ripening suns of art—Titian, Rubens, Renoir—till the present day, and in this case the reason is easily discovered, for this is the perfect symbol of fruitfulness, feeling earth's pull, like a hanging fruit, yet scarcely concealing in its structure a spring of sensual energy. But in other poses of the female nude our sense of completeness is almost inexplicable. Such, for example, is the outline that so enchanted the men of the Renaissance, the figure of Psyche on a Hellenistic relief (now lost) known as the *Letto di Policleto*. Like a folk song heard at a fair that, once discovered, serves as thematic material for generations of composers, we find this same outline in the masterpieces of Raphael, Michelangelo, Titian, and Poussin,

and feel that through it the nude has achieved an independent existence, just as the song has grown to be independent of the original words.

In addition to such poses, which seem to achieve almost the status of ideograms, there are the thousands of nudes in European art that express no idea except the painter's striving for formal perfection. And this aspect of the nude has increased in importance during the last century as the importance of subject matter, the story-telling part of painting, has declined. An *Odalisque* by Ingres, although from one point of view an exceptionally "pure" pictorial construction, still embodies ideas attendant on the word Venus; *The Blue Nude* of Matisse [286] does not. To understand how this has occurred we must, I think, turn back to the point in the history of European art when the nude became the center of academic discipline.

In the Middle Ages artists were resigned to being artisans, and the painter, sculptor, or glazier was apprenticed to learn the rudiments of his craft like any other manual worker. When this old discipline of grinding colors, sizing panels, and copying approved models was removed (and, of course, it was a gradual process), what new discipline took its place? Drawing from the nude, drawing from the antique, and perspective. This new approach has been strangely associated with the words scientific or naturalistic. In fact, it is at the opposite pole. Instead of the late Gothic naturalism based on experience, it offers ideal form and ideal space, two intellectual abstractions. Art is justified, as man is justified, by the faculty of forming ideas; and the nude makes its first appearance in art theory at the very moment when painters begin to claim that their art is an intellectual, not a mechanical, activity.

The doctrines of this new academism are clearly stated in the first treatise on the art of painting ever written, Leon Battista Alberti's *Della Pittura*. It was completed in August, 1435, and dedicated to his friend Brunelleschi, who may still be reckoned the inventor of mathematical perspective. In a dedicatory letter Alberti mentions as those who have restored the ancient glories of art their friends Donatello, Ghiberti, Masaccio, and Luca della Robbia; and we may therefore assume that throughout his treatise he is basing his theories on their practice. Now, Alberti assumes that the basis of academic procedure is a study

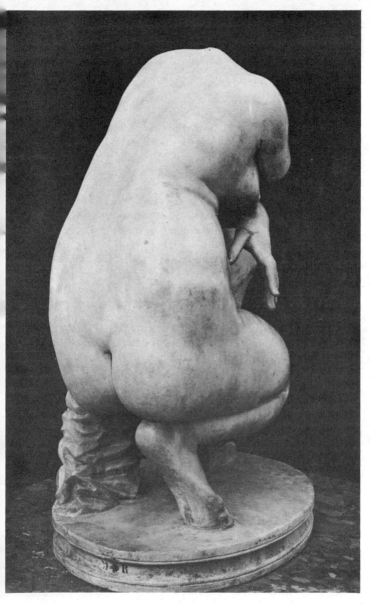

281. *Doedalsas (?), early 4th century* B.C. *Crouching Venus*

of the nude. He goes further, and recommends anatomical study of a kind that we associate with the next century. "In painting the nude," he says, "begin with the bones, then add the muscles and then cover the body with flesh in such a way as to leave the position of the muscles visible. It may be objected," he adds, "that a painter should not represent what cannot be seen, but this procedure is analogous to drawing a nude and then covering it with draperies." Here is a description of the academic practice that lasted till our own day. True, hardly any evidence of its employment in the early fifteenth century has come down to us, but that is owing solely to the paucity of fifteenth-century drawings. Of the friends mentioned by Alberti, we have no drawings by Donatello, Masaccio, or Luca della Robbia. We have, however, several scraps and copies from the workshops of Uccello and one or two superb originals by Pisanello to show that life studies existed in the early fifteenth century, and we have at least one drawing of nude figures used to form an academic compostion. It shows a dozen naked youths posed round a polygonal structure, so that two disciplines of Renaissance academism, perspective and the nude, are combined; and although it is in itself the work of an unskilled apprentice, it is an indication of the sort of studies that preceded Ghiberti's relief of Joseph in Egypt or Donatello's reliefs of the miracles of St. Anthony.

In the second half of the fifteenth century we have plenty of evidence that drawing from the naked model was a regular part of training. A score of silverpoint studies have survived from the workshops of Filippino Lippi and the Ghirlandaios; and many copies, no less than the testimony of Vasari, indicate that this was one of the chief occupations in the studio of the brothers Pollaiuolo. It is, in fact, in a work of Antonio Pollaiuolo that we find one of the first nudes to be included in a picture simply for our admiration, the man setting his crossbow in the foreground of *The Martyrdom of St. Sebastian,* in the London National Gallery [*282*]. Admirable though he is, and admired by all good judges since Vasari, he is less expressive of energy than the clothed bowman beside him.

This is the aspect of academism that is concerned with anatomy. In an earlier chapter I have shown how the Florentine passion for anatomy was related to the idea of energy, by mak-

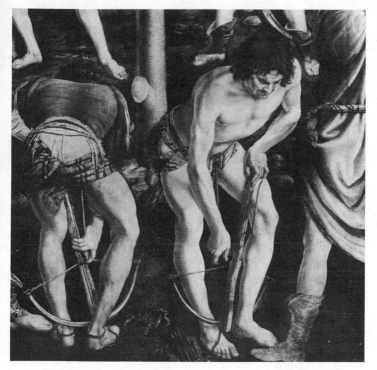

282. Pollaiuolo. Bowman (detail from Martyrdom of St. Sebastian)

ing our awareness of bodily movement more vivid and precise.
But in addition to this quality of life-enhancement, there is no
doubt that the Florentines valued a demonstration of anatomi-
cal knowledge simply because it *was* knowledge and as such of
a higher order than ordinary perception. Moreover, it involved
the recognition of certain sequences of cause and effect, so that
a sixteenth-century amateur must have followed the exact plac-
ing of every muscle and sinew with the same sort of enthusiasm
as is aroused in the twentieth-century mind by the contempla-
tion of a Rolls-Royce engine. This explains the anatomical
nudes that appear in so many compositions of the time without
the smallest justification of subject matter. They are like cer-
tificates of professional capacity. True, these figures appear

most frequently in the works of mannerists, whose display of anatomical skill is partly a mere compliance with fashion. The *écorché* statuette, which still survives as a neglected property in art schools, usually derives from a model by Cigoli and adds to its practical purpose some acquaintance with mannerist rhythm and gesture. But although a craving for details of musculature was partly a phase of style, the notion of the body as a complex of thrusts and tensions, whose reconciliation is one of the chief aims of the figure arts, remains eternally true. We are reminded once again of the *dipendenza* between the nude and architecture, and recall how, when we speak of architectural truth, we mean that in great buildings the interaction of shaft and vault or wall and buttress can be perceived intuitively as a harmonious balance of forces.

This feeling that a deeper truth is to be found in the knowledge of structure than in appearance also accounts for the practice recommended by Alberti by which, in composing a group, all the figures are first shown nude. One of the earliest and finest examples of the practice is a drawing by Raphael, now in Frankfurt, in which a group of nude athletic young men fill the places to be occupied by the Church Fathers and theologians to the left of the *Disputa* [*283*]. Visually, such figures could have little connection with the finished painting, where the flow of ample draperies, local color, and the contrast of light and shade would inevitably produce a different design; but to Raphael the consciousness that nude figures had once stood where the draped ones came to stand was both a guarantee of their real existence and an assurance that the whole composition would "work."

Raphael's drawing reminds us that another element besides knowledge was needed to produce the academic nude: the quality known by the Italian connoisseurs as *gran gusto*. Pollaiuolo's archer had the powerful body of a laborer, and the gawky youths who posed in Ghirlandaio's workshop were recognizably fellow apprentices. But at some point round about the year 1505 there was evolved a way of looking at the body that smoothed away abrupt transitions, gave a continuous flow to every movement and an air of nobility to every gesture. No doubt, this thoroughgoing idealization was based on the more perceptive study of antique sculpture that began when the

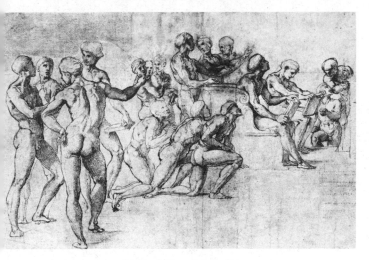

283. Raphael. Drawing for Disputa

young Michelangelo entered Bertoldo's academy in the Via Larga. But although *The Battle of Cascina* lies at the root of High Renaissance taste, Michelangelo always preferred strenuous Florentine movement to classical ease, and it is in the work of Raphael that the academic version of antique art takes its lasting form. We can, in fact, take two of Marcantonio's prints after his designs, *The Massacre of the Innocents* [*284*] and *The Judgment of Paris* [*285*], as containing almost all the characteristics and many of the actual properties that were to be approved and used in art schools till this century. The design for *The Massacre of the Innocents* dates from the first years of Raphael's residence in Rome, and the memory of Michelangelo's battle cartoon is still fresh in his mind. But there are two significant differences. First, many of Michelangelo's soldiers are replaced by women; and, second, the male figures are shown nude with no factual justification whatsoever. Michelangelo had taken pains to choose for his battle cartoon an incident when the soldiers really were naked, but no one could have supposed that Herod's executioners had laid aside their clothes. They were accepted, as the naked Greek soldiers in an Amazon battle were accepted, simply because their bodies could display grace of

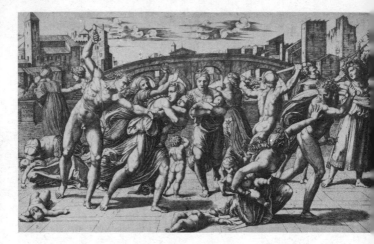

284. Marcantonio engraving after Raphael. Massacre of the Innocents

movement and knowledge of anatomy; and their beautiful poses bear no more relation to their brutal intentions than if they were ballet dancers. This arbitrary use of the nude in "historical painting" was, in fact, too Greek for the painters of the *seicento*. It was never attempted by Poussin, and even at the meridian of classicism the nude warriors in David's *Intervention of the Sabine Women* were included as an afterthought on the in- stigation of that most implacable prophet of the ideal, Quatre- mère de Quincy.

In Raphael's *Massacre of the Innocents* the women, following antique precedent, remain draped. We know from preparatory drawings how gladly he would have depicted their bodies, but he felt, and subsequent classicists agreed with him, that this was possible only in subjects drawn from Greek mythology. Of this he provided a model in his design for *The Judgment of Paris.* It is the crystallization of the academic idea. We need think only of the mythological paintings of Poussin—*The Realm of Flora,* of Dresden, or the *Venus and Aeneas,* at South Kensington —to recognize how completely Raphael's design anticipates the use of the nude in learned picturemaking. His naked divinities are there with no other purpose but to display themselves as perfect units of form, and in fact we recognize in the river god

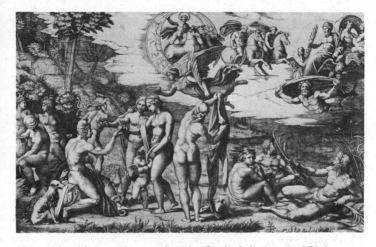

285. *Marcantonio engraving after Raphael. Judgment of Paris*

to the right and the naiad sitting at his feet two of those peren-
nially satisfying poses referred to at the beginning of the chap-
ter. That Manet used them in his *Déjeuner sur l'herbe* has been
claimed as a sort of joke against academism; in fact, it was an
intelligent acceptance of its value. The *un*intelligent acceptance
is to be found in such a prize-winning composition as Poynter's
Visit to Aesculapius, but even there a distant memory of Marcan-
tonio's print has saved him from the more efficient banalities of
the Salon.

The predominance of the female nude over the male, of
which Raphael's *Judgment of Paris* is the first example, was to
increase during the next two hundred years, till by the nine-
teenth century it was absolute. The male nude kept its place
in the curriculum of art schools out of piety to the classical
ideal, but it was drawn and painted with diminishing enthu-
siasm, and when we speak of a nude study or *académie* of that
period we tend to assume that the subject will be a woman.
No doubt this is connected with a declining interest in anatomy
(for the *écorché* figure is always male) and so is part of that pro-
longed episode in the history of art in which the intellectual
analysis of parts dissolves before a sensuous perception of
totalities. In this, as in much else, Giorgione's *Concert champêtre*

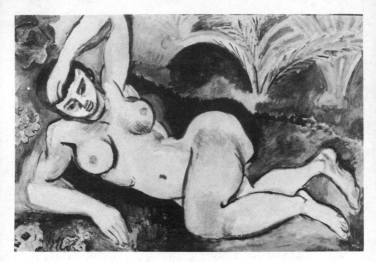

286. Matisse. Blue Nude.

is like a first spring of feeling, and it is notable that there the clas-
sical practice is reversed: the men are clothed, the women nude.
Giorgione's pastoral has already been quoted as one of the
earliest triumphs of Venus Naturalis, and no doubt in the
eventual establishment of the female model the tug of normal
sensuality must have a place. But it is also arguable that the
female body is plastically more rewarding on what, at their first
submission, seem to be purely abstract grounds. Since Michel-
angelo, few artists have shared a Florentine passion for shoul-
ders, knees, and other small knobs of form. They have found it
easier to compose harmoniously the larger units of a woman's
torso; they have been grateful for its smoother transitions and
above all they have discovered analogies with satisfying geo-
metrical forms, the oval, the ellipsoid, and the sphere. But may
not this argument reverse the order of cause and effect? Is
there, after all, any reason why certain quasi-geometrical
shapes should be satisfying except that they are simplified state-
ments of the forms that please us in a woman's body? The re-
current search by writers on the theory of art—Lomazzo,
Hogarth, Winckelmann—for a "line of beauty" ends, not in-
appropriately, in a question mark; and he who pursues it

further is soon caught in the sterile fallacy of one cause. A shape, like a word, has innumerable associations that vibrate in the memory, and any attempt to explain it by a single analogy is as futile as the translation of a poem. But the fact that we can base our argument either way on this unexpected union of sex and geometry is a proof of how deeply the concept of the nude is linked with our most elementary notions of order and design.

We have come to accept this almost as a law of nature, but medieval and Far Eastern art proves that we are mistaken. It is to a large extent an artificial creation owing to the system of training that came into being at the moment of transition from medieval to modern art. From the antique room to the life class: this progression, inaugurated in the workshops of Renaissance Rome and Florence, has lasted till the present day, and Western artists have unconsciously derived from it their sense of scale, their system of proportion, and their basic repertoire of forms. A return to the fundamentals of design has always meant to them a return to the nude; and yet to a creative artist the nude was deeply compromised by its subjection to the formulae of academic training. This is the dilemma that confronted the great revolutionaries of the present century.

Two pictures painted in the year 1907 can conveniently be taken as the starting point of twentieth-century art. They are Matisse's *Blue Nude* [*286*] and Picasso's *Demoiselles d'Avignon* [*289*]; and both these cardinal, revolutionary pictures represent the nude. The reason is that the revolt of twentieth-century painters was not against academism: that had been achieved by the impressionists. It was a revolt against the doctrine, with which the impressionists implicitly agreed, that the painter should be no more than a sensitive and well-informed camera. And the very elements of symbolism and abstraction that made the nude an unsuitable subject for the impressionists commended it to their successors. When art was once more concerned with concepts rather than sensations, the nude was the first concept that came to mind. But in 1907 it was a concept with many odious associations. It is difficult for us to realize how complacently the official and cultured world of 1900 accepted the standards of degraded Hellenism, especially in France. England had felt the influence of Ruskin and the

287. Matisse. Nude

Pre-Raphaelites; America had already recognized impressionism as the painting of democracy. But in France the great official edifice of the *beaux-arts* seemed impregnable, and the concept of *le beau* on which it rested was still not very far from that which had governed Louis XIV in his admission of antique statuary into the Galerie des Glaces. We may look back with nostalgia to such security of taste, but a wide-awake and intel-

ligent artist was bound to reject it; and inevitably the two painters who may, without apology, be taken as representative of their epoch have treated the nude with considerable violence.

Matisse and Picasso are, of course, two artists with almost antithetical characters, and their reactions to the nude have been very different from one another. Matisse was a traditionalist picturemaker whose life drawings could almost be mistaken for those of Degas, and, like Degas or Ingres, he deduced from the nude certain pictorial constructions that satisfied his sense of form and that were to obsess him for a great part of his life. *The Blue Nude* represents such a construction. It was an important part of himself, and he not only carried out the same pose in sculpture, but brought it into numerous other compositions. This is the standard use of the nude as an end in itself or, if the term be acceptable, as a means of creating significant form. The revolutionary character of Matisse's picture resides not in the end but in the means. That enjoyment of continuous surfaces, easy transitions, and delicate modeling which had seemed such an essential factor in painting the nude is sacrificed to violent transitions and emphatic simplifications. This problem of simplifying the lady was to obsess Matisse and all the most intelligent painters of his time. The classical system had been the hard-won solution of the problem, and when it was no longer an acceptable solution some other had to be found. Matisse sought for it in an earlier phase of the Greek tradition, and produced *La Danse* and *La Musique*, the two decorations now in Moscow. He sought for it in Japanese prints and in the Islamic Exhibition of 1910. Above all, he sought to achieve it by the same sort of logical processes by which Paul Valéry tells us he was composing his poetry. Sometimes his search is successful, particularly in his etched illustrations to Mallarmé, where the graphic medium preserves an illusion of spontaneity [287]. But sometimes he seems to grow exhausted in pursuit of a quarry that, like the unicorn, can only be subdued by love. Such is the impression we receive from a series of eighteen photographs taken of the stages in the construction of a painting known as *The Pink Nude*. Almost thirty years have passed since *The Blue Nude*, but the first stage is remarkably similar in pose. He is still coping with the same obsession. But the handling is less vigorous, and we can understand why the simplifi-

cations had to be achieved by argument and not by instinct. Perhaps only the countrymen of Descartes can believe that works of art come into existence in this way, and although the last stage of *The Pink Nude* achieves a monumentality absent from the preceding eighteen, it has, to my eye, the same august flatness as a copy of the *Doryphoros*.

But this is not because Matisse had lost interest in the body. On the contrary, at the same epoch that he was using the female nude as the basis for a "pure" pictorial construction, he was doing a series of drawings of naked women that reveal a kind of frenzy almost without precedent in art. There are Rodin drawings in which the model rolls and stretches with an inhuman lack of modesty; but even in these Rodin is further from his models and from us. Matisse breathes down our necks and brings us so close to the sprawling naked body that I, at least, retreat in embarrassment.

This contrast between the calculated formalism of Matisse's painting and the animality of his drawings supports one of our chief conclusions about the nude: that the antique scheme had involved so complete a fusion of the sensual and the geometric as to provide a kind of armor; and the words *cuirasse esthétique,* used by French critics to describe the formalized torso, struck deeper than was intended. Once this armor had grown unwearable, either the nude became a dead abstraction or the sexual element became unduly insistent. In fact, if this element is allowed to make itself felt at all, abstraction and distortion will tend to increase its impact. A more simplified version of the female torso than that by Brancusi [*288*] can hardly be conceived, and yet it is more disturbingly physical and, may we say, less decent than the Knidian. This is partly because the eye instinctively looks for analogies and amplifies them, so that a face imagined in the pattern of a wallpaper may become more vivid than a photograph; and partly because the discipline of art schools has given all skillful draftsmen such innate sense of the construction of the female body that this can make its proportions felt through almost any disguise. The fullest illustration is to be found in the work of Picasso.

Unlike Matisse's steady, traditional pursuit of a few motives, Picasso's relation to the nude has been a scarcely resolved struggle between love and hatred. The *Demoiselles d'Avignon*

288. Brancusi. Nude

[289] is the triumph of hate. Starting from a brothel theme,
· which seems to have owed something to Cézanne's groups of

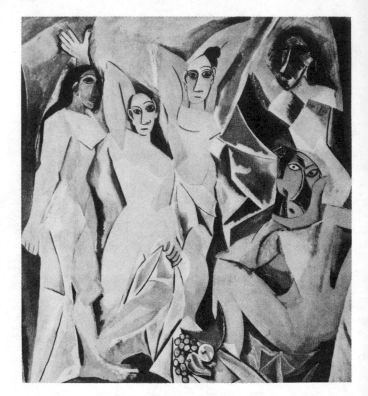

289. Picasso. Les Demoiselles d'Avignon

bathers, it developed into an enraged protest at everything in-
volved in the conventional notion of beauty. This meant not
simply representing ugly women, as Toulouse-Lautrec had
done, but finding some formula for the treatment of the body
that should owe nothing whatsoever to the classical tradition.
As I have tried to show, this is extremely difficult. Even the
Eve of Hildesheim and the worshipers at Amaravati have some
remote connection with Greece. It happened, however, that
the painting of the *Demoiselles d'Avignon* coincided with the first
appreciative study of Negro sculpture; and there, at last, was a
totally un-Hellenized stylization of the body that, from its in-
tuitive geometry, can be classified a nude. The date and

degree of Picasso's indebtedness to the Congo are matters of dispute, and perhaps only the heads of the two right-hand Demoiselles show a direct derivation; but the general sense of form, with its sharp contours and shallow concave planes, indicates a moment when consciousness of African carving had begun and cubism was on the way.

With cubism come the first of Picasso's dismemberments of the nude. Compared to what was to follow, it was relatively mild. The members are not monstrously displaced, but are simply subjected to a general law of refraction; and the fact that he was voluntarily subject to a law gave to Picasso's cubist pictures a tranquillity very unlike the rest of his work. His love-hate relationship to the nude was temporarily suspended, because the classical style was at such a safe distance. But in 1917 Jean Cocteau persuaded him to join Diaghilev in Rome, and together they visited Naples and Pompeii. Here for the first tme he realized that classical art had once been alive. In Paris he had thought of it as a hollow machine used by the enemy in their battle with the rebellious young. But no man of imagination can tread the soil of Campania without feeling the nearness of paganism and the eternal freshness of its art; and within a year Picasso had done the drawing [3] that I have compared to a Greek mirror back, but that equally recalls a white-figure vase. Actually, this experience of antiquity was to remain in absorption for another two years, and when it emerged it was as part of a reassertion of classical values that affected all the arts in the early 1920's. A slight element of modishness in this movement gives an air of expediency to some of Picasso's classical nudes. They furnish agreeably his illustrations to Ovid or Aristophanes, but when worked up into large drawings or paintings their willful renunciation of vitality is rather oppressive. Picasso is above all things an animator, but this gift, which was so fascinating when manifested through the stubbornly inanimate materials of cubism, was not allowed to disturb the ponderous objectivity of his classical nudes. When vitality reasserted itself, it was through new and crueler distortions. No doubt there was an element of provocation, halfway between that of a naughty child and an angry god, in the indignities to which the body was subjected. In his rage Picasso no longer attacked the classic nude, with its

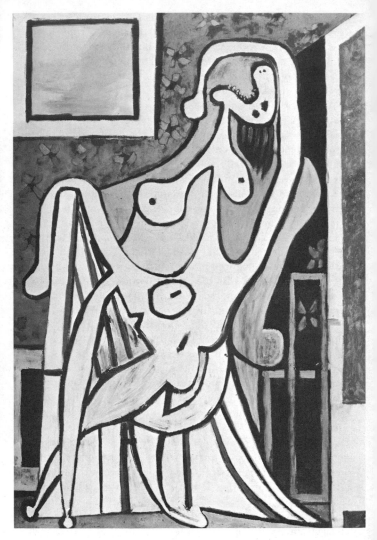

290. Picasso. Woman in an Armchair

exhausted *beaux-arts* associations, but the accepted nude of con-
temporary painting. In the picture of a woman in an armchair

of 1929 [*290*] the relation of the figure to the chair and of the chair to the wallpaper and picture frame, all recall one of Matisse's *Odalisques* of three or four years earlier. To pretend that these savage distortions have been contrived solely in the interests of pictorial construction is to look at the picture with the mind half closed. On the contrary, the arm bent over the head, a motive frequently used by Matisse as a means of achieving a satisfactory shape, is here given some of its antique force as a symbol of pain, and the displacements of the members all contribute to the same expression of agony. The extraordinary thing is that we recognize them at all. Some of the "bathers" done in the next five or six years show an even greater desire to displace and deform, although in these we often feel that hatred is accompanied by a certain pleasure in the metaphysical ingenuity and once more we are reminded of the naughty child. "Look what I've made, Mummy; it's a man. Yes, it *is* a man."

Yet, in the end, the controlling impulse is godlike—to create in his own image something that shall have its own independent existence as design. Parallel with the eighteen stages of Matisse's *Pink Nude* are the eighteen proofs of a lithograph of two nude women done in the winter of 1945–46 [*291*].

The subject is one of the few to which Picasso has frequently returned, and which must be to him what the *Baigneuse* and the *Grande Odalisque* were to Ingres, one figure lying asleep, while the other sits and watches. Essentially it is the Cupid-and-Psyche motive, and in the years immediately preceding this lithograph he had executed a series of large drawings of the subject that seemed to me, when I saw them in his studio in 1944, to be most beautiful works of modern art. In these the sleeper was a boy, the watcher a girl, but in the lithograph both are women, and from the first we feel that the subject has lost some of its symbolic importance to him and become more a purely pictorial problem. It is also evident that the watcher is so much more stylized than the sleeper (who by comparison is academic) that ultimately she will take command. She does so definitely in the tenth state, turning round to face us, and bequeathing her legs (most surprisingly) to the sleeper. Clearly this will not do, and in the next state the sleeper is transformed, becoming, in turn, more abstract than the watcher. A sort of competition then sets in between them, in which the watcher's

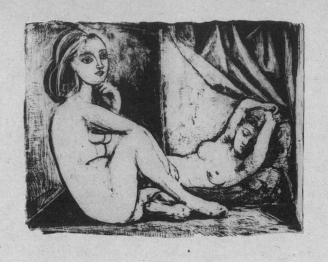

291. Picasso. Four of the eighteen stages of Les Deux Femmes nues

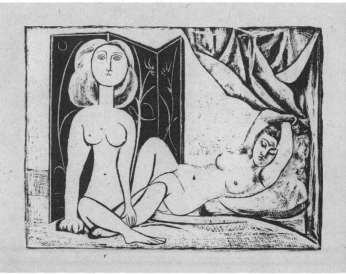

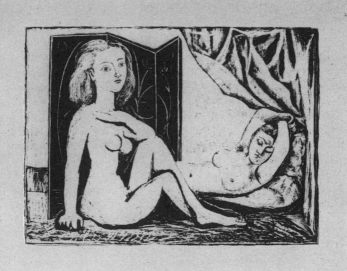

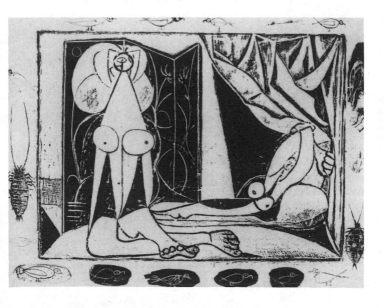

body expands and contracts and the sleeper remains unchanged, until finally both achieve a high degree of independence. But, like all independence, it involves a further frustration. Aesthetic essences are never pure enough; and if accidents must persist, the familiar accident of our bodily shape is perhaps preferable to a pattern so arbitrary and inconclusive.

The death of the antique system, which had split Matisse's conception of the nude in two, produced a similar duality in the mind of Picasso. But his response to the situation was less narrowly aesthetic. For one thing, he retained, and even exploited, erotic images in his abstract work. For another, he saw as clearly as any church elder that the flaw in the whole respectable edifice of the academic nude was the relationship between the painter and his model. No doubt an artist can achieve a greater degree of detachment than the profane might suppose. But does this not involve a certain callosity or dimness of response? To scrutinize a naked girl as if she were a loaf of bread or a piece of rustic pottery is surely to exclude one of the human emotions of which a work of art is composed; and, as a matter of history, the Victorian moralists who alleged that painting the nude usually ended in fornication were not far from the mark. In some ways nature can always triumph over art.

Picasso's drawings of the painter and his model go back to the illustrations he did in 1927 for an edition of Balzac's *Le Chef-d'oeuvre inconnu*. In these the model is impassive and ideal; in the struggle between art and nature, they represent a victory for art. As Balzac's story demands, her influence is not perceptible on the painter's canvases, but her classical outlines inform us that at the height of his surrealist period Picasso has by no means lost faith in physical beauty. A few years later he is still brooding on the relationship between art and nature, in a series of etchings dated 1933. They show the artist and his model, both nude, contemplating various pieces of sculpture, amongst them one that Picasso himself was to execute in bronze. A puzzled Pygmalion, the sculptor seems uncertain whether the independent form of his own creation really excels the living girl who crouches beside him

Finally, during the winter of 1953–54, in a series of 180 drawings, he set down his feelings on the painter-model relationship with ironical simplicity. The series has been compared

to Baudelaire's *Mon Coeur mis à nu,* and some of the painter's admirers have made heavy weather of these sparkling pages. But whatever its bearing on Picasso's life, it is also a serious commentary on the whole practice of painting the nude as an accepted part of the academic system. This time the model comes off best and the painter, with few exceptions, cuts a poor figure. She is a satisfied animal, a work of nature more graceful and alive than anything he is likely to produce by art. He peers at her anxiously, myopically, hoping to calculate the exact curve of her behind. No wonder she prefers the company of a black kitten or even a baboon. The most ravishing model of all poses for a resolute lady, who subsequently shows her canvas, huge and incomprehensible, to a group of complacent toadies. None of them think of looking at the model, who, in a pose of voluptuous relaxation, is a sight for the gods.

In later pages of his "diary" Picasso shows the same short-sighted artists who had peered so painstakingly at a delightful body gazing with equal earnestness at the deplorable body of a middle-aged female. We are left in no doubt about his impatience at the occupational blindness of his colleagues, and indeed with the whole concept of drawing from the life as it had developed in the nineteenth century. The first inventors of the nude would have agreed with him. The Greeks wished to perpetuate the naked human body because it was beautiful. Their athletes were beautiful in life first, and in art afterward. The physical perfection of Phryne was considered as important as the artistic endowment of Praxiteles. To draw from a misshapen model would have seemed to them incomprehensible and revolting, and the coldhearted contempt with which Picasso has represented such models, far different from Rembrandt's pity or Dürer's curiosity, is truly Mediterranean. Even when a Greek artist achieved independent plastic constructions as severe as the athletes of Polykleitos, he did so on the basis of a fervent admiration for physical beauty. To have abstracted from the model a number of plastic components without having regard to the totality of sensuous impression, as was the practice in neo-classic discipline no less than in the drastic simplification and rearrangements of the last thirty years, is fundamentally un-Greek.

This does not mean that the attempt to create an independ-

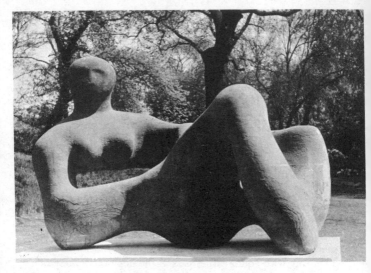

292. Henry Moore. Recumbent Figure

ent form on the basis of the human body is a lost cause; only that the old approach by which art-school nudes are, so to say, scrambled into a new pictorial language involves too great a sacrifice of fundamental responses. Such a metamorphosis, in so far as it seems to be necessary to our peculiar needs, must take place deep in the unconscious, and not be achieved by trial or elimination. I may take as an example the work of Henry Moore.

Almost alone of the generation succeeding Picasso, he has not felt himself swamped or frustrated by that ruthless torrent of invention. It is true, of course, that he has found some of these inventions liberating and directive. Anyone familiar with Picasso's drawing of 1933 known as *An Anatomy* will find that it forestalls not only some of Moore's experiments of the succeeding years, but also his way of presenting them in rows or groups of three. But there the resemblance ends. Where Picasso is volatile, Moore is tenacious; Picasso swoops, Moore burrows. A seesaw between love and hate, elegant classicism and enraged distortion, is entirely foreign to his single-minded character. Moore is an impressive draftsman of the nude, but

practically none of his life drawings are directly related to his sculpture; none, for example, represent the figure in that reclining pose which was for long his favorite motive. His great sculptural ideas appear first in his sketchbooks almost exactly as they will be when executed in wood or stone. They are, so to say, abstract from the first; the metamorphosis has been intuitive, the result of some deep internal pressure. Yet they are clearly the work of a man in whom the body has aroused powerful emotions.

Two of Henry Moore's most satisfying works are the stone *Recumbent Figure* of 1938 [*292*] and the wooden *Reclining Figure* of 1946 [*293*]. Many different associations converge in these carvings: in the former there is the feeling of the menhir, the memory of rocks worn through by the sea; and in the latter there is the pulsation of the wooden heart, like a crusader's head, burrowing in the hollow breast. But in both, these conflicting memories are resolved by their subordination to the human body, and in fact they develop two basic ideas of the nude first embodied in the *Dionysos* and the *Ilissus* of the Par-

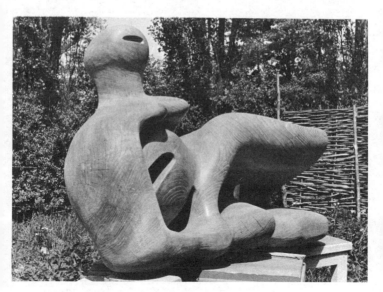

293. Henry Moore. Reclining Figure

thenon, the stone figure with bent knee rising from the earth like a hill, the wooden figure with averted thorax and open legs, struggling out of the earth like a tree, not without a powerful suggestion of sexual readiness.

Thus modern art shows even more explicitly than the art of the past that the nude does not simply represent the body, but relates it, by analogy, to all structures that have become part of our imaginative experience. The Greeks related it to their geometry. Twentieth-century man, with his vastly extended experience of physical life, and his more elaborate patterns of mathematical symbols, must have at the back of his mind analogies of far greater complexity. But he has not abandoned the effort to express them visibly as part of himself. The Greeks perfected the nude in order that man might feel like a god, and in a sense this is still its function, for although we no longer suppose that God is like a beautiful man, we still feel close to divinity in those flashes of self-identification when, through our own bodies, we seem to be aware of a universal order.

NOTES

Velásquez and the nude. We have record of at least five paintings of the nude by Velásquez. In addition to the National Gallery picture, which belonged to Don Gaspar de Haro y Guzmán in 1651, there were a *Cupid and Psyche* and a *Venus and Adonis* in the possession of Philip IV, a nude woman in the estate of Domingo Guerra Coronel in 1651, and a recumbent *Venus* in the painter's own possession at the time of his death in 1660. There is some reason to suppose that the National Gallery painting was done in Italy, for Velásquez did not return to Spain till the summer of 1651; and it can hardly be earlier than his departure to Italy in 1649. Cf. Maclaren, *The Spanish School,* p. 76.

It is commonly said that Velásquez took the pose of the *Rokeby Venus* from Rembrandt's etching of a Negress lying down (Munz, 142), but as this is dated 1658 the connection between the two poses must be accidental. Ultimately it derives from the Borghese *Hermaphrodite,* now in the Louvre, which had attained great celebrity at the time Velásquez was in Rome, and had been restored by Bernini. Velásquez ordered a cast of it for the Spanish royal collection. See note for p. 211 below.

S. Alexander, *Beauty and Other Forms of Value,* p. 127. In fairness to Professor Alexander, it must be said that this has been for many years a commonplace of aesthetic philosophy, and is a branch of the accepted doctrine that our responses to subjects and situations represented in art are fundamentally different from our responses to the same subjects and situations in life. Experience suggests that they differ in some important ways, but not fundamentally.

For the *naked figure in Japanese prints,* cf. Stratz, *Die Körperformen in Kunst und Leben der Japaner,* who demonstrates, by means of photographs, their naturalism. There are some beautiful naked figures by Utamaro—e.g., a print in the Musée Guimet of a woman stepping into a bath (reproduced in Lhote, *Theory of Figure Painting,* pl. 92), which was apparently known to Matisse. But it is notable that in the so-called pillow books of Utamaro, which are illustrated guides to sexual intercourse, the whole naked body is never shown. That Western man, even at his crudest, has rejected specialization in this particular activity is to some extent a legacy of that Greek belief in wholeness which created the nude.

PAGE 31

Etruscan tomb figures with big stomachs are known to archeologists as *obesi,* perhaps in reference to the stock epithets applied to them by the Roman poets of the Augustan era, *pingues et obesi Etrusci.* It has been suggested that these prominent stomachs had a symbolic meaning and referred to the prosperity or status of the deceased. But in fact they are probably only one more example of the inherent naturalism of Etruscan art. The majority of men over middle age reclining in this position would show a similar proportion.

Professional athletes. The ugliest are to be found in the series of mosaics from the Baths of Caracalla, now in the Museum of the Lateran. They represent the debased gladiatorial spirit that we associate with imperial Rome. But professionalism and specialization had already begun to affect athletics in fifth-century Greece. Socrates, in Xenophon's *Symposium* (II, 17), is made to lament that the bodies are not developed evenly, but that the runner has overdeveloped legs, the boxer enormous chest and shoulders, etc. Cf. Gardiner, *Athletics of the Ancient World,* ch. VII passim.

The *ivory panel of Apollo and Daphne* in the Museum at Ravenna is usually dated in the late fifth century, and is related to a large number of Coptic ivories. Of the *objets de luxe* referred to, the most characteristic are the silver dishes that seem to have been made all over the eastern Mediterranean in the sixth century and are frequently decorated with pagan divinities—e.g., the dish with Venus and Adonis in the Cabinet des Médailles, Paris (illustrated in Peirce and Tyler, *L'Art byzantin,* II, pl. 74). For silverware decorated with Nereids, cf. p. 371.

The Veroli Casket in the Victoria and Albert Museum is one of a group of ivory caskets of which forty-three have come down to us complete and as many in separate panels. All are decorated with pseudo-antique motives derived from silver plate or manuscripts, put together with little understanding of the original significance. They are usually thought to have been made in Constantinople during the iconoclastic period—i.e., eighth and ninth centuries; see Longhurst, *Catalogue of Carvings in Ivory,* p. 34.

The fate of the *Knidian Aphrodite in the Middle Ages* is considered in Blinkenberg, *Knidia,* pp. 32–33. Picard, *Manuel* (III, 562–63), implies that she was still in Constantinople in 1203, basing his statement on the chronicle of Robert de Clari. But the statue Robert describes was of "copper" (bronze). According to him, it was "a good twenty feet in height" and although, in an otherwise accurate account, he tends to exaggerate sizes, it must have been over life size. His description does, however, make it clear that the figure was a Venus Pudica, so it was probably a copy or a derivative of the Knidian. Cf. Robert de Clari, *The Conquest of Constantinople* (ed. E. H. McNeal).

PAGE 32

Villard de Honnecourt's notebook, containing drawings of the works of sculpture and architecture that had particularly impressed him, was compiled in the second half of the thirteenth century. It is now in the Bibliothèque Nationale, F. F. 19093. The two antique figures on f. 22 are taken from representations of Dionysos and Hermes, probably in Gallo-Roman bronzes. For a list of similar figures, see Hahnloser, *Villard de Honnecourt,* p. 131. Another nude figure, also extremely ugly, is on f. 11 v. It appears to be copied from a late-antique mosaic, painting, or book illustration.

PAGE 36

Vitruvian man, in the narrow sense of a human figure illustrating Vitruvius' doctrine of proportion, appears first in Francesco di Giorgio's book on architecture in the Laurenziana, Florence (Ashburnham, 361), which was owned and annotated by Leonardo. But the image of man as a microcosm of the universe is present in the background of medieval thought and goes back to Plotinus; cf. Wittkower, *Architectural Principles in*

the Age of Humanism, p. 15, note. There are many examples of medieval drawings showing man as a microcosm, with arms and legs spread out filling a circle, remarkably similar to the Vitruvian man of Cesariano [*10*]—e.g., a representation of the Harmony of the Spheres in a Rheims ms. of 1170, illustrated in Swarzenski, *Monuments of Romanesque Art,* p. 210.

PAGE 41

Dürer never went to Rome, so that the clear reminiscences of the *Apollo Belvedere* in the studies that culminate in the Adam must derive from drawings that he had borrowed or acquired of the recently discovered figure. We know that Dürer armed himself with material of this kind when in Italy—cf. his copies of drawings by Leonardo da Vinci and Pollaiuolo. If his drawing in the British Museum inscribed *Apolo* [*40*] is really datable *c.* 1501, he must have acquired a record of the *Apollo* during his first visit to Italy, 1494–95. But this date seems to me doubtful (cf. note for p. 58), and I think his acquaintance with the *Apollo* must date from just before his second visit to Venice, *c.* 1504, and have led directly to the engraving of *The Fall of Man.* The schematized drawing of a nude [*12*] is traced through and made into a study for the Adam.

Dürer's admission that either a stout or a thin figure may be beautiful occurs also in Alberti's *Della Architettura,* bk. IX, ch. V (original Latin edition of 1485, f. 164ᵇ). It has long been assumed that Dürer was familiar with Alberti's *Della Pittura;* it seems probable that he knew the *De re aedificatoria* as well.

PAGE 52

Nudity and the Inquisition. The inquisitor who made this reply to Paolo Veronese was a cleric of exceptional enlightenment. In general, after the decrees of the Council of Trent (1563), nudity was objected to in sacred subjects, and some of the more zealous popes contemplated destroying or painting over Michelangelo's *Last Judgment.* In fact, Paul IV instructed Daniele da Volterra to paint draperies over those parts which (in Alberti's words) "porgono poco gratia"; which he did with such tact that they do not affect the composition. Clement VIII was prevented from destroying the painting completely by the appeals of the Academy of St. Luke. Nevertheless, it was largely owing to the unassailable prestige of Michelangelo that the nude survived the Counter Reformation. Even such an earnest interpreter of

Tridentine doctrines as Gilio da Fabriano expressed his admiration for the *Last Judgment;* cf. Blunt, *Artistic Theory in Italy,* pp. 118–24.

Apollo. Throughout this chapter I am concerned with the idea of male beauty based on harmony, clarity, and tranquil authority. This idea is most shortly conveyed by the word *Apollo;* but it will be seen that by no means all the figures referred to were intended to represent Apollo. The male beauty of an Olympian was subject to slight variations of proportion even in antiquity, although this was owing far more to the taste of the epoch or the idiosyncrasy of the artist than to any set typological requirements. In the late Renaissance, however, the proportions and characteristics of the gods were schematized— e.g., the Apollo type was nine faces high, the Jupiter type ten faces, and so forth; cf. Lomazzo, *Trattato,* II, 77. Such artificial classifications in no way affect the argument of this book.

Kouroi. Cf. Richter, *Kouroi,* where, however, the author's bias in favor of a narrowly naturalistic aesthetic is sometimes misleading.

The Ephebe of Kritios owes its name to a supposed resemblance of both head and body to the *Harmodios and Aristogeiton* attributed to Kritios and Nesiotes by Pausanias (I, 8, 5). The fragility of this evidence is apparent when we consider (1) that the head of the Naples *Harmodios* is a characterless copy; (2) that there is strong reason to doubt that the head of the Akropolis youth originally belonged to it, although it is of about the same date; cf. Payne and Young, *Archaic Marble Sculpture from the Acropolis,* p. 44; (3) that comparison between a static body and a body in action is, at this date, bound to be incomplete, and even if a similarity can be maintained, it is agreed that the tyrant slayers would have been a later work. Nevertheless, the name may be retained for convenience.

Uccello-school drawing (BB, 27790). Also from the circle of Uccello is a drawing in Stockholm (BB, 2779K) that shows a group of male nudes standing on a polygon, thus combining on one sheet the two roots of Renaissance academism. The

earliest nude drawn from the life that has survived seems to be the sheet by Pisanello in the Boymans Museum, Rotterdam (Degenhart, *Pisanello*, pl. 26). Life studies from the Florentine workshops of *c.* 1450 are quite common; cf. Berenson (BB, 545a), a youth leaning on a stick, attributed to Benozzo Gozzoli, who is already posed to look like an antique, and so has some of the artificiality that "academies" have retained.

PAGE 64

Bronze and marble. The extent to which Greek sculpture has been traduced by the reproduction of bronzes in marble can be seen from the one example in which an original bronze and a marble copy have both survived, the bronze athlete of Ephesos in the Kunsthistorisches Museum, Vienna, and the marble athlete of Ephesos in the Uffizi. In spite of the fact that the bronze had been broken into 234 fragments and the marble is a copy of high quality, the former remains a vivid, life-communicating work of art, while the latter is dead.

PAGE 67

The *cuirasse esthétique.* At an early date the symbolic importance of this schematization led to a form of armor known as the *cuirasse musclée.* It has been found in tombs of the fifth century B.C., but did not become usual till the fourth. It was Greek in origin, and seems to have been made of metal or leather covered with metal plates. In the third and second centuries it was usually made of hardened leather and molded even more closely to the torso (cf. Reinach, *Répertoire de reliefs,* III, 442ii, 446ii). During all this time it was reserved for higher ranks, and the more elaborate metal examples were worn by generals. In the first centuries of the Christian era its use was extended to centurions and finally to ordinary soldiers (Reinach, I, 264–67). From its frequent appearance in Roman relief—e.g., Trajan's Column—it was known in the Renaissance as armor *alla romana* and became *de rigueur* for all academic or mannerist compositions of the sixteenth century.

PAGE 68

Idolino. Discovered in Pesaro in 1530, and long considered the only surviving bronze of the type and period of Polykleitos. Although archeologists are temporarily united in classing it as an archaizing work of the Roman epoch, it is of an altogether dif-

ferent quality from those furnishing bronzes from Herculaneum which attempt a fifth-century style, and could be an eclectic work of the early fourth century B.C. There is much evidence (e.g., bronzes in the Cabinet des Médailles, Paris, and the Metropolitan Museum, New York) that Polykleitan works were still being produced then.

PAGE 72

Apollo of Kassel may not reproduce a figure of which we have a literary record, but certainly goes back to a Pheidian original. A superior head of the same figure is in the Palazzo Vecchio, Florence; cf. Picard, *Manuel,* II, 314, and fig. 133.

PAGE 76

Hermes of Praxiteles. It was discovered in 1877, and immediately identified as the figure mentioned by Pausanias (V, 17, 3). Two recent theories are worth noting. First that it is of Roman date. The arguments are set out by Cuttle in *Antiquity* (June, 1934) and may be summarized as, first, that the back is carved by a flat chisel not used by the Greeks for bodywork; second, that the hair is worked by a running drill; third, that the drapery appears to be of a later date. These theories were first put forward by Blümel, whose latest work, *Der Hermes eines Praxiteles,* dismisses it also on stylistic grounds and suggests that Pausanias was referring to another Praxiteles of the Hellenistic epoch. The other theory is put forward by Antonsson, *Praxiteles' Marble Group in Olympia,* who maintains that the figure was originally a Pan (signs of horns in the hair, only possible copy represents a satyr) and was altered in Roman times to a Hermes, thus accounting for the Roman tool marks. Neither theory has gained wide acceptance.

PAGE 82

Lysippos. Of the works claimed as his on the basis of resemblance to the athlete scraping himself (*Apoxymenos*), the most convincing are the *Hermes* tying his sandal, in Copenhagen, and the *Eros* with a bow, in the Capitoline. There is also a scrap of evidence that the *Farnese Hercules* and others of this type derive from Lysippos. Other attributions are purely hypothetical, and as he is said to have executed fifteen hundred pieces of sculpture there is plenty of room for speculation.

PAGE 83

Antinoüs. The chief surviving examples are two reliefs, in the Villa Albani and the Terme, and two statues, known as the *Mandragone* and the *Braschi,* in the Louvre and the Vatican respectively. This new ideal of beauty must have been created between 130 (death of Antinoüs) and 138 (death of Hadrian), but, given Hadrian's taste for early Greek art, it is not impossible that the type was influenced by a Pheidian *Athena;* cf. Picard, *La Sculpture antique,* pp. 427–29.

PAGE 84

Apollo Belvedere. The date of its discovery is unknown, but it appears in a *quattrocento* pattern book of antiques, known as the Codex Escurialensis, ff. 53 and 64, so must have been above-ground in the 1480's. It was found in the garden of San Pietro in Vincoli, of which Giuliano della Rovere was cardinal, and when he became Pope Julius II he took it to the Vatican, where it still stands. The Escurialensis drawings and Marcantonio's engraving (B, 331) show it as better preserved than it is today. (Incidentally, the drawing on f. 53 is taken from precisely the same viewpoint as the Marcantonio, which, although about thirty years later, might have been taken from a common original.) Of the right hand, only the fingers were broken. Before restoration the arm was chopped off at the elbow, and the present arm, with its rhetorical gesture, was added by Montorsoli in 1532 (Vasari, VI, 633). The effect of opening out a closed composition is similar to that of his restoration of the *Laokoön.* The *Apollo* was drawn and engraved many times in the Renaissance, starting with Nicoletto da Modena's fanciful reconstruction of about 1500 (Hind, *Catalogue of Early Italian Engravings,* V, p. 121, no. 34) and an early Marcantonio (B, 5) in which it is represented as *David.* Recent writers think so poorly of the *Apollo* ("as a work of art little short of abominable"— Dickins, *Hellenistic Sculpture,* p. 70; "Present day comparison with many statues of greater merit makes the encomiums of older critics appear ridiculous"—Lawrence, *Classical Sculpture,* p. 337) that they have made no serious attempt to study it. Clearly, it is a copy, made for the Roman market, of a Hellenistic bronze, but the date and provenance of the original are disputable. The old connection with the name of Leochares is purely hypothetical. It was certainly made after the period of Alexander, perhaps in Syria, as the head and hair are fundamentally un-Greek. The *Diana* of Versailles appears to me to

reproduce a work by the same sculptor, and is so similar in both style and feeling that the original bronzes might have been a pair. The height of the *Apollo* is 224 cm.; that of the *Diana,* 211 cm.

The Spinario was one of the few antique bronzes that remained unmelted aboveground throughout the Middle Ages. Its pose first appears (clothed) on Brunelleschi's bronze trial piece for the Baptistery doors. At that time it was probably in the Lateran cloisters, and was accessible to Donatello during his visit to Rome. The quasi-archaic simplification of forms in relation to the technique of bronze casting is exactly that used by Donatello in the *David.* In a decree of 1471 Sixtus IV presented it to the newly constructed Palazzo dei Conservatori, where it has remained ever since. Toward the end of the *quattrocento* it became one of the most popular antiques, and was much reproduced in small bronze replicas—e.g., three in the Louvre, four in Vienna; cf. Bode, *Die italienischen Bronze-statuetten der Renaissance,* pl. 81. Archeologists now tend to consider the *Spinario* an archaizing work of the Roman period; but the technical arguments are inconclusive, and in comparison with analogous bronzes in the Naples Museum (e.g., *The Muses*) it has a warmth and a freshness that persuade us to believe that it is an original of the fifth century.

Dürer's Apollo drawing raises a number of problems. That it was originally inspired by Jacopo de' Barbari's engraving of *Apollo and Diana* (B, VII, 523, 16) is proved by the seated female figure on the right. Perhaps it was the unresolved pose of this figure that led Dürer to abandon his project (evident from the reversed inscription) of engraving direct from the drawing. He did not abandon the idea of contrasting the male and female nude, but, having no model for the latter as canonical as the *Apollo Belvedere,* he undertook a series of systematized drawings from life (Winkler, II, nos. 411–18). He also executed another *Apollo* study (Winkler, ·44) in which the pose of the Belvedere figure is varied by the head's being turned in the direction of the weight-bearing leg. This is the pose used in the final engraving, *The Fall of Man* (B, VII, 30), although for the head he has reverted to the original *Apollo* drawing. The engraving is dated 1504, as is a drawing of the subject in the Morgan

Library (Winkler, II, 333). It is usually assumed that the *Apollo* drawing was done some years earlier, but for this there is no evidence, and the resemblance to Michelangelo's drawings of *c.* 1501 makes an earlier date improbable. The legs are an almost exact copy of the Dionysos in Mantegna's engraving of the *Bacchanal with a Wine Press* (B, XIII, 240, 19), but the upper part of the figure is very close to the *Apollo Belvedere*, the right arm being shown exactly as it was before Montorsoli's restoration.

Michelangelo and Cavalieri. A selection from Michelangelo's letters to Cavalieri is to be found in Tolnay, III, 24. The same passionate feelings are given more philosophic expression in Michelangelo's poems. In Cavalieri's perfect body he sees an image of universal beauty. He is the *forma universale* (Frey, *Dichtungen*, LXXIX). He is the incarnation of the divine idea, and, contemplating his beautiful features, Michelangelo feels himself ascending to God (Frey, LXIV and LXXIX).

Michelangelo's drawings of Apollonian youths. The most important are (1) the standing youth, in the Louvre (R.F. 1086 r.; BB, 1590), inspired by an antique and perhaps drawn from nature; usually dated *c.* 1501, but possibly earlier, as it was a drawing of this type that influenced Dürer's *Apollo* (cf. preceding note). (2) The figure, also in the Louvre (R.F. 688 r.; BB, 1588), with Mercury's cap and Apollo's viol added later, apparently a memory of the *Mercury* of the Horti Farnesiani, which was also used by Raphael for the Mercury in his fresco of the *Council of the Gods* in the Farnesina; datable *c.* 1501. (3) The youth running with left arm extended, in the British Museum (Wilde, *British Museum*, 4 r.; BB, 1481); a memory of the *Apollo Belvedere*, but turned into a figure in action, and used in relation to *The Bathers* cartoon; so datable *c.* 1504. (4) A drawing, known only from a copy in the Louvre (R.F. 694; BB, 1730), that shows two views of an antique with a broken left arm, apparently a *Hermes,* but made by Michelangelo to look entirely sixteenth century.

Thickening of the torso may have been felt to give the figure superhuman authority, for the same proportion is to be found in statues of the deified rulers of late antiquity—e.g., the colossal bronze statue of the Emperor Trebonianus Gallus, 251–53, in the Metropolitan Museum, New York [*294*].

294. *Roman. Emperor Trebonianus Gallus.*

Naked Aphrodite: Oriental cults. The nakedness of the Mesopotamian goddess Lilith was aggressive and symbolic, not merely convenient as in early Egyptian statuettes of slaves; cf. Frankfort, *The Art and Architecture of the Ancient Orient,* pl. 56. To her naked body were added the wings of an owl and the feet of a lion. This witch and harpy was dreadful to both Greek and Hebrew thought. In the Authorized Version her name is rendered "screech owl" or "night monster"; in the Bishops' Bible of 1568 the same word is translated as Lamia (Isaiah 34:14).

Spartan girls. The information that they stripped and wrestled with each other is in Xenophon, *Government of Lacedaemon,* I, 4. The tradition that they wrestled with the boys seems to derive from Euripides' *Andromache,* 569 ff.

The *Girl Runner* of the Vatican is a late marble replica of a fifth-century votive bronze. The authentic character of the sculpture can be recognized only when the restored arms are removed.

Esquiline Venus. Archeologists have long been in doubt as to whether she is a fairly close copy of a fifth-century figure or a "Pasitelean" (i.e., archaizing) imitation; and many have gone so far as to suggest that the upper half of the figure reproduces a fifth-century original while the legs are in a later style. However, the organic unity of the whole figure argues strongly against this theory, and the discovery of the Louvre torso, which is almost identical, suggests that both are copying some well-known original. It would probably have been in bronze, possibly of the school of Rhegium. As the support and other attributes have been added in the copy, they cannot be used as evidence of the figure's original purpose, but it is unlikely that she represented a Venus. Amelung, *The Museums and Ruins of Rome* (I, 207), was probably right in identifying the Esquiline copy as a *Votary of Isis,* but that cannot have been the subject of the original.

The Nereid monument is the name commonly given to the monumental tomb or *heroön* discovered in Xanthos, Lycia, in 1838 and now in the British Museum. The floating figures of women show an extreme use of clinging drapery, but this is no real

evidence that the device originated in Asia Minor, for the Nereids are slightly feeble in construction and are probably imitations of some more central style. The date usually accepted is *c.* 430 B.C., on grounds of style, but a later date would be more convincing.

Venus Genetrix. The beautiful figure that has come down to us in several replicas (Louvre; Boston; and, in reverse, Conservatori, Rome; and Este Collection, Vienna) is now generally believed to have been the work of Kallimachos. It has also been claimed for Alkamenes on the basis of its resemblance to the *Nike* tying her sandal of the Akropolis. But the attribution of the *Nike* is by no means certain. The inappropriate title by which this figure is commonly known is owing to the accident by which it was represented, with the inscription VENERI GENETRICE, on a coin of the Empress Sabina. The Louvre replica was discovered at Fréjus in 1650. The replica known in the Renaissance was in the Casa Sassi. It was drawn by both Amico Aspertini and Maarten van Heemskerck, and engraved, with a fanciful head, by Marcello Fogolino. Cf. Hind, VIII, 803.

Munich bronze girl. Cf. Sieveking in *Münchner Jahrbuch der bildenden Kunst,* V, 1910, p. 1. The date usually assigned to her, *c.* 450 B.C., on the basis of her hair and features, is probably too early. As with the *Idolino,* we may ask whether in the years of uncertainty at the very end of the fifth century work was not sometimes produced with a slightly archaic flavor.

Knidian Aphrodite. All available information, including the passage from the false Lucian, in Blinkenberg, *Knidia.* The chief facts not mentioned in my text are: (1) we can identify the pose of the *Knidian Aphrodite* from the Roman coinage of Knidos. (2) The coloring, which contributed greatly to its success, was by the famous painter, Nikias. (3) A free copy of the original was evidently cast in bronze, and of this the second replica in the Vatican, the *Venus Belvedere,* is a rendering in marble. This was retranslated into bronze in the sixteenth century by Pierre Bontemps, and the resulting cast in the Louvre is perhaps the most satisfactory surviving reminiscence of the *Knidian.*

PAGE 130

Medici Venus is a replica of a post-Praxitelean original, probably a bronze usually dated about 200 B.C. From the type of the dolphin support, it is thought to have been executed in the Augustan epoch; see Muthmann, *Statuenstützen und dekoratives Beiwerk,* pp. 28, 91 ff. The affected gesture of the right arm is a restoration, and the head has been broken and reset at the wrong angle. The original position of the head can be seen from a replica in the Metropolitan Museum of New York, which is in other respects a very close copy. It is, however, slightly more fully modeled, and may be earlier. The correct position of the head gives it a more authentically Greek appearance; cf. C. Alexander in *Metropolitan Museum Bulletin,* XI, no. 9.

PAGE 134

Byron, Childe Harold, canto IV, stanza 49. But in a letter to John Murray, April 26, 1817, he says that "the Venus is more for admiration than for love"; and in *Don Juan* (III, 118), when he felt free to tell the truth, he writes (of sculptors):

> *A race of mere impostors, when all's done—*
> *I've seen much finer women, ripe and real,*
> *Than all the nonsense of their stone ideal.*

PAGE 135

Venus of Arles. Its history throws some light on the concept of ideal art in the seventeenth century. It was discovered in Arles in 1651 on the site of the ancient theater, complete except for the arms. Under the direction of an artist named Jean Sautereau, it was restored and placed in a cupboard in the Hôtel de Ville. Unfortunately, the people of Arles boasted about this treasure and in 1684 decided to win royal favor by presenting it to the King. In spite of protests, it was taken to Paris by water and placed in the Galerie des Glaces at Versailles in April, 1685. The King found her torso too accented, and ordered Giradon to make it smoother; also to provide her with arms and hands, one of which was to hold an apple, the other a mirror—thereby settling the controversy whether she represented Venus or Diana. Before the figure left Arles a number of casts were made, one by Jean Peru and at least seven others by Italian workmen. Only one of these survived the Revolution, and even this seems to have been damaged by a sans-culotte, and the breasts have been restored. It was rediscovered in 1911 and is now in the

Museum of Arles. Comparison with the original in the Louvre shows how much of the character of an antique had to be polished away before it could qualify for admission to the Galerie des Glaces.

PAGE 137

Aphrodite of Melos. In his famous redating Furtwängler (*Meisterwerke der griechischen Plastik,* p. 601) had suggested a date between 150 B.C. and 50 B.C. Of many attempts to situate her more exactly, the most convincing is that of Charbonneaux, *La Revue des arts* (I, 8), who points out her similarity to a figure in the Louvre known as the *Inopos,* which is in fact an idealized portrait of Mithridates the Great. This gives a date between 110 B.C. and 88 B.C.

PAGE 138

Hellenistic Aphrodites. Examples of the chief motives are as follows:

Aphrodite Anadyomene, with drapery held to her legs (marble, Museo Nazionale, Syracuse).

Aphrodite Anadyomene, wringing the water from her hair (marble, Vatican; Palazzo Colonna, Rome).

Aphrodite putting on a necklace (bronze, British Museum).

Aphrodite unfastening her sandal (bronze, British Museum; terra cotta, Metropolitan, New York).

Aphrodite putting on Ares' sword (marble, Uffizi—but this may be a Renaissance invention when restoring an antique).

In addition there are several fine original torsos of which the motive is uncertain—e.g., Bibliothèque Nationale, Paris; Vatican; Brussels. Their richer forms suggest Alexandrian workmanship.

PAGE 141

Three Graces. In addition to the group in Siena, Renaissance artists were familiar with a replica in the Vatican, engraved, with a fanciful background of palm trees, by Marcantonio Raimondi (B, 340). The earliest reference to this is on a drawing in the Albertina of the Siena group, perhaps by Francesco di Giorgio or, as Salis suggests (*Antike und Renaissance,* p. 153), by Federighi, on which is written *in Roma anche.* There was also

a rough but charming fragment in the Campo Santo, which, although Papini (*Bollettino d'arte*, IX, 1915) claimed it as a fourteenth-century Pisan imitation, is certainly late antique. In spite of the chaste character imposed upon them in the Renaissance, there are grounds for thinking that the three Graces were frequently used as a sign for a brothel. Such is evidently the intention of a relief in Berlin inscribed *Ad Sorores IIII;* cf. Salis, p. 161.

PAGE 148

The popular concept of Venus Naturalis: An example is the painted tray in the Louvre [75]. Among engravings, cf. *Virgil the Sorcerer,* Hind, pl. 46.

PAGE 150

Botticelli's Graces. For the literary inspiration, cf. the admirable article by E. H. Gombrich in *Courtauld Warburg Journal,* 1945. Among other antique examples of transparent drapery Botticelli may well have known a replica of the *Venus Genetrix* type (cf. note for p. 78). Already in the *Della Pittura* (1435) Alberti had recommended painters to make their draperies seem as if blown by the wind, so that on one side the nude body is revealed, while on the other the draperies flutter in the air with a graceful movement (ed. Janitschek, p. 131). Clearly he was thinking of antique maenad figures, which are usually considered the chief source of Botticelli's Graces. For the elongated proportions he had many examples in Roman *stucchi,* of which those from the site of the Farnesina survive in the Terme.

PAGE 153

Ruskin and Botticelli's Venus. In the appendix to *Ariadne Fiorentina* (*Works,* XXII, 483), he prints as the "probable truth" a note by Mr. Tyrwhitt, in which he says that the Venus must represent Simonetta and adds, "Now I think she must have been induced to let Sandro draw her from her whole person undraped, more or less; and that he must have done so . . . in strict honour as to deed, word and *definite* thought, but under occasional accesses of passion of which he said nothing and which in all probability and by the grace of God refined down to nil, or nearly so, as he got accustomed to look in honour at so beautiful a thing. First her figure is absolutely fine Gothic; I don't think any antique is so slender. Secondly she has the sad, pas-

sionate and exquisite Lombard mouth. Thirdly her limbs shrink together, and she seems not quite to have 'liked it,' and been an accustomed model."

PAGE 155

Truth in Botticelli's Calumny. Her extreme purity is in accordance with the various descriptions of the subject that Botticelli seems to have used—e.g., in Alberti's *Della Pittura,* when she is called *pudica et verecunda,* or in the poem of Bernardo Rucellai, who says:

> La tarda Penitenza in negro ammanto
> Sguardò la Verita, chè'è nuda e pura.

PAGE 160

Signorelli's one exception, a straight borrowing from antiquity in the Ghirlandaio manner, is the nude young man seated in the foreground of the fresco of the *Testament of Moses* in the Sistine Chapel. That it is taken from a relief or gem is suggested by the wisp of drapery following the line of the arm. The same relief must have influenced the *ignudi* of Michelangelo, and more particularly the pose of the Erythrean Sibyl, who in fact is to be found above the Signorelli youth in the chapel. I should perhaps add that a figure of a youth in the background of Signorelli's *tondo* of the *Virgin and Child* in Berlin is in the pose of the *Spinario.*

PAGE 164

Antonio Federighi. The Sienese architect and sculptor, born about 1420, died 1490. The scanty documents concerning him give no indication why his work has this strangely classicistic character. The Adam and Eve must in fact be one of his latest works, *c.* 1482. The symbolic contrast of male and female bodies does not seem to occur in antiquity, although it is common in Indian art—e.g., the first-century relief at Karli, Bombay, in Kramrisch, *The Art of India,* 1954, pl. 26. The first famous example in European art is Dürer's engraving of *The Fall of Man,* dated 1504 (cf. note for p. 58, above), which may well have induced Raphael to prepare his design for the engraving of Marcantonio.

PAGE 168

Cardinal Bibbiena's bathroom. Bembo, in a letter to Cardinal

Bibbiena of April 19, 1516, describes Raphael as at work on the bathroom and anxious for details of the subjects. These are in fact the *History of Venus and Cupid* and the *Triumphs of Love*. The room is, with the Villa Madama, the most nearly complete reproduction of antiquity achieved by the Renaissance. Few of the scenes appear to have been touched by Raphael's own hand. Photographs of the bathroom are not available and access to it is discouraged, but the subjects have long been known through copies in the Hermitage (formerly in the Villa Mills on the Palatine) and in certain engravings of Marcantonio (B, 321, 325).

PAGE 171

Marcantonio's engravings of antiques. Cf. Thode, *Die Antiken in den Stichen Marcantons.* Of the famous nude figures given currency through engravings, I may note: the *Apollo Belvedere*, twice (B, 328, 331); the *Crouching Venus* (B, 313); *The Three Graces* (B, 340); the *Ariadne* of the Vatican (B, 199); *Fauns Carrying a Child* (B, 230); all generally attributed to Marcantonio. By Marco Dente da Ravenna: the *Laokoön* (B, 353). By Giovanni Antonio da Brescia: the *Aphrodite* of the Belvedere (Hind, pl. 536), inscribed ROME NOVITER REPERTUM; the *Torso of Hercules* (Hind, pl. 539), inscribed IN MONTE CAVALLO.

For *Rizzo's Eve* and the influence of Van Eyck's nudes, see note for p. 420, below.

Mantegna's representations of the female nude are all from the last decades of his life and his period of work for Isabella d'Este. In general, they are taken from antiquity—e.g., the Venus in the so-called *Parnassus* of the Louvre. But a curious problem is presented by the beautiful drawing in the British Museum representing Mars between Diana and (?) Venus, in which the figure of Venus is closely related to the right-hand Grace in Botticelli's *Primavera*. The disposition of the legs is identical, and the slender proportions are unlike Mantegna's usual classicizing figures. The drawing is thought to be a late work (Tietze-Conrat, *Mantegna*, p. 206), so that there can be no question of Botticelli's having been influenced by Mantegna. On the other hand, Mantegna was in Florence in 1466, and the *Primavera* was not painted till about 1477. The resemblance could be due to a common source in antiquity—e.g., on Aretine ware or the end of a sarcophagus in the Campo Santo (Lasinio,

IC); or Mantegna could have seen a Botticelli drawing for the Graces; or it is just possible that he visited Florence again.

Giorgione and the classic Venetian nude. To the influences mentioned in the text must be added that of Jacopo de' Barbari, who, although a second-rate artist, was undoubtedly a precursor where the nude was concerned; cf. Dürer's interest in his studies of the human figure (notes for p. 58 and p. 324). Some of his engravings and drawings of the nude must date from before his huge woodcut of Venice (1500), and may account for such a classically Venetian nude as we see in Dürer's drawing (Winkler, 85) dated 1495 (this date and signature may, however, be apocryphal). Jacopo's engraving of *Victory and Fame* (B, VII, 524, 18) is usually thought to have influenced Dürer's engraving of *The Four Witches* (B, VII, 89, 75), dated 1497 (see pl. *263*). Jacopo was closely connected with the Fondaco dei Tedeschi, and it was here, in 1507–8, that Giorgione executed a series of nude figures as the main part of the decoration. These are known to us only from the etchings by Zanetti (*Varie Pitture*, Venice, 1760), and they show that Giorgione had conceived his nudes in isolation, like antiques in niches. Taken in conjunction with the Hermitage *Judith,* they make it probable that Marcantonio's engraving of a woman watering a plant (B, 383) is from a design by Giorgione. Michiel mentions in the collection of Pietro Bembo a copy by Giulio Campagnola after Giorgione of a nude woman lying with her back turned to us and another of a nude woman watering a tree (*The Anonimo,* ed. G. C. Williamson, p. 24). The former may well be represented in an engraving by Giulio (Hind, p. 781). I am inclined to accept Wilde's suggestion that a picture by Girolamo da Treviso in the Kunst-historisches Museum, Vienna, of a nude woman standing beside an antique torso, is a copy of a Giorgione. Her pose is repeated in the figure of Christ in the *Noli me tangere* in the National Gallery, London, which is perhaps a Giorgione finished by Titian, and is reproduced in Marcantonio's engraving of *Venus and Cupid* (B, 311).

PAGE 175

Leonardo's Leda. He made at least two cartoons with a standing figure, and one with the figure kneeling. The earliest must have been done before 1505, since it was known to Raphael, who copied it in a drawing (Windsor Castle Library, 12759). It could have been done earlier still—i.e., in Milan—though

hardly before 1497. The second cartoon could be considerably later, and we may deduce from the position of the babies that it was this which was carried out as a painting. The general idea of the standing figure must, of course, be taken from an antique, but it differs from that of the ordinary Aphrodite Anadyomene pose in that the arms are turned away from the weight-bearing leg. The kneeling figure could also have been influenced by an Aphrodite Anadyomene kneeling in a shell, as on the sarcophagus (Robert and Rodenwaldt, *Die antiken Sarcophagreliefs*, V, no. 69).

PAGE 178

Pater's essay on the school of Giorgione was written in 1877 and so appeared for the first time in the second edition of *The Renaissance* (first edn., 1873). It was in a sense a commentary on Crowe's and Cavalcaselle's *History of Painting in North Italy*, in which the traditional concept of Giorgione had been drastically and, as we now realize, quite incorrectly revised.

PAGE 179

Raphael's Judgment of Paris was inspired by a sarcophagus in the Villa Medici (cf. Cagiano de Azevedo, *Le Antichità di Villa Medici*, p. 68, pl. XXVIII). This belongs to a well-known type thought to represent the design of a lost painting; certainly it is quite unsculptural and gains by retranslation into a graphic medium. Raphael has followed the subject closely, but used only a few of the actual outlines. It is commonly said that he was also influenced by a relief in the Villa Pamphili, but I cannot find one that bears any resemblance to the engraving.

PAGE 181

Sebastiano del Piombo and the female nude. It first appears in that extraordinary composition, *The Death of Adonis, c.* 1511 (Uffizi, 916), which anticipates at almost every point the classical academism of the seventeenth century. If a series of pen drawings in the Uffizi representing antiques, and generally attributed to him (e.g., Pallucchini, *Sebastian Viniziano*, pls. 86–89), are really from his hand, then we must assume that several engravings of nude women follow his design. The life drawing referred to is for *The Martyrdom of St. Agatha*, dated 1520 (published by Pouncey, *The Burlington Magazine*, XCIV, 1952, p. 161).

Titian's Sacred and Profane Love. For the classical exposition of the subject, see Panofsky, *Studies in Iconology* (p. 150 et seq.), which establishes that in Titian's picture of the twin Venuses, Venus Naturalis is clothed. Such may have been the raw material of iconography, but as transmitted to us by Titian the effect is almost the reverse.

PAGE 183

Ellesmere Venus. The date can hardly be established, owing to Titian's own repainting, and other changes, which can be seen in an X ray; cf. North in *The Burlington Magazine,* LX, 1932, p. 158. The idea of isolating the figure derives from Giorgione's frescoes in the Fondaco dei Tedeschi. Evidently there was an antique of Venus wringing the water from her hair in a Venetian or Paduan collection in the early sixteenth century, as the pose appears several times in Venetian art. Probably it is represented in the early Marcantonio engraving (B, 312).

PAGE 187

Titian's Danaë was inspired by Michelangelo's *Notte* and not, as might have been expected, by his *Leda;* i.e., the body is turned toward us to show the front of the torso and not away from us as if to enclose the swan. The position of the right arm, however, is that of the *Leda,* and may have been inspired directly by the same antique relief of Leda that was known to Michelangelo. See next note.

PAGE 194

Michelangelo's transformation of the Notte into a Leda must be related to the fact that the *Notte* was itself taken from an antique relief of Leda. The drawings for the *Notte*—e.g., Frey, 217, at Oxford —date from *c.* 1525. The drawings for the *Leda,* done from a male model (Casa Buonarroti, Tolnay, no. 98, and British Museum, 48 v.), are datable 1530. They prove that Michelangelo thought the figure out afresh, with many significant variations. The body was more turned in, and the right leg was bent under the left so that the legs enfolded the swan. Michelangelo's painting of *Leda* is lost. The fascinating and pathetic history of how Michelangelo gave the painting and drawing to his *garzone* Antonio Mini to take to France as a dowry and how Mini was swindled out of them by a tax collector in Lyons is

told by Dorez in *Bibl. de l'École des Chartes,* LXXVII and
LXXVIII.

The Florentine sculptors of the later sixteenth century who produced the
ideal of tapering elegance that is chiefly associated with Giam-
bologna have not yet been studied with enough chronological
detail for us to say to whom this ideal was chiefly owing; also,
attributions remain uncertain—e.g., there is no real evidence
that the bronze illustrated [*102*] is by Ammanati. We can at least
say that the fountain in the Piazza della Signoria, Florence
(*c.* 1570), was executed under his direction, and that the elegant
abstractions of the female body that surround it are his develop-
ment of Michelangelo's *Evening,* although some of them, as
Venturi suggests (X, 2, 416), may be the work of Andrea Cala-
mecca. Cellini may also have contributed to the ideal, although
his Venus on the base of the *Perseus* (*c.* 1550) is less elongated
and more naturalistic. Perhaps the most complete example is
the latest—the marble *Venus* by Giambologna in the grotto of
the Boboli Gardens, which, from its setting, seems to have been
consciously designed as a sixteenth-century equivalent to the
Knidian Aphrodite (1583).

Slaves of academism. This sentence cannot pass without a reference
to the greatest *master* of academism, Nicolas Poussin. The female
nude is common in his early work and shows a profound study
of Raphael (via Marcantonio), Titian, and the antique. But as
always his learning is warmed by a noble sensuality, and some-
times—e.g., his *Sleeping Venus* at Dresden—he permits himself
an approach to the body more direct than anything in sixteenth-
century Italian art. How well he understood the real purpose
of the nude is evident from his letter to Chantelou quoted in
the second note for p. 159. Nevertheless, it is hard to say that
Poussin adds anything to its history.

She shows us her back. The more frequent appearance of the motif
in the late seventeenth and eighteenth centuries is probably
owing to the prestige of the antique figure of *Hermaphrodite,* of
which the most famous example, in the Borghese collection, had
been restored by Bernini. This version, discovered in the early

295. Greco-Roman. Hermaphrodite.

seventeenth century near the Baths of Diocletian, is now in the Louvre. Of many other replicas, the best is that now in the Terme [*295*]. Whether or not these figures reproduce the famous bronze *Hermaphrodite* mentioned by Pliny as the work of Polykles (*Historia naturalis*, XXXIV, 80) seems to be an insoluble problem. In Renaissance art the earliest example of a nude woman lying with her back to the spectator is the Giulio Campagnola engraving (Galichon, *Gazette des Beaux Arts,* series I, vol. XIII, p. 344, 13), which probably represents a design by Giorgione, of which a miniature copy by Giulio Campagnola is mentioned by Michiel (see second note for p. 114).

PAGE 213

Un chinois égaré. This justly famous *mot* concludes the malicious essay on Ingres by Théophile Silvestre in his *Histoire des artistes vivants,* p. 33. He can have seen very little Chinese painting, but deduced its qualities of prehensile line from porcelain, wall-papers, etc.

Ingres' ideas of the nude. To the four mentioned in the text must be added a fifth, the beautiful figure of Angelica (Andromeda), which follows the main lines of the Bacchante figure on a sarcophagus in the Terme, but with the head thrown back in languorous, Raphaelesque despair. The first dated example is the picture in the Louvre (1819), for which there is (also in the Louvre) a study in oils (Wildenstein, 127), copied by Seurat. Ingres showed his satisfaction with the figure by repeating it several times—e.g., National Gallery, London, No. 3292 (ex-Degas); Montauban, dated 1841; and Wildenstein, 287, dated 1859, but said to have been painted earlier. There is no evidence

that Ingres thought of this figure much earlier than 1819, and it is therefore the last nude to come from his inner core. Following the *Grande Odalisque,* it shows a move away from classic fullness toward a more slender and youthful proportion.

PAGE 214

Ingres' Venus Anadyomene and La Source. They have a long and complex history. The earliest records (1807) are the two outline drawings at Montauban for the *Venus,* one showing her in the pose of the Pudica, the other with both hands placed below her breasts. In the second the disposition of the *amorini* at the feet is almost that followed in the final version. He must have carried the design much further in the next year, as the picture at Chantilly is inscribed *J. Ingres faciebat 1808 et 1848,* but we have no evidence as to whether he had adopted the all-important motive of the right arm bent over the head, as the drawings showing this motive (*Dessins des maîtres français,* V: *Ingres,* pls. 44 and 45) clearly belong to a later period. I believe that Ingres derived it from the famous relief of a nymph on Goujon's *Fontaine des Innocents,* of which a drawing by Ingres is in the Guy Knowles Collection, London. This derivation accounts for the fact that as early as 1820 Ingres had begun work on a second version of the figure in which the motive of wringing her hair was replaced by that of pouring from a pitcher, the origin of *La Source.* It is said that in 1821 and again in 1823 Ingres promised to complete the *Venus Anadyomene* for various patrons. He does not seem to have worked on *La Source* again till 1856, when he is said to have been helped in its execution by two pupils, Paul Balze and Alexandre Desgoffe. The story that he was fired by the sight of his concierge's daughter occurs frequently in Ingres literature, but I have not been able to trace it to a reliable source.

PAGE 219

The two versions of the Odalisque et l'esclave are in the Fogg Museum, Cambridge, Mass. (1839), and Walters Gallery, Baltimore (1842). The assumption that this *Odalisque* is the same as in the lost picture bought by Murat, King of Naples, in 1809 rests not only on the early drawing referred to (Maruccia), but also on a number of small replicas (Wildenstein, 55, 56, 57), one of which (in the Victoria and Albert, Ionides Collection) appears to be an original. The idea of reusing the figure in a scene of the harem appears (with three attendants) in a sketch at Montauban (Longa, *Ingres inconnu,* fig. 84), on which Ingres notes the name

of a French model, thus suggesting that the figure was restudied from nature after his return to Paris.

The note for L'Âge d' Or (reproduced in Longa, p. 106) reads as follows: "Les adolescents à bord du tableau pour mettre de la beauté à droite; cette beauté qui charme et transporte. Il faut bien passer les détails du corps humain, que les membres soient, pour ainsi dire, comme les fûts de colonnes—tels les maîtres des maîtres." It is interesting to compare this with a letter from Poussin to Chantelou, dated March 20, 1642, which Ingres cannot have known: "Les belles filles, que vous aurez vues à Nîmes, ne vous auront, je m'assure, pas moins délecté l'esprit par la vue que les belles colonnes de la Maison Carrée, vu que celles-ci ne sont que de vieilles copies de celles-là."

PAGE 221

Manet's Déjeuner sur l'herbe. In fact, the derivation from Marcantonio's engraving was recognized almost immediately by Chesneau (*L'Art et les artistes modernes en France et en Angleterre,* p. 190); but his discovery passed unnoticed till the year 1908, when it was made afresh in Gustav Pauli, "Raffael und Manet," *Monatshefte für Kunstwissenschaft,* I, 1908, p. 53.

Hiram Powers' Captive Slave, now in the Corcoran Gallery, Washington, D. C., does not seem to have been so much criticized during the Great Exhibition, but when the Crystal Palace was moved to the purer air of Sydenham a number of protests were published. What troubled contemporary moralists was the use of nude models in art schools—cf. as typical a pamphlet entitled *The Statue Question. A Letter to the Chairman of the Crystal Palace Company, dated 8th July, 1854;* and *An Appeal against the Practice of Studying from Nude Human Beings by British Artists, and in Public Schools of Design,* by William Peters. In such pamphlets antinudery is usually combined with antipopery, chauvinism, and bourgeois democracy: they are easily ridiculed. But the fact remains that a number of people staring intensely at a naked woman is, in ordinary human terms, a disturbing concept.

PAGE 223

Courbet's Baigneuse of 1853 outraged judges of art more enlightened than Napoleon III; Mérimée, for example, said she would be best appreciated in New Zealand, where figures were valued on account of the flesh they would provide for a cannibal feast.

But her enormous buttocks did not conceal from Delacroix her fundamental academism: "La vulgarité des formes ne ferait rien; c'est la vulgarité et l'inutilité de la pensée qui sont abominables. . . . Elle fait une geste qui n'exprime rien" (*Journal,* April 15, 1853).

<center>PAGE 231</center>

Renoir's later nudes point to the future (i.e., Picasso, Laurens), whereas the nudes of Maillol look to the past. Nevertheless, it would be unfair to omit Maillol altogether, for few men have rendered so well the completeness of the female torso. His small statuettes look Greek not because they are imitations of antique art—in fact, they are far more realistic—but because he has the same plastic conviction nourished by the same uncomplicated sensuality. He is a pagan in the earliest sense of the word, the inhabitant of a country cut off from time; and his work, like his personality, has fostered our belief in a Golden Age.

<center>PAGE 233</center>

Lascaux caves. There is in fact one pin man with a birdlike head at Lascaux. The so-called human figure at Altamira is doubtful. See Windels, *Lascaux Cave Paintings,* p. 134, fig. 57.

<center>PAGE 234</center>

Pollaiuolo dancing figures. The likeness to the dancers on Etruscan pottery was first pointed out by Shapley (*Art Bulletin,* II, 1919, p. 78), who does not, however, seem to appreciate how much all Pollaiuolo's silhouetted figures in action must derive from the same source.

<center>PAGE 237</center>

Temple of Aigina. Cf. Furtwängler, *Aegina.* The pediment carvings, discovered in what would now be considered fairly good condition, were brought to Rome and restored under the direction of Thorvaldsen, then at the height of his fame. He felt no compunction in improving them: in fact, considering that they were spoken of as "hyperarchaic," his restorations were remarkably self-effacing. Bought by King Louis of Bavaria for the Glyptothek at Munich.

<center>PAGE 238</center>

Time and the torso. Probably our whole concept of a satisfying plastic unit has been influenced by the accident that antique

NOTES 501

sculpture has come down to us chiefly in the form of torsos.
The modern sculptor's practice of offering a torso as a com-
plete work of art might never have gained currency if antique
art had survived in bronze rather than in broken marble.

PAGE 239

Diskobolos of Myron. The three best known versions are (1) the
marble of the Palazzo Lancelotti, discovered 1781, complete
with head; (2) the marble from Castel Porziano, now in the
Terme, lacking head, right arm, and lower legs, not known till
1906; (3) a small bronze in Munich with a Hellenistic head.
There are also representations on several gems, and presum-
ably it was these which were known, in the Renaissance, as fig-
ures in the round would have been too famous to have passed
unrecorded. Illustrations are usually from a cast made up of
the Castel Porziano body and the Lancelotti head, colored to
look like bronze. Naturally, all consistency of style and medium
is lost.

PAGE 243

Few single nude figures in violent action. Here once more our whole
concept of antique art may have been falsified by the fact that all
the available bronzes were melted down, and we know it from
the medium of marble. Other evidence (e.g., the reverses of
coins) suggests that figures in action were not uncommon.

PAGE 245

Flying drapery. It is fair to assume that the flying draperies that
appear in such an evolved form in Greek sculpture after about
450 B.C. derive from painting. For example, the draperies in-
dicated in the background of the frieze of the temple of Bassae
(*c.* 420 B.C.) are plastically unrelated to the figures and reveal a
degree of artifice quite outside the range of the vigorous but
rather rustic carvers who executed it. I should also predicate a
graphic source for the relief in the *heroön* of Trysa (Gulbashi),
c. 420 B.C. It must have been a *rotula* remarkably similar to the
Joshua roll of the Vatican—showing how little antique art
changed in seven hundred years.

PAGE 250

Harmodios and Aristogeiton recorded by Pausanias, 1, 8, 5. The
best copy is in Naples, to which has been added a cast of
a head of Aristogeiton in the Vatican, apparently a close copy
of the original.

PAGE 251

Shield of Athene. The various copies are important, for this was probably where many of the most famous poses expressive of heroic action first made their appearance. The chief source is the so-called Strangford shield in the British Museum, round which may be grouped several fragments in Rome, the Piraeus, and the Glyptotek, Copenhagen.

Horse tamers. Furtwängler (*Masterpieces of Greek Sculpture,* ed. Sellers, p. 95) had the insight to recognize in these clumsy monsters a crude reflection of Pheidian grandeur. It was through them that one of the great ideas of the nude of energy was transmitted through the Middle Ages to the Renaissance, and they recur repeatedly—e.g., on the pulpits in San Lorenzo begun by Donatello and finished by Bertoldo. They furnished the motive for two of the most popular pieces of sculpture in the Great Exhibition of 1851, the *Arabian Horses of the King of Württemberg,* from which are descended the bronze ornaments still to be found in almost every English pawnshop.

PAGE 255

Herakles and Mesopotamian seals. It is now generally accepted that the Greek Herakles was an adaptation of an Asian deity. Whatever his prehistoric origin (for which, see Levy, *Journal of Hellenic Studies,* LIV, 1934), his exploits are similar beyond coincidence with those of the deities Akkad and Sumer. The Greeks themselves seem to have accepted this Oriental origin. Cylinder seals showing a standing hero overcoming a rampant lion date from the early dynastic period of Ur (3000–2340 B.C.). During the Akkadian and neo-Sumerian periods (2340–2025 B.C.), the motive evolves into a form not dissimilar from that taken over by the Greeks in vases of the sixth century or in the carvings at Delphi. The hero is sometimes shown struggling with a bull as well as a lion; cf. Frankfort, *Cylinder Seals,* and the plates at the end of Zervos, *L'Art de la Mésopotamie.*

PAGE 258

Pollaiuolo's small Hercules pictures. It has always been the practice of artists to make small replicas of their famous works at a later date—e.g., El Greco's *Espolio,* Ingres' *Grande Baigneuse;* and the two miniature versions of the Hercules legend may have been painted considerably later than 1460 but have preserved the

main line of the originals. They disappeared from the Uffizi when the gallery was evacuated during the 1940–45 war and have not been seen since.

Hercules and Antaeus. It is usually said that the numerous representations of this subject in the Renaissance go back to an antique marble group in the courtyard of the Palazzo Pitti (engraved in Rossi-Maffei, *Raccolta di statue antiche e moderne,* pl. 43, and Reinach, I, 1920, 472). Of this piece, however, only the head, the torso, and part of the left arm of Hercules are original. His legs, and the head, arms, and legs of Antaeus, are a restoration, perhaps by Vincenzo de' Rossi. There must have been some evidence of how his body joined that of Hercules, enough to suggest that Hercules was lifting a man and not some other victim, but not enough to justify any particular reconstruction. Antaeus was being raised on Hercules' right side. The fragment can therefore have had no influence on Pollaiuolo. The drawing in the Windsor Castle Library, 12802 (Popham and Wilde, 17), shows a pose accidentally similar to the present restoration, but in reverse. The Marcantonio engraving (B, 246), which looks like the copy of a Giulio Romano, probably derived from this fragment, although the reconstruction of the Antaeus is different. The numerous engravings by Giovanni Antonio da Brescia and other followers of Mantegna (Hind, VI, pl. 515, 516, 517, 525, 527, 528) have a different origin. Another group is included in Reinach (*Répertoire,* II, 1908, 233), as at Wilton, No. 223. It is, of course, always possible that a better preserved antique group of the subject existed in the Renaissance and is now lost; but given the rarity of the subject and the fact that it is not mentioned in any contemporary sources, this is improbable; and Hercules and Antaeus emerges an almost complete creation of the Renaissance, based on descriptions in literature, a few small reliefs, and one fragment mutilated almost beyond recognition.

Battle of naked men. Ultimately, the source of this motive was the series of antique sarcophagi of which those in the Campo Santo, No. II (Lasinio, CXXXVI) and No. XXX (Lasinio, CXII), and one in the Duomo of Cortona seem to have been the most influential. But the fashion for the subject in late fifteenth-century Florence was probably owing to a piece of sculpture by Pollaiuolo, of which Vasari (III, 296) says that he "made a

very beautiful battle of nude figures in low relief and of metal, which went to Spain; and of this every craftsman in Florence has a plaster cast." The bronze relief is lost, and not one of the casts has survived, but we may trace the influence of the relief in both sculpture and drawings—viz., in Francesco di Giorgio's relief of *Discord* in the Victoria and Albert Museum, and probably in Raphael's drawings in the Ashmolean. I believe that some indication of the original may be provided by the Venetian sculptor Gambello in two bronze reliefs made for his tomb and now in the Museo Archeologico, Venice (cf. Planiscig, *Bildhauer der Renaissance,* p. 309, fig. 325). Bertoldo's bronze relief in the Bargello is a compound of the two Campo Santo sarcophagi, and was probably intended to correct the *quattrocento* style of Pollaiuolo by insisting more dogmatically on antique taste.

PAGE 270

Holkham grisaille. This is the copy from which our knowledge of Michelangelo's cartoon for *The Battle of Cascina* is derived. It was made by Aristotile da Sangallo in 1542 from a (lost) drawing made in his youth before the cartoon was destroyed. It was already recognized by Vasari (VI, 433 f.) as being the only complete record of the cartoon, and comparison with Michelangelo's own drawings proves it to be remarkably reliable.

PAGE 275

The athletes of the Sistine. Michelangelo had already employed the nude figures of young men as the background of a sacred subject in the Doni *tondo* in the Uffizi, which was clearly inspired by the Signorelli *tondo* in the same gallery. In the Signorelli, however, the young men are represented as herdsmen and have some factual justification. In the Michelangelo they are, so to say, a philosophic decoration. The scale and attitudes of the Sistine athletes were certainly influenced by Donatello-school reliefs in the courtyard of the Palazzo Riccardi, Florence. These in turn were little more than enlarged copies of antique gems. The most famous of these gems, depicting Diana, belonged to Paul II and the Medici family. It was lost in 1494, but copies of it had already been made. For a list of possible sources for the athletes, see Tolnay, II, 65–66. Some of the gems originally related to these figures may be Renaissance copies, but antique originals undoubtedly existed. The Hellenistic relief of *Bacchus and Ariadne* that influenced the *Persica* is in the Vatican; cf. Tolnay, II, fig. 391.

PAGE 279

Michelangelo's Victory. Obviously datable during the 1520's and related to the figures in the Medici tombs, but its exact date and intention are unknown. It was in Michelangelo's possession at his death and is first mentioned in a letter from Vasari to his nephew. Wilde (*Michelangelo's "Victory"*) argues that it was one of the figures intended for the third version of the tomb of Julius II, on which Michelangelo was at work in Florence between 1516 and 1527. He believes that it was to be balanced by a *Hercules and Cacus,* of which the terra cotta in the Casa Buonarroti is a sketch. He places it at the end of this period, 1526. One may doubt whether, by this time, Michelangelo undertook such a work with a precise intention in mind, but the date is convincing.

PAGE 285

Archers shooting at a mark. For a full discussion of problems connected with the date and authorship of this drawing, see Popham and Wilde, *Windsor,* p. 248. The doubts as to its authorship expressed by such eminent students of Michelangelo as Popp, Panofsky, and Tolnay may come to be considered among the curiosities of modern connoisseurship. This, like some other of the so-called "presentation" drawings, seems to have been a conscious effort to re-create a lost masterpiece of antiquity. The subject was known to Renaissance artists through a decorated panel on a ceiling in the Golden House of Nero, now destroyed but recorded in a water color by Francisco de Hollanda (cf. Codex Escurialensis text, pl. III). A pupil of Raphael used the same motive in a fresco decoration in Raphael's villa (now in the Villa Borghese).

PAGE 297

Four legends. I originally included a fifth antique embodiment of pathos, the captive barbarians, either standing with hands bound before them or seated with hands bound behind, who once more embody the idea of defeated rebellion against a superior or quasi-divine power. But on examination few of these standing figures on sarcophagi and other reliefs are nude. The fact that they were represented naturalistically, dressed in their barbarian trousers, was intended to distinguish them from the ideal nudity of Romans or Hellenes. The seated prisoners with arms bound behind them are more often nude; cf. Bienkowski, *Die Darstellungen der Gallier in der hellenistischen Kunst,*

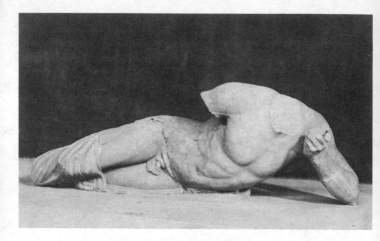

296. Greek, 5th century B.C. The River Alpheios.

pls. IV, V^a, IX^a, etc. Although nude standing captives were ex-
ceptional in antique art, their "pathetic" poses appealed so
strongly to the Renaissance that they are often shown nude in
Renaissance art—e.g., in Bertoldo's battle relief in the Bargello.
Seated prisoners are common—e.g., the relief of the *Flagellation*
by Francesco di Giorgio in Perugia, etc., influenced by the
sarcophagus in Cortona, which he had seen when at work on
the church of the Calcinaio, outside that city.

PAGE 298

The earliest Niobids. The figures discovered in the Gardens of
Sallust, Rome, now in the Terme and at Copenhagen, are usu-
ally considered fifth-century work, but archeologists have
always felt uneasy about their date and origin. The workman-
ship, especially in the Copenhagen figures, is lacking in vitality,
and I believe them to be free copies of a pediment group of the
same date as the east pediment of Olympia, and perhaps by the
actual carver. Comparison of the dying son at Copenhagen with
the river god Alpheios at Olympia [*296*] shows not only a similar
sense of form but an identical treatment of details—e.g., the
drapery. But the Olympia figure, where invention and execu-
tion are one, makes its appeal to our feelings directly through
its plastic vigor and expressiveness, whereas the Niobid can
only do so at second hand through identification of the subject.

In fact, we have no reason to believe that the river Alpheios was intended to be in pain or sorrow; otherwise, this early masterpiece of *contrapposto* could be cited as the first great embodiment of pathos.

The origin of these Niobid groups is wholly a matter of speculation. Archeologists, on grounds of certain early representations on vases (e.g., a krater at Orvieto), are inclined to trace them back to a painting by Polygnotos. As usual in antique art, the main lines of the composition, some of the motives, and the general sentiment survived for five hundred years. The most complete group, discovered near the Lateran in 1588, is now in the Uffizi. By the time this group was made (first century A.D.?), its original purpose as part of a pediment had been forgotten. Other Niobid poses deriving from lost masterpieces of painting and sculpture are known only on sarcophagi—e.g. Vatican, 1445; Museo Profano of the Lateran, etc.

PAGE 300

Death of Meleager. See Salis, p. 61 et seq.

PAGE 301

Marsyas. The group of the flaying of Marsyas was one of the most popular works of sculpture of the Hellenistic period. It was probably in bronze and consisted of three figures, Apollo, a slave sharpening his knife, and Marsyas hanging by his hands. Their general disposition can be seen on the sarcophagus of Harmogenes in the Ny Carlsberg Glyptotek, Copenhagen. Of these figures, the Apollo has come down only in a fragmentary copy (Berlin), the slave in a famous marble in the Uffizi known as the *Arrotino,* and the Marsyas in a large number of marble copies (Rome, Florence, Berlin, the Louvre, Constantinople, etc.). They are of two types, one invariably in red marble, the other in white. Of these, the red are more expressive and probably represent the bronze more closely; the white go back to a prototype copy in marble in which the emotion was softened. In the restrained and classical character of the body, no less than in the treatment of the hair, they resemble the dying Gauls (Campidoglio, Terme), which are copies of the bronze groups dedicated by Attalos soon after 240 B.C., and the Marsyas clearly belongs to this epoch rather than to the more "baroque" style of the Pergamon altar in Berlin, which was about fifty years later.

Many replicas of the Marsyas were known in the Renaissance. In the Medici Collection alone there were both a red and a white version. The former was restored by Verrocchio, and is mentioned both in Tommaso's inventory (Cruttwell, *Verrocchio*, p. 243) and in Vasari (III, 367); it has now disappeared. The latter was said by Vasari (II, 407) to have been restored by Donatello. If this is true, it must also be lost, as the two figures of Marsyas now in the Uffizi are restored by a poor artist at a later date.

Laokoön. The date and authorship have been much disputed. Pliny (XXXVI, 37) says "out of one block of marble did the illustrious artists Agesander, Polydorus, and Athenadorus of Rhodes, after taking counsel together, carve Laokoön, his children, and the wondrous coil of snakes." There are several signatures on bases of Athenadorus, son of Hagesandros, and the coincidence of these two names has naturally led archeologists to assume that these were identical with the carvers of the *Laokoön.* The inscriptions are datable in the first century, and in fact two men of this name (actually brothers) are recorded as receiving honors in 22 and 21 B.C. Against this it has been argued by Gisela Richter (*Three Critical Periods in Greek Sculpture,* Appendix, p. 69) that these names were common in Rhodes throughout the Hellenistic period. She concludes that the *Laokoön* is by other sculptors of the same name who lived in the second Pergamon period—i.e., early in the second century. The stylistic affinity of the *Laokoön* with the Pergamon altar formerly in Berlin (partly destroyed by bombing, 1944) is unquestionable. But I do not agree that it is an original marble of that period and that the first-century dating of the names of two of the sculptors is a mere coincidence. The whole sculptural character of the *Laokoön* suggests that it was originally conceived and executed in bronze. It is well known that practically all the signatures on marbles of the Roman period are of the craftsmen who executed the copy. Names of the original artists are hardly ever preserved (cf. Richter, pp. 45–47). It therefore seems probable that the names recorded by Pliny were those of the copyists, whose virtuosity in rendering an elaborate bronze group in marble was much admired. (Incidentally, Pliny is mistaken in saying that it is carved from a single block). The fact that Pliny is our chief source of written information about antique art must not lead us to place much reliance on his judgment in artistic matters. As with the *Apollo Belvedere,* we have only to look at the bronze cast of the *Laokoön* by Bontemps, in the Louvre, to see how much more satisfying it is in that

medium. Pliny's contention that the marble is the work of three craftsmen is borne out by the fact that it exhibits three different degrees of skill. It would be hard to believe that the admirable carver of the father's torso should also have executed the lifeless surfaces of the elder son's body. The *Laokoön* was restored in 1532 by the Florentine sculptor Fra Giovanni Montorsoli (Vasari, VI, *633*). The greater part of the original father's arm is in the Vatican and could be put back in its correct position behind his head, had not the present restoration become itself a historical document.

PAGE 309

For the origin of the "pathetic" Crucifixion, see Reil, *Christus am Kreuz in der Bildkunst der Karolingerzeit,* which reproduces the earliest example of the *curva bisantina* from the later ninth century, the prayer book of Charles the Bald (pl. IX) and the Drogo-Sakramentar (pl. X). For the diffusion of the pathetic Crucifixion through the spread of Rhineland crucifixes, see an admirable article by Franchovich, "L'Origine e la diffusione del Crocefisso Gotico doloroso," *Jahrbuch der Bibliotheca Hertziana,* II, 1938.

Gregory of Tours. The passage is quoted by Schlosser, *Schriftquellen des frühen Mittelalters,* p. *9.*

The draped Crucifixion fell out of use from Carolingian times onward, partly, no doubt, because it could not be accommodated to the "pathetic" body. An example of a crucified Christ who, because of his drapery, seems to be dancing is an ivory plaque in the Musée de Cluny, Paris. By the fifteenth century the Jerusalem type of Crucifixion had been so completely forgotten that when it survived (e.g., at Lucca) it was thought to represent a bearded woman and became identified with the legend of a saint, variously known as Liberata, Wilgefortis, Kummernis, and Uncumber, who grew a beard in order to preserve her virginity.

PAGE 311

The two thieves. In the earlist representation of Christ crucified between two thieves, a panel on the doors of Santa Sabina, Rome, fourth century, the thieves are miniature replicas of the Christ and stand in the same pose. But at some point it was felt

297. School of Metz, 9th century. Crucifixion

necessary to distinguish between their human agonies and the sublime sufferings of Christ. Early in the Middle Ages they were taken from their straight crosses, which involved the same schematic image as the Christ, and put on rough-hewn trees— e.g., an ivory plaque of the Metz school, *c.* 850, in the Bibliothèque Nationale, MS. lat. 9388 [*297*]; when the figure of Christ was shown hanging in pain, the attitudes of the thieves had to be more contorted—e.g., in Germany, a picture by a Bavarian artist at Schleissheim, *c.* 1440 (Glaser, *Zwei Jahrhunderte deutscher Malerei*, p. 48); or, in Italy, Antonello da Messina's picture in Antwerp, 1475. In the *Grandes Heures de Rohan* (mid-fifteenth century) the profane character of the thieves is emphasized by their being depicted in their underclothes. They were thereby given a status as natural man, whereas Our Lord was associated with an ideal form of geometry.

PAGE 312

Masaccio's Eve, as has frequently been observed—e.g., Mesnil in *The Burlington Magazine*, XLVIII, 1926, pp. 91–98—is in the

pose of a Venus Pudica. That at least one antique of this type was known to artists of the thirteenth century is proved by the *Temperance* of Giovanni Pisano (see p. 147), and Masaccio, who had spent the preceding year in Pisa, may have derived the pose direct from Giovanni's figure. The earliest description of a Venus Pudica is in Benvenuto Rambaldi da Imola's commentary on Dante's *Divina Commedia*, which must date from about 1340 (cf. the edition of 1855, translated by Tamburini, II, 207). He says that he saw it in a private house in Florence, and adds that it is said to be a work of Polykleitos, but he does not believe it. The *Venus* described by Ghiberti in his *Memoriale* (ed. Schlosser, I, 62) cannot be the same, as she had draperies halfway up her thighs—i.e., the type of the *Venus of Syracuse*.

Ghiberti's Isaac and the antique. There can be little doubt that it was inspired by a Niobid, but no figure in precisely this attitude has survived. It has been thought to derive from the *Ilioneus* in Munich, which was at one time believed to have been in Ghiberti's own collection (cf. Grünwald in *Wiener Jahrbuch*, XXVIII, p. 155).

PAGE 315

Pietà was one of the last great motives to be added to Christian imagery. It originated in Germany in the early fourteenth century out of a fusion of the Lamentation over the Dead Christ and the Madonna and Child (in the earlist *Pietàs* the Christ is as small as a child). No detailed study of the subject is known to me, but cf. a booklet by Pinder, *Die Pietà.*

PAGE 319

Raphael's Entombment. In addition to the antique *pietà militare* and Michelangelo's *Pietà*, we must note the influence of Mantegna's engraving of *The Entombment* (B, 3), of which a copy exists in the so-called Raphael sketchbook. From this Raphael took the man carrying Our Lord's body on the left, the disposition of the fainting Virgin on the right, and many other compositional ideas.

PAGE 325

Of the *fallen giants* who inspired Michelangelo's "unfinished" style, the most influential was the fragment of a group (probably Menelaos with the body of Patroklos) known as the *Mastro Pasquino*, which stood, and still stands, at the side of the Palazzo Braschi, Rome. As was first pointed out by Grünwald

(*Wiener Jahrbuch*, XXVII, 1907–9, p. 130), Michelangelo certainly had this figure in mind when he executed his earliest "unfinished" figure, the *St. Matthew*.

The Ariadne of the Vatican was discovered in the early sixteenth century and identified as a Cleopatra. It was part of a group of *Dionysos and Ariadne,* and the magnificent bronze cast by Bontemps in the Louvre suggests that the original may itself have been a bronze. This group must have been similar to the originals of the Uffizi Niobids, and both may ultimately derive from Skopas, although their enhanced pathos suggests a later date. The *Ariadne* was drawn by Raphael at the time he was working on the *Parnassus*. A photograph of a copy of this drawing was shown to me by O. Fischel, but I can no longer trace it. The droop of her head, and still more the turn of Niobe's head as we know it in several replicas (e.g., Brocklesby Park), provided the model of feminine pathos from Raphael onward. Niobe is the origin of all the eye-rolling, heaven-supplicating martyrs of Counter Reformation art, and a cast of her head is the subject of a drawing inscribed by Ingres *Mon premier dessin 1789* (Lapauze, p. 19).

Of the *three drawings done for Vittoria Colonna,* only one has survived, the *Crucifixion* in the British Museum; and even this was considered a copy by every critic except Thode until its recent vindication by Wilde (*British Museum,* no. 67). He dates it between 1538 and 1541. Provenance (it was in the collection of the King of Naples) and comparison with numerous copies (Oxford, Louvre, British Museum) persuade me to accept it as the original.

The Y-shaped Cross is almost certainly an invention of the Rhineland. It appears first in an ivory of the Metz school of *c.* 850, in the Bibliothèque Nationale [297], but is there assigned appropriately to one of the thieves. It seems to have been transferred to the Cross of Our Lord in the eleventh century and must have been widely diffused in Italy. Rhenish crosses of this type are to be found in many Italian churches (Pisa, Orvieto, Spalato, etc.), but most of these are late thirteenth century, and the first datable instance of the motive is Nicola Pisano's pulpit in the Cathedral of Siena, 1265. It may be

298. Boldrini after Titian. The Monkey Laokoon

fairly assumed that this was derived from a Cross of the Rhine-land school, now lost. Either this, or Giovanni Pisano's some-what similar *Crucifixion* in Sant' Andrea, Pistoria, was probably what lay at the back of Michelangelo's mind when he adopted the Y-shaped Cross; but we know from the St. Peter's *Pietà* that he appreciated the pathos of Gothic carving, so he may also have been thinking of a Rhineland crucifix. The Y-shaped Cross is rare in painting, the only examples known to me being in a diptych in the Florence Academy in the style of Berlinghieri and a picture by Ugolino in the Siena Gallery, No. 34.

PAGE 343

Monkey Laokoön. This woodcut [298], which is neither signed nor dated, is first mentioned by Carlo Ridolfi, and his attribution to Titian has never been questioned. It is in a style similar to that of the woodcuts after Titian executed by Boldrini, who was working for Titian in 1566, but there is no reason to assume that Titian's design was so late. The correct position of the Monkey Loaköon's left arm suggests a date earlier than Montorsoli's restoration of the original (1532). Many theories have been put forward to explain this group. The earliest, that

it was intended to satirize Bandinelli's copy of the *Laokoön,* is improbable on many counts. The latest (Janson in *The Art Bulletin,* XXVIII, 1946, p. 49), is that it was connected with a famous controversy on the nature of human anatomy in which Vesalius had accused Galen of describing the structure of an ape, not a man. There is not sufficient evidence for this ingenious theory, and the simplest explanation is the best: that Titian was satirizing the excessive admiration bestowed on the group and on classical art in general. To ridicule the solemnities of human life by depicting them as being enacted by animals is a universal artistic practice—e.g., the so-called Toba Sojo role (early twelfth-century Japanese) and the many thousands of carvings and manuscript borders of the Middle Ages. The fact that Titian admired the group and owned a cast of it would no more prevent him from ridiculing it than a priest of the medieval Church was prevented from carving a monkey Mass on a miserere seat.

PAGE 358

Nereid sarcophagi: the only systematic study is in Robert and Rodenwalt, *Die antiken Sarcophagreliefs,* vol. V, 1939, no. 69. An almost complete corpus, classified iconographically, it nevertheless throws little light on the subject from the point of view of form or pictorial invention.

PAGE 359

Spartan girls dancing. The *Saltantes Lacanae* of Kallimachos, mentioned in Pliny, were evidently celebrated, for in addition to the reliefs in Berlin they have come down in certain coins of Abdera, on a number of pieces of Aretine ware, and on fragments of Roman glass (cf. Rizzo, *Thiassos,* figs. 29–30). They also appear, together with the maenads mentioned in the next note, on a marble base from the Grimani Collection in the Museo Archeologico, Venice. The identification of these figures with the passage in Pliny is confirmed (*a*) by their short Spartan kilts; (*b*) the crownlike hat, presumably of Egyptian origin, known as the *kalathiskos,* which was worn by Spartan priestesses of Apollo at Delphi.

Maenads: cf. Rizzo for a full treatment of the linear type and their relation to Kallimachos. The Skopaic type has not, as far as I know, been examined. No doubt both types incorporate much iconographic material of an earlier date, of which we

find evidence in vase paintings throughout the fifth century, from the famous cup by Makron in Berlin (*c.* 490) onward.

PAGE 363

Ecstasy in the round. The satyr looking at his tail was evidently popular and exists in several replicas—e.g., in the Terme (499) and the Uffizi. The so-called *Dancer* of Tivoli (Terme, 108596) is the best example of a type that also exists in Berlin and Vienna, and that, through Canova's free variations, became popular in the nineteenth century.

PAGE 365

The Dresden Maenad was discovered at Marino, not far from Lake Albano. Up to 1945 it was in the Albertinum, Dresden (133). From its likeness to plaque 1014 of the Mausoleum [cf. 137] and from other characteristics, it has also been accepted as a copy of the *Maenad* of Skopas, but one of an unusual kind. Instead of the lifeless "pointed" copy generally supplied to the Roman market, it was much reduced in scale (the height of the fragment is sixty centimeters), and is executed with exceptional freedom, amounting in places of roughness. One is led to suppose that this is the work of an individual artist making, so to say, a sketch of the original rather than of a professional copyist.

The numerous Bacchic figures on reliefs and vases in a style related to the Mausoleum and the Dresden *Maenad* are all decorative derivations by more or less competent craftsmen. The most famous is the Borghese Vase, now in the Louvre [*212*], found (like the Niobids) in the Gardens of Sallust. It probably dates from the first century B.C., and the Skopaic motives have been considerably altered for decorative purposes.

PAGE 367

The origin of the Nereids seems to be an insoluble problem, since the sarcophagi in which they appear are all later than the first century B.C.; whereas the motives can be traced back to the fourth century. They were obviously taken from "pattern books," which probably reproduced famous paintings. We can say that these patterns were of two types, the decorous and the abandoned, representing classicizing and Orientalizing tendencies in Hellenistic art; but this is only art historians' patter. The abandoned Nereid, in the same outlines that were to last till the fifth century A.D., is to be found painted on a duck-

shaped askos in the Louvre, discovered in south Italy, datable fourth century B.C.; only there she is represented as a winged genius.

PAGE 371

A study of the *diffusion of Nereids* in the fourth century would resolve itself into a study of trade routes in the late Roman Empire. Matsulevich, *Byzantinische Antike*, reproduces (pl. 6) a Nereid found in Baku. Foucher, *L'Art gréco-bouddhique du Gandhâra* reproduces (fig. 130) a Nereid relief in the Lahore Museum.

PAGE 383

Titian's Bacchanals were intended to be re-creations of antique painting, and the subjects were drawn directly from antique literature. The *Bacchus and Ariadne,* as pointed out by Wind (*Giovanni Bellini's Feast of the Gods,* p. 56), illustrates a passage in Ovid (*Fasti,* III, 505–508), although certain details are taken from Catullus (*Carmina,* LXIV), as was originally observed by Lomazzo. Since Wickhoff (*Jahrbuch der Preussischen Kunstsammlungen,* XXIII, 1902, p. 118), the Madrid *Bacchanal* is always said to have been derived from a passage in Philostratos (*Imagines,* I, 25) describing how, on the island of Andros, Bacchus caused a river of wine to flow. Philostratos says quite definitely that this river shall be the subject of the picture, but Titian depicted only the resulting bacchanal and may well have had some other source in mind.

PAGE 384

Letto di Policleto. This was the name given to a marble relief of Cupid and Psyche at one time in the possession of Lorenzo Ghiberti, which had an extraordinary influence on Renaissance art. From the figure of Psyche Raphael derived the nude woman (? Hebe) in the foreground of his fresco of *The Wedding of Cupid and Psyche* in the Farnesina, Correggio derived the Io (*c.* 1530), Titian derived the Venus in his Prado *Venus and Adonis* (1553), and Poussin derived (in reverse) the Nereid to the right of his *Triumph of Galatea*. Of the recumbent male figure (Cupid) we have a copy by Michelangelo at Windsor (Wilde, 422, r.).

The relief passed into the hands of Ghiberti's grandson Vittorio, himself a sculptor and friend of Michelangelo; it was later sold to Cardinal Bembo. Its subsequent history is hard to follow, as there was at least one other relief of the same subject

(? a forgery) and also a bronze. We may deduce that the mo-
tive was common in antiquity, as it appeared on Aretine ware,
for which an original mold stamp is in the Metropolitan
Museum, New York (cf. Museum *Bulletin*, XXXII, 1937, pp.
96–97). All three have disappeared and our only replica of the
original is a rough seventeenth-century copy in the Palazzo
Maffei, Rome (illustrated in Goldscheider, *Michelangelo Draw-
ings*, fig. 143). Cf. Popham and Wilde, p. 246; Schlosser,
Ghibertis Denkwürdigkeiten, II, 172.

The mutilation of Correggio's Io. The story quoted in the text,
although it appears in standard works (e,g., Ricci's *Correggio*),
does not withstand an examination of the picture's history, as
the *Io* was definitely in the Imperial Collection in Vienna by
1702. The Correggios in the Regent's Collection were the *Leda*
and the *Danaë*, and it was the former that was destroyed
by Louis d'Orléans. It seems to be true that Coypel collected
the pieces and that the head was missing, but the present
head cannot have been painted by Prud'hon (as is often said),
for in 1755 the *Leda* passed into the possession of Frederick the
Great. It is equally impossible that Prud'hon should have
painted, or restored, the head of the Io in Vienna. Perhaps the
confusion arose from the fact that the Regent owned a *copy* of
the Io, which was also destroyed by Louis d'Orléans. In view
of this fact, I have let the passage in the text stand as I gave it
in the lecture.

PAGE 400

Pagan idols. The most accessible summary of postclassical atti-
tude toward representation of the Olympian gods is Edwyn
Bevan, *Holy Images*, 1940; but he does not allow sufficiently for
variations in different parts of the Roman Empire or for spor-
adic revivals of paganism. Cf. Af öldi, *Die Kontorniaten.*

PAGE 404

Bronze doors: see Goldschmidt, *Die deutschen. Bronzetüren des frühen
Mittelalters*, p. 23, and von Einem, "Zur Hildesheimer Bron-
zetür," *Jahrbuch der Preussischen Kunstsammlungen*, 1930. The
doors can be dated precisely between 1008 and 1015. Several
artists were employed, of whom far the most gifted and indi-
vidual was the portrayer of the Creation and Fall. The sense
of spacing suggests a ninth-century Tours manuscript—e.g., the
Bamberg Bible—but the animation is far superior, and the

author may have seen antique prototypes, now lost, on which
the Tours Bibles were also based.

PAGE 407

The idea of basing a *Last Judgment on an antique sarcophagus* rep-
resenting the victory of Romans over barbarians first appears
on Nicola Pisano's pulpit in the Baptistery at Pisa, 1260. Not
only are individual figures imitated, but the whole composi-
tional idea is the same, the defeated groveling below the victo-
rious in dignity above. This explains why the Last Judgment at
Pisa differs so strikingly from the other sides of the pulpit. At
Orvieto, Maitani does not follow the classical composition, but
many of his damned are clearly inspired by defeated Gauls. In
the Last Judgments of Rogier van der Weyden and Memlinc
at Beaune and Danzig the figures are more naked and defense-
less and are in fact an instance of the unflinching truth of late
Gothic art; as we realize when we see photographs of Belsen or
of the struggle for the sacred baton at the Kwannon Temple,
Saidaiji (cf. *Illustrated London News,* Jan. 1, 1955, p. 18).

PAGE 410

Paul de Limbourg and antique sculpture. His patron the Duc de
Berry, although a great collector, does not seem to have owned
any antiques: at least, none is mentioned in his inventories. So
Limbourg probably saw the kneeling figure from which his
Adam is derived during his visit to Italy. It was a figure in the
round, not a coin or gem, as it appears again drawn from a
different angle, on f. 34v (Durrieu, *Les Très Riches Heures de . . .
Duc de Berry,* pl. XXV). It was evidently a type similar to the
Youth of Subiaco in the Terme, and so could be either a Niobid
or, more probably, a vanquished Persian from a group such as
the Attalos figures in Naples.

PAGE 420

Gothic nudes in Italy. One famous painting of nudes, presumably
in what I have called the "alternative convention," reached
Italy early. This was Jan van Eyck's picture of women in a
bathroom, which was the property of Cardinal Octavian (created
cardinal in 1408). It is described at length in Bartolommeo
Fazio's *De viris illustribus,* written *c.* 1455 (ed. Florence, 1745,
p. 46). It contained several figures, some lightly veiled, and of
one it was possible, by means of a mirror, to see her back as

well as her breast. This remarkable work is usually identified with the painting by Jan van Eyck referred to by Vasari: "al duca d'Urbino Federico II, la stufa sua" (I, 184; Milanesi points out that Vasari must mean Federico I). Another picture by Van Eyck of a nude woman and her maid, recorded in Van Haecht's copy of C. van der Geest's gallery, is sometimes confused with the picture mentioned by Fazio, but does not tally with his description.

Pisanello, who had probably visited France and Burgundy, gave a Gothic character to his nudes, even when they were free copies of the antique. A similar character is to be found in two *cassone* panels, a *Judgment of Paris* in the Burrell Collection and a *Diana and Actaeon* in the Fuld Collection, now attributed to the workshop of Domenico Veneziano and datable *c.* 1460. There are numerous Gothic nudes in popular engravings evidently derived from German cuts.

In sculpture, a curious example is one of the figures supporting the holy-water stoup at the main door of Siena Cathedral by Antonio Federighi, *c.* 1460–70. The most famous "Gothic" nude in Italian art is the Eve of Antonio Rizzo on the Arco Foscari of the Doge's Palace in Venice. It has frequently been compared to Jan van Eyck's Eve on the Ghent altarpiece, but no direct influence is probable or necessary. It is, however, somewhat earlier (*c.* 1483) than the German bronze and boxwood figures that it so closely resembles.

The fat bacchante in Mantegna's engraving (B, XIII, 240, 20) was based on an antique relief, presumably a Bacchic sarcophagus, recorded in an antique pattern book of the Renaissance of which a few sheets are in the Ambrosiana (Luca Beltrami gift; cf. *Rassegna d'arte,* X, 1910, p. 6). It was probably in Rome, as were the other antiquities recorded in this pattern book—e.g., the *Triton and Nereid* now at Grottaferrata (see p. 283).

<div style="text-align:center">PAGE 421</div>

Dürer and Jacopo de' Barbari. The whole story of their relationship is full of puzzles, on which we must hope that scholars of Dürer will shed more light—e.g., if the masterly drawing of a nude woman seen from behind, in the Louvre (Winkler, 85), is really 1495, why did Dürer do a timid imitation of Jacopo on his second visit to Venice in 1505 (ex-Lubomirski, Winkler, 410)? And why, after all his researches of 1505, did he still wish to possess Jacopo's book? By 1521 he must have seen prints and drawings of antiques and of Raphael's work far more evolved

and systematic than anything by Jacopo. Incidentally, the Regent of Malines refused to let him have the book, saying that she had promised it to her court painter, Bernart van Orley (cf. Veth and Müller, *Albrecht Dürers Niederlandische Reise,* I, 84).

PAGE 424

For the *title page of Erasmus' New Testament of 1519* Froben used a woodcut known as *Imago vitae aulicae,* by Ambrosius Holbein, which seems to have been published in the preceding year. Apparently, no one commented on its inappropriateness, which gives some justification to the later strictures of the Council of Trent.

PAGE 435

The Diana of Anet. Roy (*Artistes et monuments de la Renaissance en France,* I, 320) shows that the attribution to Goujon is of recent origin and cannot be upheld. Nevertheless, it is hard to believe that such a perfect and individual work is by an unknown carver, and on grounds of style one would gladly accept the suggestion put forward by Blunt (*Art and Architecture in France, 1500 to 1700,* p. 76) that it is the work of Germain Pilon, were it not that the *Diana* was in place in 1554, and Pilon himself gave the date of his birth as 1536 "or there-abouts." Even allowing that he was precocious (he undertook the sculpture for the tomb of Francis I in 1558), the *Diana* is an incredibly assured work for a young man of about twenty.

PAGE 437

Pels, *Gebruik en misbruik des tooneels,* p. 36. This passage from the poem is quoted with approval by Arnold Houbraken in his life of Rembrandt (*De groote Schouburgh der Nederlantsche Konstschilders en Schilderessen,* vol. I, Amsterdam, 1718, translated in Borenius, ed., *Rembrandt, Selected Paintings,* p. 26). Houbraken himself says, "His nude women, however, the most wonderful subject of the brush, to which all celebrated masters from time immemorial have given the best of their industry, are too pitiful (as the saying goes) for one to make a song about." This represents the conventional attitude to the nude in which both classic and baroque schools of thought concurred. That there was in fact a certain demand for "nudes" of a grossly plebeian kind had been proved by the success of Jordaens.

PAGE 448

The Parthenon was not entirely unknown in the Renaissance, for Cyriac of Ancona had visited it in 1435 and 1447 and made a Gothicizing drawing of the west front (published by T. Mommsen, *Jahrbuch der preussischen Kunstsammlungen,* 1883, p. 78). This drawing may have been used by Giuliano da Sangallo in his representation of the Parthenon in his book of studies in the Vatican Library, although this contains evidence of knowledge of the metopes, which was not included by Cyriac. Cf. C. K. F. Huelsen, *Il Libro di Giuliano da Sangallo,* pp. 41–42. Cyriac had turned the sculpture in the pediment into Gothic figures (the Neptune is a woman in a fashionable Burgundian dress), and the indication of sculpture in Giuliano's drawing was certainly not clear enough to have had any influence on artists, and in so far as similarities between Michelangelo's reclining figures and those on the pediment of the Parthenon are not due solely to a similar feeling for the architecture of the body, they arise from reminiscences of Pheidian motives still to be found in Greco-Roman sarcophagi.

PAGE 449

The association of the *Crouching Venus* with the name of Doedalsas of Bithynia derives from a corrupt passage in Pliny, *Historia naturalis,* XXXVI, 35 (in *The Elder Pliny's Chapters on the History of Art,* tr. K. Jex-Blake, pp. 208–9). It reads: "Venerem lavantem se sedaedalsus stantem Polycharmos." As the word *sedaedalsus* is meaningless, scholars have supposed that it is a corruption of Doedalsas, who is said by Eustathios to have been a Bithynian sculptor working in the second century. The representation of a crouching Venus appears on various coins of Bithynia. It also, however, occurs on other coins (cf. ibid., p. 239), and on vases such as the Attic hydra of Thetis in the British Museum, and it was certainly current early in the fourth century. The appearance of this pose on coins of Bithynia of the second century need not, therefore, be related to Doedalsas, even supposing that the emendation that produced his name out of the incomprehensible passage of Pliny is correct.

PAGE 452

Pisanello: his nudes are of two kinds. The more numerous are studies from the antique to which Pisanello has given the accent of late Gothic realism. These are to be found in the Am-

brosiana (Degenhart, figs. 30 and 31); in Rotterdam (Degenhart, fig. 33); and in the Louvre, Recueil Vallardi. There are also a few studies from the life, amongst which we must class the *Luxury* in the Albertina [*229*]. Of these, the most remarkable is a sheet in the Boymans Museum, Rotterdam, formerly Koenig's Collection (Degenhart, fig. 26), that bears four studies of a naked woman done direct from the model, with practically no reference to antiquity either in pose or proportion (the right-hand figure in the pose of the Venus Anadyomene is clearly drawn from life). Almost equally surprising is a drawing from Pisanello's workshop (not from his hand) in the Print Room, Berlin, no. 487 (reproduced in Meder, *Die Handzeichnung,* fig. 155). It shows a naked woman lying, seated, and bending over a washbasin in totally unclassical poses. These two sheets remind us how little our scanty evidence permits us to know of the background of *quattrocento* art.

One drawing of nude figures used to form an academic composition is in the National Museum, Stockholm, inv. 11 (cf. BB *Drawings of the Florentine Painters,* no. 2779K). It is reproduced in Meder, *Die Handzeichnung,* fig. 304. Although Berenson classifies it as "school of Uccello," I believe that such studies as these were also common in the more conservative workshops. Similar drawings are attributed to Benozzo Gozzoli (e.g., BB, 445A); and the nude figures in the background of the *Adoration* in the National Gallery, Washington, now considered a joint work of Fra Angelico and Filippo Lippi, may derive from academic studies of this kind. Berenson (176E) also classes with "following (in the widest sense of the word) of Fra Angelico" one of the earliest nude drawings of a woman, British Museum, *Catalogue* (1950), no. 273, pl. CCXXXVI. The foreshortened hand and tall headdress show us that this was inspired by a *kalathiskos* dancer similar to one on the Grimani pedestal in the Museo Archeologico, Venice, and probably known to the draftsman from a piece of Aretine ware (cf. Rizzo, p. 45). A similar use of the antique is to be found in a drawing, also in the British Museum (*Catalogue* [1950], 152), inspired by *The Horse Tamers* of the Quirinal, which seems to come from the same Benozzo-Filippo Lippi circle, although Berenson (986) attributes it to Granacci.

The origin and development of *the écorché figure* deserve to be studied. The earliest surviving examples are in drawings by

Leonardo da Vinci (e.g., Windsor, 12625, 19003 r. and v.,
19013 v., 19014 r. and v.); but several drawings from the fol-
lowing of Antonio Pollaiuolo e.g., British Museum, *Catalogue,*
226) suggest that *écorchés* from his hand once existed. There is
a long-standing tradition that Michelangelo made an *écorché*
figure, known as *La Notomia di Michelangelo* (cf. G. G. Bottari in
his edition of Vasari's *Vita di Michelangelo,* p. 172). Dr. Wilde
tells me that three drawings at Windsor (nos. 439–41), which
he now ascribes to Michelangelo, and two at Haarlem, Teyler
Museum (K. Frey and F. Knapp, *Die Handzeichnungen Michel-
agniolos Buonarroti,* nos. 333, 334), imply that the tradition is
correct. Michelangelo probably made small anatomical models
of parts of the body similar to those in the Victoria and Albert
Museum (4109 to 4113–1854), and these seem to be referred to
in a letter from Sebastiano del Piombo (G. Milanesi, *Les Cor-
respondants de Michel-Ange,* p. 100). But if he had made an
écorché figure of any size, such an important event in the artistic
life of sixteenth-century Italy would surely have been recorded.
The tradition that Marco d'Agrate's figure of St. Bartholomew
of 1562, in Milan Cathedral, admired by generations of tourists,
including Mark Twain in *Innocents Abroad,* was based on a model
by Michelangelo is first recorded by F. Le Comte, *Cabinet des
singularitez.* This figure, which scarcely deserves its notoriety,
has no obviously Michelangelesque characteristics. On the other
hand, Cigoli's bronze *écorché* in the Bargello does recall, both in
pose and physiological type, some of the Leonardo drawings in
Anatomical MS. A, Windsor, 19003, V, and suggests that an
échorché model from his hand may once have existed.
Raphael's compositions of nude figures. An interesting point is raised
by a famous drawing in the Albertina (inv. no. 17544) that
shows all the figures in the *Transfiguration* nude. This is certainly
not by Raphael, and the question arises whether it is a copy of
an original drawing or whether some sixteenth-century artist
has translated the *Transfiguration* into nude figures. Meder
(p. 318, n. 2) holds the second view, and uses it to prove the aca-
demic mannerist craze for nudity. In view of the number of
authentic drawings by Raphael in which he has made up
compositions of undraped figures, including two for the *Trans-
figuration* itself, one in the Louvre (O. Fischel, *Raphaels Zeich-
nungen,* no. 339) and the other in the Ambrosiana, Milan
(Fischel, no. 340), I am inclined to think that the Albertina
drawing follows a Raphael original.

LIST OF WORKS CITED

[Abbreviations used in the notes: B = Bartsch. BB = Berenson. See below.]

AFÖLDI, A. *Die Kontorniaten, ein verkanntes Propagandamittel der heidnischen Aristokratie in ihrem Kampf gegen das christliche Kaisertum.* Budapest, 1943.

ALBERTI, LEON BATTISTA. *Della Architettura* (Cosimo Bartoli, tr.). Bologna, 1782.

————. *Della Pittura* (Hubert Janitschek, ed.). Vienna, 1877.

————. *De re aedificatoria.* Florence, 1485.

ALEXANDER, CHRISTINE. "A Statue of Aphrodite," *Bulletin of the Metropolitan Museum of Art,* XI, 9 (May, 1953).

ALEXANDER, SAMUEL. *Beauty and Other Forms of Value.* London, 1933.

AMELUNG, WALTHER. *The Museums and Ruins of Rome.* London, 1906.

ANTONSSON, OSCAR ARVID. *Praxiteles' Marble Group in Olympia.* Stockholm, 1937.

BARTSCH, ADAM VON. *Le Peintre graveur.* Leipzig, 1854–70. (Volume given except in case of that on Marcantonio, which is vol. XIV.)

BENVENUTO DA IMOLA, *see* RAMBALDI, BENVENUTO.

BERENSON, BERNARD. *The Drawings of the Florentine Painters.* Chicago, 1938.

BEVAN, EDWYN R. *Holy Images.* London, 1940.

BIEŃKOWSKI, PIOTR. *Die Darstellungen der Gallier in der hellenistischen Kunst.* Vienna, 1908.

BLINKENBERG, CHRISTIAN SØRENSEN. *Knidia.* Copenhagen, 1933.

BLÜMEL, CARL. *Der Hermes eines Praxiteles.* Baden-Baden [1948?].

BLUNT, ANTHONY. *Art and Architecture in France, 1500 to 1700.* Harmondsworth, and Baltimore, 1953.

———. *Artistic Theory in Italy, 1450-1600.* Oxford, 1940.

BODE, WILHELM VON. *Die italienischen Bronzestatuetten der Renaissance.* Small edition. Berlin, 1922.

BORENIUS, TANCRED (ed.). *Rembrandt, Selected Paintings.* London, 1942.

CAGIANO DE AZEVEDO, MICHELANGELO. *L'Antichità di Villa Medici.* Rome, 1951.

CHARBONNEAUX, JEAN. "La Vénus de Milo et Mithridate le Grand," *La Revue des arts,* I (1951).

CHESNEAU, ERNEST. *L'Art et les artistes modernes en France et en Angleterre.* Paris, 1864.

CROWE, JOSEPH ARCHER, and CAVALCASELLE, GIOVANNI BATTISTA. *A History of Painting in North Italy.* London, 1871.

CRUTTWELL, MAUD. *Verrocchio.* London, 1904.

CUTTLE, W. L. "Problems of the Hermes of Olympia," *Antiquity,* VIII, 30 (June, 1934).

DEGENHART, BERNHARD. *Antonio Pisanello.* Vienna [1941?].

DELACROIX, EUGÈNE. *Journal* (André Joubin, ed.). Paris, 1932.

———. *The Journal of Eugène Delacroix* (Hubert Wellington, ed.; Lucy Norton, tr.). London, 1951.

DICKENS, GUY. *Hellenistic Sculpture.* Oxford, 1920.

DOREZ, LÉON. "Nouvelles Recherches sur Michel-Ange et son entourage," *Bibliothèque de l'École des Chartes,* vols. LXXVII, LXXVIII (1916, 1917).

DURRIEU, PAUL. *Les Très Riches Heures du duc de Berry,* Paris, 1904.

EGGER, HERMANN. *Codex Escurialensis.* Vienna, 1906.

EINEM, HERBERT VON. "Zur Hildesheimer Bronzetür," *Jahrbuch der preussischen Kunstsammlungen,* LI (1930).

FAZIO, BARTOLOMMEO. *De viris illustribus.* Florence, 1745.

FISCHEL, OSKAR. *Raphaels Zeichnungen.* Strassburg, 1898.

FOUCHER, ALFRED CHARLES AUGUSTE. *L'Art gréco-bouddhique du Gandhâra.* Paris, 1905–18.

FRANCOVICH, GEZA DE. "L'Origine e la diffusione del Crocefisso Gotico doloroso," *Jahrbuch der Bibliotheca Hertziana,* II (1938).

FRANKFORT, HENRI. *The Art and Architecture of the Ancient Orient.* Harmondsworth and Baltimore, 1954.

———. *Cylinder Seals.* London, 1939.

FRAZER, J. G. (tr.). *Pausanias's Description of Greece.* London, 1898.

FREY, KARL. *Die Dichtungen des Michelangelo.* Berlin, 1897.

———, and KNAPP, FRITZ. *Die Handzeichnungen Michelagniolos Buonarroti.* Berlin, 1925.

FURTWÄNGLER, ADOLF. *Aegina das Heiligtum der Aphaia.* Munich, 1906.

————. *Meisterwerke der griechischen Plastik.* Leipzig and Berlin, 1893.

————. *Masterpieces of Greek Sculpture* (tr. of foregoing; Eugénie Sellers, ed.). New York, 1895.

GALICHON, ÉMILE. "École de Venise. Giulio Campagnola, peintre-graveur du XVIᵉ siècle," *Gazette des Beaux-Arts,* ser. I, vol. XIII (Oct., 1862).

GARDINER, EDWARD NORMAN. *Athletics of the Ancient World.* Oxford, 1930.

GHIBERTI, LORENZO. *Ghibertis Denkwürdigkeiten* (Julius von Schlosser, ed.). Berlin, 1912.

GLASER, CURT. *Zwei Jahrhunderte deutscher Malerei.* Munich, 1916.

GOLDSCHEIDER, LUDWIG. *Michelangelo: Drawings* (R. H. Boothroyd, tr.). London, 1951.

GOLDSCHMIDT, ADOLPH. *Die deutschen Bronzetüren des frühen Mittelalters.* Marburg, 1926.

GOMBRICH, E. H. "Botticelli's Mythologies," *Journal of the Warburg and Courtauld Institutes,* VIII (1945).

GRÜNWALD, ALOIS. "Über die Schicksale des Ilioneus," *Jahrbuch der Kunsthistorischen Sammlungen des allerhöchsten Kaiserhauses.* Vienna, 1907–09.

HAHNLOSER, HANS ROBERT. *Villard de Honnecourt.* Vienna, 1935.

HAUSENSTEIN, WILHELM. *Der nackte Mensch in der Kunst aller Zeiten und Völker.* Munich, 1913.

HIND, ARTHUR M. *Catalogue of Early Italian Engravings Preserved in the Department of Prints and Drawings* [of the British Museum]. London, 1909–10.

HOUBRAKEN, ARNOLD. *De groote Schouburgh der Nederlantsche Konstschilders en Schilderessen.* Amsterdam, 1718–21.

HUELSEN, CHRISTIAN KARL FRIEDRICH (ed.) *Il Libro di Giuliano da Sangallo.* Leipzig, 1910.

JANSON, HORST W. "Titian's Laocoon Caricature and the Vesalian-Galenist Controversy," *The Art Bulletin,* XXVIII (March, 1946).

JEX-BLAKE, K. (tr.). *The Elder Pliny's Chapters in the History of Art.* London, 1896.

KRAMRISCH, STELLA. *The Art of India.* London, 1954.

LANGE, JULIUS. *Die menschliche Gestalt in der Geschichte der Kunst.* Strassburg, 1903.

LAPAUZE, HENRY. *Ingres: sa vie et son œuvre.* Paris, 1911.

LASINIO, GIOVANNI PAOLO. *Raccolta di sarcofagi, urne e altri monumenti di scultura del Campo Santo di Pisa.* Pisa, 1814.

LAWRENCE, ARNOLD WALTER. *Classical Sculpture.* London, 1929.

LE COMTE, FLORENT. *Cabinet des singularitez d'architecture, peinture, sculpture et gravure.* Paris, 1699–1700.

LEVY, G. RACHEL. "The Oriental Origin of Herakles," *Journal of Hellenic Studies,* LIV (1934).

LHOTE, ANDRÉ. *Theory of Figure Painting* (W. J. Strachan, tr.). London, 1953.

LOMAZZO, GIOVANNI PAOLO. *Trattato dell'arte della pittura, scultura ed architettura.* Rome, 1844.

LONGA, RENÉ. *Ingres inconnu.* Paris, 1942.

LONGHURST, MARGARET H. *Catalogue of Carvings in Ivory. Victoria and Albert Museum.* London, 1927–29.

MacLAREN, NEIL. *The Spanish School.* London, 1952.

MARTINE, CHARLES. *Ingres: soixante-six reproductions.* Paris, 1926.

MATSULEVICH, LEONID ANTONOVICH. *Byzantische Antike.* Berlin, 1929.

MEDER, JOSEPH. *Die Handzeichnung.* Vienna, 1919.

MESNIL, JACQUES. "Masaccio and the Antique," *The Burlington Magazine,* XLVIII (February, 1926).

MICHIEL, MARCANTONIO. *The Anonimo* (Paolo Mussi, tr.; George C. Williamson, ed.). London, 1903

MILANESI, GAETANO (ed.). *Les Correspondants de Michel-Ange.* Paris, 1890.

MOMMSEN, THEODOR. "Über die Berliner Excerptenhandschrift des Petrus Donatus," *Jahrbuch der preussischen Kunstsammlungen,* IV (1883).

MUNZ, LUDWIG. *Rembrandt's Etchings.* London, 1952.

MUTHMANN, FRITZ. *Statuenstützen und dekoratives Beiwerk.* Heidelberg, 1951.

NORTH, S. KENNEDY. "Titian's Venus at Bridgewater House," *The Burlington Magazine,* LX (March, 1932).

PALLUCCHINI, RODOLFO. *Sebastiano Viniziano.* Milan, 1944.

PANOFSKY, ERWIN. *Studies in Iconology.* New York, 1939.

PAPINI, ROBERTO. "Le Collezione di sculture del Campo Santo di Pisa," *Bollettino d'arte,* IX (1915).

PATER, WALTER. *The Renaissance: Studies in Art and Poetry.* London, 1919.

PAULI, GUSTAV. "Raffael und Manet," *Monatshefte für Kunstwissenschaft,* I (1908).

PAUSANIAS, *see* FRAZER, J. G.

PAYNE, HUMFRY, and YOUNG, GERARD MACKWORTH. *Archaic Marble Sculpture from the Acropolis.* London, 1936.

PEIRCE, HAYFORD, and TYLER, ROYALL. *L'Art byzantin.* Paris, 1932–34.

PELS, ANDRIES. *Gebruik en misbruik des tooneels.* Amsterdam, 1681.

PICARD, CHARLES. *Manuel d'archéologie grecque. La Sculpture.* Paris, 1935–54.

————. *La Sculpture antique des origines à Phidias.* Paris, 1923.

PINDER, WILHELM. *Die Pietà.* Leipzig [1922?].

PLANISCIG, LEO. *Venezianische Bildhauer der Renaissance.* Vienna, 1921.

PLINY, *see* JEX-BLAKE, K.

POPHAM, A. E., and WILDE, JOHANNES. *The Italian Drawings of the XV and XVI Centuries in the Collection of His Majesty the King at Windsor Castle.* London, 1949.

POUNCEY, PHILIP. "A Study by Sebastiano del Piombo for *The Martyrdom of St. Agatha,*" *The Burlington Magazine,* XCIV (April, 1952).

RAMBALDI, BENVENUTO, DA IMOLA. *Comentum super Dantis Aldighierij comoediam.* Florence, 1887.

REIL, JOHANNES. *Christus am Kreuz in der Bildkunst der Karolingerzeit.* Leipzig, 1930.

REINACH, SALOMON. *Répertoire de reliefs grecs et romains.* Paris, 1909–12.

————. *Répertoire de la statuaire grecque et romaine.* Paris, 1897–1904.

RICCI, CORRADO. *Correggio: His Life, His Friends, and His Time* (Florence Simonds, tr.). London, 1897.

RICHTER, GISELA M. A. *Kouroi.* New York, 1942.

————. *Three Critical Periods in Greek Sculpture.* Oxford, 1951.

RIZZO, GIULIO EMANUELE. *Thiassos.* Rome, 1934.

ROBERT, CARL, and RODENWALDT, GERHART. *Die antiken Sarcophagreliefs.* Berlin, 1897–1952.

ROBERT DE CLARI. *The Conquest of Constantinople* (E. H. McNeal, ed.). New York, 1936.

ROSSI, DOMENICO DE, and MAFFEI, PAOLO ALESSANDRO. *Raccolta di statue antiche e moderne.* Rome, 1704.

ROY, MAURICE. *Artistes et monuments de la Renaissance en France.* Paris, 1929–34.

RUSKIN, JOHN. *Works* (E. T. Cook and Alexander Wedderburn, eds.). London, 1903–12.

SALIS, ARNOLD VON. *Antike und Renaissance.* Erlenbach [1947?]

SCHLOSSER, JULIUS VON. *Schriftquellen des frühen Mittelalters.* Vienna, 1891.

SHAPLEY, JOHN. "Recent Contributions to Art History," *The Art Bulletin,* II, 2 (December, 1919).

SIEVEKING, JOHANNES. "Griechische Bronzestatuette eines nackten Mädchens im Münchner Antiquarium," *Münchner Jahrbuch der bildenden Kunst*, V (1910).

SILVESTRE, THÉOPHILE. *Histoire des artistes vivants français et étrangers*. Paris, 1856.

STRATZ, CARL HEINRICH. *Die Körperformen in Kunst und Leben der Japaner*. Stuttgart, 1919.

SWARZENSKI, HANNS. *Monuments of Romanesque Art*. Chicago, 1954.

THODE, HENRY. *Die Antiken in den Stichen Marcantons*. Leipzig, 1881.

TIETZE, HANS, and CONRAT, ERICA. *Mantegna: Paintings, Drawings, Engravings*. London, 1955.

TOLNAY, CHARLES DE. *Michelangelo*. Princeton, 1943–54.

VASARI, GIORGIO. *Vita di Michelangelo* (Giovanni Gaetano Bottari, ed.). Rome, 1760.

———. *Le Vite de' più eccellenti pittori, scultori ed architettori* (Gaetano Milanesi, ed.). Florence, 1878–85.

VENTURI, ADOLFO. *Storia dell'arte italiana*. Milan, 1901–39.

VETH, JAN, and MÜLLER, S. *Albrecht Dürers niederländische Reise*. Berlin, 1918.

WICKHOFF, FRANZ. "Die Andrier des Philostrat von Tizian," *Jahrbuch der preussischen Kunstsammlungen*, XXIII (1902).

WILDE, JOHANNES. *Italian Drawings in the Department of Prints and Drawings in the British Museum*, vol. I: *Michelangelo and His Studio*. London, 1953.

———. *Michelangelo's "Victory."* London, 1954.

WILDENSTEIN, GEORGES. *Ingres*. London, 1954.

WIND, EDGAR. *Giovanni Bellini's Feast of the Gods: a Study in Venetian Humanism*. Cambridge, 1948.

WINDELS, FERNAND. *The Lascaux Cave Paintings*. London, 1949.

WINKLER, FRIEDRICH. *Die Zeichnungen Albrecht Dürers*. Berlin, 1936–39.

WITTKOWER, RUDOLF. *Architectural Principles in the Age of Humanism*. London, 1949.

ZANETTI, ANTONMARIA. *Varie Pitture a fresco de' principali maestri Veneziani*. Venice, 1760.

ZERVOS, CHRISTIAN. *L'Art de la Mésopotamie*. Paris, 1935.

A page number preceded by an asterisk indicates an illustration. A page number preceded by N indicates a note for that page; see pp. 475–523 for the notes.